THE BOOK OF FORGOTTEN CRAFTS

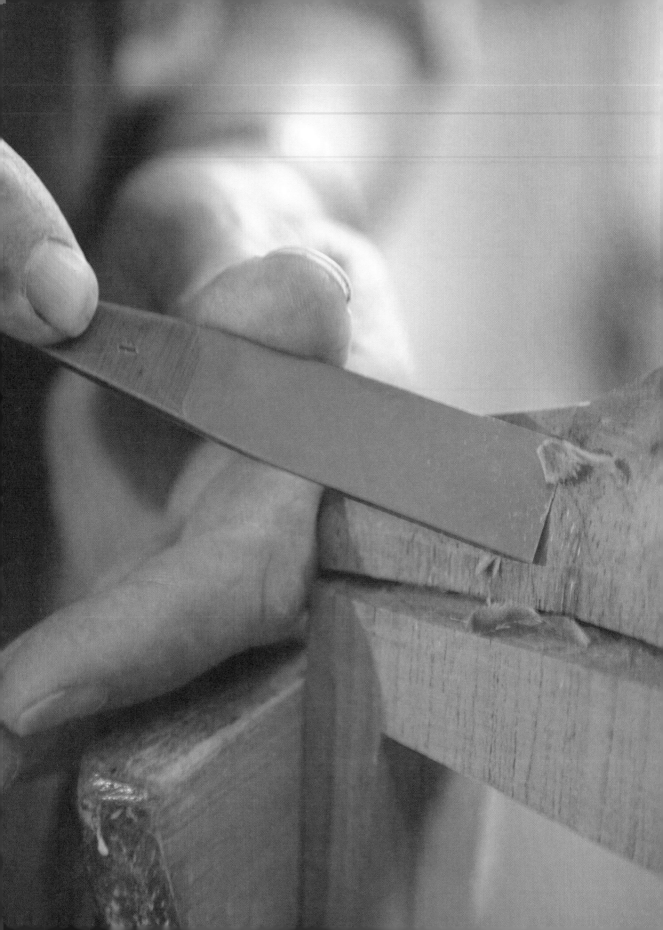

THE BOOK OF FORGOTTEN CRAFTS

PAUL FELIX, SIÂN ELLIS, TOM QUINN

D&C
David and Charles

A DAVID & CHARLES BOOK
Copyright © David & Charles Ltd, 2011

David & Charles is an F+W Media, Inc. Company
4700 East Galbraith Road Cincinnati, OH 45236

First published in the UK in 2011

Text © Sîan Ellis, Tom Quinn, 2011
Images © Paul Felix

Paul Felix, Siân Ellis and Tom Quinn have asserted their right
to be identified as author of this work in accordance with the
Copyright, Designs and Patents Act, 1988.

The illustrations in this title were originally published in *The
Complete Practical Book of Country Crafts*, by Jack Hill (D&C,
1979).

Photographs on pp34–39 were taken at Clyston Mill courtesy of
the National Trust

A catalogue record for this book is available from
the British Library.

ISBN 13: 978-0-7153-3831-5
ISBN 10: 0-7153-3831-5

Printed in China by RR Donnelley
For David & Charles Ltd
Brunel House, Newton Abbot, Devon, TQ12 4PU

Commissioning Editor: Neil Baber
Editor: Verity Muir
Art Editor: Kevin Mansfield
Proof reader: Val Porter
Production: Bev Richardson

David & Charles publish high quality books on a wide range of
subjects. For more great book ideas visit: www.rubooks.co.uk

Contents

Foreword

This book is very timely. There seems to be a great resurgence of interest in traditional trades and crafts and perhaps the most important aspect of the book, and the work of the people it features, is that it is inspirational.

Reading the stories of these talented individuals, it often seems to be a chance encounter that set them on the path to master their particular skill. What follows is years of dogged determination – almost obsessional – driven as much by the desire to really understand their raw materials and difficult techniques as by the need to earn a living.

Whilst traditional craftspeople share dedication, above all, to their materials,

skills, and the pursuit of excellence, they also share the fact that they are an intrinsic part of our heritage. Smith is our most common surname and the Potters, Turners, Dyers, Thatchers and Wrights show that we were a nation of craftspeople. We seem to be only just realising that these skills, passed down through many generations, are as much a part of our heritage as our historic buildings and monuments, and it is our duty to ensure this inheritance is passed on to the next generation.

Who knows, perhaps this book will be the chance encounter that sets a new generation of craftspeople on their own inspirational journey.

Robin Wood
Chair
Heritage Crafts Association

Introduction

Craftsmen and crafts have been in my life since, as a young boy, I watched my carpenter father build a large model of HMS *Victory*, cutting and carving the wood and even making the cannons and cannon balls. He was a tradesman of the old school like his father before him – not a craftsman, he insisted, but a tradesman; I think it is a very fine line where one stops and the other starts.

I didn't follow him. Instead I became a photographer, first for newspapers in London, then for magazines and colour supplements. Over the years I found myself on assignments photographing craftsmen all over the country and became fascinated by their work. As the newspaper and magazine worlds changed they largely forgot about crafts, but by then the subject had become a special interest for me so I continued to seek out and photograph traditional craftsmen whenever I could.

Gradually I built up a large photographic library and continue to add to it all the time. On my photographic trips for this book I took with me either Sîan Ellis or Tom Quinn, my long-time collaborators and fellow craft fans, who got the craftspeople to talk and explain their life and methods.

What never fails to impress me is the commitment of the craftspeople I meet. They have unrivalled knowledge of their subject and the tremendous skill that comes of focusing on their chosen work for many years, but they also have an intense passion for what they do. In many cases they are continuing a long tradition of craftsmanship that stretches back into the mists of time, often using the simplest of tools and methods that would have been familiar to their counterparts centuries ago. That is not to say that in some cases they have not taken advantage of modern technology, however, that does not stop the products they make from being thoroughly hand crafted.

My father was shown the way by the previous generation, but that chain has largely been broken and the skills are in danger of being lost altogether. That's what makes the dedication of the people in the pages of this book so important. It is heartening to see a number of younger craftsmen starting out, often following a family tradition, and I hope this book will help to encourage more people of all ages to take an interest and get involved.

Paul Felix

VILLAGE
WORKSHOP CRAFTS

The Wheelwright

WHEELWRIGHTS & COACHBUILDERS

'The wheelwright was always referred to as the King of Carpenters,' Greg Rowland says. 'A lot of people struggle to work in a circle, there are so many angles to get right and there aren't any square joints. If you have a 12 spoke wheel, for example, you have 31 joints that all have to be perfect. We work to an age-old formula.'

A look around the workshop and grassy courtyard of Mike Rowland & Son – Greg is the son – instantly highlights the diversity of this family business in Colyton, Devon: in addition to giant wooden wheels, there could be farm wagons, gypsy caravans, a show dray, handcarts and cannons, either awaiting repair or being built. As Royal Warrant Holders to Her Majesty the Queen in the position of Wheelwrights and Coachbuilders, an honour received in 2005, the Rowlands' enterprise is also called upon to help maintain world heritage vehicles in the Royal Mews.

'We aren't allowed to talk about the royal work we do,' Greg says. 'But with regards to the rest, we make wheels and vehicles for every imaginable purpose. Our customers are private individuals, farmers, military and naval, museums and film companies. We've made Roman trebuchet wheels for a period film and my father was adviser on wagons and heritage to *The French Lieutenant's Woman* [filmed in Lyme Regis in 1980].'

{ *Our customers are private individuals, farmers, military and naval, museums and film companies* }

A FAMILY TRADITION

Woodworking has been in the Rowland family at least since the mid 1700s and there is a suggestion that links go farther back even than this.

'The wheelwright who made the wheels on the wagons that carried stone to build Exeter Cathedral in the 1100s was called Edward de Rowland and he lived in Colyton. So we've been at it a fair old while,' Greg says with classic understatement.

In the modern era his father Mike, now in his 70s and still busy working, set out as a carpenter and joiner.

'I was taught by men who learnt their trade in the Victorian period,' Mike says. 'We did everything, including coffins. But I was always the one who had an aptitude for curved work, like stairs and bay windows, and I used to repair wheels for gypsies. That's how it all started.'

In 1964 he set up independently as a wheelwright and coachbuilder. Greg, who joined him 19 years ago following a stint in the Army and a period running his own forge, says, 'There are always new things to learn. I'm probably half way through a 40 year apprenticeship.'

RIGHT *Mike Rowland Wheelwrights & Coachbuilders was established in 1964 and produces wheels and vehicles to the highest standards.*

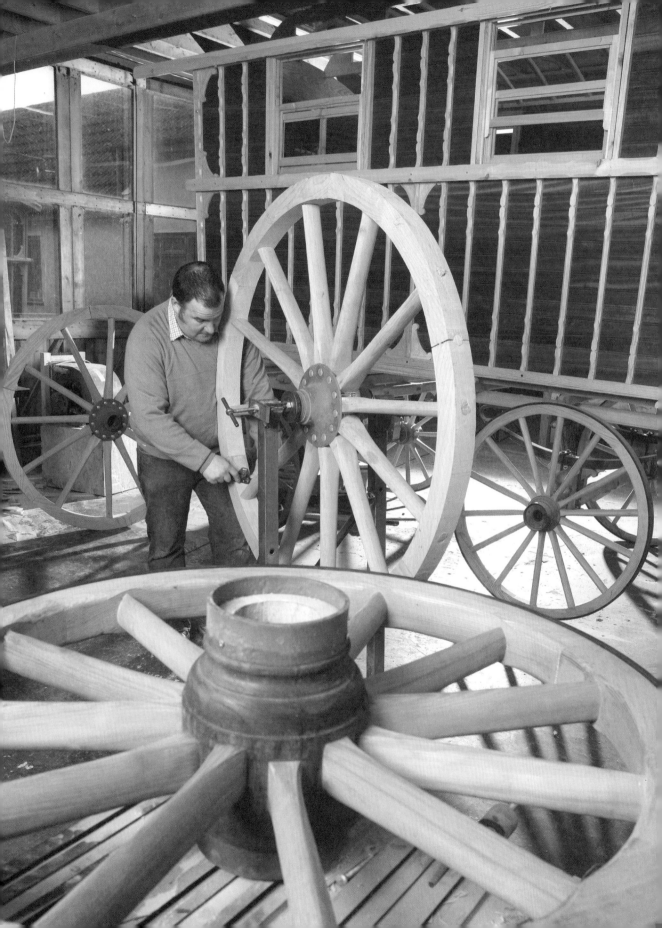

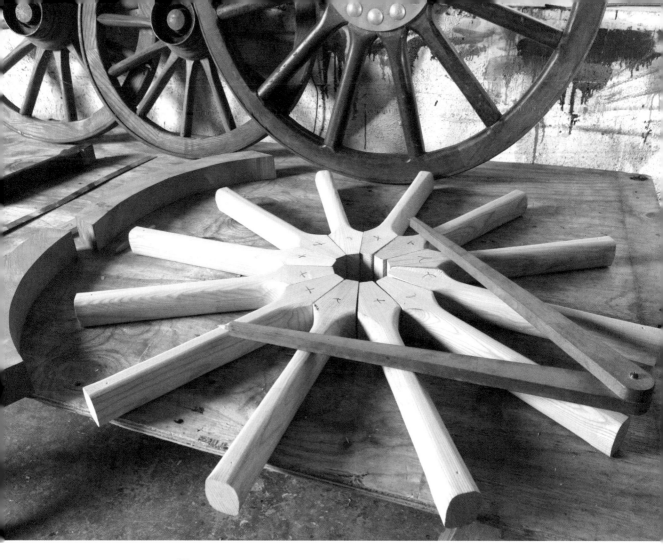

THE MODERN WHEELWRIGHT

In days gone by when there was a wheelwright in most towns and villages, trainees were apprenticed for seven to ten years, then often went from workshop to workshop as 'improvers'. In rural areas wheelwrights usually made carts and wagons, too.

'Today there are probably just two or three wheelwrights working on our scale in the country, although there must be around 50 who work part time or maybe have another job,' Greg says.

This contrasts starkly with 1911 Census figures – at the heyday of the working horse – of 23,785 wheelwrights active in England and Wales. But while motorised transport has ousted horsepower on road and farm, recently new wheelwrighting markets have evolved as veteran vehicles have been renovated for museums and commercial uses like weddings. Carriage racing has gained in popularity and even in agriculture there is renewed demand from some quarters.

'We've had a few farmers come to us,' Greg says. 'There's one in Land's End who is turning to horsepower and we've worked on wagons for haymaking and seed drilling.

'Regulations make it almost impossible to employ apprentices these days and there is no longer any formal national apprenticeship scheme. But I do think there is a future for wheelwrighting,' he adds.

ALTERATIONS THROUGH HISTORY

The saying, 'you can't reinvent the wheel', is literally true, although there have been a few improvements over millennia. No one knows who first used a stone or log to roll something along, but solid wheels fashioned from three planks c. 5,000BCE were found in Mesopotamia. By 2,000BCE more robust, lighter, spoked wheels were being used in Asia Minor. The rims of these were made from sections of wood, now called felloes or fellies, which were curved into a circle. From around 1,500BCE the rims were fitted with metal bands, or tyres, which made them far more durable on rough tracks.

> *The saying, 'you can't reinvent the wheel', is literally true, although there have been a few improvements over millennia*

'The Romans and Saxons were very good at making wheels with spokes and continuous tyres, then we lost the technology or people didn't want to bond their wheels in that way,' Greg says. 'They made the metal tyre in sections or strakes and these were nailed onto the rim, called straking. That went on until about the 1940s because farmers thought it gave the wheel better grip. It doesn't and it's better to put on a continuous band.

'There is a tradition for using certain timber for certain parts of the wheel,' he continues. 'The hub, also called the naff, nave or stock depending where you come from, is made of elm, because the grain is locked and won't rip apart. Oak is used for the spoke, and ash, which is tough but flexible, for the fellies.

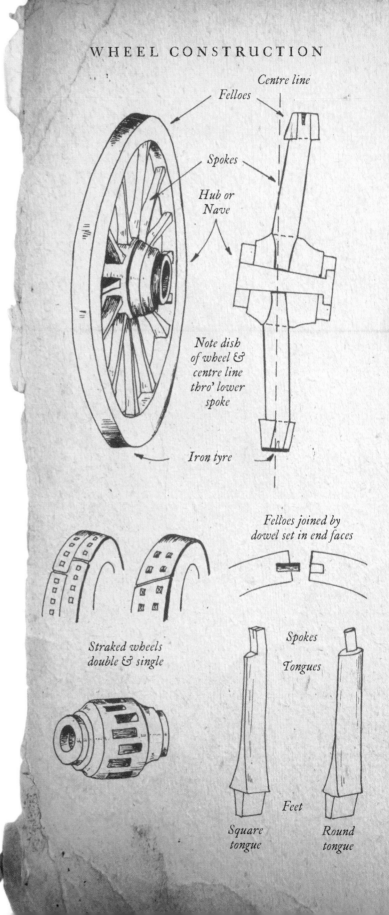

WHEEL CONSTRUCTION

Centre line

Felloes

Spokes

Hub or Nave

Note dish of wheel & centre line thro' lower spoke

Iron tyre

Felloes joined by dowel set in end faces

Straked wheels double & single

Spokes

Tongues

Feet

Square tongue

Round tongue

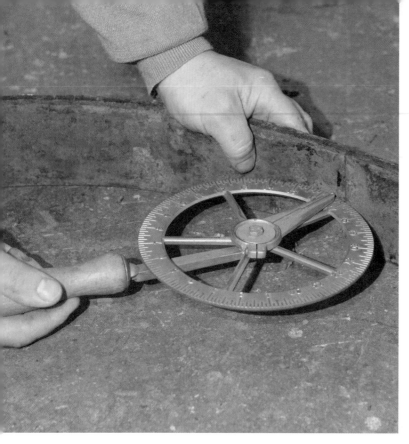

*the wheel is hot bonded,
a scene that fills the
courtyard with the
adrenaline-inducing sight,
sound and smell of flames,
steam and hissing.*

'In reality, people used what was available. We now tend to use ash for the spokes, because people find oak too expensive.'

Electricity in the workshop strikes a modern note, but otherwise tools of the trade are those that have always been used, including spokeshaves, drawknives, callipers and a traveller – a small, calibrated wheel for measuring the circumference of the wheel.

CONSTRUCTING THE WHEEL

Work is done without written plans. 'You know what overall size the wheel needs to be and the number of spokes. The only pattern we make is for cutting the fellies,' Greg says.

The hub is turned on a lathe and mortised to receive the wooden spokes, which have been shouldered, or flared, so that they will sit down on their tenons. The other ends of the spokes are 'tanged' with a hollow auger and the fellies, shaped to form a perfect circle, are fitted. Neighbouring fellies are joined to each other with oak pegs or dowels.

Viewed edgeways on, the wheel is slightly saucer shaped with its concave face on the outside: this 'dishing' is achieved by careful angling of the spokes into the hub and gives the extra strength needed to withstand the sideways motion and jolts of the vehicle. Crucially, each spoke is vertical when it is upright between the ground and hub and carrying maximum weight.

Next, the wheel is hot bonded, a scene that fills the courtyard with the adrenaline-inducing sight, sound and smell of flames, steam and hissing. A steel tyre, which has been welded slightly smaller than the

ABOVE *The wheels are measured with a traveller ready for bonding.*
RIGHT *After seasoning the felloes are trimmed down to their final size and shape.*

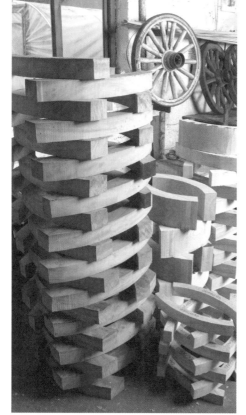

Traveller

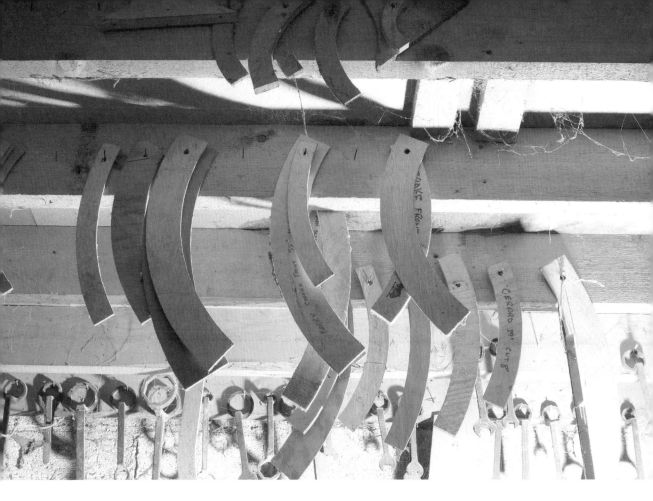

circumference of the wheel's wooden rim, is heated in a fire so that it expands. Then it is lifted with tongs, swiftly fitted around the wheel and, before it begins to burn the wood, quenched with water so that it shrinks tightly on the rim. All the preceding measurements, calculations of gaps and shrinkage need to have been absolutely accurate.

'You get a feel for it. In this trade, if it looks right, it is right,' Greg says.

This basic procedure is followed for most wheels, with variations according to use. The Rowlands have previously made authentic replica oak wheels – each weighing more than half a tonne – for cannon used at the 17th century siege of Londonderry, now in pride of place on the city walls. And there have been English Civil War cannon wheels that had to be straked and nailed.

The bulk of the vehicles they work on are restorations and repairs, although they have recently built from scratch two gypsy-type caravans: no plans were drawn up for panels, boards, joints and wheels because Mike conceived everything in his head.

The key thing to remember when building is, Mike says, 'You're governed by horsepower and you don't want to kill your horse, so you need to build vehicles as lightly as possible. You shave off all the timber: it's rather like the bones in the body, where the joints are fixed but the bones taper in the middle, and it gives them a spring. We normally shave off an eighth of the weight of a wagon just by chamfering and so on. We won't let a vehicle out of the shop unless we can push it along with one finger.'

ABOVE *The usual practice is to work to shapes pencilled in from one of the dozens of felloe patterns kept in the wheelwright's shop.*

The Cooper

ALASTAIR SIMMS

A roll around a Yorkshire brewery yard in a 54 gallon hogshead slop-full of stale ale and wood shavings is not for the fainthearted. But Alastair Simms gives a hearty laugh when he recalls the traditional 'trussing-in' ceremony back in 1983 that marked the end of his four year bound apprenticeship to become a journeyman cooper.

'It's a rite of passage that has been carried on for centuries. An apprentice also used to have to ask his boss, the master cooper, for permission if he wanted to have a girlfriend, a fiancée, or get married, have a mortgage and a child. That no longer applies, but it did when I was an apprentice; it taught respect for your boss.'

> *An apprentice used to have to ask his boss, the master cooper, for permission if he wanted to have a girlfriend*

Times move on and since 1995 Alastair has been master cooper at Wadworth brewery in the Wiltshire market town of Devizes, lured south from his native Yorkshire by his liking for the company's 6X beer, he claims. Every day he makes and repairs oak casks using coopering techniques that can be traced back via Egyptian tomb paintings to 2,690BCE.

'The earliest coopering evidence in Britain dates from the late Iron Age, and the Romans were great users of casks to transport wine,' Alastair says. By the Middle Ages the cooper's trade was thriving, called upon to provide containers for all manner of wet and dry goods, from liquors and

vinegar to flour and Navy gunpowder. Any couple setting up home would visit their local cooper to buy their day-to-day utensils: buckets and bowls, dolly tubs for laundering, a churn for making butter and casks for home brewed ale.

'People often refer simply to barrels, but in the brewery trade a barrel specifically means a 36 gallon cask,' Alastair says. 'The word first came into use in Norman times and derived from France. Other cask names show the early Dutch influence on our beer industry – the hogshead, a kilderkin at 18 gallons, a firkin, which holds 9 gallons and a pin, which is 4.5 gallons. The other measures are a puncheon at 72 gallons and a butt at 108 gallons.'

The proliferation of brew houses in the 16th century brought the brewery trade into dispute with coopers' guilds: the latter, wishing to maintain their monopoly of business, insisted brewers bought their casks from independent cooperages; the brewers preferred to entice the best coopers, expert in making liquid-tight casks, into direct employment. The argument went to Parliament where the Coopers' Company furthered its cause by bribing the Lord Chancellor with half a butt of malmsey in 1533. Wrangling and liquid inducements continued for three more decades and, although a well watered Parliament found in the guilds' favour, the brewers disregarded the judgments: they simply employed

RIGHT *England's last remaining master brewery cooper Alastair Simms began working as an apprentice cooper on his 16th birthday and finally achieved the rank of master in 1994.*

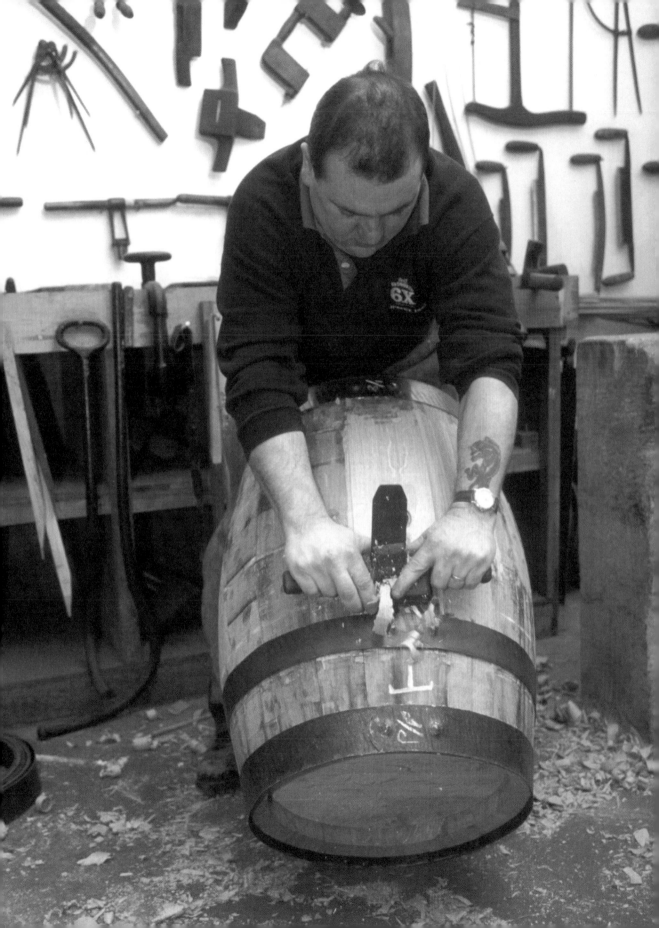

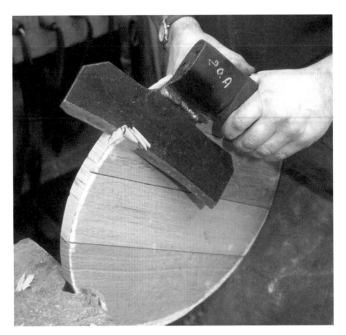

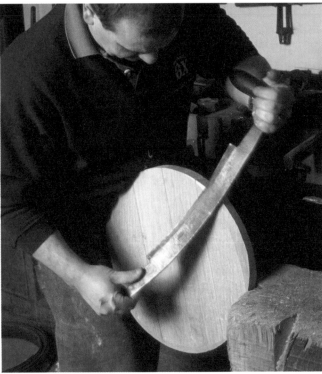

coopers on a piecework system.

It is estimated that there were thousands brewery coopers working in Britain in the first half of the 20th century. 'Today there are just four and I'm the only master brewery cooper – that means a journeyman cooper who has had an apprentice,' Alastair says. 'Since 1965 metal casks have been used in a big way and so there's been a huge decline in brewery cooperage. But I think beer conditions better in wood, because the temperature is more stable and so the ale is more natural tasting.'

Alastair originally wanted to be a carpenter and joiner, but a school holiday job at Theakston's brewery in his hometown

{ For the trial period and the first two years of your apprenticeship you are not allowed to use any electrical tools }

of Masham got him interested in coopering. At the age of 16, after a six month trial, he signed his indentures and began his apprenticeship.

'For the trial period and the first two years of your apprenticeship you are not allowed to use any electrical tools whatsoever. Everything has to be done by hand,' he says. 'It really teaches you the skills.'

Over the years he has had two apprentices, inheriting one of them in the will of his former master, Clive Hollis, who died in 1998. 'It used to be standard practice for a master to leave any apprentice to someone in his will, so he could continue training,' he says.

MAKING THE CASK

Deep inside the Victorian tower building of Wadworth brewery Alastair's cooperage is stuffed full of beechwood and metal tools that hint at the complexity of cask making: axes and adzes, topping planes, knives by the dozen,

ABOVE (top) *Each head is made by dowelling a number of planks of wood together and cutting a circle from the result.* ABOVE *Alastair saws out the circle, then uses the adze and the heading knife to cut out the bevel around the upper and lower edges.*

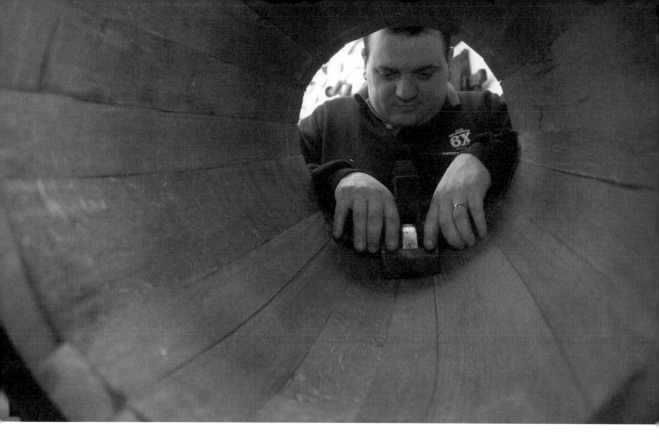

ABOVE *Once the staves are bent, the truss hoops are removed and then four or six permanent mild-steel hoops are hammered into place and Alastair heats the cask over a cresset fire of burning shavings to 'set' it. Then it is dressed out to make the insides smooth.*

as well as more graphically named pieces like the knocker-up, a bent iron bar that is inserted through the cask's bunghole to slug the top cask head into place. Some are pre-Victorian and Alastair maintains, 'Old, second-hand tools are better quality and more comfortable.'

As the mid-morning ferment of rich ale aromas percolates through the window, he demonstrates the basics of making a cask, though he says with a grin, 'The age-old cooperage laws of secrecy mean I can't show you exactly how I make them.'

He begins by 'listing' staves of English oak, cutting and tapering them to size, shaping them with an axe, hollowing with a knife, planing and jointing the edges. When he has sufficient staves, he 'raises' them up in a mild-steel hoop, then softens them in a steam bell for 40 minutes so that they can be bent into the familiar bellied form. The traditional way of doing this,

which Alastair sometimes follows, is to vigorously hammer down wooden truss hoops over the staves, with the smaller hoops pinching the staves in towards the ends of the cask. Alternatively, and in a fraction of the time, he uses a hydraulic bending machine.

Once the staves are bent, he removes the truss hoops, then hammers and rivets four or six permanent mild-steel hoops into place and heats the cask over a cresset fire of burning shavings to 'set' it. 'Then I dress it out to make the insides smooth, adze it up, chiv it and make the heads,' he summarises.

The cask heads are fashioned from jointed planks sealed with 'flag' or reed from East Anglia's Great Ouse. The bevelled edges of the head fits neatly into grooves around the cask that have been cut with a croze, 'which is like a medieval Black & Decker router'. River reed at the back of the grooves keeps the seal tight.

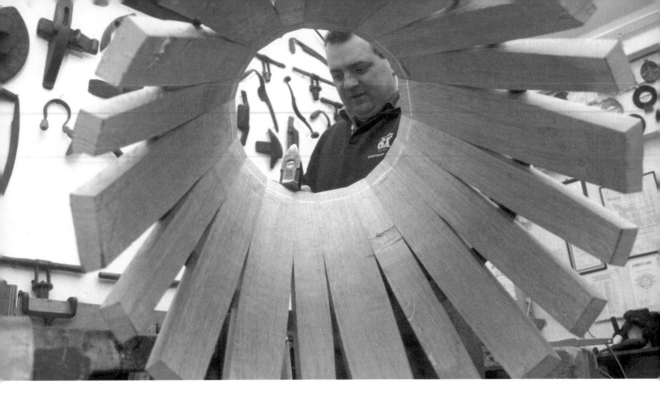

ABOVE *With all the staves dressed, Alastair uses truss hoops to shape up one end of the cask.*

After the outside of the cask has been dressed, silicon brass rings are added to the augered bunghole. Finally, Alastair brands the finished cask with a number and his initials: the block mark issued when he came out of his apprenticeship.

At least that is the simplified description of a process requiring superb eye–hand coordination. The joints Alastair crafts must be accurate to within two thousandths of an inch to avoid leakage of liquid under pressure, and he checks with his eye alone that the belly he is putting into the cask is correct to within a pint's capacity. The heads must be fitted at the right level for the required volume, too, while increasing requests for glass heads demand incredible dexterity to fit without breakage.

Throughout the whole process his most high tech measuring devices are a pair of compasses and metal pins called diagonals. At every stage he is planing off curls of wood and he says, 'I can always tell by the way someone holds an inside shave [a chunky, double-handed plane] if they have the technique and potential to become a cooper. You need a natural talent and to have it nurtured.

'A wooden cask will last 80 years and after that you can cut it down a size and use it again. Coopers are the original recyclers,' Alastair adds. 'We also buy in whisky casks to recycle into beer casks. I turn some old casks into water butts, plant pots and garden furniture, too. It is what has always been done.

'I make and re-make about 1,000 casks a year and we're getting increasing business from the growing English wine trade: there's good potential there, but at the moment there won't be the coopers to meet it.'

Alastair is passionate about keeping alive the skills of his trade. The public can tour the brewery, including the cooperage, and he promotes coopering at agricultural shows, in schools and through The Worshipful Company of Coopers, of which he is a liveryman. He firmly believes there should be greater support for training 'in all heritage crafts'. In the near future he hopes to take on another apprentice and he says with a chuckle, 'I'll observe all the rites of passage.'

SIMPLE COOPERING

1. Cut sufficient staves to size. Make groove for base

2. Mark out taper as required and saw or plane to shape. If power saw and sawing jig used there is no need to mark out

3. Bevel both edges – use suitable bevelling jig and hand plane held upside down in a vice. On power saw or plane set fence to appropriate angle

4. Cut base from any suitable material and chamfer edges as shown left not right

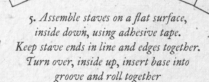

5. Assemble staves on a flat surface, inside down, using adhesive tape. Keep stave ends in line and edges together. Turn over, inside up, insert base into groove and roll together

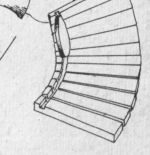

6. If all is well glue up and reassemble

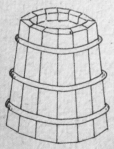

7. Secure with stout rubber bands until glue has set. Use a waterproof glue

8. Dish hoop by hammering on edge

9. When hoop is dished rivet ends together

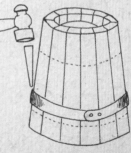

10. Fit hoops from bottom, use hardwood wedge to knock into place

Handles can be fitted (as shown on tankard by dowels)

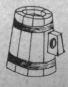

Two staves left long to form handles

The Tanner

J & F J BAKER

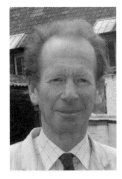

Andrew Parr's family have run their traditional Devon-based leather tanning business since 1864. Since that time little has changed in essentials as Andrew Parr, the current head of the firm, explains:

'We make our leather using traditional methods and ingredients which means we are slower than more modern tanneries but we produce really good quality leather that lasts.'

The process of leather tanning begins with the raw hides and, as Andrew explains, you can't just buy any old hide.

'We only use hides from beef cattle supplied by a hide merchant down here in the South West. Hides from dairy cattle will have been stretched during the cow's lifetime as a result of calving which means they will produce poorer-quality leather.'

When the hides first arrive at the tannery they are still covered in hair on one side and traces of fat on the other. This all has to be removed before the tanning process can begin in earnest. To use the jargon, the hides are first de-haired using a special mixture of lime and water.

'We put the hides into lime pits filled with a mixture of lime – calcium hydroxide – and water which loosens the hair at its roots. It's quite a weak solution but it does the

Our hides are moved by hand every week for three months

trick. The hide then goes through a special machine that removes the loosened hair completely. Once the hair problem has been solved we turn the hides over and use a fleshing machine to remove all the traces of fat.'

As Andrew explains, these early process are vital if the finished product is to meet the company's exacting standards.

'Preparation is time consuming but vital which is why we make sure each hide is just right before we start the tanning process proper.'

The essential ingredient of the company's tanning process is oak bark – nothing else produces the same finished quality. 'It's a bit like making tea,' says Andrew with a smile. 'We buy the oak bark from a specialist suppliers and then grind it down before putting it into pits filled with water to soak out the tan. The resulting liquor, as we call it, then goes up to our tan yard – here there are seventy-two pits. Newly made liquor goes to the top of the yard and into the first pit then, over time, it is gradually pumped back slowly through all the pits one at a time. Our hides are moved by hand every week for three months. They are moved from pit to pit but always moving from the pits with the weakest solution towards the pits containing the really

RIGHT *J & FJ Baker is Britain's only remaining traditional oak bark tannery.*

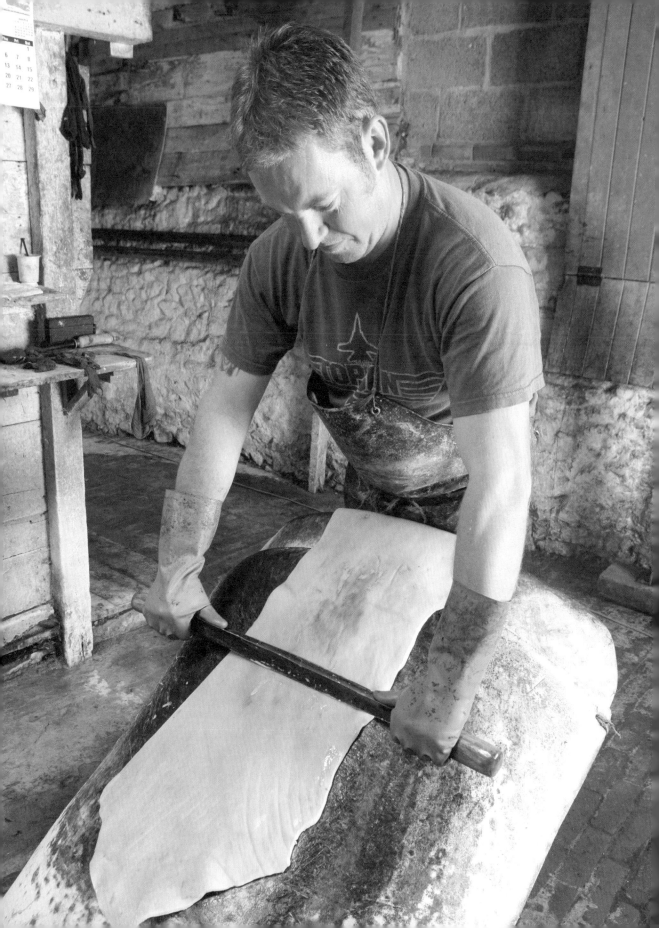

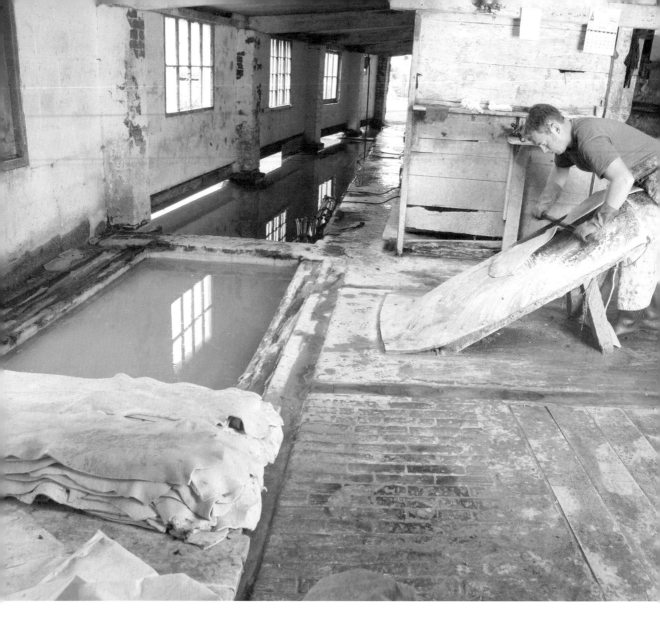

The hides are first de-haired using a special mixture of lime and water.

strong stuff. The process is entirely organic because we only use natural oak and Devon freshwater.'

There is no magic to putting the hides in the solution, they are simply laid one on top of another and the whole process from weak to strong solution takes a year. It is the tannic acid in the bark that converts the raw hide into top-quality leather. In fact tannin is the same chemical that gives red wine its distinctive flavour.

But what is perhaps most remarkable about the Parr's business – he owns the company jointly with his sister – is that it

is the only one of its kind in Britain. Many other companies make leather, of course, but only J &FJ Baker uses the ancient oak bark system.

So why stick to an old-fashioned and rather slow method of tanning leather?

'Modern systems are certainly faster but they have disadvantages – modern chemicals open up the fibres in the hides that reduce the quality where, by contrast, we can keep the natural weave of the fibres in the leather.'

Baker leather is supplied to bespoke shoemakers including some of the most

exclusive in Britain. It also goes to Northampton bench-made shoemakers. These firms produce top quality shoes but in larger numbers and using different techniques from the bespoke makers. The other industry that relies heavily on Baker leather is the top quality equestrian leather industry. The best bridle and stirrup leather will very often have come from Andrew's Devon works.

Remarkably, the company also supplies leather for wall and floor coverings.

Though rebuilt many times, there has been a tannery on the site of J &FJ Baker's Hamlyn Mill since Roman times.

Compared to highly mechanised industries,

> *Modern systems are certainly faster but they have disadvantages – modern chemicals open up minute holes in the hides*

Andrew's firm is something of a cottage industry. They process just sixty hides each week, but the order books are full and, having cornered the market for a product that will always be in demand by the wealthy, there is every chance that J &FJ Baker leather will continue to be made for at least another century.

BELOW **Leather being stained.**

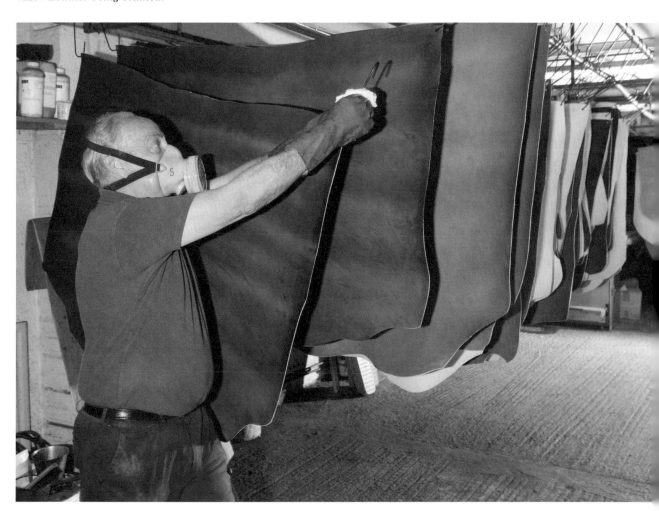

Leather Bottle Maker

PHIL QUALLINGTON

Phil Quallington makes a living from creating leather items such as letter trays and blotters and is not averse to employing modern techniques to produce these in quantity for his clients. But his real interest lies in creating leather bottles, tankards and other items – once the indispensable everyday objects of all – using the same techniques to make them that would have been familiar to his medieval predecessors.

Most of us have probably never used a leather vessel of any kind to contain liquid but before glass was universally and cheaply available, every inn and tavern as well as ordinary households would typically use either pottery or leather jugs and mugs. Leather had the distinct advantage of not breaking and so was much better suited to rough wear or to being carried around.

Not surprisingly Phil's most enthusiastic customers for these items are historians and archaeologists:

'I make them for London theatres, film companies and a lot for historical re-enactment societies. I also supply museums,' Phil says.

Working from a small workshop at Wigmore in Herefordshire he is careful to use only the basic traditional tools and keep his techniques as close to those believed to have been used by the craftsmen whose work he is recreating.

'The earliest leatherworkers made strictly utilitarian goods – clothing, simple shoes and hats, water pouches, along with jugs and mugs,' he explains, 'by Saxon times the technique of moulding leather, forming it into rigid vessels for everyday use was well established.'

To make a jug (known as a 'bombard') or tankard (sometimes called a 'blackjack') Phil first soaks the leather to make it flexible. The basic shapes are cut out using a knife with a curved blade called a 'clicky' and then holes are marked and punched for sewing.

'It takes time to work the leather. You need strong hands and good sharp tools. I always use good leather and all the stitching is done by hand, working with a saddler's clamp between my knees. The excess leather is cut away very close to the stitching for a neat finish,' Phil explains adding that he uses a pricking iron to create the evenly spaced holes, as leatherworkers have done for centuries.

The pricking iron, which is sometimes used, is a multi toothed tool which is pressed onto the leather to mark the position of where it will be sewn. Fitting the first

> *You want it as flexible as possible – it's essentially like working with a wet leather bag*

RIGHT *Phil Quallington at work fixing the leather between his knees with a saddler's clamp*

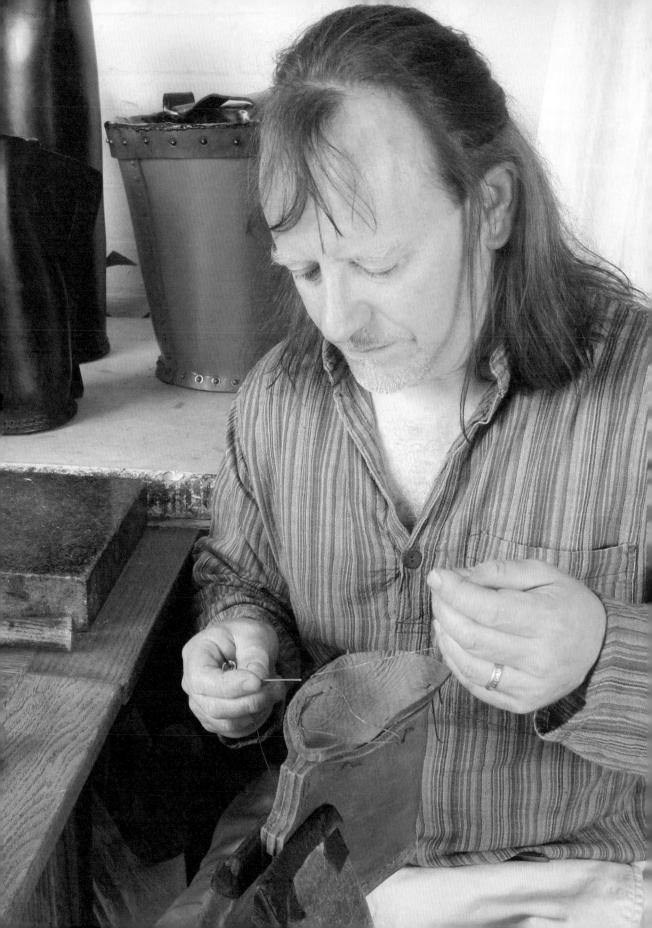

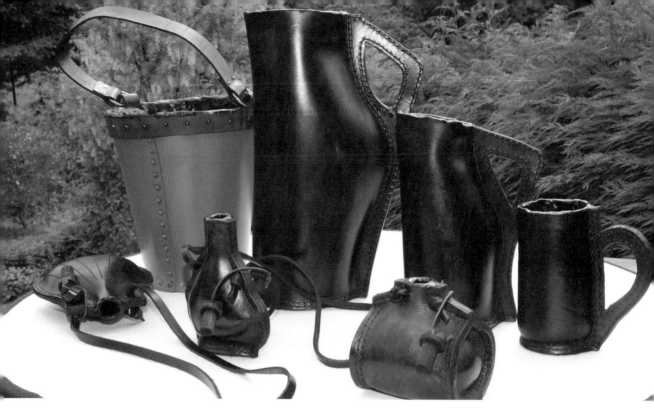

ABOVE *Phil's bombards,*
blackjacks and leather
bottles

prong of the iron into the last mark of the
previous impression keeps the spacing
even. A diamond awl is the used to make
a hole. Phil then holds the leather in place
with his saddler's clamp and stitches it
together by hand.

'The twine I use is made from linen which
is very strong and resilient, but also a
natural and traditional material. It wouldn't
seem right to use nylon. Riveting is a later
technique for joining the leather which I use
on items like my 19th century bucket. For
this I use solid copper rivets.'

Once the bottle is sewn, the leather is
soaked again before starting to pack it with
dry sand to form the final shape.

'You want it as flexible as possible – it's
essentially like working with a wet leather
bag at this point.'

With the leather pliable, dry sand is
gradually driven in and packed using a
wooden block or dolly until the leather
cannot stretch any further. When no more
sand can be packed in, the block is wedged
into the top to create an even spout to the

vessel. The dry sand draws all the moisture
out of the leather and it dries hard in its new
shape. Waterproofing is achieved by lining
the vessel with a layer of bitumen, which is
one area where Phil has had to depart from
traditional technique:

'Originally they used pitch, which is
actually toxic. I use bitumen instead, so my
bottles are absolutely safe to drink from.'

The finish of Phil's vessels is achieved with
a natural leather stain and then waxing to
create their beautiful dark brown
polished sheen.

Re-enactment societies and museums
like very accurate reproductions for obvious
reasons and Phil has recently been called
upon to create items for the the Mary Rose
Trust, the York Civic Trust and Shakespeare's
Globe theatre London for their productions.
This has led to work in the film industry and
Phil's handiwork has starred in the *Pirates*
of the Caribbean films as well as *Troy* and
Alexander and he is now working on several
forthcoming film projects.

As well as the leather bottles and tankards

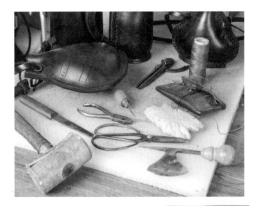

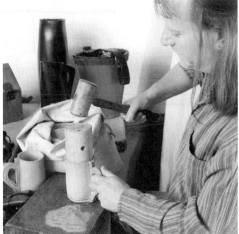

TOP *The tools of a leather workers trade .*
ABOVE *Phil packing dry sand into a tankard*

he is also regularly called upon to make all
sorts of other traditional leather items from
15th-century style jewelry caskets to various
shields, pouches and scabbards using more
complex decorative techniques.

'Leather carving is a bit of a misnomer,' he
says, 'tooling is a better word. What you do is
compress areas of the surface leaving other
areas proud which gives a 3D effect.'

With what seems like an ever-increasing
popular interest in history and the fashion
for historical and fantasy history films Phil's
work is in growing demand. As well as your
local cinema, it is displayed, demonstrated
and traded at castles stately homes and
historic battlefields throughout Britain,
and Phil is often there too giving practical
demonstrations of his craft to rapt audiences.

STITCHING LEATHER

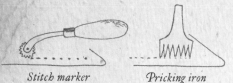

Stitch marker *Pricking iron* *Round awl*

*All used to mark position and line of stitch holes.
Awl used on corners*

Three stitches for hand sewing

Running stitch *Back stitch* *Saddlers stitch*

RIVETING LEATHER

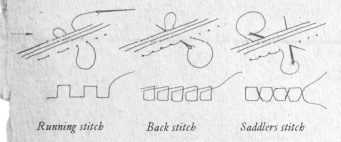

A. *Two piece rivet gives a neat finish both sides.*
B. *Bifurcated or split rivet.*
Hollow punch used for 'setting' rivets.
*Mark and punch hole same size as
rivet shank. Strike with wooden mallet on hard
surface or use a setting punch and 'anvil'*

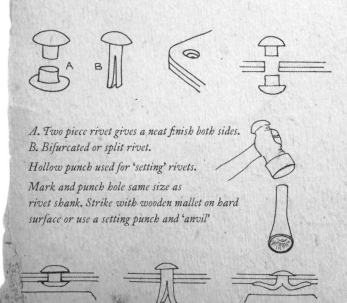

The Papermaker

NEIL HOPKINS

'There are many apocryphal tales about papermaking,' says Neil Hopkins of Two Rivers Paper Company, Pitt Mill in Somerset. 'It was certainly a Chinese invention, about two millennia ago. One contention was that a man watched a wood wasp chewing wood pulp to make its nest – which is effectively paper.'

However papermaking was originally invented, it slowly spread via Asia to Europe and, as the Middle Ages faded, it began to supersede vellum for literary purposes. All paper was made by hand until the early 19th century, when a machine that produced rolls rather than individual sheets was developed.

'Today, Two Rivers is unique in the UK,' Neil says: a commercial hand mill that has also been restored to use waterpower to make paper from old rags in the traditional manner. Its high quality watercolour papers are much sought after by artists and its use of speciality fibres – principally cotton and linen flax, but also seeds, flower petals, hemp, esparto and recycled rag – creates papers with individual texture and character.

The mill itself, in its scenic green Exmoor setting, is 400 years old and retains much ancient wooden machinery. The Two Rivers business, set up in 1976, relocated here under fourth generation papermaker Jim Patterson in 1990.

> *It's a two day production cycle to take a sheet of paper through from start to finish*

'Jim had always been something of an amateur painter and he saw a gap in the market to make very high quality watercolour paper, the like of which would have been available in JMW Turner's day,' Neil says.

'Most paper now sold as art paper is terribly absorbent. Ours – like the older papers – is dipped in gelatin to finish it off, so your colours don't sink into the paper and your picture can look really vibrant. One of the fundamental elements of 18th century watercolour painting was that the paper allowed you to do a lot of correction and lifting out.

'All our paper is made to archival standards,' he adds. 'Paper from wood pulp, which has lignum in, decays over time. Paper made with pure fibres like linen and particularly cotton, which is the purest form of cellulose, will last for hundreds of years.'

Neil began papermaking 12 years ago, after becoming friends with Jim. 'I learnt on the job, though I have a slight technical background. I used to work as an industrial chemist for Cadbury,' he explains. Now he manages Pitt Mill while Jim runs a small early 19th century continuous papermaking machine at a museum in Hemel Hempstead.

On days when Neil is pulping down recycled linen and cotton rags, he opens the sluice gates on the nearby stream and water pours down the leat to turn the 100-year-old 10ft overshot metal mill wheel. This powers

RIGHT *Neil Hopkins of Two Rivers Paper Company, which is one of just a few commercial hand mills still operating in Europe.*

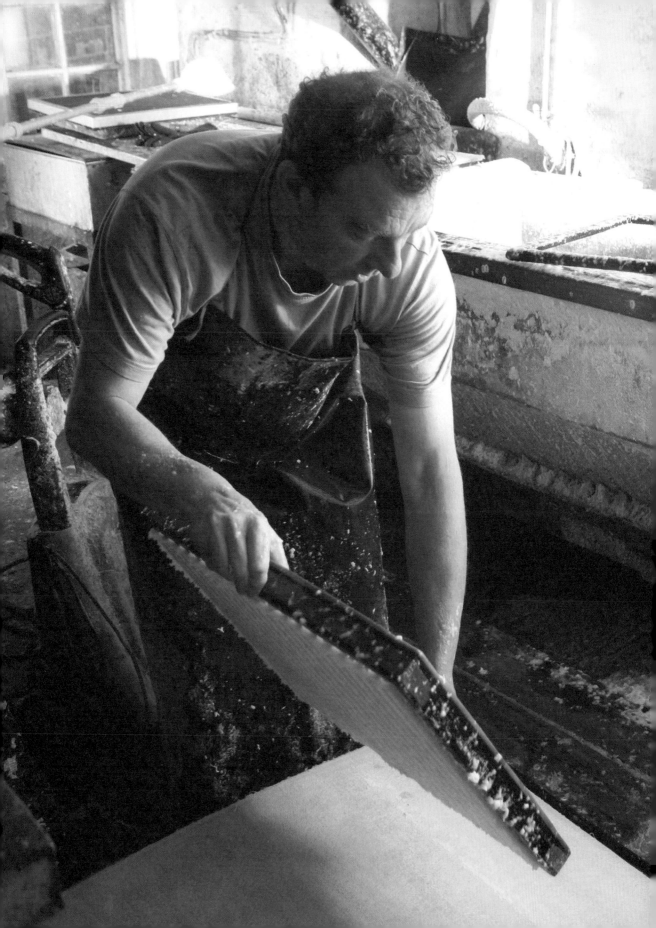

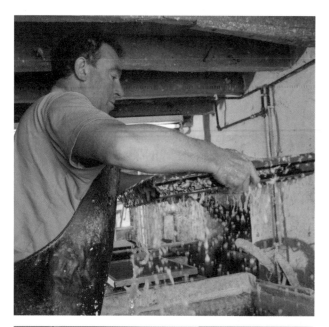

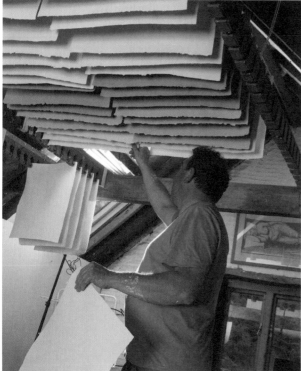

the 1841 Hollander rag-breaker, which, as its name implies, breaks down the rags. In summer, when the water flow from the stream isn't strong enough, he has electrical equipment to fall back on.

'It's a two day production cycle to take a sheet of paper through from start to finish,' Neil explains. 'It's simple but intensive and you need knowledge of fibres. I could teach someone the rudiments of making good paper in a week.' This latter comment, once he has walked you through the processes, raises a wry smile.

PAPER PROCESS

First, he puts the fibres – semi-processed cotton, linen, rag – and water from the mill's well into a huge tank called a stuff chest, where they are pumped around through a beater for about 3 hours. 'The purpose is to open out the fibres. The more you beat the fibres, the more you'll develop the strength of the final paper. Cotton is good because it has long, strong fibres.'

During beating, the fibres are internally 'sized' using pH neutral 'Aquapel': a synthetic wax that will help make the finished paper less absorbent. If the paper is to be coloured, lightfast and permanent pigments are also added.

When the porridge-like stock is the right consistency, it is pumped to a vat. Here the 'vatman' forms each individual sheet of paper using hand moulds and deckles. The moulds are effectively phosphor bronze wire sieves and the deckle is a wooden frame that sits around each mould to create a shallow tray, sized according to the required dimensions of the finished paper. It's the characteristic ragged deckle edge that is a signifier of handmade paper.

Neil dips a mould into the stock, lifts it and sieves the water out, shaking it slightly to even up the pulp left behind. 'It almost wants to make itself: all the fibres immediately connect to each other,' he says. 'With thick papers, you don't need to shake much and it's like a thick porridge. It's much more skilful to make thin papers: if you think of ripples on a pond, that's what it is like, and you have to get an even sheet on a big mould. It's also one of those nasty paradoxes that, although it takes longer and more skill to make thin paper, people don't want to pay more for it!'

And how does he ensure that each sheet, individually sieved, is the same thickness? 'It's done by a simple

ABOVE (top) *The sheets are formed individually using traditional hand moulds and deckles, which give the sheets strength and a characteristic ragged edge.*
ABOVE *Slow air-drying in the rafters of the mill loft completes the process.*
FAR RIGHT *The traditional waterwheel powers a 19th century rag-puping machine within the mill.*

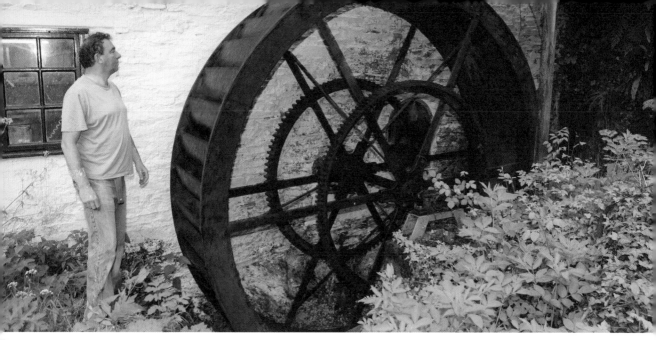

mathematical calculation that begins with the dry weight you measure into the production at the start,' he says. It may be 'simple' but it's long, involving multiplications of the dimensions of the mould, divisions on the side of the vat, and 'a process called mass flow hypothesis that culminates with an equilibrium point'. The crucial skill of feeling what is right in the mould has to be factored in, too.

Each sheet from the mould is pressed off: sandwiched between pieces of felt, which build into a stack or 'post'. This is called 'couching' (pronounced 'cooching'), from the French *coucher*, to lie down. When the post is large enough it is capped off with a wooden board and gently pressed in a hydraulic press.

'Afterwards, the sheets are still about 50 per cent water and quite delicate, but you can lift them off the press,' Neil says.

Upstairs, in the mill loft, the paper is further dried in a restraint dryer before being dipped in gelatin: the all-important surface sizing. Another pressing gets rid of excess gelatin and the sheets are hung in the loft overnight to dry. A fourth and final pressing between dry felt completes the process.

'The finish we produce is called "not", a texture that comes naturally off the felt. The paper hasn't been hot pressed and it isn't polished or glazed,' Neil says.

The mill can produce around 120 sheets of paper a day. Its TR Original and DeNimes papers – flecked with blue denim rag – are core sellers, in a range of sizes, weights and colours. In addition to watercolour painting, they suit

pastels, oils, printmaking, photographic processes and mixed media.

Bespoke papers include watermarked certificate paper; watermarks are achieved through stitching, for example letters, into the face of the mould, to displace the layer of pulp underneath the paper. Requests for stationery have included an order for Rod Stewart's 2007 wedding with Penny Lancaster. And Neil has made many different seed papers by adding viable wildflower seeds into the pulp mix.

'The seeds survive because of the very gentle way we dry the paper. People can cut the paper into cards and the cards literally grow. We can make specific designs or use specific seeds. I did a range of kitchen seeds for one customer, using basil, thyme and oregano.

'Another popular request is paper made with animal poo,' he laughs. 'It started with elephant dung, then people wanted sheep poo, rhinoceros poo, and I've even made paper with reindeer poo and Norwegian spruce for Christmas. You mix a small amount in and it doesn't bear any resemblance to where it has come from. Actually elephant dung has lovely long fibres because the animal's digestive system isn't very effective and a lot passes straight out the back end. It's just a chemical process, after all.'

Such commissions apart, Two Rivers has built and maintains its reputation on quality artists' paper. 'Badly made paper has a lot to answer for; it can make people think watercolour is an insipid art form,' Neil says. 'If you paint on really good paper, pictures dry to a vibrant finish, so I feel we are doing our bit from an aesthetic point of view.'

The Millwright

MARTIN WATTS

Martin Watts is a millstone dresser, although, strictly speaking, his work encompasses far more than that fascinating task, for he is one of the last of the country's traditional millwrights. He can make and repair the wooden cogs and wheels of a wind or watermill as well as setting up and dressing the all-important millstones.

'I have been a working millwright for more than 30 years. A lot of my work on watermills and windmills involves setting up the machinery, making new cogs and of course dressing millstones.

'In a wind or watermill with timber machinery the gear cogs are made of wood and each one is fitted individually; sometimes they are set in iron wheels.'

Martin's interest in old mills started at a time when the idea of preserving these old buildings was still in its infancy.

'Back in the late 1960s when I started there was a growing movement to restore and repair the last remaining water and windmills, many of which had been lost in the years after World War II. Mind you, even in the 1970s mills were still being gutted or converted at an alarming rate, but at least a reaction against all that was underway and various conservation bodies, in particular the Mills Section of the Society for the Protection of Ancient Buildings,

{ *With traditional mills being saved of course you need traditional millwrights* }

were targeting mills to try to save. And with traditional mills being saved of course you need traditional millwrights!'

Martin's engineering skills are entirely self-taught, but they have always been soundly based in his passion for old buildings.

'I'd always been interested in our built heritage but particularly in timber-built machinery. I'm not an engineer but I studied design and construction at art college. I remember going round an old mill in the 1960s on a college trip to East Anglia. One of my tutors asked me to arrange a windmill to visit so I chose Bourn Mill near Cambridge, a 17th century post mill which is still there today. As I'd found it I had to talk about it! And it really fired my interest.'

Martin grew up near Bath with its wealth of period architecture and its unashamed love of the past. His first job on leaving college was, appropriately enough, in an architect's office.

'We dealt mostly with refurbishing Georgian buildings. It was great experience and then in the late 1970s I got a job running a mill museum in South Yorkshire and it was then that I started millstone dressing. I needed to learn how to do it because part of my job was making wholemeal flour in the watermill.'

Martin is very matter of fact about the art and craft of millstone dressing and he makes it sound relatively straightforward.

'There are two basic aspects to dressing a

RIGHT *Martin Watts is a millstone dresser and one of the last of the country's traditional millwrights.*

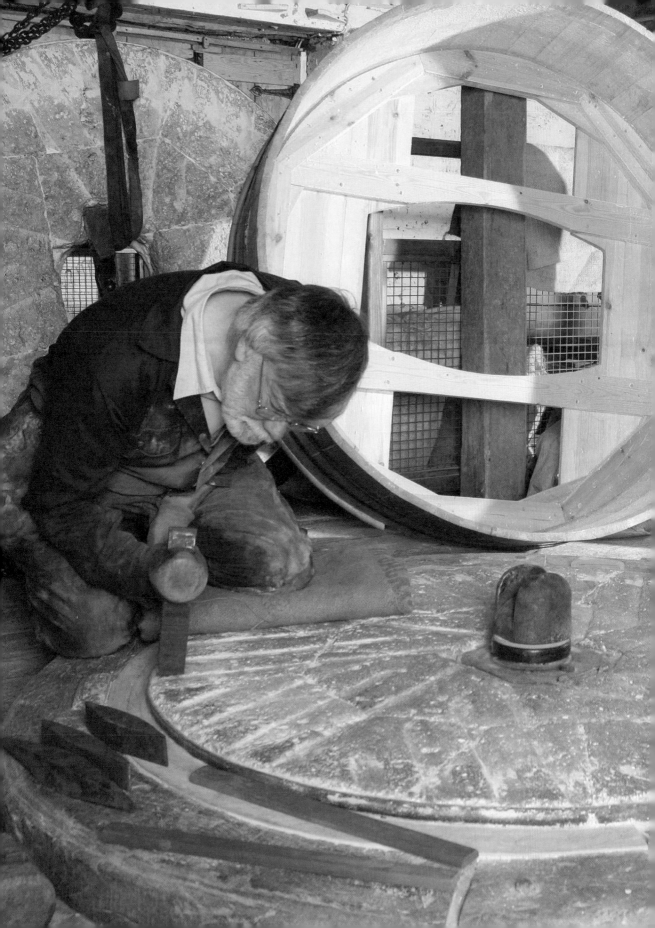

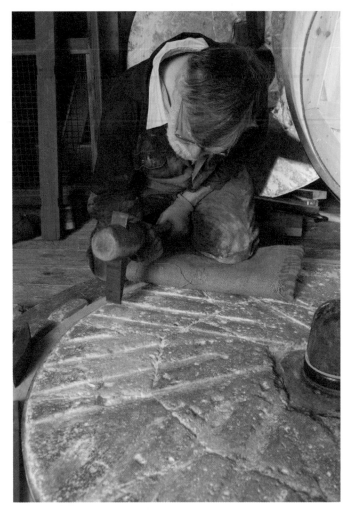

millstone. Making sure that the flat parts of the stone really are flat and making sure the furrows – the grooves in the stones – are cut to the right shape and depth. That's pretty much it!'

But there are difficulties – not least the fact that the millstones are very big and very heavy.

'Each millstone weighs between half a ton and three-quarters of a ton but when they have been set up properly they can be adjusted minutely to create a different result in terms of what they produce, and you can adjust them while the mill is running. The oldest and best test of how the stones are working is the feel of the meal – that's unrefined flour – as it comes out of the spout; whether it feels sandy or gritty or powdery.' The finer the meal, the better the quality of the flour that can be sieved from it.

Like so many craftsmen who have picked up skills that were in the process of vanishing forever, Martin learnt a great deal just by talking to and watching people.

> *I reckon that there are about a dozen millwrights left in the UK and perhaps half still do some millstone dressing professionally*

'I learnt the practical side of dressing millstones by being shown the principles, then having a go myself, and I was helped enormously by talking to people who had done the job before. In Yorkshire, for example, I was lucky to have a friend who helped to run a windmill and he knew a number of elderly millers whom we visited and watched at work.'

For millstone dressing the most important tool is a double-ended chisel known as a mill bill. Traditionally a millstone dresser would have had a large number sharpened ready, to avoid having constantly to re-sharpen them as they went blunt.

'Mill bills are diamond-shaped, and one end

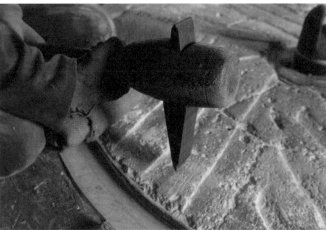

ABOVE (top) *Millstones are uncomfortable to work on and the classic working pose involves kneeling over a softening sack.*
ABOVE *The thrift is a wooden handle that holds interchangeable mill bills and picks.*

is wedged into a slot in a wooden handle called a thrift. The old chisels had steel tips and in the old days different blacksmiths had different recipes and techniques for tempering them. Most modern mill bills have tungsten tips, which tend to stay sharper longer. Millstone dressers' tools were still available to buy from specialist mill furnishers when I started, but these days you have to have them specially made.'

It may not be about to die out completely, but the skills of the millstone dresser are increasingly rare. Part of the reason is, of course, the simple fact that there is not much work for them.

'I reckon that there are about a dozen millwrights left in the UK,' says Martin, 'and of those perhaps half still do some millstone dressing professionally. I'd say there are around 400 preserved wind and watermills left in Britain and as many as ten per cent are still milling on a regular basis so that's only 40 or so – not a huge amount of work even if you spread it among a relatively small number of craftsmen.

'I've worked on about a dozen mills that still produce wholemeal flour – some regularly get me in but not nearly as often as they would have in the old days. Unless they are used a lot, millstones don't need dressing that often. In the old days, to mill fine flour the stones might have to be dressed every two weeks – these days it's more like every two years. In terms of the kind of grain milled I would say that with wheat the stones need re-dressing after 50 tons of throughput. Grinding fine to make white flour wears the dressing out faster than milling wholemeal.'

Millstone dressing is also physically arduous. A millstone is a big piece of equipment and to dress it properly takes time, as Martin explains.

'Dressing millstones is incredibly hard on the elbows – you'll be leaning on each stone gradually working your way around for one to one and a half days per stone. My local mill here in Devon is owned by the National Trust and I dress their stones every two years or so, and at the end of it I feel pretty exhausted.'

The two stones in a mill are dressed identically and they work lying face to face. The dressing itself involves cutting a complex and precise pattern of grooves.

'The furrows or grooves that we cut have a

ABOVE. *In the Domesday Book, compiled in 1086, there is a record of a mill on the Manor of Clyston (now Broadclyst) worth 20s.*

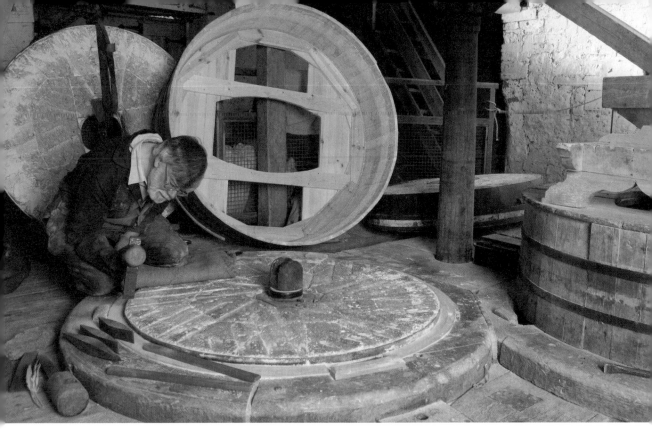

bias – they are not radially but tangentially cut to an imaginary circle in the middle of the stone. That might sound difficult to imagine but what it means is that when the two stones are facing each other and doing their work the grooves cross each other rather like scissor blades. The grain is fed through a hole – the eye – in the centre of the top, rotating, stone, and is reduced as it makes its way from the centre to the edge, ending up as meal.

'We know from Roman millstones that the design has changed little in more than 2,000 years. The pattern of furrows was less refined back then but the layout is basically the same. Millstone dressing has changed little for the simple reason that the pattern of furrows and lands [flat areas] that was arrived at empirically works very well.

'The process of dressing a millstone – or more properly a pair of millstones – starts when you take the top stone off. You then decide whether to do the top or bottom

stone first. You start by using a wooden proof staff, which has a true, flat face that was traditionally coated with red sheep dye, which is dragged across the surface of the stone. Where the colour marks the stone you know you have high spots that have to be removed. When the faces of the stones are nicely flat then they will work properly.

'The next job is to mark out the furrows using wooden battens or splines as guides. In the old days the pattern of furrows would be drawn on the stone using a goose quill dipped in red sheep dye. It works well and I still keep a supply of goose quills!

'After that you start to cut the furrows. There may be anything from 24 to upwards of 40 furrows on a stone. The face of each stone is divided into triangular sections called harps. There are three or four furrows in each harp and eight to ten harps per stone. The longest furrow – the master furrow – may be up to 2ft long, almost the radius of the stone. I'd say you'd be

ABOVE *The projection in the middle of the stone is called the mace, an iron fitting on top of the spindle which turns the upper millstone.*

doing well to finish one stone in a day and a millstone dresser would normally work on each stone alone. For the simple reason that working on a round stone with someone else would mean constantly banging each other's elbows!' (Although it's good to have company and know that someone else is working on the other stone!)

Most UK millstones are made from Millstone Grit from the Pennines. In Wales and the West Country a sandstone conglomerate was also used and granite was once common in the South West. But most mills had at least one pair of French millstones, which were considered to be the best for milling fine white flour, as Martin explains.

'Wherever wheat is ground you find French stones. Generally they were considered the best and you can't fail to identify them, being built up of wedge-shaped blocks of a very hard siliceous stone cemented together, backed with plaster and bound with iron hoops. Granite or Millstone Grit stones by contrast are made from one huge piece of stone.

'The furrows are no more than a quarter of an inch deep and they have a sharp edge and a shallow edge. Each furrow is between one and three-eighths and one and a half inches wide and it is the shallow edge that does the work, the sharp edge being the back edge. The milling is done on the flat parts of the stone between the furrows – these parts are called the lands – but the furrow provides ventilation and an escape route for the milled grain. The grain comes down a chute into the centre of the stones, is drawn up the shallow sloping side of the furrows and on to the lands where it is broken open. The gap between the stones is greater at the centre, to let the whole grain in, and lessens as you move from the centre to the edge, to grind the grain finer and finer. The pattern and cutting of the furrows and this fine tuning of the stones shows that in some respects it is quite a high tech business.

'The upper stone sits on an iron fitting, a

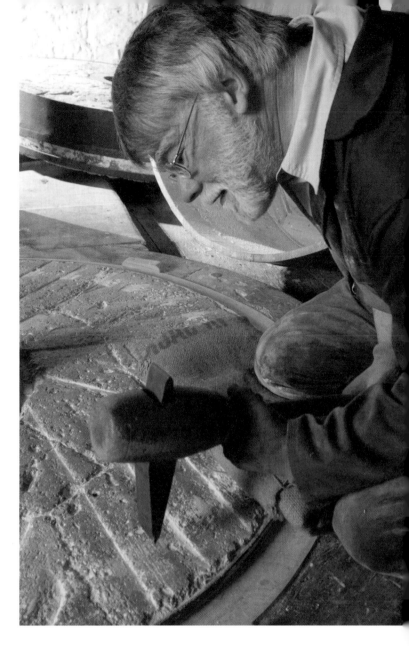

form of flexible joint, and if it is made from a solid block the chances are it will run fairly level and evenly. If it is a French stone made from different density blocks it may need to be balanced and to do this we use lead balance weights – like large versions of the balance weights you have on a car wheel to make it spin true.

'The wooden parts of a mill are mostly oak simply because it is durable or elm because its complex grain means it won't split easily which is why it was also used for chair seats.'

ABOVE *The face of each stone is divided into triangular sections, known as harps. There are three or four furrows in each harp and eight to ten harps per stone.*

The Potter

KEVIN MILLWARD

Kevin Millward makes hand thrown pots and he cheerfully admits that most of what he does is based on early pre-industrial ceramics.

'Mostly my work is based on mid 18th century work or earlier – the clay I work most with at the moment is cream-ware with translucent lead glaze of the type that Josiah Wedgwood would have used more than two centuries ago.'

Kevin's enthusiasm for ceramics is undimmed after more than 35 years work at the potter's wheel. He loves the fact that his pots, bowls and plates never look mass produced. In fact each and every pot, jug and bowl is unique.

Passionate about crafts at school, he set off for art college where he studied painting, photography, printmaking and pottery. But with art school behind him his interest in pottery increased dramatically.

'My first job back in the early 1970s was in a studio in Cheshire where we made stoneware for what was then a rapidly growing market. Pottery was popular at the time because the country was going through a reaction against the sort of boring stuff – bone china covered with flowers – coming out of Stoke-on-Trent.'

Kevin comes from a farming background,

> *He loves the fact that his pots, bowls and plates never look mass-produced. In fact each and every pot, jug and bowl is unique.*

but he is proud of the fact that his great-grandfather was a monumental mason whose work on superb Victorian monuments can still be seen in the graveyards in and around his home town of Leek in Staffordshire.

After leaving that first studio job Kevin found himself working at the Gladstone Pottery Museum at Stoke-on-Trent, as he explains.

'That was I think the first working museum in the country – by which I mean it didn't just have things on show but also demonstrated how they were made. We ran a studio producing garden ware and reproductions of 17th and 18th century pottery, which was then sold in the museum shop. It was great because I learned so many early techniques. I also worked with a well known potter called David Rook – I was his apprentice I suppose'.

The most remarkable thing about throwing pots, as Kevin explains, is that once you have acquired the skill, it is a quick and relatively easy thing to do, but learning to do it is another matter.

'It takes somewhere between five and seven years to learn to throw really well. You have to learn set manoeuvres and positions to get the clay into the air – by that I mean make a cylinder of clay. You have to make a cylinder before you can start putting the

RIGHT *Kevin Potter has been potting for over 30 years and his studio is based at the world famous Gladstone Pottery Museum in Stoke-on-Trent. He presents seminars, workshops and lectures, as well as training potters from all over the world.*

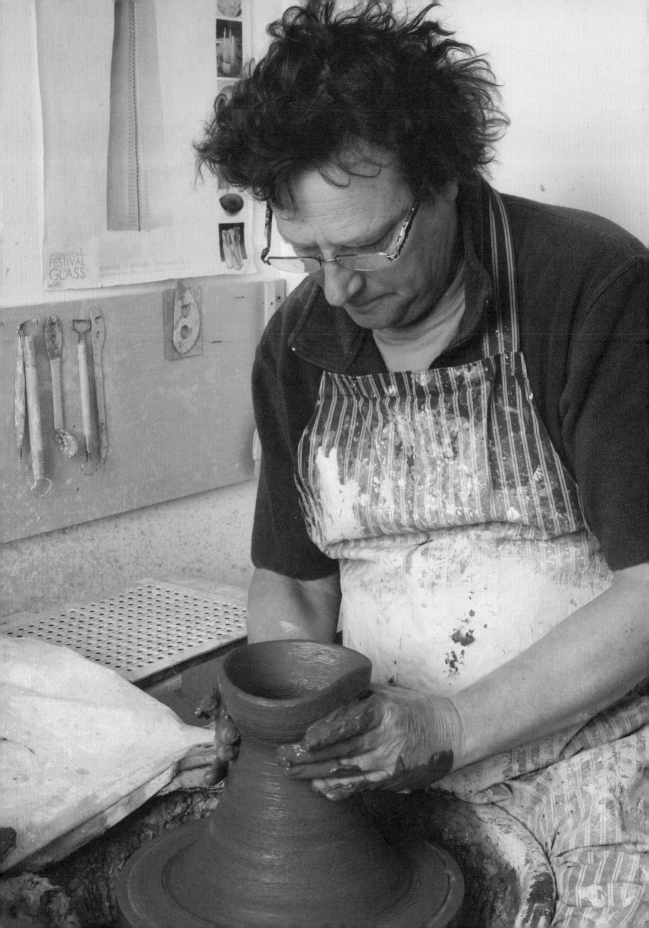

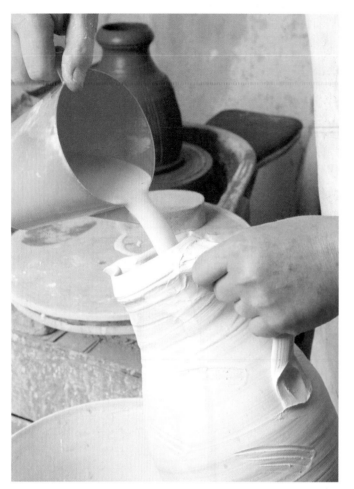

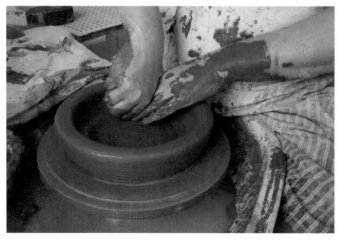

shape in – and making the cylinder is the tricky bit because you want the clay to go up and the clay will always try to go sideways. To be really good would take 30 years – I'm still learning and I've been doing it for nearly 35. And it can be as tricky to make a tiny pot as to make a pot using a 50lb lump of clay. But I still make the whole range of items – bowls, jugs, plates and pots.

'Marbling is one of my favourite early techniques – to do it you first throw the bowl or pot and then leave it to dry out for 24 hours. You then flood the bowl with three colours of liquid clay. Typically a bowl like this might mix design elements of the 18th and 19th centuries as well as elements from the 1930s so it will have an Art Deco feel to it.

'The nice thing about marbling is that it is relatively simple but has a complex look about it. Marbling is still important to me but there is probably a greater demand now for cream-ware.

'I don't do Japanese or Chinese style work largely because for a long time I worked in and around the Potteries district of England and their influence on me has been huge.'

Something of an expert on early ceramics Kevin sees his work in a long tradition of craftsmanship that existed even in the industrial era.

'People forget that the early industrial ceramics in Britain were still handmade. Wedgwood's early ceramics were all handmade but he had the brilliant idea of setting up an early kind of production line process – he got one expert potter to throw the bowl, one to turn it, one to make the handles and one to decorate it. Each man was an expert but Wedgwood didn't have to wait a lifetime for one man to learn all these skills.'

These days Kevin works from his studio at home but he also lectures on ceramics at a number of universities and one of the key things he emphasises to his students is the need for patience.

'Once you can do it, throwing a pot may take just three to five minutes but that is just the beginning of a long process. After it has been thrown a pot or bowl has to be left for 24 hours.

ABOVE (top) *The marbling technique involves flooding a pot with liquid clay after it has been left to dry for 24 hours. It is a simple technique which results in a complex finish.*

ABOVE *Once a lump of clay is centred on the wheel, Kevin pushes down with the palm of his hand to open out the clay and create the thickness of the base.*

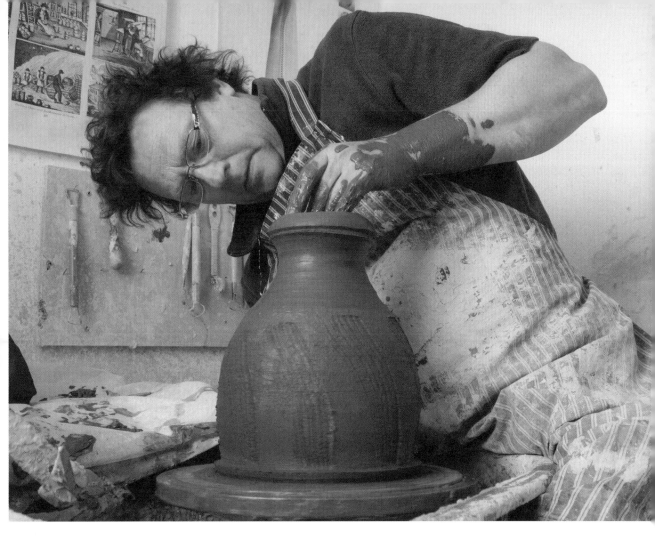

Adding the three slip glaze colours might take another five minutes, but then you have to set the bowl aside for two days. Then it has to be turned before being left for a week to dry. It's then tidied up and any bits of residue removed before being fired at 1,000°C. It's then glazed with a mixture of lead, silica and china clay before being fired again to about 1130°C.

'And even when you're an expert things

> *At any stage the ceramic may fail – for cups, mugs, and bowls you have to expect to lose 10 per cent of your work*

can and do go wrong. At any stage the ceramic may fail – for cups, mugs and bowls you have to expect to lose 10 per cent of your work, for plates it can be up to 25 per cent. Clay is a natural material so sometimes it just breaks. That's why Wedgwood and Minton and all the other pottery firms never, historically, made huge profits – one firing only has to go wrong and you may have lost a week's work.'

These days Kevin has a varied workload – he could be designing for prestigious manufacturers such as Port Merion, lecturing or selling his work through some of Britain's most prestigious galleries. But as he says himself, the basic skill never changes and only a lifetime of experience can provide a real sense of the potter's art.

ABOVE *Kevin uses his knuckles and fingertips to pull the clay upwards and into the required shape.*

The Rhubarb Forcer Maker

JOHN HUGGINS

One year in the late 1980s when potter John Huggins was exhibiting at Chelsea Flower Show, the Duke of Edinburgh wandered over and enquired if he made terracotta rhubarb forcers. John didn't but was sufficiently quick witted to reply, 'Only to order.' The encounter unfortunately failed to produce a royal commission; however, it did set John thinking that rhubarb forcers might be a good idea. And so it proved: he has since hand-made several thousand in his small workshop in the Forest of Dean, continuing a tradition straight out of the country potteries that once flourished across the regions.

Rhubarb was a relatively late arrival to these shores, first introduced in the 17th century. Rare and expensive, it was also highly valued for its medicinal properties, a feature that no doubt appealed later on to the valetudinarian leanings of the Victorians. Or maybe they simply loved their sticky rhubarb puddings. As demand for the fleshy leafstalks rocketed, so entrepreneurial growers devised forcers to encourage a quicker, earlier and juicier yield.

> *I wasn't looking to do anything new or different, I just wanted to re-create them*

'You would have seen thousands of forcers in rhubarb fields,' John says. 'When I first had the idea of making them, you could still see them in fields near Bristol, although they are all gone now. More intense methods of commercial rhubarb cultivation are used these days. At the time I began making them I went around reclamation yards looking for surviving originals and measured up a few. I wasn't looking to do anything new or different. I just wanted to re-create them. I can think of only one other pottery that hand makes them now.'

A GOOD POT IMPROVES WITH AGE

The design he came across in the West Country and on which he has modelled his own forcers is a classic chimney shape. He makes two sizes, 18 or 24 inches tall, and he also throws bell-shaped sea kelp forcers at 17 or 24 inches. With around 45lb of clay required for the smaller forcers and 65lb for the larger ones, the process is clearly not for the fainthearted.

*RIGHT **John Huggins in his workshop: small forcers start life as a 45lb lump of clay (larger ones start life as 65lbs), and is made entirely by hand.***

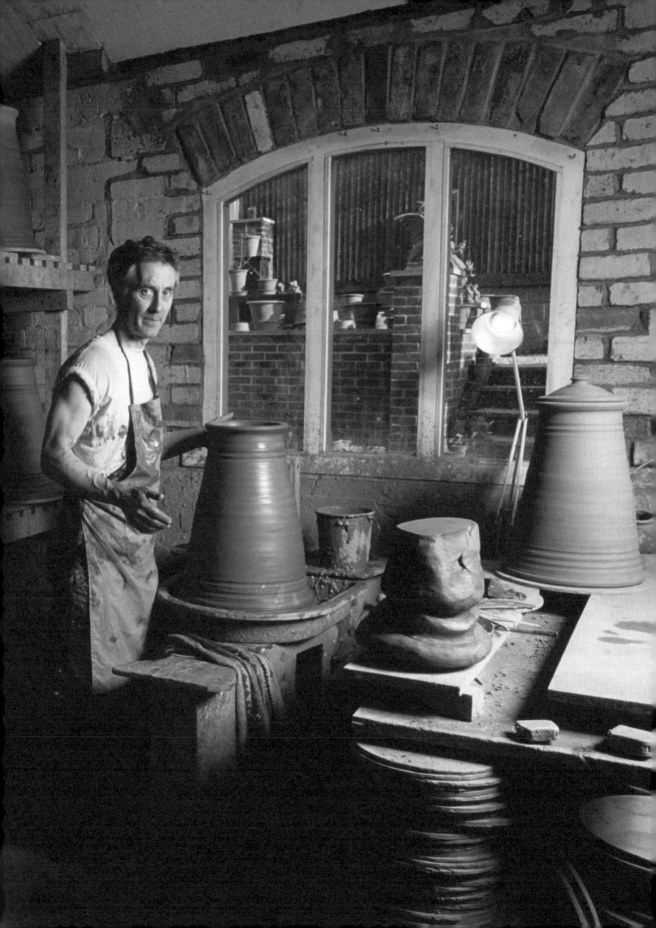

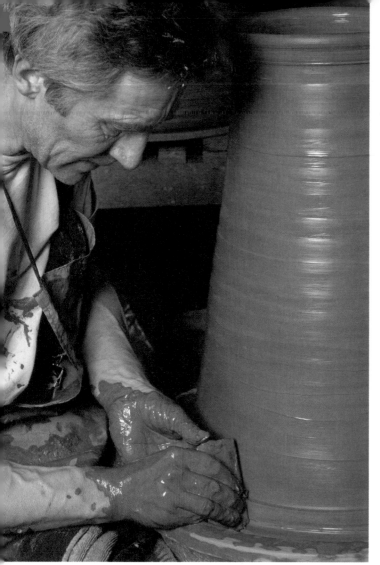

'The secret is to use your body structure rather than just muscles,' John explains. 'I lean into the clay and position my body with my left leg backwards to make a straight line going up into my arm. In the initial stages where you are centring the massive clay on the wheel, you've got to be rigid as the clay knocks against you. You've got to impose your will on the clay but you also have to be receptive, it's that kind of balance.'

John used to blend two different clays to make his forcers but these days saves time by buying in prepared surface marl clay from Stoke. 'I always throw it through the pug mill to mix it all up, which seems to enliven it,' he says. 'Then it takes about 20 minutes to make each forcer on the wheel. The three basic procedures of throwing any pot are centring, opening out and lifting the clay. It's just that I'm working on a bigger scale than most potters.

'I make the pots a bit thicker at the bottom in order to support the weight and I then ensure an even thickness all the way up – it's simply a question of experience and skill being able to gauge the feel of it with my fingers. In the past forcers were usually plain so I keep decoration to a minimum, just creating three lines at the bottom and at the top by pressing my fingers in. I use a roulette [printing wheel] to add RUARDEAN GARDEN POTTERY between the lines at the top.

'Lids are thrown separately,' John continues. 'I throw each as an upside down bowl; when leather hard the excess clay is turned/trimmed off and a knob thrown on. I can make around 18 of the 18in forcers in a day, which are then left on a shelf to harden. As I usually make them from September to Christmas, when the air starts getting damper, it takes about four weeks for them to dry before they can go into the kiln. It's a bottle gas-fired kiln and firing takes place over three days.'

Eventually the forcers emerge in their familiar red terracotta hues, ready to be sent all around the country to customers.

'Part of the appeal is they look so attractive

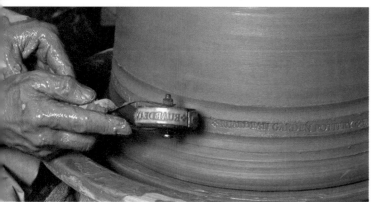

ABOVE (top) *Using a simple straight-edged tool, John smoothes the outside of a forcer. After this it will be left to dry for several weeks before being fired.*
ABOVE *An imprinting wheel adds a guarantee of quality, telling each buyer that this is a unique handmade forcer.*

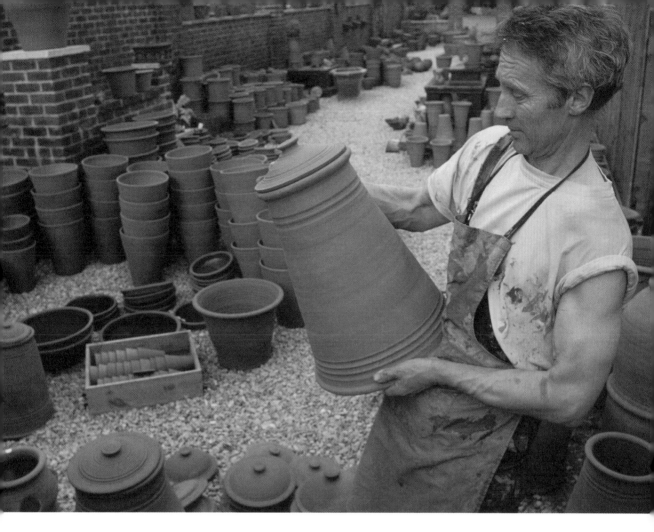

in the garden and so some people buy them as monumental ornaments, not for forcing rhubarb,' John smiles. 'Terracotta catches the sun and always has that lovely warm glow about it. A good pot improves with age as the lichen and mosses are attracted to it and it goes green and yellowy, whereas an inferior machine-made pot will always get worse with age. We're happy to give a ten year guarantee against frost damage.'

John has been running his production pottery workshop since 1979. 'I was a lexicographer before I became a potter,' he reveals. 'But I had been quite interested in pots and so when a friend went to a pottery evening class I thought I would have a go, too. Clay has a momentum of its own and once you start making a pot you go back and make another, and it went on like that really.' These days it's John who takes the role of teacher, running weekend classes once a month and a 'big pot course' each summer when he passes on his experience in tackling large pieces.

Over the years he has produced a wide range of imaginative wheel thrown terracotta. He currently focuses less on traditional garden pottery and more on contemporary limited edition press moulded pieces, including unusual fern pots incorporating the impression of individual fresh fern fronds. 'As a small maker, you've got to be making things that people don't find in every garden centre they go into,' he says.

When not busy in his workshop, John admits to an enjoyment of gardening and that, of course, includes growing rhubarb. 'My wife, Rose, makes it into a delicious rhubarb fool,' he adds with relish.

ABOVE *Huggins' rhubarb forcers are keenly sought by everyone from practical gardeners to interior designers.*

The Blacksmith

DON BARKER

Don Barker is a blacksmith with a passion for his work. He believes that metalworking is in his blood, which is hardly surprising given his ancestry.

'My male ancestors seem to have mostly been blacksmiths going right back to about 1700,' he explains, and I really believe that I've been drawn towards the work because it's as if it's there in my genes.'

But Don's route to metalwork wasn't a straightforward one, as he explains.

'My most recent blacksmithing ancestor was my grandfather and back in the 1930s when he saw what was happening in the Depression he decided that his sons should be teachers rather than blacksmiths.'

When it was Don's turn he trained as an engineer. He enjoyed the work but hated what he saw as the endless bureaucracy.

'I started to do a bit of blacksmithing in my spare time; I had a knack for it and I was enthusiastic, so a few jobs started coming in.'

He enjoyed watching the blacksmiths he worked alongside.

'I'd seen blacksmiths forging metal where I worked and was inspired by them, so I started doing it as a hobby. It took up more and more of my time and I really enjoyed it, so in 1983 when I was 38 I decided to quit

{ *I started blacksmithing in my spare time, but I had a knack for it and I was enthusiastic* }

my job and be a full-time blacksmith. I set up a limited company and I've never looked back.'

Don's experience as an engineer stood him in good stead when he started work as a blacksmith, but he is the first to admit that despite his enthusiasm and the spare time he had put into his passion, he still had a lot to learn.

'I did need to train and I did it through CoSIRA (Council for Small Industries in Rural Areas), a government quango that ran workshops up and down the country. I met Joe Hansom, who worked for CoSIRA, and he taught me a lot. I remember going on a CoSIRA course with Joe at Harrogate showground, which isn't that far from my home in York. In fact I did several one week courses. Joe taught me the intricacies of forge work and how to use a power hammer to best effect.'

By this time the years of hobby blacksmithing were paying off and commissions were already coming in steadily. Don was being asked to make everything from gates and railings to pokers and firedogs.

'I thought I was doing pretty well, but it helped enormously to learn how to do intricate forging work such as making an

RIGHT *Don Barker is a medal holder and Fellow of the Worshipful Company of Blacksmiths and is very proud to be the first working smith to become Prime Warden of the Company for 200 years. His 40 year love affair with blacksmithing has never waned and he continues to work in the forge shaping metal into beautiful things.*

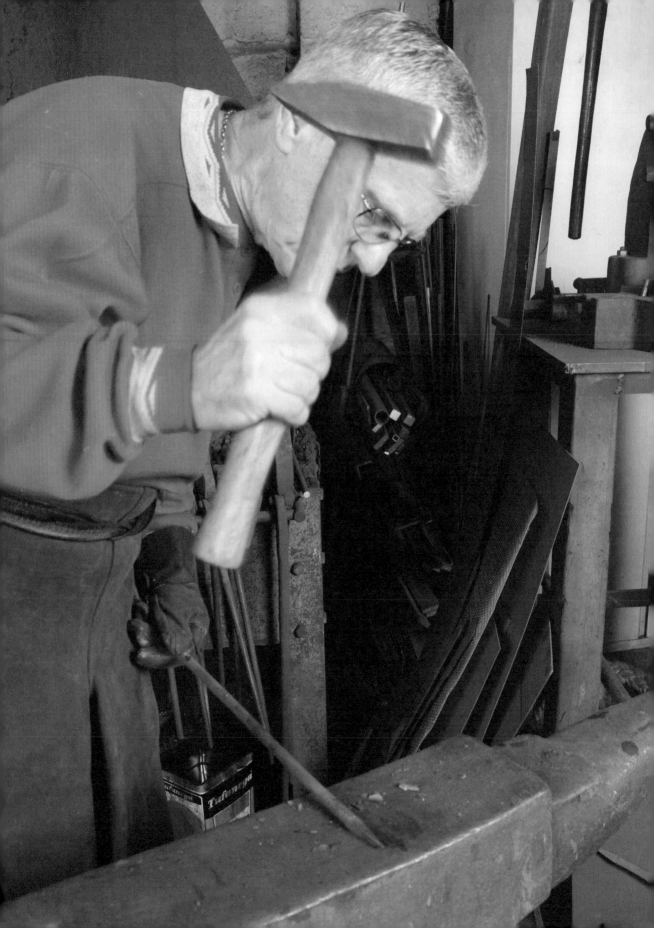

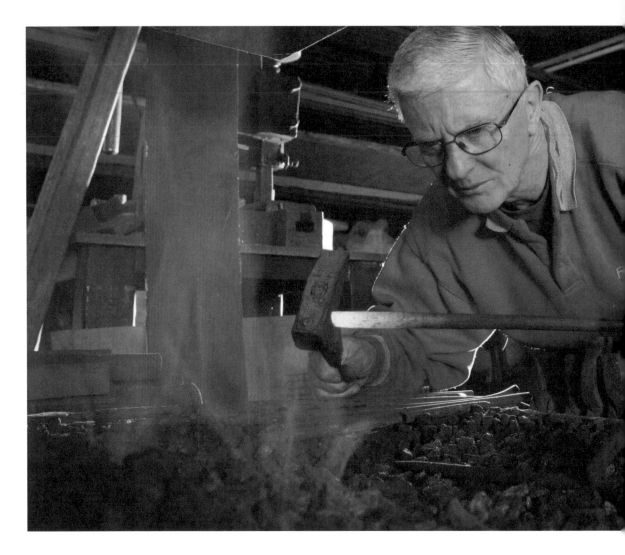

ABOVE **By drawing the metal out of the fire the blacksmith can gauge its temperature by looking at the colour, which changes as it heats up.**

animal head on the end of a bar of metal. That's much more difficult than it might sound, because you are working with white-hot metal and you have to shape it with a limited number of tools – just chisels and hammers.'

Like most blacksmiths, Don buys his metal in the form of bars. Stock bars of mild steel come from a stockholder. They are the basic raw material for most of Don's work.

'We buy them in a range of sizes – maybe half an inch square or an inch square or more – and we forge whatever people want. If they want decorative gates, we'll make them; if they want special railings, we'll make those too. If it can be made in metal, then we will make it.'

JUDGING THE HEAT

Part of the skill of blacksmith work is judging the correct temperature of metal for specific types of work.

'When you are heating at a forge, the general rule is the hotter the metal the softer and easier it is to work. For fire welding – that is, welding two pieces of metal together – you want it almost melting. For steel tools, which have to be very hard,

{ *When heating at a forge, the general rule is the hotter the metal the softer and easier it is to work* }

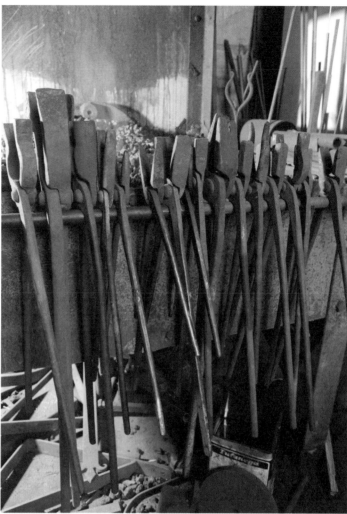

you'd only heat a bar till it is red, so not nearly as hot.'

Once Don has judged the temperature, he gets down to the business of shaping and cutting.

'The real skill is in forging – doing scroll work for gates, for example, or making what we call fishtail end scrolls, bolt end scrolls, leaf work or ha'penny snub scrolls.

'All this decorative work takes a lot of practice and skill. You just can't learn to do it overnight. For most of our work wherever possible we don't use tongs to hold the bar – we just make sure the bar is long enough to hold at one end while working on the other end. If it's a short bar though we will use specially fitting tongs.'

Watching a blacksmith at work is a remarkably satisfying experience. With a minimum of fuss and seemingly effortlessly he can turn a plain bar of metal into something complex and decorative.

'Apart from getting the forging temperature right, there's an art in striking the metal in just the right way. And it's this creative skill that I believe I've inherited from my blacksmith ancestors.'

ABOVE *A bar along the side edge of the forge is used to hang all the various tongs the blacksmith needs to hold pieces of hot metal.*

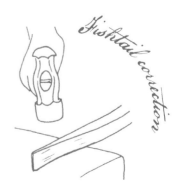

Fishtail correction

ABOVE **Management of the fire is critical. The blacksmith must be careful not to leave the metal in the fire or it will burn and ruin.**

BELOW **In addition to the anvil, the blacksmith's tools include hammers, tongs and scrolling irons.**

Light taps with the hammer produce the delicate work, but Don is always happy to use the power hammer to take the backbreaking element out of heavier work.

'We don't use the power hammer for delicate work like leaf scrolls but it is very useful for more straightforward work on heavier pieces of metal.'

According to Don, experience is a key factor. Skill comes with developing a sure touch and that can only happen over time.

'Each time you make a leaf scroll, or a ram's head, you get better at it and you begin to put your own stamp on things. Blacksmiths always recognise their own and other people's work. There is standard practice in forging but beyond that you are free to add as much of yourself as you like.'

His meticulous description of making a complex item for the top of a poker reveals something of the skill involved.

'You start by forging what we call a flat piece, which you split. Each side is then bent back, fire welded and textured with chisels to make the face, the ram's nostrils and what-have-you. Then we use tongs to twist the horns. A ram's head made like that sounds pretty straightforward but it only becomes so after years of practice. I reckon it would take me about 20 minutes to make one and, although I've made many, I never lose the sense of satisfaction in making one really well.'

In addition to many local commissions for gates and railings, curtain rails and even shackles, Don has worked on some major blacksmithing projects.

'I did a really important job for the

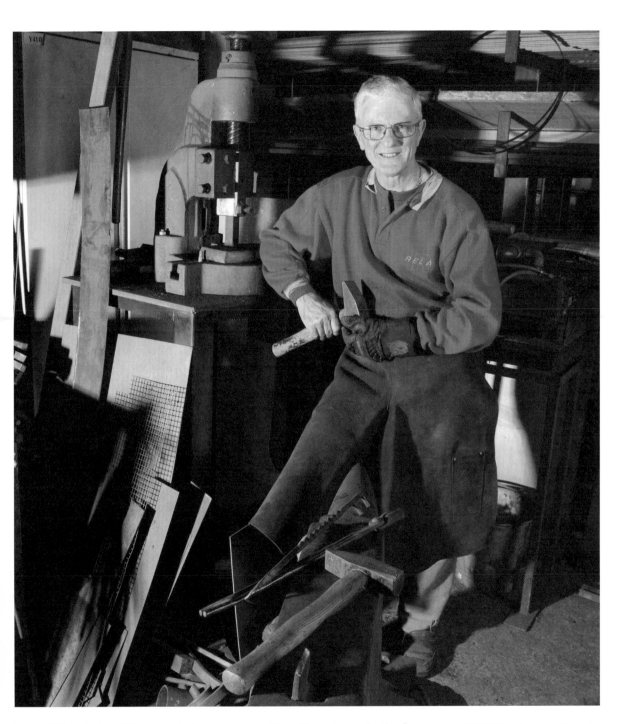

front of Westminster Abbey – a set of traditional gas lamps. I also made four 6ft high bronze lamps and 65m of bronze handrailing for the Queen Mother's memorial in the Mall. Closer to home, we made a pair of stainless steel gates for a park in York after winning a design competition. Those lamps for the Queen Mother's memorial had a lot of work in them – they took eight months to make, so you can see it's slow careful work. But for all our work, however large or small, it's not about speed, the important thing is to get it right.'

ABOVE *Don is never happier than when he is in the forge surrounded by all his traditional tools and heaps of metal – and a roaring fire.*

The Rope Maker

NORMAN CHAPMAN

Rope has been made in the remote market town of Hawes in the Yorkshire Dales for more than 200 years, but in that pre-industrial era almost every town and village in the land had at least one ropemaker, which is why so many streets and lanes are still called ropewalks.

From 1905 Outhwaites, the Hawes Ropemakers have been in business. The family took over from another ropemaking family, the Whartons, who had run the business from well before 1841 when records began.

As the 20th century progressed big factories began to take over ropemaking and small ropemakers up and down the country were forced out of business. So Outhwaites is a rare survivor and it survived because it was always able to find specialist markets that the big producers tended to neglect.

So how did they do it? Ruth Annison, who now runs the company with her husband, explains. 'We always keep an eye out for new ideas and we've tried to get a bigger share of a diminishing market. We also pride ourselves on our customer service. A new customer came to us once on a Thursday evening, for example, and he needed a huge amount of rope in a particular style and colour by the following Tuesday. We had the right materials so we worked over the weekend and got it ready on time.'

Ruth is acutely aware of specialist markets too – farmers always need halters for their animals and when an animal goes to a show it needs a top quality halter and only a firm like Outhwaites can supply both.

'We also make dog leads,' says Ruth, 'because people want soft rope to hold when they are walking their dogs and if you think there are seven million dogs in the UK that's a big market!'

Outhwaites have mechanised a small part of the traditional process of ropemaking but the basic technique is unchanged in centuries, as Norman Chapman – who has been ropemaking at Outhwaites for more than 30 years – explains:

'The addition of the electric motor to the ropemaking machine in 1952 really only

RIGHT Set in the heart of the Yorkshire Dales countryside, Outhwaites Ltd Ropemakers, which was established in 1905, manufactures pet accessories, barrier ropes, bannister ropes, polyester and polypropylene braids.

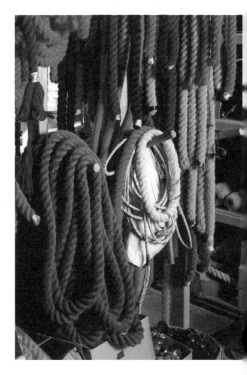

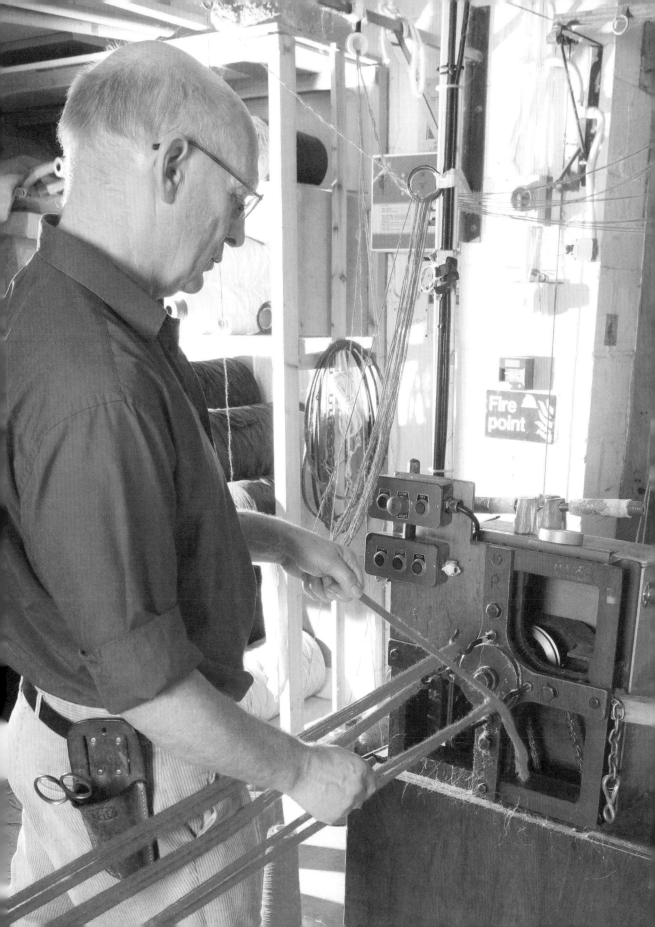

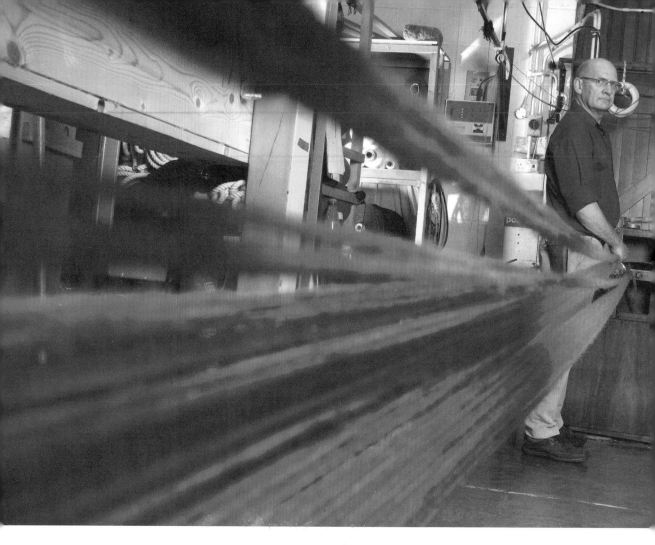

ABOVE **Rope thickness is determined not only by the number of fibres drawn out but also by the speed of hook rotation.**

{ *People want soft rope for dog leads and when you think there are seven million dogs in the UK that's a big market!* }

speeded things up a bit – the traditional method is still the same. Each rope we make is made to the exact specifications of the customer. The maximum length we can make is about a hundred feet – if it needs to be a bit longer we open the door at the end of the ropewalk and go out into the yard! But most people want shorter ropes for banister and barrier ropes, for example, or for dog leads, 6ft leading reins for ponies and 11ft lengths for making halters for cattle and horses.'

The ropemaking process starts with 'warping up', where yarn is attached to two, three or four

crooks (hooks) on what's known as a twisting machine. The yarn is then attached at the other end to one hook on a device called a sledge. When the twisting machine starts to turn the ropemaker moves into action, as Norman explains.

'The ropemaker uses a grooved wooden device – a top – to keep the strands under control and apart from each other while the machine is twisting them together and as the strands twist together the rope inevitably shortens, which slowly pulls the sledge forward, but the whole thing stays under tension the whole time.

'Next the rope is laid. When the wooden top – the device for keeping the strands separate – has moved forward along the

ABOVE *The wooden top prevents the strands from becoming tangled as the rope is made.*

rope a temporary tie is put round the rope at the crook end to stop it unravelling.

'The final stage is the backtwist – this involves turning a handle at the back of the sledge. The backtwist eases the tension in the rope and balances it to prevent it snarling up.'

Once they are made, the ropes are carefully stored ready to be converted into the finished product, whatever that may be.

Company owner Ruth Annison explains that high quality cotton is used for ropes that need to be soft for animals, but other traditional materials are also still used at Hawes, including flax, sisal and jute. Hemp was once used extensively but it is now almost unobtainable.

One of the great things about the Hawes ropeworks is that they use a great deal of waste yarn from the textile and carpet making industries.

'We use it to make low cost ropes and multi-coloured skipping ropes,' says Ruth. 'They are just as strong as any other rope but we can sell them for less because the raw materials cost us less.'

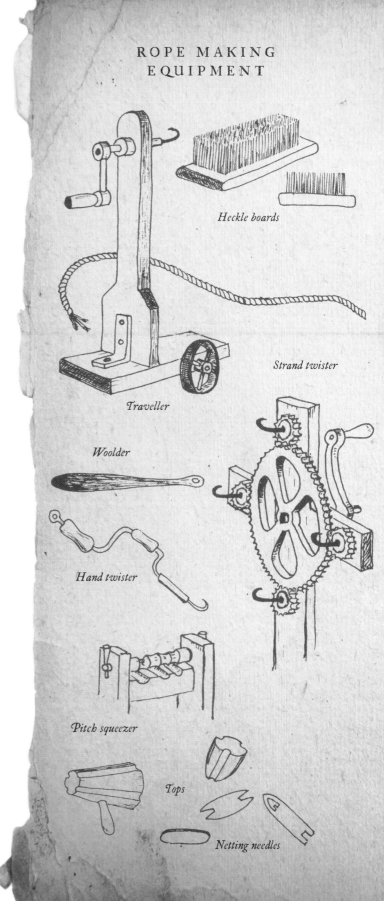

ROPE MAKING EQUIPMENT

Heckle boards

Traveller

Strand twister

Woolder

Hand twister

Pitch squeezer

Tops

Netting needles

DECORATIVE CRAFTS

The Woodcarvers

EDWIN WILLIAMS AND IAN BRENNAN

What could be more different than a carved wooden spoon and a heraldic crest, a small utensil of humble domestic origin and a large stylised sculpture that embellishes Westminster Abbey? The contrasts certainly illustrate the versatility of different woods, the promise of their grain and textures, and the purposes to which they may be fashioned.

Man has carved wood since time out of mind, creating everything from workaday implements to magnificent statues, and tools used today – chisels and gouges – have changed little for centuries. The craftsman's skill lies in his ability to envision and liberate a design from the piece of wood before him, to work with the natural character of his material, both its beauty and its flaws.

WELSH LOVESPOON CARVER

'Sometimes the wood shouts at you, telling you what to do,' says Edwin Williams, a Welsh lovespoon carver for over 30 years. Fashioned from a single piece of wood, the spoons in his workshop and gallery in Pontarddulais, south Wales, reveal impressive feats of the woodcarver's art: chains, swivels and interlocking rings, intricate patterns and piercing, relief carving and fretwork.

'Lovespoons – *llwyau caru* in Welsh – were originally courting gifts,' he explains. 'A young man carved one to give to a girl and if it was accepted courtship began. These days lovespoons are given for lots of reasons, to mark friendship, weddings, birthdays and St Dwynwyn's Day [January 25], the Welsh equivalent of St Valentine's Day.'

The custom probably dates back to the 16th century in Wales and carefully carved lovespoons demonstrated not only a suitor's devotion, but also his practical skills: a significant marital selling point when many folk earned a living with their hands. Originally utilitarian, the gifts developed from 'cawl' (broth or soup) spoons, but they became ever more elaborate and ornamental over the years.

Edwin, the son of a coal miner, says there was no tradition of artists in his family. 'But I loved to carve from childhood and I studied at Swansea College of Art. I worked as a woodcarver for a furniture company in London before lecturing and returning to Wales. I made my first lovespoon when a local fellow wanted to carve one and I showed him how. It featured a Celtic knot, meaning "no beginning and end" or "together forever". I visited St Fagans, the National History Museum near Cardiff, to look at the design of the lovespoons there. Since I began, demand has been non-stop.

'I've developed a range of more than 600 designs,' he continues. 'There are lots of

> *Lovespoons were originally courting gifts. A young man carved one to give to a girl and if it was accepted courtship began*

RIGHT *Edwin Williams has been a Welsh lovespoon carver for over 30 years. The lovespoon dates back to the 16th century when complex carved wooden spoons were given as tokens of affection.*

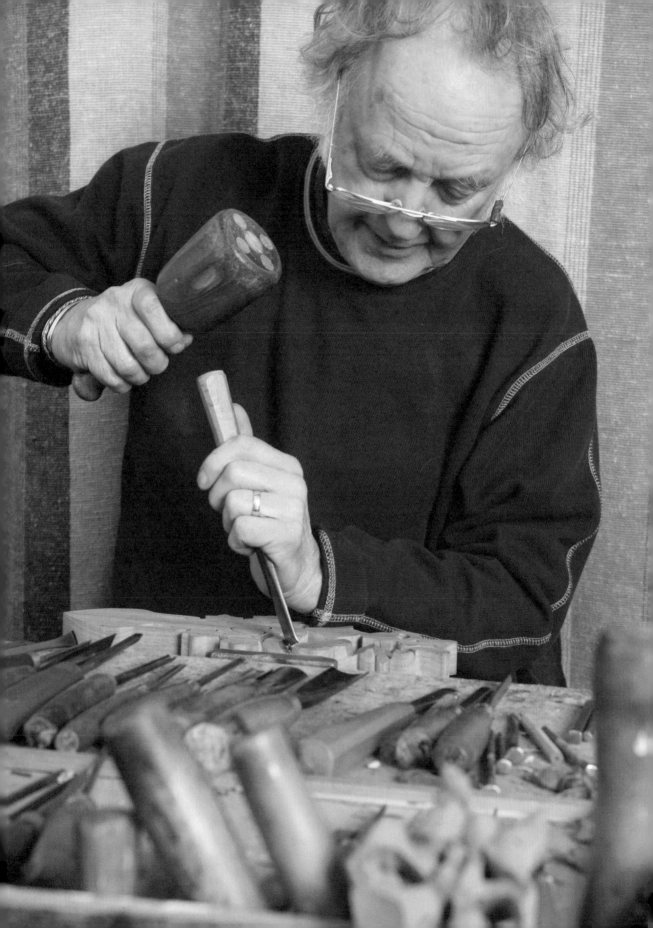

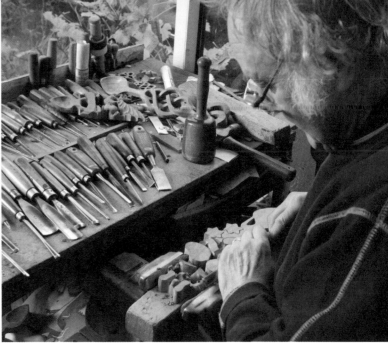

Chisels

traditional motifs. Anchors mean finding a safe place to settle down, a ship signifies a safe voyage through life and a heart symbolises love. A vine means love grows and balls indicate the number of children you want. In 1988 when Prince Charles came to a show in London where I was demonstrating my work I offered to carve a lovespoon with ten balls for him. He laughed. I made him one with a ship on it instead.'

Other recipients of Edwin's work have included Nelson Mandela when he was made a freeman of Cardiff in 1998. 'I carved a lovespoon featuring a springbok and daffodils, the symbols of South Africa and Wales.

'I've had some unusual requests,' he adds. 'I was asked to incorporate a toilet into a design for a plumber. The most interesting part of my work is creating new designs for people.'

Edwin, who is also an abstract artist and sculptor, can be found most days from 6.45am to 9pm in his garden workshop. His wife Olivia and son Odin join him at his benches, design templates hanging behind them, vices and chisels laid out in front. It can take a few hours or a few months to carve a lovespoon, depending on the size and complexity.

'The wood needs to be tight grained and I mainly choose lime, walnut, yew and oak,' Edwin says. He draws his design on paper to make a template – if the design is to be re-used he will make it in wood. Then he marks out the template on the wood for the spoon. This is then cut out on a jigsaw or band saw.

'I usually have the wood about an inch thick. I like a chunky feel and then you can carve into it and have a flowing movement. I might use 15 different-sized chisels for the carving.' Sanding, staining, sealing and polishing complete the painstaking work.

Edwin also specialises in natural spoons – literally pieces of wood with their hollows and gnarls polished to create the bowl and handle. These can be up to 35 inches in length. 'The wood itself suggests ideas to you: the movement in the grain and any faults that you might use to your own advantage,' he explains.

Of course, the big question is: what lovespoon did he present to his wife Olivia? He smiles. 'Every lovespoon I carve is really for Olivia – and then she goes and sells them in our gallery!'

Sculptor to the Most Noble Order of the Garter and the Most Honourable Order of the Bath.

Ian Brennan's woodcarving, by contrast, takes us into the colourfully stylised world of heraldry and mythical beasts. Since 1989 the Hampshire-based craftsman has been Sculptor to the Most Noble Order of the Garter and The Most Honourable Order of the Bath. As such, he fashions the outsized limewood crowns, coronets and crests that are placed over the stalls, or seats, of newly created knights: in St George's Chapel, Windsor, for Garter Knights, and in the Henry VII Chapel, Westminster Abbey, for Bath Knights.

'Heraldic sculpture is like a picture language, full of signs and symbols that reflect someone's life and career,' Ian says. 'For example, I carved a phoenix rising amid flames from the Tower of London for Lord Inge, a former Constable of the Tower, when he became a Garter Knight, and a blue badger for Lord Butler of Brockwell – brock being the name for a badger.

'The Order of the Garter is the oldest British Order of Chivalry, founded in 1348 by King Edward III and reconstituted in 1805 and 1831,' he continues. 'It's restricted to the sovereign, members of the Royal Family, 24 Knights or Ladies Companion and certain foreign royals. It's given as a mark of personal royal favour to honour people in public office, those who have contributed to national life or have served the Queen.

'If there are vacancies, appointments are announced on St George's Day, the patron saint of the order, and then I carve the crests that, together with the knight's banner and sword, sit on top of helmets above each stall in St George's Chapel. Ceremonial

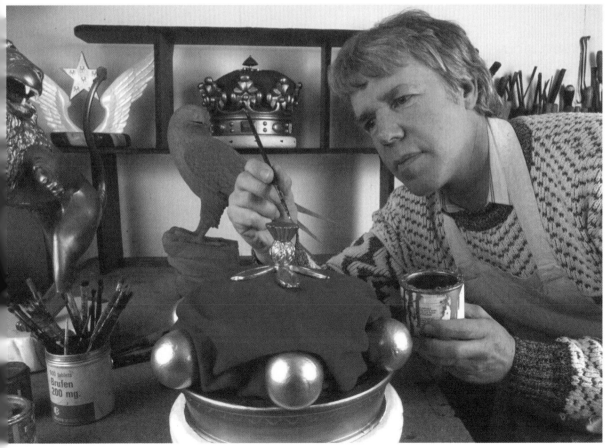

BELOW *Contemporary sculptor Ian Brennan has been a professional sculptor for over 25 years, producing highly detailed original sculptures depicting many different subjects.*

installations take place in June, but not every year. The last one was in 2008 and included Prince William.

'In medieval times a heraldic device on top of a knight's helmet was a means of recognition in pageants and tournaments,' Ian adds. 'According to legend, the blue garter emblem was inspired by a garter dropped by the Countess of Salisbury at a court ball, which King Edward scooped up and chivalrously bound to his own knee. It's more likely that it derived from a strap used in armour and symbolised the binding of members into a brotherhood.

'The Order of the Bath is mainly awarded to officers of the Armed Services – Nelson was a famous example – plus a few civil servants, and the name derives from the ritual bathing that new knights in the Middle Ages undertook as a symbol of purification. Only the most senior Knights Grand Cross are formally installed with their crest and standard, because seats available to them in the Henry VII Chapel in

Westminster Abbey are limited to 34. Some wait many years or even miss out – it's dead men's shoes. Installations are usually every four years; the most recent, for nine knights, was in 2010.'

Ian began his career as a cabinetmaker but his business literally went up in flames in 1984 when his workshop burnt down. As he miserably picked his way through the charred remains, he noticed a piece of wood that resembled a dolphin and had a go at carving it, just to console himself. From that moment, he discovered an innate talent for wildlife sculptures, what he calls 'the ability to see three-dimensionally, to see what animals look like inside a block of wood and to set them free.'

Soon, people were buying his carvings and his work was spotted in an exhibition by the Secretary of the Garter who, coincidentally, was looking for someone to take over the role of the recently deceased Sculptor to the Orders of the Garter and Bath.

'I was told that the main criterion for

my job was that I should be able to carve anything,' Ian says. 'The designs are so varied. I'm given a watercolour of each – there could be a couple or a dozen for installation – and I transform it into a mainly limewood carving, just as centuries of craftsmen before me have done, although little is known about my predecessors.

'My heraldic sculpture, which usually takes up four months of the year, greatly differs from my realistic silver, bronze and wood sculptures. Each design for the Garter and Bath must be unique and obey certain rules according to an individual's status. Sovereigns, for instance, have crowns, a baroness like Margaret Thatcher has a coronet, and other people have crests.

'I over-carve heraldic sculptures, so that when I put several layers of paint on, they don't obscure the detail. The carvings are installed quite high up above the knights' seats and are up to 28 inches tall with lots of detail, so they can be clearly seen. Real animals and heraldic animals are totally different beasts: a heraldic lion might have its tongue out, for example, because it's all about expression.

'For my realistic work I mostly carve from a single block of limewood, but the crests have to be hollow to keep their weight down when they are put in place so I carve and join pieces together. I've over 300 chisels, many of them made especially to suit my needs. Some are bent to a specific shape, for instance to carve behind the ruffled feathers of a swan. I use scalpels for very fine detail, and I sometimes make delicate parts from a marble resin mixture to give strength. I finish with several coats of enamel paint and gilding.'

Since taking up his appointment, Ian has completed 104 royal commissions, including Lion of England crest for Prince William. 'He became the 1,000th Garter Knight and he departed from tradition by incorporating a red "escallop" from his mother's coat of arms on the white label around the lion's neck. It's unusual for members of the Royal Family to include maternal symbols in their heraldic emblems.

'Normally I get a phone call from the Royal Household to tell me which knights will be installed. But the Queen herself told me about William's knighthood at a reception I had been invited to at Windsor Castle. We had a long chat about the Order of the Garter – Her Majesty is very, very knowledgeable. There was little old me, brought up on a council estate, talking away to the Queen. It was amazing.'

BELOW *A totally unique scale model of the First Rate Ship of the Line, Lord Nelson's Flagship* **HMS Victory.** *Created by sculptor and woodcarver Ian G Brennan, the carving has taken over 5,000 hours of work and although it may look rather fragile being carved from centuries old original oak from the lower gun deck of* **HMS Victory,** *it is exceptionally strong.*

The Glass Blowers

COLIN AND LOUISE HAWKINS, LOCO GLASS

Glass blowing is a mesmerising spectacle: a theatre of fire and movement as the craftsman gathers, shapes, blows and twirls a huge molten blob of treacly glass. It's certainly a process that holds visitors to LoCo Glass spellbound. While the white-painted studio in the Gloucestershire market town of Cirencester is practical and plain, the glassware that emerges from the dexterous shape shifting dazzles with colour.

LoCo Glass, founded and run by Colin and Louise Hawkins, creates free blown handmade work ranging from production runs of functional pieces such as vases and decanters, to special commissions, interior accessories and eye-catching outdoor sculptures. Techniques and processes are a fusion of traditional and modern.

'We have two different styles, really,' Colin says. 'Louise is more intensively inspired by nature, or in particular the lines and form. I tend to be inspired by the glass itself, so when I see something behaving in a certain way, like one colour on top of another colour, I use and adapt it. Louise's designs are usually on paper and we try to re-create them as closely as we can. I tend to enjoy myself on the bench while I've got hot glass in my hand, sculpting and playing with it.'

A browse of their ranges reveals striking sea anemone bowls sprouting tendrils that have been individually gathered from the furnace, shaped and applied while still hot. Inca vases intrigue with their subtle layering of colour, and trails of glass winding around pieces in the Strata range, often used for lamp bases, dance with the surrounding light

'Glass works so much better when it has sunshine on it, so it also lends itself perfectly to the outdoors,' Colin adds. The studio has produced all sorts of imaginative glass catkin pods, blooms and moss spires to prove just that point. 'As long as you get the joins right between the glass and metal stems, they are completely weatherproof. Even in strong winds they are flexible and robust. Glass is only fragile if it gets hit, for example by a football.'

While many outdoor pieces take their cue from nature, some spring from pure technical fun. Lightning Sphere, a huge black cannonball of glass streaked with white flashes came about 'because we wanted to see just how big we could blow a bubble,' Colin admits. 'We got it up to about 50cm in diameter. It's heavy and you need an awful lot of glass to get that big without it actually collapsing.'

LoCo Glass pieces are sent to galleries around the country, while individual customers have included Sir Elton John, Madonna and Sir Bobby Charlton. There have been unusual wedding commissions – a glass axe for a fireman to use to cut the cake – and

> { *I tend to enjoy myself on the bench while I've got hot glass in my hand, sculpting and playing with it* }

RIGHT *LoCo Glass is the creative partnership formed by Colin and Louise Hawkins. Together they have been designing and making glass for over ten years, handblowing their glass at the studio at the refurbished New Brewery Arts centre in the Cotswolds.*

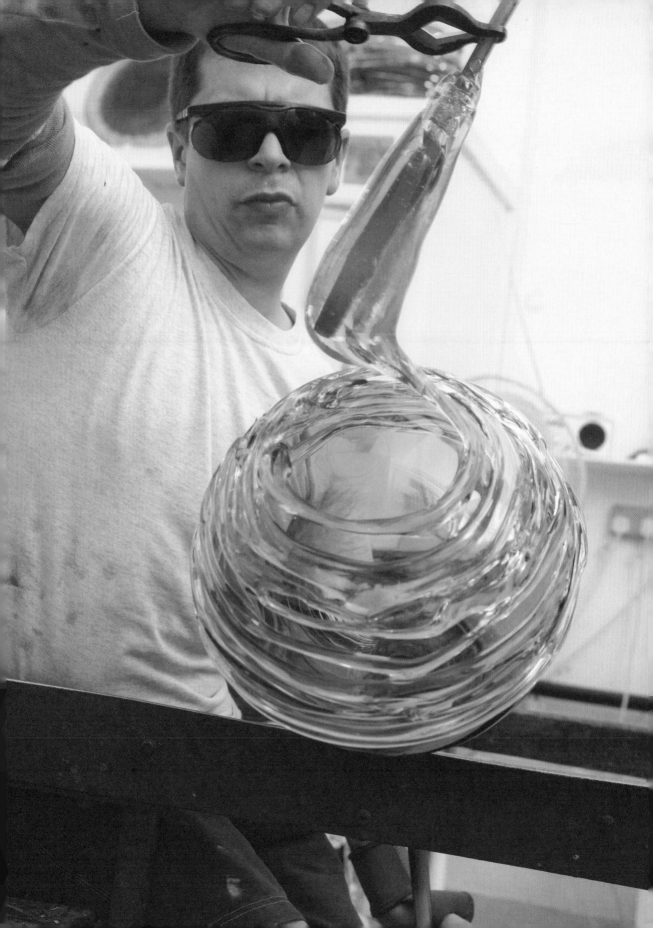

ABOVE *The exact amount of molten glass should be gathered on the blowing iron to suit the job in hand. The molten glass collects at the end of the iron, and from then on the 'treacly gob' can be kept on the nose only by constant rotation.*

FAR RIGHT *Blowing needs unerring judgement of temperature and pressure in order to produce vessels of a consistent size and thickness.*

many requests for repairs, from cathedral glass to 'auntie's favourite vase'.

There's a charming tale that glass was first discovered around 4,000BCE by merchant sailors carrying a cargo of nitrate (some versions say natron or soda) in the Mediterranean. As night fell, they dropped anchor and made a fire on a beach using wood and some of the nitrate as fuel. Next morning they found small jewels amid the ashes: the fire had melted the sand and the nitrate had acted as a flux to create sparkly droplets of glass.

Folklore aside, the earliest known glass objects are beads from Mesopotamia c. 3,000–2,000BCE. Casting or pressing into moulds were among the first techniques used, and there was much carving from solid blocks of glass. The Egyptians created hollow vessels by dipping a core of clay on a stick into molten glass and trailing it with colours; once the vessel had cooled, the core could be picked out. Then around 50BCE, probably in Syria, someone began blowing glass through a hollow rod and today's craft was born.

'It was the Romans who really developed blowing and a lot of the techniques and tools haven't really changed since,' Colin says.

Glassmaking arrived in Britain with the Romans and the industry remained focused in forested areas like Surrey well into the Middle Ages. This changed in 1615 when James I, concerned about the shortage of timber for shipbuilding, banned the use of wood for firing glass furnaces: glassmakers decamped to the new coal mining areas, or places where coal could be imported, including the West Midlands, London and Bristol.

Britain made its mark as a quality producer with such names as George Ravenscroft, who invented lead crystal in the 17th century. But today, Colin says, handmade free blown glass is a dying trade on the factory scale. 'There are quite a few smaller studios around the country; however increasing costs of raw materials and gas for fuel, as well as imports, are making life difficult. Colin and Louise formed LoCo Glass in 1998 after they met while working in a glass studio. He had trained in glass at Sunderland University and the Royal College of Art, London, while she studied design at Goldsmiths College before taking the Glass Techniques and Technology course at the International Glass Centre, Brierley Hill. They now employ five other workers plus an apprentice. While Louise focuses largely on design, Colin concentrates on glassmaking.

The main constituent of glass is silica (often in the form of sand), to which alkaline fluxes are added to lower the melting point to a temperature that can be managed in a furnace. Other ingredients help to stabilise the mix and metallic oxides add colour. Colin and Louise source their raw material from Dartington Crystal in the form of chunks of clear broken glass, called cullet, which they melt down in the furnace at c. 1,100°C (2,012°F).

To make a 'simple' scent bottle or vase, Colin gathers glass from the furnace on to the end of a pre-heated blowing iron, winding it

p into a toffee-like blob. Then, sitting at his bench, e shapes the molten globule using wooden blocks r a thick pad of newspaper held in his hand. 'In ears gone by they would have used leathers or apyrus, but newspaper, soaked in water overnight, s a fantastic insulator,' he says. 'We use broadsheets, ecause the red tops tend to have lower quality ink, vhich can smear onto the hot glass.'

Next, he blows down the pipe to create a bubble n the glass. 'Then the skill is all about controlling vhere the bubble blows. It's hand–eye coordination, nanipulating the glass to get it to do what you want.'

Any number of techniques may now be mployed: the molten glass may be swung to longate it, for example, or coloured glass trails nay be applied having been rolled on a steel narvering table. Colin constantly returns to the eheating chamber (also known as the glory hole) nd team members are on hand to help.

After shaping, a punty or bridging iron is ttached to the flattened bottom of the piece to ake it off the blowing iron. The hole left by the lowing iron is heated and a rim formed, either by utting or opening it out with paper jacks.

When Colin is satisfied with the piece he deftly nocks it off the punty using a knife, places it in a iln to cool slowly overnight (the annealing process) nd next day takes it out for cold processing: rinding, polishing, sandblasting, cutting, oppering, or whatever is required.

For coloured pieces he has recourse to rods of ome 200 different solid pigments, made from clear lass mixed with metal oxides – from 'burgundy' o 'turquoise'. He picks up a small amount of olour on the end of his blowing iron right at ne beginning of the process, gathering the clear lass from the furnace over it. When he blows ne bubble, the colour forms a skin on the inside iving the illusion that the whole piece is coloured. ometimes he rolls the molten piece in coloured lass chips to add special effects to the outside.

'I enjoy people coming to watch us and they see ust how much work goes into each piece,' Colin eflects 'Even if you are making something that ou have made hundreds of times before, it still ehaves differently. It's constantly challenging you.'

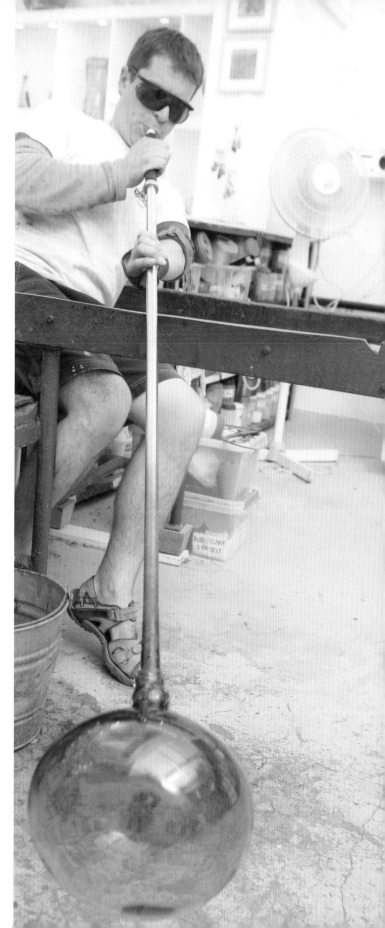

The Goldsmith

RHIANNON EVANS

'I think jewellery is talismanic and spiritual, and gold is a wonderful medium to work in: it is malleable and has a special sheen and rich colour you could compare to velvet or silk. Gold is associated with the sun and gods.' So says goldsmith Rhiannon Evans, who has been handcrafting jewellery in her Tregaron workshop for nearly 40 years.

Tregaron, between the wildly beautiful Cambrian Mountains and the romantic sweep of the west Wales coast, is an unusual little town in which to find a family business with an international reputation. Yet Rhiannon would not want to work anywhere but surrounded by countryside suffused with 'Awen': the muse that has inspired an unbroken tradition of Celtic art and culture in this Welsh-speaking corner of Britain for over 3,000 years.

'I really admire the craftsmanship of the ancient Celts and I am inspired by their style and methods, but I never copy,' she explains. Thus she might introduce a cat into a conventional Celtic knotwork design, for example. At other times, it's heroic legends of the wizard Merlin and Uther Pendragon from medieval Arthurian tales that she distils, or images and rhythms from Welsh folklore and dance. Mountains, sea and wildlife that she observes on walks transform into brooches, necklaces, earrings and cufflinks.

Rhiannon works in both silver and gold, including now rare Welsh gold. 'It has been mined in Wales since prehistoric times,' she says. 'Pre-Christian Celtic chieftains wore gold torcs and armbands of exquisite workmanship and became wealthy as a result of trading in gold and other metals. Much later, the Romans took possession of some of the mines and developed larger-scale operations.

'In the modern era, only the Clogau and Gwynfynydd mines near Dolgellau in North Wales have produced significant quantities of gold. By tradition they provided gold for the Royal Family's wedding rings.'

Today mining for Welsh gold has ceased, but Rhiannon has sufficient supplies to last her another ten years. She was one of just three goldsmiths licensed to use extractions from Gwynfynydd in the late 1980s when a rich vein was discovered there, and in 2009 she was lucky enough to buy another batch, complete with Crown licences and letters of authentication, held by a licensed prospector.

'It is the same batch from which the gold came for the wedding ring Prince Charles gave to Camilla,' Rhiannon says. 'The fact that Welsh gold is traditionally used for royalty does add to its cachet. Of course gold is gold, but you are also buying something

> *She has made silver crosses for Bishop Tutu and the Archbishop of Wales, and 100 per cent Welsh gold dragon cufflinks for Prince Charles*

RIGHT *Rhiannon Evans is an award-winning jewellery designer who works in pure and mixed Welsh gold. Over the last 35 years she has been commissioned by national institutions for royalty, archbishops, celebrities, governments, and even for Welsh national stamps.*

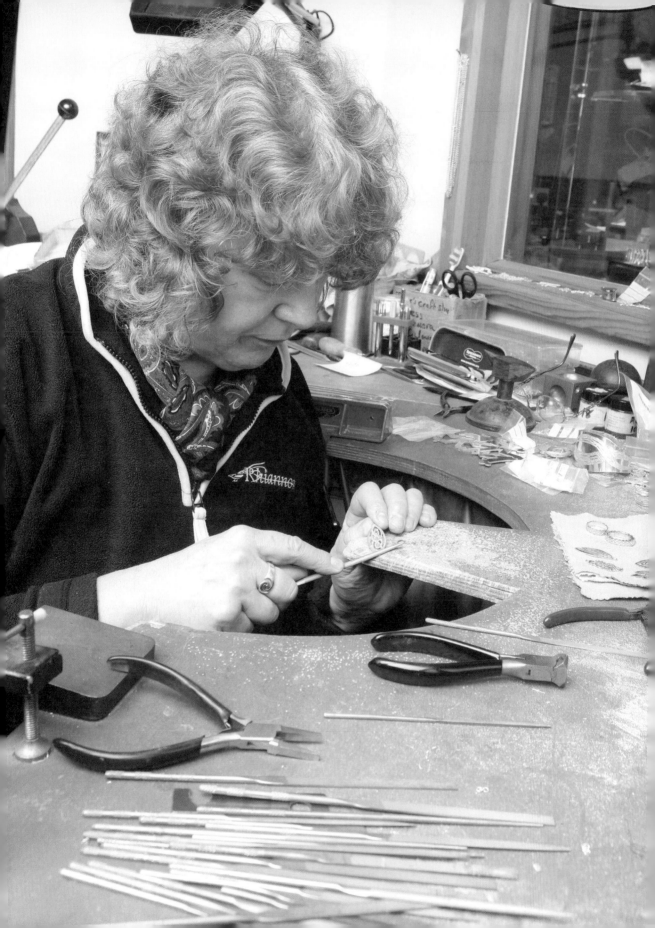

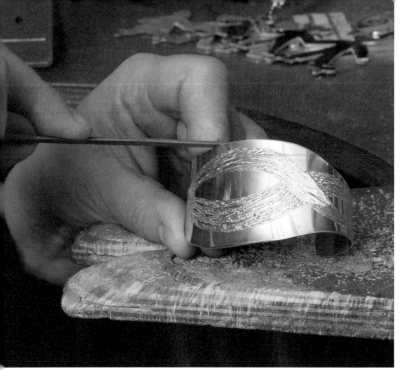

ABOVE **Rhiannon works in both silver and gold, including now rare Welsh gold, which has been mined in Wales since prehistoric times.**

that has come from deep within the Welsh mountains and carries that history with it. Any jewellery I make with it comes with a certificate and bears the Rhiannon Welsh Gold Registered Mark, as well as my trademark initials.'

Rhiannon, who was raised in nearby Aberystwyth, was interested in art from an early age and first set up in business selling crafts, including home-knitted woollens. It was a visit in the early 1970s to a London exhibition of the finest stone and metal Celtic artefacts from Britain and Europe that set her on the path of her vocation as a goldsmith.

'I was stunned by the outstanding quality of the designs and by the exquisite workmanship I saw,' she recalls. 'I also felt very privileged to be able to understand the symbolism thanks to the literary tradition of my Welsh mother tongue.' She determined to share the Celtic magic with a wider audience by producing new work within the same ancient traditions.

> *Because I'm self-taught it is important that I pass on my particular methods, which differ from conventional goldsmithing*

Following copious research into working with precious metals and armed with little more than a Black & Decker, Rhiannon cut her first piece. a triangular silver serviette ring. It won her £50 at the 1976 National Eisteddfod and kick-started her career.

Since those early beginnings, she has made silver crosses for Bishop Tutu and the Archbishop of Wales, and 100 per cent Welsh gold dragon cufflinks for Prince Charles. Her most well-known commission was the gold and silver Celtic morse, or clasp, she crafted for Dr Rowan Williams' gold silk cope on the occasion of his enthronement as Archbishop of Canterbury in 2003. The morse featured red and white gold dragons rampant on either side of a silver cross of Canterbury overlaid with a Celtic design.

'The dragons come from the 9th-century Merlin Prophecy, in which the red dragon triumphs over the white one in a tremendous battle – symbolising a victory of the ancient Britons over the invading Anglo Saxon hordes,' Rhiannon explains. 'The morse blended Celtic and Christian motifs, and if you go back in history you do find the lines between the two blurred. It is the design he wanted.'

Each of Rhiannon's pieces begins as a drawing on paper – she uses graph paper to develop intricate knotwork. Due to the scarcity of Welsh gold she creates her own alloy according to a secret recipe, similar to one used by the ancient Celts, she reveals. Ten per cent of the nine-carat gold is guaranteed mined in Wales. She melts the grains of gold to roll her own sheets and the production process is then almost exactly the same as it has been for thousands of years – with the additional help of some electrical power.

Visitors to Rhiannon's workshop, showroom and tearoom are welcome to watch her making her jewellery. Alongside conventional files, hammers and pliers, a spent World War I shell sits on the bench – providing an ideal surface for beating out metal. A drill

that bears a resemblance to a tool of dread at a dentist's surgery hangs nearby, and thick leather aprons are slung beneath work surfaces to catch any precious 'waste' that can be recycled. Cobblers' lasts, used to shape metal, recall the trade plied by Rhiannon's grandfather.

If she is working on a knotwork pattern, Rhiannon traces her design on to the gold metal sheet and cuts it out with a fine saw: a wedding ring with many intricate holes can take two weeks. For other jewellery she uses rubber moulds, made from silver models, and casts pieces in a semi-finished state.

'It's more conventional and much cheaper to make models in wax, but I taught myself my craft by working with hard metal,' she says ruefully. 'I do keep all the silver models and eventually I'll pass them on to someone in the family or maybe a national institution.'

She hand finishes pieces by sanding, grinding and polishing.

Rhiannon's designs are characterised by their movement and flow, no more so than in the sinuous intertwinings of knotwork rings that symbolise eternal life and never-ending love. She also draws on the patterns of Welsh music and dance: one knotwork 'Seaside' brooch, combining wave-like rhythmic patterns, is inspired by the traditional love song *Ar lan y Môr* ('Down by the Sea').

Traditional symbols of Wales are also popular motifs, including *y ddraig goch*, the red dragon. But perhaps most evocative are pieces that recall the birds and animals of Celtic and Welsh legends: white waves crashing upon the coast become 'Ceffylau Manawydan', the Horses of the seagod Manannan. Three birds recall 'Adar Rhiannon', the magical Birds of Rhiannon, Queen of the Otherworld. 'They were never seen but their singing was so sweet that anyone who heard it was immediately transported into a world of unearthly beauty, health and happiness,' Rhiannon elaborates.

Despite being surrounded by so much jewellery, Rhiannon wears just one special necklace she has made. Depicting a wolfhound and cross, it recalls a favourite dog – she breeds Irish wolf-hounds – and also weaves in the legend of Beddgelert: the hound Gelert saved Prince Llewelyn's baby son from a wolf, only to be mistakenly slain by his master. Every piece of Rhiannon jewellery contains a story.

In the past she has trained apprentices. 'It takes two years and because I'm self-taught it is important that I pass on my particular methods, which differ from conventional goldsmithing,' she says. 'It is difficult for traditional goldsmiths to survive and there are fewer people to hand the craft on to.' After a spell making her jewellery on her own, she has recently taken on her son-in-law as an apprentice, while her youngest son, Llywelyn, runs the office. 'I'm hoping that my young grandchildren will be creative, too – one already helps me in the workshop,' Rhiannon says.

BELOW *The pieces are hand finished by sanding, grinding and polishing.*

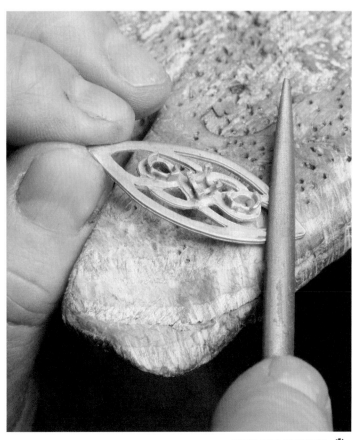

The Stained Glass Artist

SOPHIE LISTER HUSSAIN

The art of stained glass making dates back at least to medieval times. It combines a range of craft skills with the skills of the painter. To many it evokes ancient church windows, but it is actually an important artistic discipline that has survived throughout the centuries intact and largely unchanged, though the colours and designs used by stained glass artists today would astonish and perhaps even delight their medieval counterparts.

Sophie Lister Hussain is a talented stained glass artist who grew up on the Isle of Anglesey, off the coast of North Wales, which was a primary influence in her early artistic development.

'My earliest memories are of my grandmother. She taught me to knit and to sew and the combining of a multitude of different materials. She also instilled in me the self discipline to strive to do my very best with anything I made.'

This creativity inspired Sophie early on, so that when she left school she was determined to go to art college, but making a decision about which precise medium to study was not quite so straightforward.

'I found a course studying glass and ceramics at Wrexham College of Art in North Wales and I really liked the sound of it, but I had had no relevant experience

> One design proposal was for the main window overlooking the pool at Wrexham Swimming Pool. This was judged by renowned stained glass artist Eugene Politti

of glass working. In order to secure a last minute place on the course I persuaded the course tutor, Mel Harris, to interview me. I arrived with a portfolio of fashion drawings, landscape drawings and paintings, clothes I had made, cloth that I had dyed and an array of large and small abstract pots.'

Once on the course, Sophie realised that this was something that really worked for her. She felt that she'd found her artistic home.

'It was a great course, because it taught me the disciplines of how to cut glass, and cutline glass, how to think in glass, the way large-scale colours worked and how to use them. We also learned technical skills such as sand blasting, surface decoration, kiln work and hydrofluoric acid etching. We learned how art and architecture could work together.

'One specific design proposal was for the main window overlooking the pool at Wrexham Swimming Pool. This was my first design project and was judged by renowned stained glass artist Eugene Politti.

'In my final year I designed a window for a church just outside Oswestry in Shropshire – my design was of alpha and omega and I did it in really bright colours and in handmade double-plated English glass. Everyone on the course had to come up with a design, but my

RIGHT *Sophie Lister Hussain creates highly individual stained glass designs for public and private clients and has found the medium the ideal outlet for her creativity.*

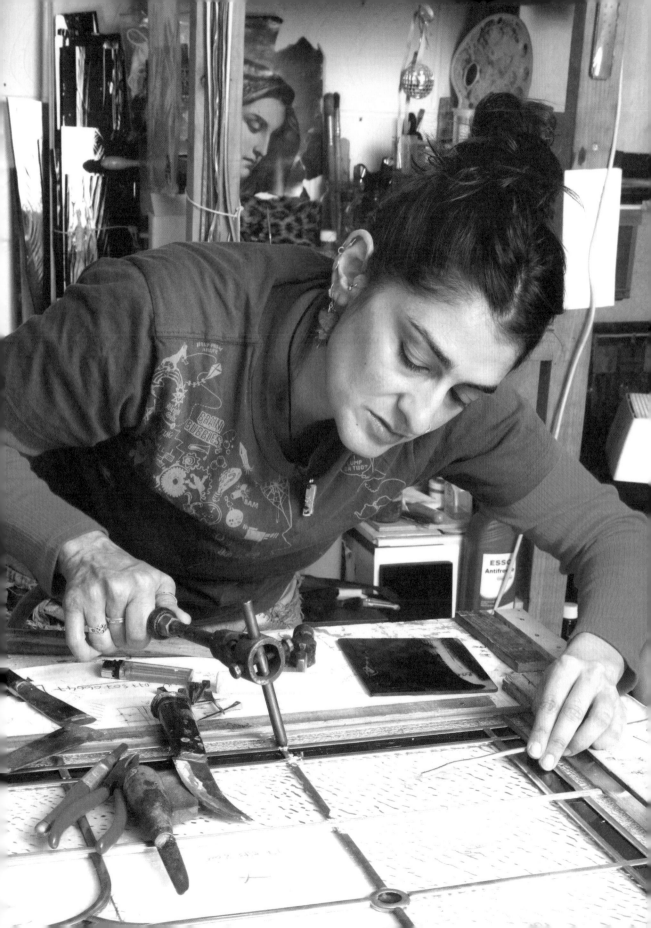

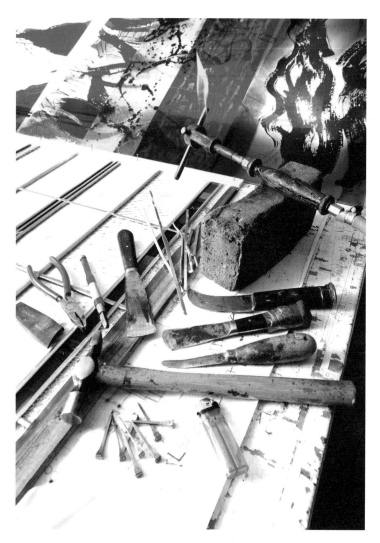

first real working experience within a major stained glass studio, as she was offered a work placement during the following summer months at the prestigious firm of Goddard & Gibbs.

After leaving Wrexham College, Sophie studied Two- and Three-Dimensional Glass and Ceramics at Sunderland University.

'It was a three-year course that gave me the time to carry on working for Goddard & Gibbs every summer. After finishing at Sunderland I worked for G & G for a year and then took the plunge and went freelance, working for a number of other studios – I worked for some of the great names in stained glass making, including Alf Fisher and Bernard Becker, Deborah Coombs and Ginger Ferrell.'

Sophie insists that when it comes to glass there is inevitably more to learn, which is why she is always keen to meet and work with other artists. It wasn't until 2000 that she felt fully confident that she knew enough to start completely on her own.

'I lived on a traditional narrowboat in West London and built a make shift little lean-to studio at the side of the boat. I managed to get lots of interesting work, often making bespoke stained glass windows, and it taught me the rudimentaries and gave me the skill base for all the work I've made since.'

The process of working through a commission with the client is something that Sophie likes to oversee carefully from the outset.

'You begin by meeting the client and discussing various ideas. You might talk to them on numerous occasions to hone details down to the final design, until they are satisfied. Some clients are quite sure of what they want, while others will largely leave it up to me.'

She still makes stained glass for small private houses, but she also works on big

design won, which was a brilliant boost for me. I remember I etched the design into the glass using hydrofluoric acid.'

After that success there was no looking back, and Sophie went on to come joint first in the Stevens Architectural Glass competition to design a commemorative window for Laurence Olivier.

'That was a really interesting project,' she recalls. 'It was a competition run by the Worshipful Company of Glaziers. My design, which incorporated a line drawing of the National Theatre, won and, although the window was never made, it was great to feel that my design had really stood out.'

Winning the first prize also opened up her

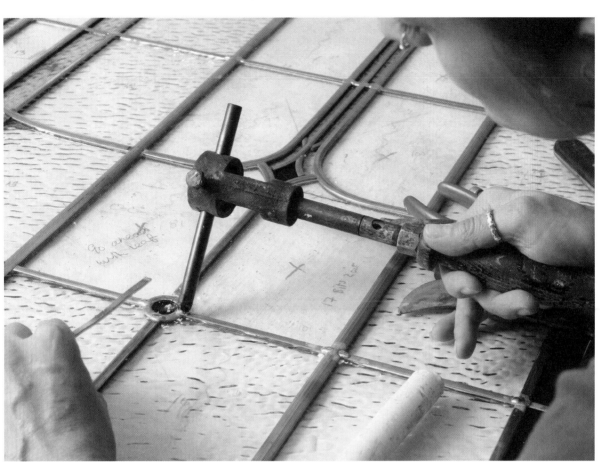

ABOVE *Soldering a joint with the gas iron.*

public commissions.

'A recent commission was a window for the Chapel at St Saviour's and St Olave's School in London. They asked me to design two windows incorporating the school motto in glass.'

After this commission Sophie was approached to make a centenary glass and mosaic window for the school's stairwell. This was officially opened by Queen Elizabeth II.

Sophie is fascinated by all types of glass work, but especially her own specialism of stained glass.

'The majority of my work is stained glass. It's always etched with acid or painted with kiln firing paints, silver stained or surface decorated by sandblasting stencil work; a combination of any or all of these techniques can give a detailed and rich texture to the surface of glass. Sandblasting gives glass a frosted appearance, and can be used to shade areas of clear glass; painting can be done in many different colours straight on to the glass; and etching produces a range of interesting effects, melting away the surface of unmasked glass.

'After the client is happy with the design, the making of the glass follows the same procedure each time. First I measure the window frame – this has to be done accurately. The rebate, sight size, full making size, tight size and mullions all need to be accounted for, support bars, tie wires, internal steel-cored lead,

{ *I worked for some of the great names in stained glass making, including Alf Fisher and Bernard Becker* }

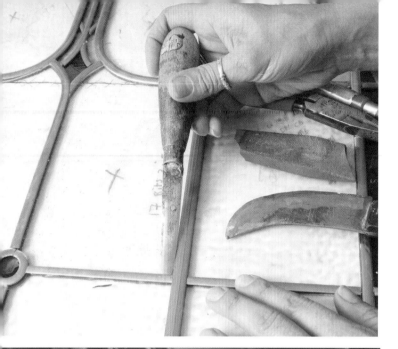

saddle leads, thread leads, the list is endless.

'Once they have been approved, designs are enlarged to a full size working drawing. Any indication of glass paint, silver stain and etching is marked, drawn to scale and even sketched on to the cartoon.

'A cutline drawing is taken from the cartoon, which shows each and every piece of glass: the lines indicate the heart of all the leads, a line that glass cutters know should not to be crossed.

'When the glass pieces are ready you "lead it up" – start fixing all the pieces into their positions using a lead knife, pliers and horseshoe nails.'

Stained glass tools wear into the hands of the maker, and it takes time to become accustomed to a new tool. Glass painting brushes are especially hard to break in and require hours of work to become effective and supple.

After the glass has been fitted into the leads, the windows soldered and cemented, the old frame amended to fit again, or the new frame securely installed into the building, then the finished piece can finally be installed into the frame.

For Sophie it is not technique but personality, drive and enthusiasm that really transforms a stained-glass window into something unique and important.

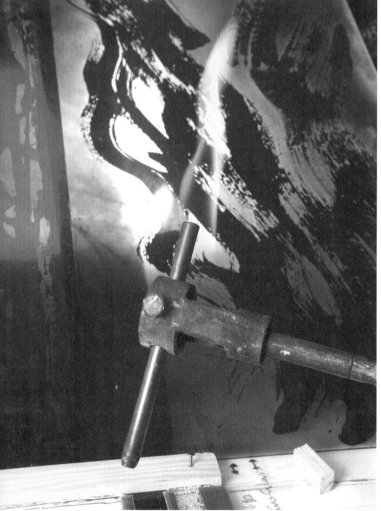

TOP LEFT *Preparing lead in the correct position for soldering.*
LEFT *Sophie prefers to use a gas soldering iron as she finds it gives a constant heat and it is reliable and faster than electric irons.*
RIGHT *Sophie is fascinated by all types of glass work but especially her own specialism of stained glass.*

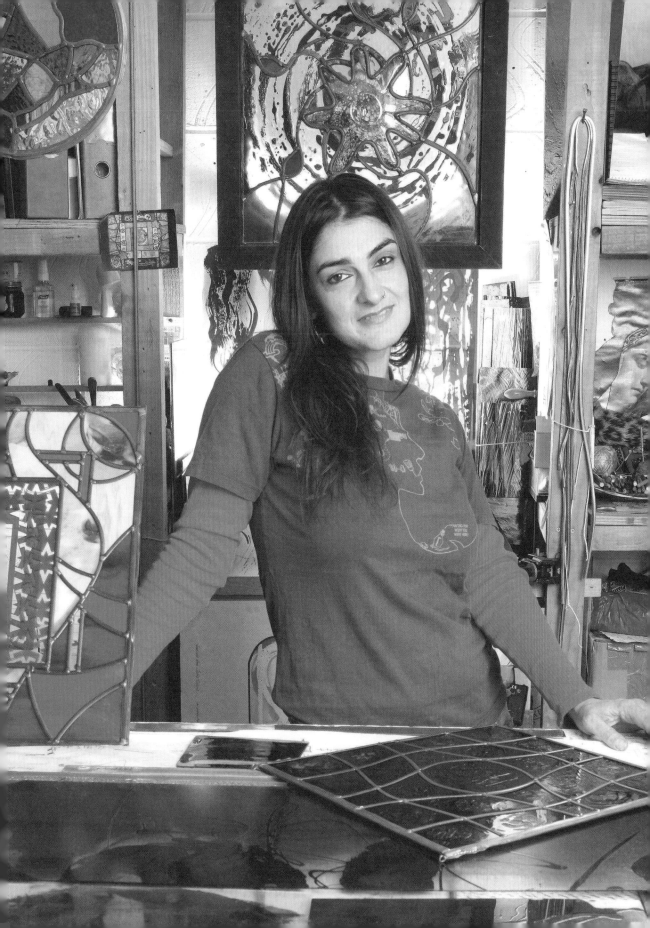

The Pub Sign Designer

GRAEME ROBBINS

When people raise an eyebrow at Graeme Robbins as he drives along in his 2CV, a pub sign poking through the open roof, he is ready with his customary response: 'It was a helluva night last night!'

In fact, not a drop of liquor will have passed his lips. A freelance pub sign designer, he is simply collecting his latest commission to take back to his Bristol studio. Sometimes the task is to restore a picture to glory, but mostly he creates fresh new images. Occasionally he paints personalised signs for home bars or gifts.

'I get looked down on by fine art circles because I paint pub signs but I enjoy cheesing them off,' Graeme says. 'My work is hanging up around the world, 24 hours a day, and lots of people look at it; if they appreciate it, even better.'

Graeme graduated from Bath Spa University with a first class degree in art a decade ago and has made a living as an artist in Bristol ever since. His output, apart from pub signs, is mainly figurative and portraits, and he has exhibited both in Britain and as far away as New York and Tel Aviv.

He painted his first pub sign around ten years ago almost by chance, when someone who knew his work passed on his name to the landlord of The Old Duke in Bristol. 'It's a renowned jazz and blues pub named after Duke Ellington, on the historic harbourside. I

> *Pub signs are part of the social history of an area and the point is to grab people's attention*

had two weeks to do two oil paintings, one on either side of the sign,' he says. Given pretty much free rein, he depicted the legendary performer at the microphone and, secondly, a monochromatic image juxtaposed with a close-up of his hands on the piano. The sign attracted media interest and 'everything started from there', Graeme says.

'Independent pub sign designers are very rare now,' he continues. 'Pub signs are part of the social history of an area and the point is to grab people's attention and get them talking. I try to make designs contemporary but without cheapening a pub. You are making a serious attempt at trying to help someone's business, forcing people's ideas of art and pub signs back a little so that they take notice, but without going too far or making an image into a cartoon. There's a fine line!'

He dislikes trends among some big breweries and leisure groups for computer generated graphics, plastic lettering or 'theme pubby' signs, and it hurts him to see TV celebrities depicted. 'Signs should be individual and include a flavour of the pub, landlord, customers and area,' he says, adding, 'I love researching a building and its surroundings, and talking to the landlord or landlady, before starting work on an image.'

He found, for example, that the name of the Blackboy Inn, Blackboy Hill, Bristol, didn't derive as most people thought from the city's links with the slave trade. Rather,

RIGHT *Artist and independent pub sign designer Graeme Robbins paints and restores pub signs all over the country.*

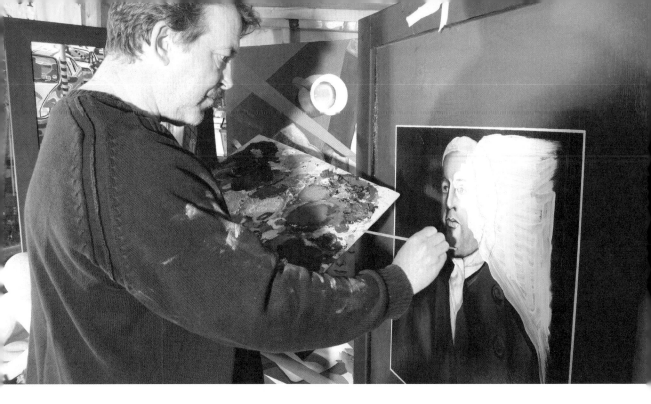

ABOVE *In days when few could read, pub signs were important to reflect the nature of an establishment.*

Blackboy was a nickname given to Charles II because of his dark good looks. 'There's a picture at the National Portrait Gallery showing Charles and a woman riding on horseback to Bristol. Evidence suggests that the pub recalls his visit when he was escaping Oliver Cromwell's mob in the Civil War, although the original Blackboy Inn was farther up the hill.' Graeme's sign shows a suitably suave and regal cove.

For The Penpole Inn, Shirehampton, he painted a watchful warrior: much digging around had revealed that 'penpole' is Anglo Saxon for 'lookout point'. Meanwhile the Castle of Comfort in the Mendips bears a striking image of chained hands beside a pint and roaring log fire: prisoners convicted by the notorious Judge Jeffreys following the Monmouth rebellion in the 17th century were permitted one last drink here before having their necks stretched on the hill.

Some signs, Graeme admits, are unconventional, including a recent commission for The Ancient Mariner in Nether Stowey, Somerset, opposite the cottage of Samuel Taylor Coleridge who

wrote the famous 'Rime'. 'It's quite a dark poem so I mimicked that with an image of the albatross at the moment when the captain shoots it. On the other side of the sign I painted a picture of the ship and the iceberg in red and black. It's quite intense and unusual, and it got the village talking.'

He paints signs in black and white, too: The Countryman for a pub in Solihull shows a man and dog silhouetted against a night sky. 'Sometimes black and white works best, to make people slow down and look. There is always a lot of colour in black and white anyway, there is a lot going on and it can be more dramatic.'

Graeme approaches restorations with reverence for what has gone before. As he stripped back layers of paint on the sign of the Sheppey Inn, a pub on the Somerset Levels, he uncovered five earlier paintings, each depicting a similar image of a man fishing. 'All the painters had signed their names and when I got to the bottom the sign was actually made of glass. The pub is nearly 300 years old.' Graeme added a modern touch to his restoration by giving the

fisherman a baseball cap to wear.

The history of pub signs can be traced back centuries. The Romans would hang a bundle of vine leaves – in Britain a bush – outside their taverns, and Saxon brewsters displayed a pole or ale stake. In days when few could read, signs were important to reflect the nature of an establishment, and in 1393 Richard II made this a matter of law for alehouses so that ale-conners (official tasters) could identify premises where they needed to test beverages before they could be sold.

In the 17th century as coaching inns competed for trade, so signs became bigger and more ornate, even straddling the highway. The risk of deaths or injuries should they collapse led to a Parliamentary Act of 1667 restricting the size of hanging signs to 4ft × 3ft.

Names in our open air gallery of social history also provide rich insights into the past. Heraldic and royal allusions showed partisan loyalties, hence the many Lions and White Harts. Others commemorated historic or legendary people and feats (The Admiral Nelson, The George and Dragon). There were pubs where tradesmen met (The Woodman) and sports were celebrated (The Cricketers). And nowadays some seem named simply to be odd, like The Slug and Lettuce.

Aware of all the traditions that have shaped his metier, and having chatted to his customer and done his research, Graeme settles to each new commission in his small garden studio. He begins with a sketch that he shows the client and then he prepares the surface of the sign for painting.

'I usually work on a hardwood frame with a marine ply panel, but signs may also be metal or glass,' he says. 'I work in oils and acrylics: oils for the more important parts of the painting and acrylics because they dry quicker. For example, I might use acrylic as a base coat for a blue sky and work oil on top. I have to work fairly quickly to earn a living, plus I need to get a sign to the customer promptly: there is nothing like a pub without a sign hanging outside for it to appear closed.

'I am painting something that must look good from 15 to 20 feet away, so every now and then I go into the house and look from an upstairs window at the sign outside in the garden, then make a few tweaks. I put my monogram, a G and R joined together, in the bottom left corner or hidden in the image itself.

'Then I seal the sign with clear yacht varnish. That takes almost as long as the painting because I usually go for six coats and each one takes about a day to dry. But it's important. Signs are out in all weathers.'

Graeme encourages landlords to keep an eye on their signs as they endure sun, wind, rain and worse, and to bring them in for free touch-ups before wear and tear gets a hold. 'It's just a personal thing. I want my signs to keep looking good,' he says.

> *As he stripped back layers of paint on the sign of the Sheppey Inn, he uncovered five earlier paintings*

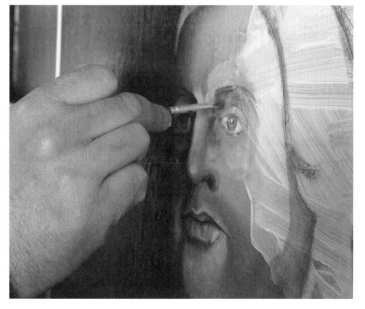

BELOW *Once the sign has been painted it is sealed with six coats of clear yacht varnish. Each coat takes about a day to dry.*

The Glass Engraver

LESLEY PYKE

Lesley Pyke grew up in Zimbabwe where her interest in glass engraving began when, in 1983, quite by chance, she saw an article in a craft magazine showing a flower delicately engraved on a glass. It was a moment she has never forgotten.

'I completely fell for it. The whole idea of art on glass was so captivating! I was already a painter – both my parents were painters too – but this was something special. I straight away joined the overseas section of a London glass engravers' group (The Guild of Glass Engravers) in 1983 and read everything I could get my hands on.'

After this enthusiastic beginning it was time to put theory into practice, which is where a chance discovery at a dental supply company, where she worked for a short while, came in useful!

'Well, I started with diamond point engraving after finding some diamond points in a box at the dental supply company during a stocktake. Diamond points are small industrial diamonds fitted to what looks a bit like a pencil. They are perfect for linear engraving – drawing using lines – or for a stipple technique that involves producing dots by tapping on the glass.'

Within a short time Lesley was selling her work through personal contacts, but Zimbabwe was a difficult place to work for a number of reasons.

It's not necessarily the size of the object being engraved that affects the time – it's the complexity of the design

'Friends and acquaintances bought my early efforts, which was encouraging, but there were no hobby shops where you could buy a small drill to enable me to work more efficiently. I even had to go to South Africa to expand the range of tools I was able to use. I bought a rotating drill there which has a much more efficient effect on the glass. It leaves the surface of the glass rough which catches the light and makes it white.'

Undaunted by the difficulties of working in Africa, Lesley gradually expanded the range of techniques she was able to use and the quality of equipment. Like so many craft workers, she has her heroes.

'I was enormously influenced by the great glass engraver Laurence Whistler who died in 2000. He used mainly stipple but he used it to great effect.' As the political situation deteriorated in Zimbabwe, Lesley decided to leave. In 2001 she arrived in the UK with only a rucksack and one small drill. Now settled in Halesworth, Suffolk, she works on a range of commissions and her own gallery pieces.

'I've engraved everything from small glasses and even earrings to large trophies and even solid glass doors. It can take a week or more to finish a piece. A rather unusual job in Harare – engraving a set of glass sliding doors – took me three months but that was exceptional. On the other hand a tiny glass engraving can take weeks so it's not necessarily the size of the

RIGHT *Using both drill and sandblasting techniques, Lesley Pyke – who taught herself to engrave from books and videos – offers bespoke glass engraving on everything from the smallest glasses to panels and sliding doors.*

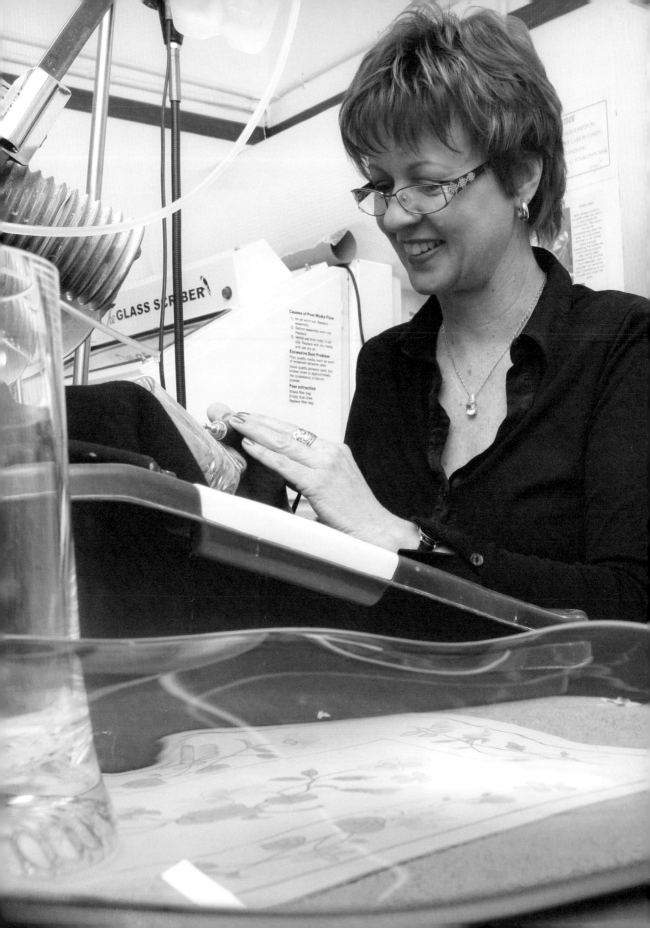

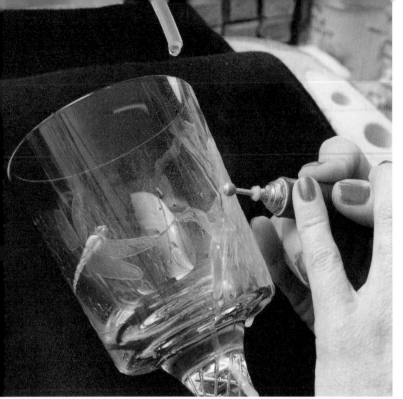

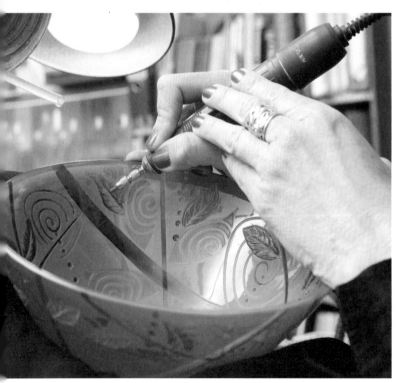

ABOVE *The depth and angle of each cut is critical to release reflections and light.*
ABOVE *Lesley uses a finely and precisely weighted drill for delicate work.*

object being engraved that affects the time – it's the complexity of the design.'

Though glass engraving is an ancient art – one of the greatest examples is the Roman Portland Vase in the British Museum – Lesley has made a few concessions to the modern world.

'I draw my designs on a computer as this enables the curved shape of the glass to be easil factored in, but sometimes I will work straight o to the glass in freehand. For an animal portrait – someone's pet, for example – I will work from a photograph but I want it to look realistic and naturalistic so I use the computer until I get the image just right and with the correct warp to fit the curve of the glass.'

In the beginning Lesley was very much an amateur but today she is as professional as an artist can be. The shift came when she decided to invest in some rather more serious equipmen in 1984.

'The biggest change from glass engraving as hobby to doing it as a professional definitely came when I bought a heavy duty drill to replac the light hobby drill I'd used in the first year.

'A small drill will get hot very quickly but the models I have now can be used all day with no problems. I also use a micro-motor – a finely and precisely weighted drill used by dental technicians. It's perfect for delicate work. The heavy duty drill, by contrast, works well when deeply carving thick crystal. I reckon I use the micro-motor 90 per cent of the time.

'Sandblasting is another technique I enjoy – it basically does what it says. Using a stencil in the shape of the design you simply blast the glass using a special grit that produces really fir detail. I use sandblasting mainly for lettering an will combine it with hand engraving for a numbe of other subjects – coats of arms, for example. Despite these modern techniques you still often have to complete the job by hand for that completely unique effect, just like painting.

'I can engrave pretty much any glass but I use crystal mostly as it is easiest to work on and produces the best results in terms of finish – it is just so vibrant! For an exquisite brightness and the best finish for detailed work I would always

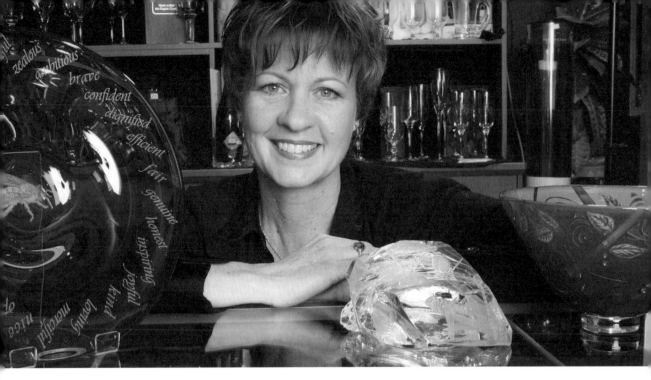

recommend crystal. Of the commercial names my favourite is Tudor crystal, with Dartington a popular crystals for my clients, but there is nothing like hand blown one-off pieces by local glassblowers created especially for engraving, often with layers of colour to carve through.

'If you look at a superb piece of ancient glass engraving such as the famous Portland Vase in the British Museum you realise that though the techniques have changed over the centuries we are still basically trying to produce the same level of quality that the ancients produced using far more basic tools. The Portland Vase is spectacular and so fine that it is difficult to see how it was done.

'We know that it is likely they used a lathe and tools they used for gem cutting and although we use electrically driven tools today the basic idea remains the same.'

From her high tech studio Lesley produces

{ *We are still basically trying to produce the same level of quality that the ancients produced using far more basic tools* }

a remarkably wide range of engraved artefacts. Most commissions are pretty standard but there have been surprises, as she explains.

'My most bizarre commission to date was for a design showing a picture of a Chinese woman with a candle sticking out of each ear. I still don't know what that was all about. I've done a few engravings of millionaires' yachts too – recently two commissions of a client's mega-yacht across three whisky decanters. These are tremendously exciting and a technical challenge!

'I have done a certain amount of architectural work for banks and nightclubs in the past, but perhaps one of the most satisfying mediums you can work with as a glass engraver is overlay crystal – this is where layers of coloured glass have been fired together so what starts as, say, a blue bowl ends up showing varied shades of blue, white and clear for example, as you cut your design through different depths. It's called cameo engraving, a fine example in fact being the Portland Vase. I have worked with layers of three or four colours and each colour will show (or not) depending on how far you engrave through the multiple layers.'

ABOVE *In practised hands, simple clear facets can be transformed to baffling 3D reflective visions, dazzlingly bright captured light mixed with soft subtle shades.*

The Serpentine Rock Carver

IAN CASLEY

Lizard, serpentine – it sounds like the beginning of some child's tale of shivery terror. But mystery and magic rather than menace prevail when you're down on the Cornish cliffs of mainland Britain's most southerly tip. The blustery plateau of the Lizard derives its name from the Celtic *lys ardh*, or 'high point'; below you rugged rocks gnaw at crashing waves and, away from the water's edge, heathland grows with rare plants.

Yet perhaps the greatest enchantment lies right beneath your footsteps: a unique geology millions of years old that has forced the 'metamorphic' rock known as serpentine to the earth's surface.

Drop into Ian Casley's small wooden workshop and showroom on Lizard Point and you'll see all manner of traditional ornaments and jewellery made of the splendid stuff. Ian is one of only five remaining local craftsmen turning and polishing serpentine, prospecting for it by agreement with landowners and farmers.

'Serpentine doesn't occur in many places worldwide and I know of only five or six, including the Lizard, where the quality is such that you can turn it,' he says. 'It's called serpentine because of the similarity of its markings to snakeskin. You get a tremendous variety of colours – anything from a green base to red or grey, with mottles, veins and stripes. No two examples are the same.

'It's also special because it's just soft enough to turn by hand on the lathe, but just hard enough to take a good polish. It has a very, very silky texture and is a wonderful raw material to work with.

'Serpentine normally lies deep in the earth's mantle,' Ian continues. 'Formed around 350–380 million years ago beneath the ocean, the rock was torn up and pushed on to the evolving landmass we know as Cornwall by the collision of two continents. It covers some 20 sq miles – over half – of the Lizard peninsula, the largest such outcrop on mainland Britain.'

> { *It has a very, very silky texture and is a wonderful raw material to work with* }

The captivating variety of its hues and patterns comes from different combinations of iron, talc, magnesite and crystals of schillerized pyroxenes.

Queen Victoria set a fashion for decorative household goods made of serpentine after she visited Cornwall in 1846 and commissioned a coffee table and other items for Osborne House, her holiday home on the Isle of Wight. The popular demand that followed this royal patronage provided employment for many locals in a water and steam-powered factory at Poltesco. However, it closed under curious circumstances in the 1890s.

'It's said a large cargo heading for France sank and the uninsured loss bankrupted the company,' Ian says. 'But some turners set

*RIGHT **Ian is one of only five remaining craftsmen on the Lizard turning and polishing serpentine, a rare metamorphic rock.***

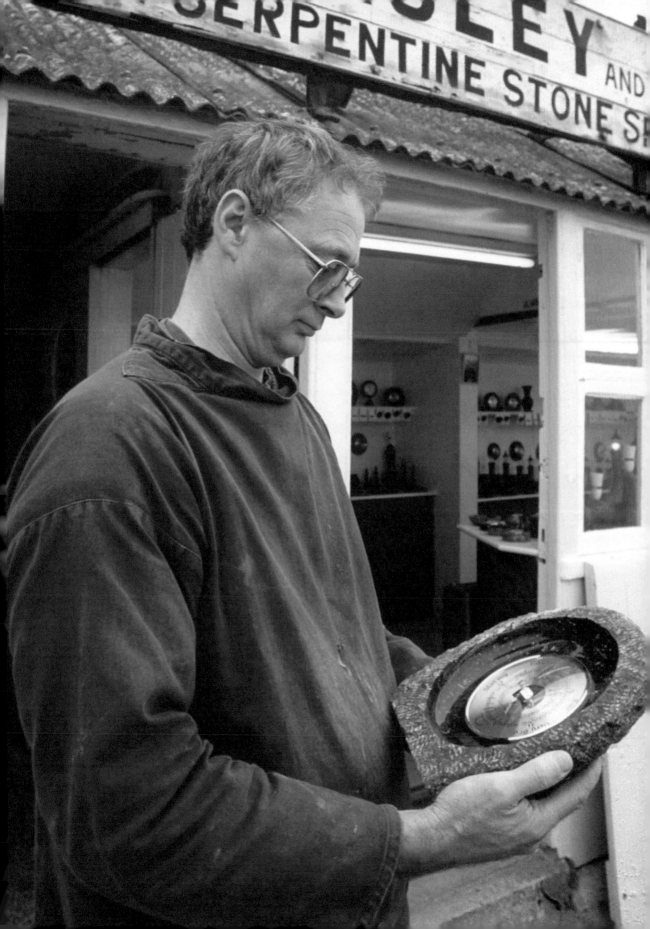

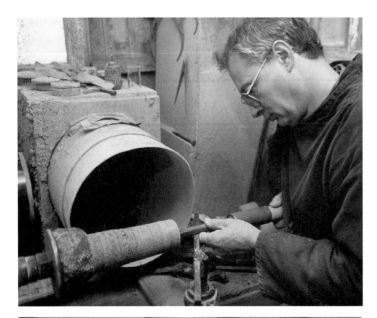

we are looking for. Occasionally we prospect by hand using an auger and probe, but that's very hard! So we mainly use a digger with a small, narrow bucket to trench the ground and backfill.

'As a rule, the best quality stone comes right up to the topsoil and it tends to be smaller with sharper defined colours. The deeper you go, the larger and more mottled the pieces are. Near the surface we might get fingers of stone measuring 3 inches upwards – they're good for making [ornamental] lighthouses, which are very popular and traditional. Deeper down, pieces could be several hundredweight.' In those instances, it's out with the sledgehammer and gad before the find can be manhandled home.

Ian checks and roughly shapes rocks at the quarry site to ensure he is retrieving only sound material. Then, in his workshop, he begins knocking out – shaping pieces more accurately with a hammer to create a round blank. By the time he has done this, around 50 per cent of waste has been discarded.

Watching him at work, you see a man totally absorbed in his craft: dressing up the bottom of the rock, gluing it on to the faceplate of the lathe, meticulously hand turning and shaping using a tungsten carbide-tipped tool.

{ *I've customers who come back year after year and who are collectors* }

Once Ian has fashioned an ornament he polishes it using wet and dry aluminium oxide paper in ever finer grades of grit, finishing with corduroy cloth impregnated with flour emery. He gives a final flourish of jeweller's rouge on a chamois leather with a little olive oil. Then his newest piece is put into his showroom beside a range of lighthouse lamps, barometers, thermometers, pedestals, clocks, vases, bowls, night-lights, attractively crafted eggs and jewellery.

ABOVE (top) *Ian shapes the piece by 'knocking out' with a hammer to create a round blank. The process loses about 50 per cent of waste.*
ABOVE *The piece is glued on to the face plate of a lathe, which is then hand turned and shaped using a tungsten carbide-tipped tool.*

up their own small businesses in Lizard village to serve tourists. My workshop and showroom were a serpentine shop as early as 1896.'

Ian followed his maternal grandfather and father into the trade in the late 1970s (his brother also turns serpentine at a nearby workshop). He usually prospects for the rock outside the main Easter–October tourist season, but if a new vein comes to light he will get digging at any time of year.

'The stone tends to be in little clusters of veins, covering half an acre, within four or five miles to the north of the village,' he explains. 'Farther away, it's not the quality

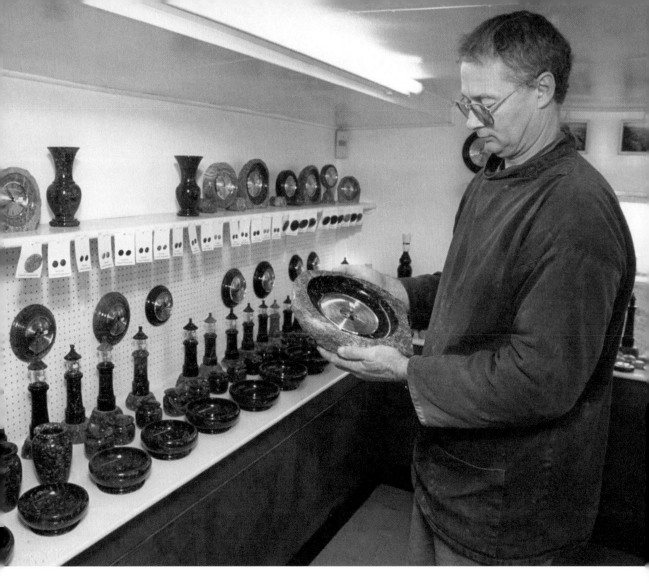

'All the local turners are very traditional in what they make – electric lighthouses, bowls – but they put their own interpretation on designs,' Ian says. His workshop and showroom are open weekdays throughout the year and he welcomes visitors to watch him hand making his ornaments. 'I've customers who come back year after year and who are collectors,' he says.

If you go church crawling on the Lizard you'll spot serpentine fonts, lecterns and bible stands and, in the past, Ian too has crafted portable tabletop fonts for chapels. But it is becoming increasingly difficult to tackle such large jobs – and here's the sting in this Lizard's tale.

'Good veins of serpentine are running out,' Ian says. 'The old men who prospected by hand before us didn't miss much! Two years ago we were lucky when we quarried in an old pit and managed to open out another layer of serpentine in the bottom. But that's a rarity now.

'I get through about three tons of rock a year but basically we're living off stocks and replenishing a little with what we still find. It means that in probably three or four years time bigger items will gradually disappear.' I'll end up making just small things like jewellery. However, we live in hope – you could have a farmer out ditching and he strikes something.'

ABOVE *Ian polishes the piece using wet and dry aluminium oxide paper, finishing with corduroy cloth saturated with flour emery.*

The Silversmith

WILLIAM HART

Hart Gold & Silversmiths is exactly the sort of business you would hope to find in an ancient Cotswold town like Chipping Campden. Along a side street of typical honey-coloured buildings whose stone seems to hold the sunshine of centuries, a door opens on a workshop scarcely altered since 1902.

'The family has been here over 100 years, using the same tools, techniques and traditions that have always been used,' confirms fourth generation silversmith William Hart.

Upstairs he and three others work on wooden benches pitted by the toils of their predecessors; tools clutter along racks and shelves with an organised chaos borne of decades of use. Overhead, invoices spanning 50 or so years hang from hooks in the beamed ceiling.

The workshop is the last operating remnant of the Guild of Handicraft established in 1888 by CR Ashbee, an architect and devotee of William Morris. The Guild aimed to revive skills and ideals of craftsmanship that had fallen by the wayside following the Industrial Revolution, and embraced silversmiths, jewellers, enamellers, woodcarvers, cabinetmakers, French polishers and bookbinders.

Initially Ashbee set up in London's East End but, to improve the quality of life for his craftsmen and give them beautiful surroundings in which to work, he moved the Guild to Chipping Campden in 1902. Some 200 people, including wives and children, descended on his Cotswold 'City of the Sun'. Among them was silversmith George Hart, William's great-grandfather.

The Guild of Handicraft became a leader in art metalwork and jewellery, noted for simple flowing shapes with an art nouveau flavour. Chipping Campden, once it had accepted the incomers, quietly flourished as a centre for Arts and Crafts study.

Sadly the experiment was not entirely successful. 'There were a lot of transport costs to Ashbee's shop in London, where his market was, and not many customers wanted to come out to the sticks,' William says. 'Plus Liberty's in London started manufacturing similar designs at cheaper prices. Economically, it wasn't a viable concern.'

After a few years Ashbee and most of his associates had drifted away, but some stayed and from 1908 George Hart took on the running of the workshop.

There were 14 silversmiths when Ashbee was here and just four when great-grandfather took over, William says. 'It was tough and he was thinking of giving it up in the 1920s, but then work came in and he got well known and turned it into a success. He passed on his skills to his son, Henry, who

> *The family has been here over 100 years, using the same tools, techniques and traditions that have always been used*

RIGHT **William Hart is a fourth generation silversmith, and his work is a mix of private commissions and presentational silverware, reproductions and ecclesiastical silverware.**

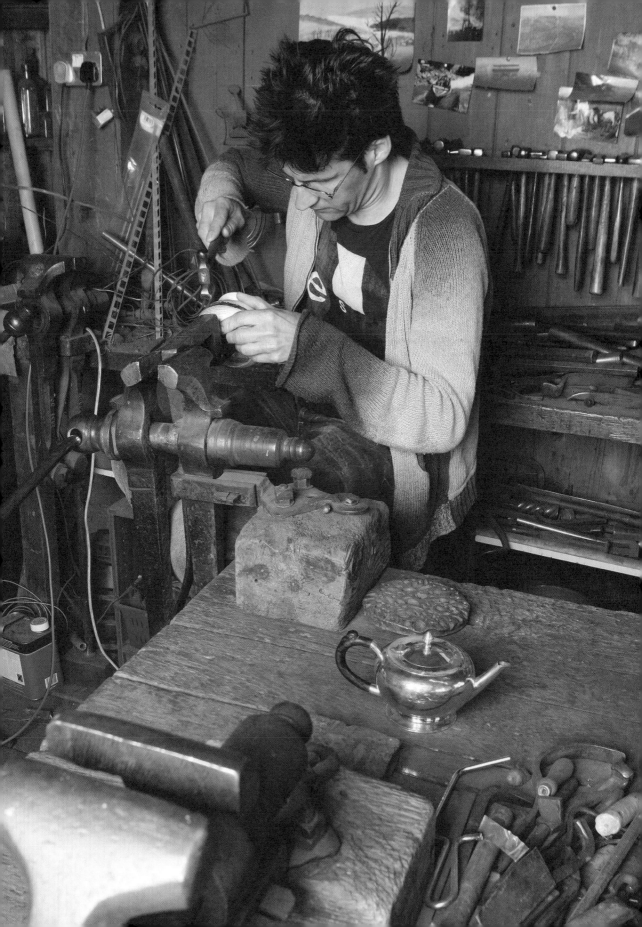

ABOVE *The silverwear will remain matt-grey until it gets planished, which involves finely shaping and smoothing the silver by hammering it against a shaped surface.*

in turn taught his son, David, my father who taught me.'

Today Hart's studio comprises David, William and his cousin Julian Hart, plus Derek Elliott who served his apprenticeship with David. Each is self-employed and they share the commissions and costs of the enterprise. In the 'open shop' tradition of the Guild of Handicraft they also welcome visitors to watch them at work.

The team specialises in a wide range of domestic silverware, from cutlery and condiment sets to tea and coffee services. They also design and make ecclesiastical and civic silver.

'Fifty years ago, we made 90 per cent ecclesiastical items and probably every church in the country had a piece of ours,' William says. 'We made a cross for Gloucester Cathedral, the biggest in the country at the time, that was used at the Queen's coronation in Westminster Abbey. These days though, silverware isn't left on display in churches in case it is nicked, so fewer things are commissioned. At least 90 per cent of our work now is domestic wares.

'People buy things for silver wedding anniversaries, big birthdays or retirement presents. Or sometimes they bring in a tea set that has a piece missing and we

recreate something to match. We sell a lot of spoons which seem to be very popular for christening gifts. We've had a few unusual requests, too: one lady wanted a silver model of her dog.'

William originally took a university degree in computing, but decided to join the workshop 20 years ago to fill the vacancy left when his grandfather retired.

'I learnt on the job exactly as an apprentice would,' he recalls. 'More than having an artistic ability, I would say that you have to have an eye for detail. You're working in 3-D and you have to grasp: if you hit an object in this place, it will change to look like that.'

When a customer comes with a commission, William discusses ideas. 'We still do some of the Ashbee designs of curved rather than angular lines, but at the end of the day we do what the customer wants and that could equally be funky and modern.'

HAND TOOLS ONLY

Silver is delivered to the workshop in 500mm × 500mm (20in × 20in) sheets that are around 1mm thick. It is standard or sterling silver: that is 92.5 per cent pure silver to 7.5 per cent copper alloy.

The whole process of making items is carried out using only hand tools, except for one piece of motorised machinery for polishing finished articles. 'We've around 100 different hammers and although some are rarely used we never throw them away because you can't buy replacements,' William says.

If he is making a simpler item, like a cream jug or bowl, William starts by cutting a flat, circular piece of silver. 'I put a compass in the middle and draw circles from the middle to the edge,' he explains. 'Then you dish the silver into a bowl shape by hammering it over steel stakes: we've a lot of stakes of different shapes so we can hammer any shape you can think of. The process is called hand raising: you hammer around the circles to

raise up the sides evenly, from a flat sheet to a shallow bowl, to a deeper bowl, to almost a beaker shape with the sides vertical and the bottom horizontal. Obviously, you never go narrower at the top than the size of the tool you need to fit into the bottom.'

During the process, the silver is annealed or heated over a flame. 'Every time you hammer the silver, it hardens, so if you don't heat it up it will crack,' William says. 'If I'm making a teapot, for example, I might heat it up red hot about 30 times to soften it, each time letting it cool naturally before I can hammer it again.'

{ *More than having an artistic ability, I would say that you have to have an eye for detail* }

The item remains matt-grey until what is called the planishing stage. 'Once I've got the shape I want, to get a nice surface on the metal I find a tool that fits inside the shape perfectly and a hammer that fits the contours outside perfectly, then I hammer lots of tiny dimples, creating little facets that lap each other and give a nice shimmer. If you wanted a completely smooth surface, you could file them out, wet and dry them, and polish them. We tend to leave them because customers prefer that: it shows an item is made by hand, not machine.'

Handles are cast and spouts are formed separately, then silver is soldered into position. Edges, such as rims of bowls, may also be strengthened by soldering on silver wire, or corking: a technique of hammering to squash out and widen the edge. Often pieces are engraved and just occasionally they are decorated, perhaps with repoussé work or chasing. But mainly these days people like things plain and elegant. In total it takes around three days to make

something like a teapot.

Pieces are stamped with the workshop's 'GofH' mark and sent for hallmarking at the Assay Office London, part of the Goldsmiths' Company which, since 1300, has been responsible for testing the quality of gold, silver and, latterly, platinum and palladium articles. Newly stamped with the sterling silver lion, pieces return to Chipping Campden for polishing: a cloth mop is attached to a motor, a mixture of pumice and wax is applied, then William holds the piece against the rotating mop to buff it. The process is repeated several times using finer polishes to achieve a final lustre.

'I think there are only about 30 small concerns hand making silverware in the country,' William says. 'I really enjoy the work, it's quite relaxing most of the time, and Chipping Campden is a lovely picture postcard town.' The Guild of Handicraft

BELOW *William uses one raising hammer over a stake to raise the object into shape.*

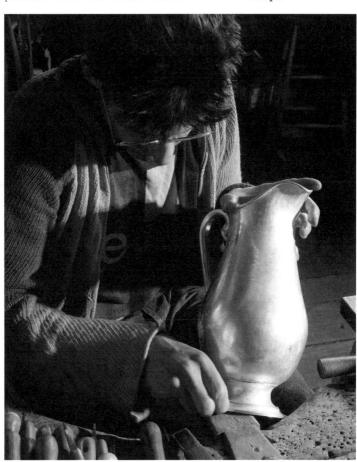

BASKETRY CRAFTS

The Basket Maker

NORAH KENNEDY

Norah Kennedy spent many years as a herdswoman working with farm animals in such far away places as New Zealand, Israel and Denmark. Then in the early 1980s, as dairy farming changed and became more intensive, Norah got married and found herself working in a whole-food cooperative in Swindon. She enjoyed the work until a small advertisement caught her eye, as she explains:

'I'd never really thought about basket making at all but then one day a local basket maker came into the shop and put a card up on the notice board – he was looking for an apprentice and as soon as I saw his ad I thought I'd like to try that – so I did!'

As it turned out, Norah found the work much harder than she'd imagined. But it is testament to her enthusiasm that she refused to give up.

'Well, I must admit I did find it very difficult at first. Getting the design and the weave right seemed a real challenge but I think I must have been really hooked because I was soon going to lessons two or three times a week. I'd given up being a herdswoman after I got married and returned from my travels and I probably needed this new challenge. I was living near Cirencester and my husband used to drop me off at the basket makers each week.'

Norah is a great believer in the idea of combining beauty and utility – creating objects that are great to look at but also do something useful.

'All my baskets are functional – they are designed to be used, which is the big attraction I suppose. And I make a wide range of baskets – everything from small fruit baskets to shopping baskets and big log baskets. They are made in a range of shapes too – everything from round through oval to square and rectangular.'

'It was probably a year after I started to learn to make baskets that I felt I was quite confident enough to work on my own. I'd realised by then that the best way to perfect a particular design or technique was to learn it and then do it over and over again. It's all about practice and repetition.

'I remember feeling delighted when I was asked to bring my baskets along to a school fete where I sold them – looking back now, I'm sure those baskets were all rather wonky! But some time later when I felt more

RIGHT *Norah Kennedy has been making baskets for 27 years. Her baskets are made from stripped and unstripped willow which are mostly grown on the Somerset levels, but with some unusual colours from Herefordshire and Powys.*

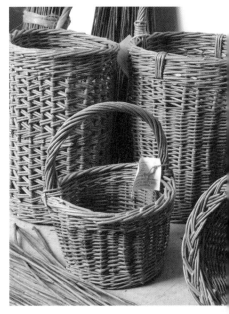

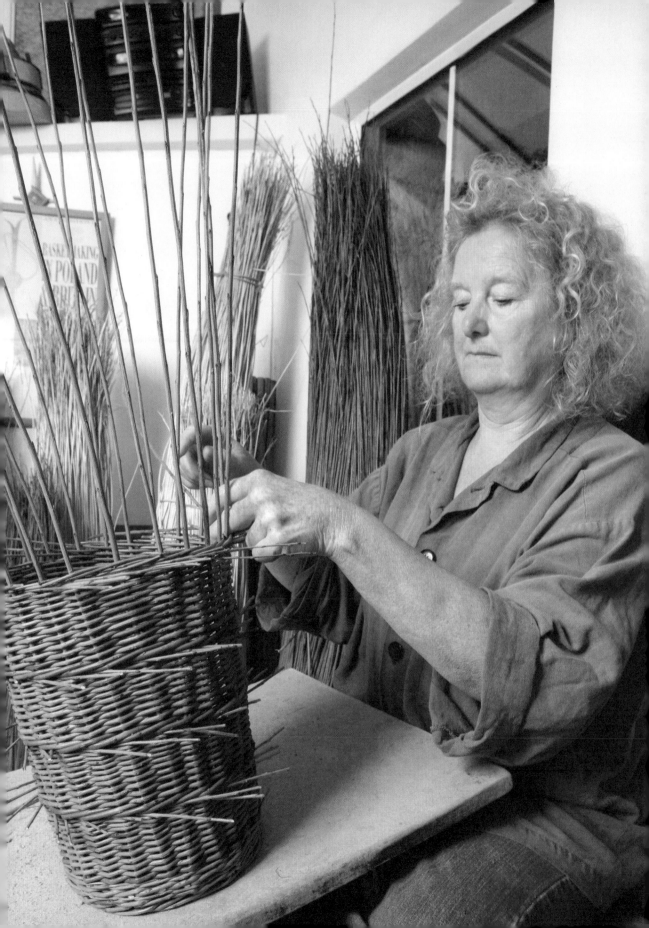

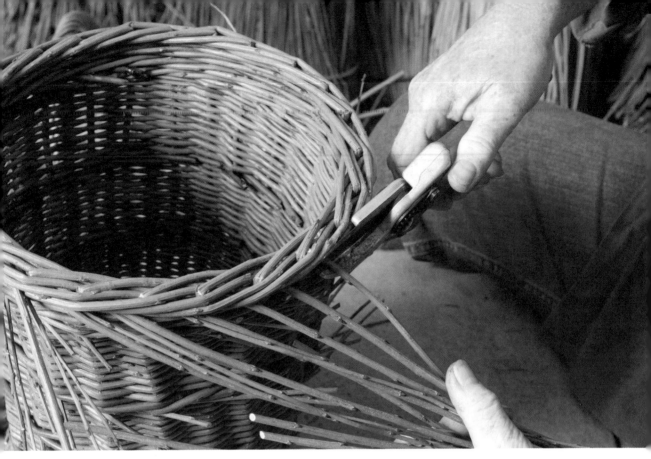

ABOVE *The basket maker has a small toolkit, including a range of instruments for shaving and cleaving willow rods, knives and devices for arranging the weave. Shears are used for trimming the ends when the work is finished.*

confident about making baskets someone asked me if I would show others how to do it. That was the beginning of my career as a basket making teacher. As it began to take off it meant that I could work quietly at home making baskets for part of the week and for another part I would be with people teaching them. The combination of teaching and making seemed ideal.'

The skills may take some time to learn, but the tools and raw materials of the basket maker are wonderfully simple and, as we look increasingly for green solutions to our various environmental problems, basket making ticks all the right boxes.

'All my baskets are made from willow, which is the most marvellous material because it can be used for so many different things. I'm very fortunate because a friend of mine in Herefordshire has her own willow bed and I get some of my willow from her. In fact, each winter I go up to see her and we cut the willow together. It then takes a

few months to dry. I'm so lucky as my frien grows about 30 different kinds of willow, which means I can make baskets in a wide range of colours.'

One of the oddities of willow basket making is that once you let the material dry out you have to wet it again before using it. 'You have to soak it to make it pliable – I us a cattle trough, which is perfectly adequate as there are no chemicals involved and it only has to be filled with water. If the bark is still on the willow you need to soak it for several days but if it's been stripped a few hours will do it. After it's been soaked I lea my willow wrapped in a blanket overnight ready for use.'

MAKING A BASKET

'With any kind of basket you start by making its base – it's difficult to describe exactly bu using three base sticks you create somethin that looks rather like a child's drawing of the sun – a central disc with the base sticks

extending from the centre like beams from the sun. As it opens up you weave around each base stick before putting the uprights in next to the base sticks. You sharpen the thick – or butt – end of the uprights and push them in next to the base sticks. When you've reached the height you want you weave what we call a border, which finishes the basket off. Sounds straightforward but it's tricky to get the hang of.

'What I like about basket making is that you use your hands and a natural material, it's as simple as that. No complicated tools and, in essentials, it's what people have been doing with willow for thousands of years. You can't make a willow basket using a machine so it is not something that can be modernised. That's the appeal for people who come on my courses – it's just willow and your hands yet at the end of the day you have something functional and attractive to take home with you. And each basket is different – unique, like a person's handwriting.'

Norah accepts commissions for unusual baskets, but one recent commission has taken her into a rather more eccentric area, as she explains.

'I have just completed a commission for the Ermin Street Guard. It's a group whose members dress up as Roman soldiers and organise re-enactments of various battles. Apparently Roman soldiers used to practise using shields made from woven willow because they were heavier than real shields – the idea was that if you got used to fighting with a heavy willow shield it would be easier when it came to a real battle with a real shield.

'Making the shields was great fun but very different from making baskets as no bottom was needed – the shields were just large, curved pieces of weaving fitted to a wooden brace.

'It takes me about an hour to make a waste paper basket. I'm rather slow compared with some! A big log basket might take three or four hours. I think the appeal of basket making is growing. Increasingly people like to make things themselves and they want to get away from the machine made back to something a little more low tech.'

BASKETRY TECHNIQUES

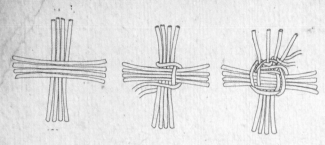

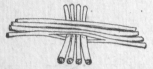

1. *Slath started by making interlaced cross as shown here*

Two decorative centres. Both begin with a cross, this one worked with two weavers interlaced

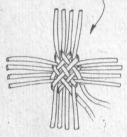

This is worked with one weaver. Suitable for skein

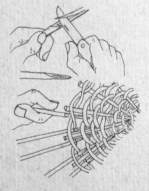

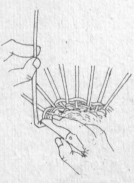

3. *Pricking up. Stakes kinked up over the point of a knife*

2. *Staking up, ends slyped and pushed in, one each side of a bottom stick*

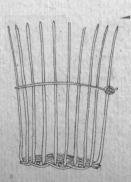

4. *Basket staked up and ready for weaving. The stakes are held upright with a temporary hoop*

The Oak Swill Basket Maker

OWEN JONES

O wen Jones is the only man in Britain still making oak swill baskets full time. He learnt his trade at the workshop of one of the old school of swill basket makers: John Barker, who in his turn learnt back in the 1930s when swill baskets were still common and made in the High Furness area of south Cumbria.

Owen moved to Cumbria from Cornwall where he worked as an engineer, but a growing interest in basketry and crafts, combined with a family connection to John Barker, led to a partnership with the old man that lasted through John Barker's retirement: 'I learnt the sort of things from John that you could never learn from a book,' says Owen, 'and if I hadn't met John and joined him in his workshop, the unbroken tradition of swill basket making of which I am now a part might have ceased.'

The origin of the swill is unknown although local parish records indicate that they dated back to the 17th century. They are also known as oak 'spale' or oak 'spelk' baskets and the industry was centred around the coppiced oak woods of the High Furness fells in south Cumbria.

After a 4–5 year apprenticeship a 'swiller' worked on piece rates making between two and three dozen swills per week, depending on the size. They were made in set dimensions and used as measures. A 20in long swill was called a 'half peck', a 22in a l'ille (meaning little)

Nick , a peck was 24in long and a 26in swill was a 'gurt (meaning large) Nick'.

They were used by farmers for broadcast sowing, picking potatoes and feeding animals.

Swills were sold in the thousands for coaling steam ships, in the local bobbin mills, by charcoal burners and in mines and foundries. Every home had a swill for logs and laundry which also doubled up as a babies cradle.

The second half of the 19th century was probably the heyday of the swill basket with a slow but steady demise throughout the 20th century and the last of the 'old-time' swillers retired in the 1980s.

*RIGHT **Britain's only swill basket maker Owen Jones at work on a basket that might be used for anything from logs to laundry. The swill basket remains unchanged in design in over 300 years.***

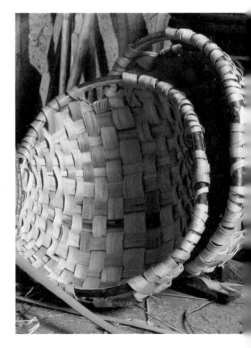

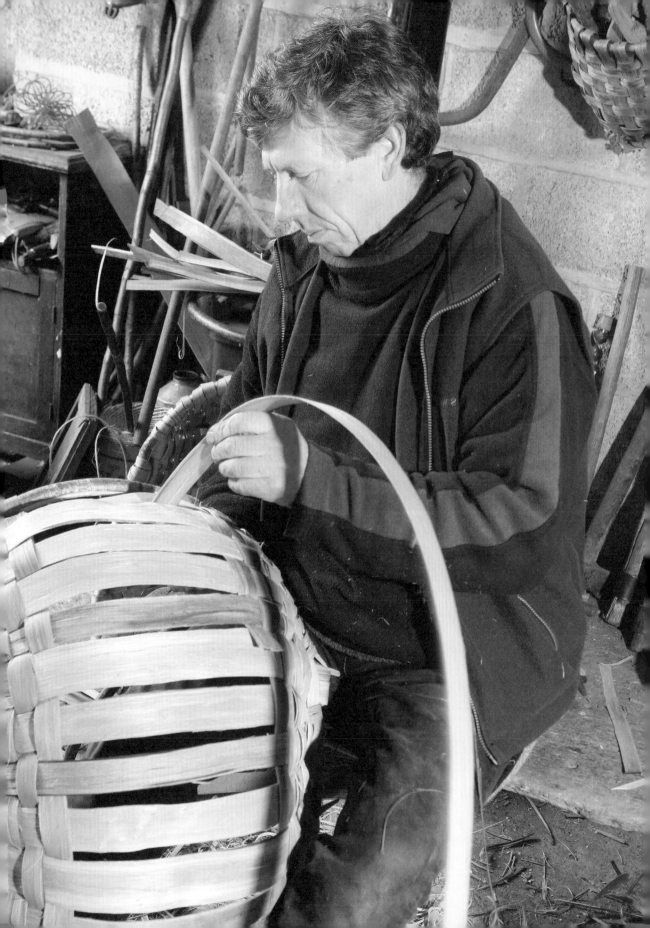

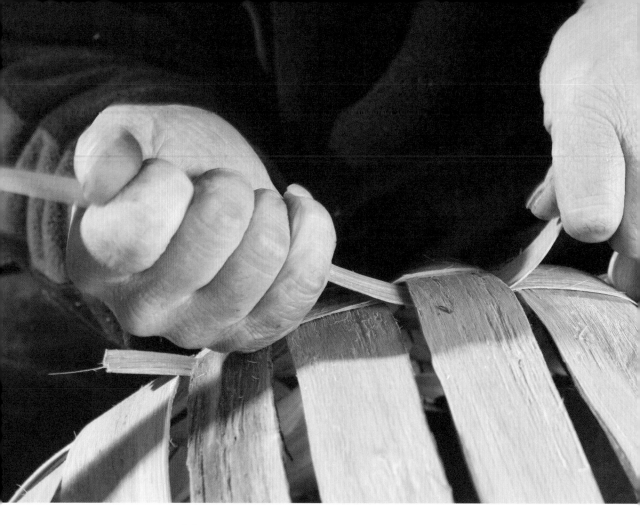

ABOVE *Looking
rather like a small
coracle, the swill
basket is made
using a great deal
of skill but only a
few simple tools*

MAKING A SWILL BASKET

It is a complicated business, but it all starts
for Owen with a visit to a coppice wood in
the Rusland valley a few miles away from his
home at High Nibthwaite, near the town of
Ulverston: 'I get all my oak from this wood.
It's all coppiced, and I'm looking for straight
trunks of oak about 6in in diameter. I use
the first 8ft of the oak, which I saw inot

*If I hadn't met John
and joined him in his
workshop, the unbroken
tradition of swill
basket making of which
I am now a part might
have ceased*

lengths of 2–5ft long. The shorter lengths
for the ribs and the longer lenghts for the
weavers. Each length is then quartered,
but not with a saw: to keep the strength
of the wood, swill basket timber is always
cleft or riven – in other words, it is split.
This means that the wood will be naturally
strong however thin the pieces, because you
are following the fibres rather than slicing
through them to create each piece. The end
result is that each piece may rise and fall
and be uneven where the fibres run round
a knot.

'The quartered bits of oak trunk are put
into a boiler – an iron trough filled with
water – where the wood is boiled for a
few hours. I then leave it all to cool down
overnight before lighting the fire again and
allowing the wood to simmer all day. Each

billet – the quartered bits of trunk – is riven while still hot: that just means I tear each piece into increasingly thin strips. The ribs or "spelks" – of the swill basket are usually about ⅛in thick; the longer bits of wood, or weavers which we call the "taws" are ¹/₁₆in thick. There is an art to splitting the wood this thin – every tree is different and much control and experience is required to rive out consistent, pliable 'taws'.

'The basket is put together in what still seems like a complicated way, but it starts with a steamed hazel rod, which is bent and fixed into an oval shape. I then smooth and shape the ribs using a drawknife and a "mare", or foot-operated vice. The swill is woven by initially inserting a few ribs or "spelks" into a split in the hazel rim or "Bool" and then tying them in with a weaver or "taw". More spelks are added, each one being followed by a taw until all 15 spelks are in place and the swill is then woven up from either side with progressively wider taws until the final widest finishing taw in the middle.'

'I regularly make swills from 16in up to a very large 36in long and including the preparation of materials an average swill takes about 5 hours to complete.'

A lot of locals buy Owen's baskets as they remember their parents having them, says Owen, and some go through a local ironmonger, but few to the wholesale trade as he doesn't like the idea of them being mass-produced: 'I get such satisfaction from the whole labour-intensive process of making the oak swill basket – from felling the tree, producing the basket and selling them – and I like to be in touch with my customers.'

When oak swill baskets were used on farms and in industrial work their life was much reduced as they were so disposable. Nowadays they are well cared for by their owners and, if kept dry, they can last a long time. Owen has even repaired baskets that are up to 80 years old!

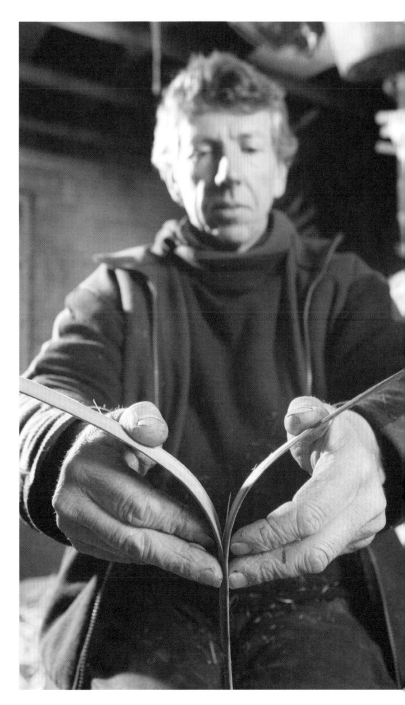

ABOVE *Each billet – the quartered bits of trunk – is riven while still hot, which means that each piece is torn into increasingly thin strips.*

The Bee Skep Maker

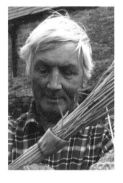

DAVID CHUBB

Farmer David Chubb started to make traditional bee skeps several decades ago when he decided he wanted one and discovered that no one was making them.

'I'd always kept bees, and skeps were the traditional way to keep them – none of these modern wooden hives. I had no idea what to do once I discovered I couldn't buy a skep, but then I had two strokes of luck. First I found a book describing bee skeps and how they were made, and then I discovered someone locally who could speak Dutch, and the two went together very nicely as the bee-skep book was in Dutch!'

Even after this lucky break it still took David over a year to gather together all the materials he needed: 'I eventually discovered that wheat straw was the best straw for a skep. I got it locally from an agricultural research station after meeting a man who made corn dollies. So as you can see, it was all chance meetings and luck; but I was very determined!'

David explains that for centuries skeps were made using bramble and hazel to keep the straw together, but his one concession to the modern world is to use cane instead, the kind used by chair makers. The technique for building up the woven straw is very similar to that used for straw mats:

'It's really quite straightforward, although difficult to describe exactly. You sort of weave in towards the centre – as in the table mat – then weave the straw out again and back into itself, and gradually the whole thing builds up. As I'm also a farmer I tend to do a couple of hours in the morning and then again in the evening. It's only ever really been a side-line, because as you can probably imagine, the demand for this sort of traditional beehive is very limited. They are more popular in Holland. In my best year, and I've been making them for a very long time remember, I made something like 230 for the Chelsea Flower Show. I once made one that was 4½ft high and 4ft wide, but the normal size is 14in wide and 9in high.'

RIGHT *Despite their old-fashioned appearance, these traditional bee hives have many advantages over their modern counterparts. They provide superb insulation, for example, and properly looked after may last a century or more.*

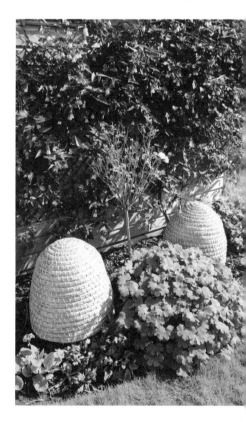

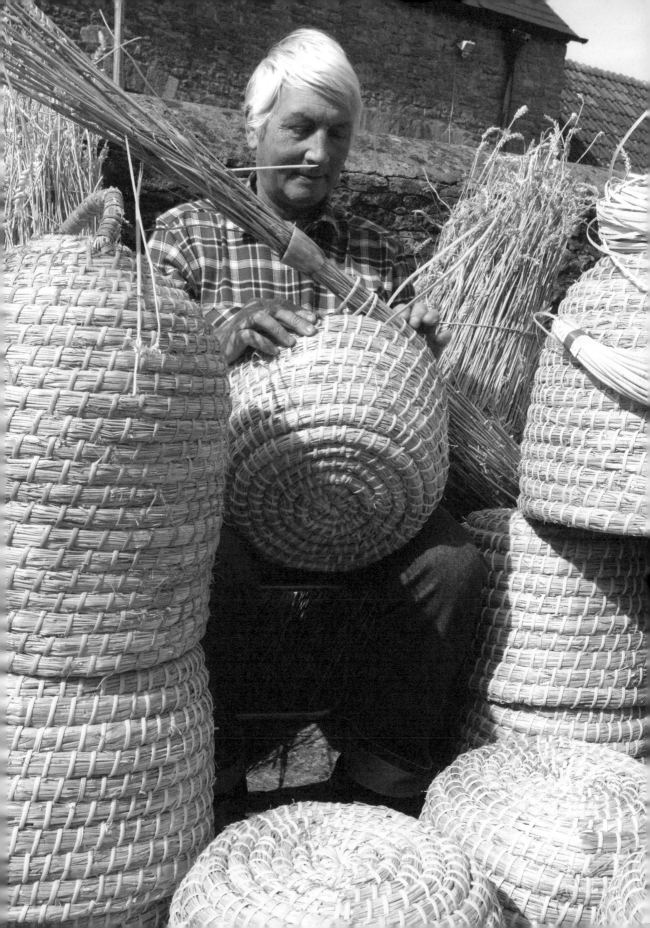

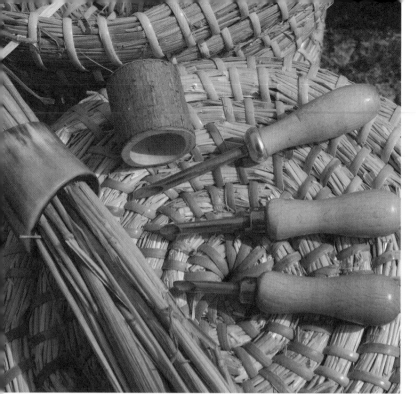

HAPPIER BEES

A bee-skep is just a hollow basket without all the extra internal arrangements that a modern wooden hive has. 'Modern wooden hives are just designed to get more money out of beekeepers,' says David. 'OK, it is a little easier to check inside a modern hive, but the bees are always just as happy – I think probably happier – in straw. After all, it takes 6in of wood thickness to produce the insulating power of 1in of straw.

{
His one concession to the modern world is to use cane instead, the kind used by chair makers
}

'Traditionally a bee skep would have what's called a hackle on top – a sort of straw hat – to keep the weather off, and it would rest on a stone slab. Under these circumstances a skep might easily last a century or more; I know that in Holland they've used the same skeps for upwards of 140 years. This is partly because the bees line the inside of the skep with a protective jelly that makes it waterproof and preserves the straw beautifully.'

These days David uses special long-stemmed wheat straw, some of which comes from the Prince of Wales's farm at Highgrove. Though orders have declined, they nevertheless still come in steadily, and David believes that the increasing desire among customers for a natural product produced in a natural environment can only be good news for the bee skep maker.

ABOVE (top) *The binding is sewn so that it crosses through the previous round on the coil, then drawn tight to lock the coil on to the growing disc.*

ABOVE *The dense 'tube' of wheatstraw is tied using a long coiled strip of cane, to produce a skep that hasn't altered in design for centuries.*

RIGHT *When in use the skeps are given a waterproof coating of wax by the bees themselves.*

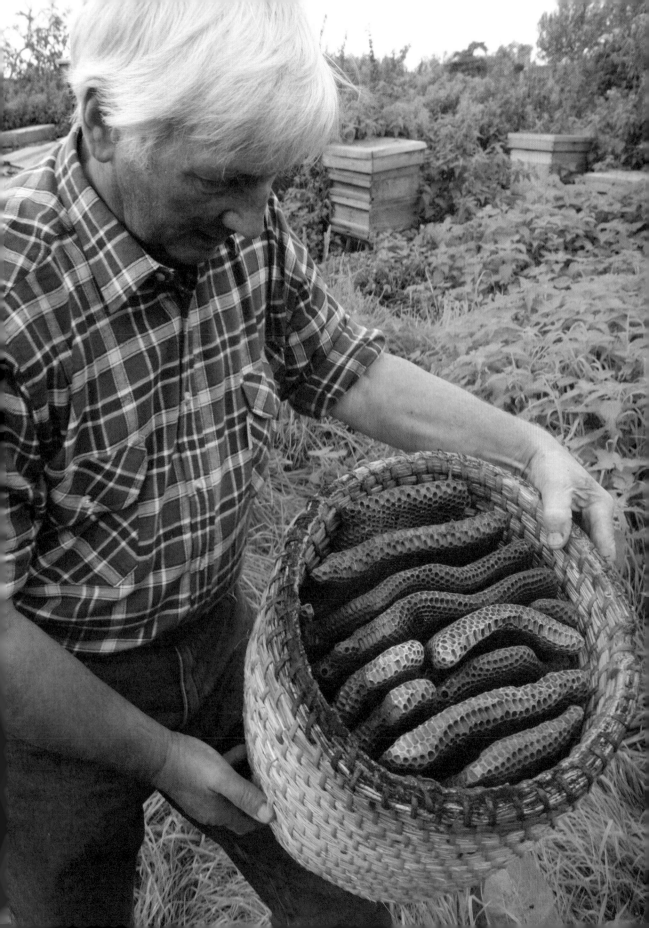

The Lobster Pot Maker

NIGEL LEGGE

Britain's west coast fishermen, from the far southwest of Cornwall to the extreme north of Scotland, have made a good living from lobster and crab fishing for at least 200 years. Anywhere where the seabed is rocky is likely to harbour that most sought-after crustacean, the lobster.

Sadly today, lobster and crab are under enormous pressure from over fishing: the economies of scale applied to commercial fishing mean that bigger and bigger ships are used, together with increasingly sophisticated fish location techniques and increasingly efficient lobster pots – and more of them. But the single-handed fisherman – the man who makes his own pots and fishes in a way that is inherently sustainable because it does not over exploit the resource – is still with us, though of course he is now something of a threatened species himself.

One such is Nigel Legge of Cadgwith near the Lizard in Cornwall. Now in his early sixties, Nigel has been lobster fishing since the day he left school. He started with his father and learnt the trade from him. He now owns his own 18ft boat and fishes alone right through the season. For lobsters the season is April to mid August, at which time he turns his attentions to the crab, the season for which lasts until November. Then in mid November the real work begins, because unlike almost every other lobster fisherman in Britain today, Nigel still makes the old

willow lobster pot. Almost everyone else has gone over to plastic and steel pots, but Nigel will have none of it.

'There's something marvellous about the old pots and partly I think it has to do with the skill of making them. It's difficult, and you need to learn it as a youngster as I did from my father at a time when all the fishermen made their own pots. You had no choice then. It was only in the mid 1960s that alternatives became available, and from then on, of course, the traditional lobster pot was more or less doomed. But apart from the pleasure of making the old pots, there's

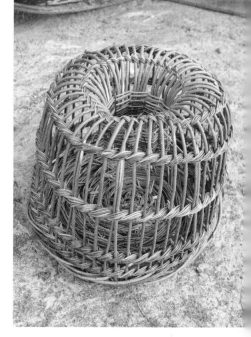

*RIGHT **Nigel Legge
spends the winter
making traditional
lobster pots, selling
them to TV and film
companies, shops
and the general
public for props and
decoration.***

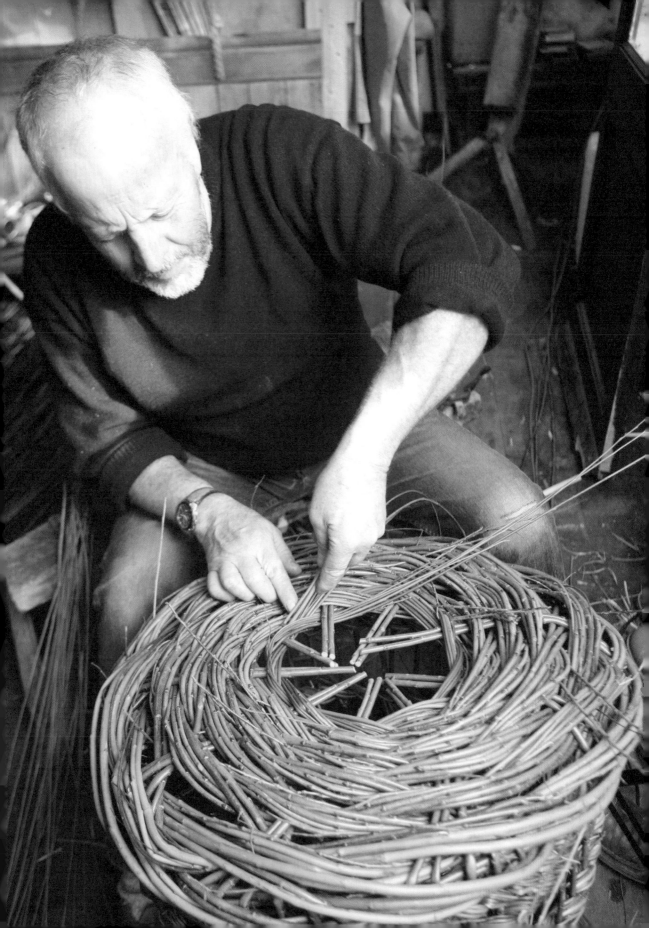

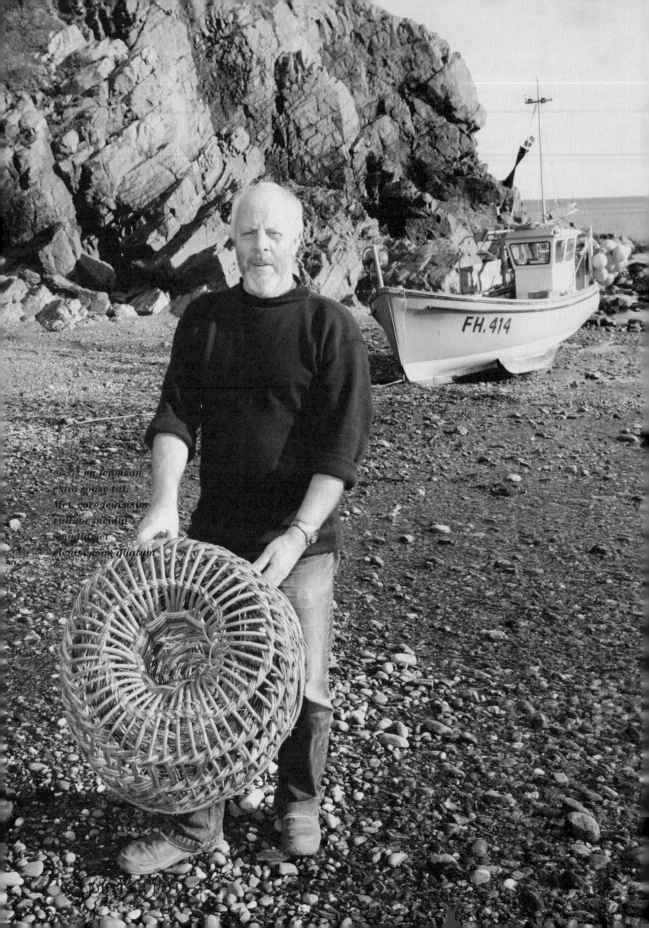

ati? a eu fenmsan
estio eouse tat.
Met, core fenisisim
euttaor incidut
smodtiamet
denisisisim duatum

FH. 414

something satisfying about catching your lobsters in something you made yourself.'

MAKING THE LOBSTER POT

Nigel has that look of enormous strength and resilience that seems to be the physical hallmark of the commercial fisherman, but his sense of the importance of tradition also makes him unique. But how do you make a traditional lobster pot?

'It takes about four hours to make a full-size one – that's about 3ft across the bottom and about 18in high. It's really a basket weaving skill combined with a few fishermen's tricks, like leaving the willow soaking in the sea for a few days to make it pliable enough to work. I get my willow from a Somerset basket maker – willow from the Somerset levels is definitely best. The pot has to have a carefully woven tunnel through which the lobster or crab can make his way to the bait. It has to be just right so that he can get in, but not back out again. But lobsters are crafty creatures, and if you leave your pot down too long they will find their way out. A good pot – and all mine are good 'uns! – will last for several years.

'Sometimes I use local Cornish black willow withies for the bottom of the pot because they are much tougher than the Somerset kind, but the whole pot is made from willow of one kind or another.'

Working his 18ft boat single-handed out from Cadgwith, Nigel would expect to fish anywhere from right under the cliffs to about one mile out. In 8 hours he can set 180 pots which, two days later, he will spend another hours hauling out of the water. It's arduous work, but highly satisfying when he gets a good haul – particularly as he'll have used his own pots rather than pots made in some anonymous factory.

'I don't really like the modern ones – it's not very satisfying using them, and they're no more efficient than the old ones. Besides,

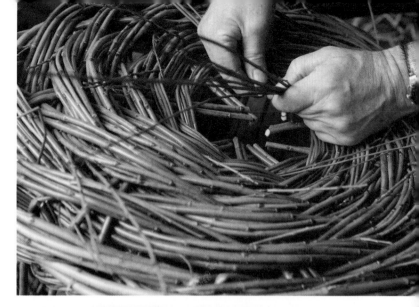

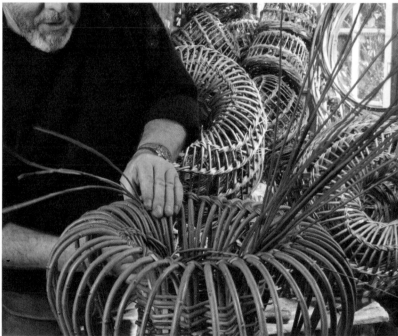

I keep my pot making for the winter months when the fishing stops anyway. If I didn't make the pots – and I really enjoy making them, apart from anything else – what else would I do?' The enormous appeal of the traditional lobster pot can be judged by the fact that Nigel recently received an order for several hundred from Laura Ashley, the clothing firm.

'That kept me busy for a while, I can tell you,' he says with a chuckle, 'but I get lots of smaller orders from people who just want to keep flowers in them. I'm always happy to oblige.'

ABOVE *Nigel weaves the willow through the upright canes*
ABOVE (top) *The willow has to be soaked for several days until it is pliable*

The Rush Seat Maker

TONY HANDLEY

'I'm working so fast that my hands are going through the sound barrier,' Tony Handley quips. Cracking noises shoot across his white-painted wooden workshop as he smoothes trapped air from the rush he is twisting and weaving to restore a chair seat. It is a craft he has been practising for over 35 years, using freshwater rushes he harvests – with the help of family and friends – from the River Thames.

'I bring back to life chairs of all shapes and sizes,' Tony says. 'The earliest I've worked on dated from around 1650 and I once re-seated a William Morris Sussex chair for the V&A. I wasn't allowed to put right the loose wooden joints, but at least it had a good rush seat when I had finished with it!'

Other customers have included Salisbury and Canterbury cathedrals, Oxford colleges and countless private individuals. In a week, he can restore seats on up to ten different chairs, either in the workshop or under the gazebo in his garden at East Lockinge, Oxfordshire.

Rushes have been used for many centuries and for diverse purposes. In medieval times they were strewn on stone or earth floors to provide warmth and scent, and to this day rush-bearing ceremonies continue in some churches. Evidence of early rush seating, however, is scanty, perhaps due to its ephemeral nature.

'There is a chair from ancient Egypt in the British Museum which shows traces of papyrus and reeds,' Tony says. 'But in England rush used in seating as we know it today dates from the mid 17th century. Such chairs served both peasant and high society.'

While the names of famous furniture makers are well recorded, those of the humble 'bottomers' or 'matters' who wove rush seats are long forgotten. In any case, rush fell out of fashion among the well-to-do in the 18th century, when upholstered seats were preferred. A revival came in Victorian times, championed in great part by William Morris and the Arts and Crafts movement. The elegance and simplicity of Morris's rush-seated Sussex chairs, or the ladderback chairs of artist-craftsman Ernest Gimson, remain standards of excellence.

In the 20th century, rush seats became

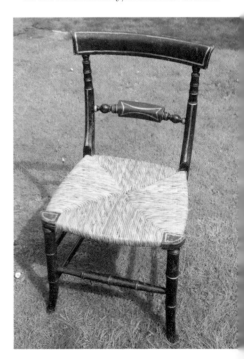

RIGHT *Tony Handley has been making rush seats for over 35 years using freshwater rushes harvested from the River Thames.*

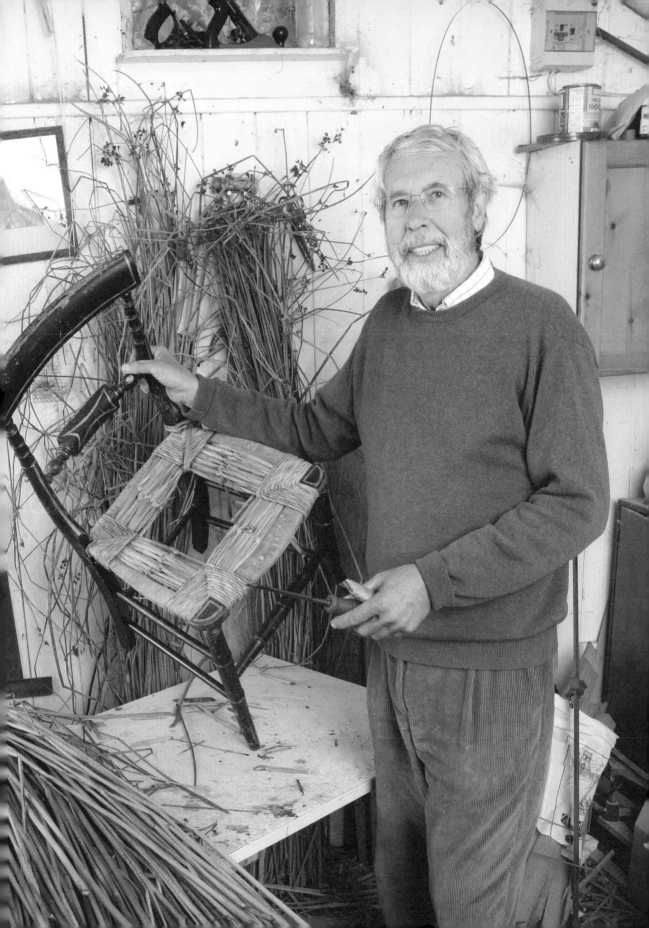

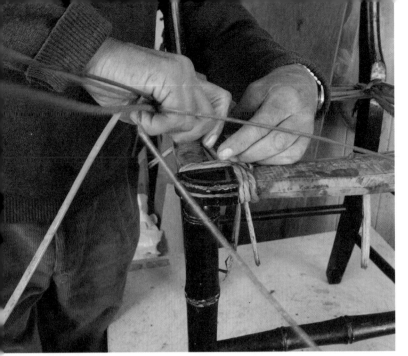

popular again from the 1960s and have never been out of vogue since.

Tony took up his craft in the early 1970s. At the time he was working as a representative for a glue company and, calling on one prospective customer, he saw a chair being seated in rush; he decided he would like to do it too.

'My parents were already seating chairs in sea grass, which is similar. But I found someone working with rush to show me how to do that and, more importantly, how to make a living from it,' he says. 'I wasn't prompted by some romantic notion; I wanted to earn a living.'

He set up in business, complemented by his wife, Kate, who had coincidentally learnt from her mother-in-law how to re-seat chairs in cane. Demand for his skills was immediate and has continued to this day, while the number of weavers in the country has been dropping, he says.

'There were 60 other rush weavers, now we supply just a dozen with the rush we harvest from the Thames. As they retire there are few new people coming through. Over the years we've had several apprentices, but they haven't carried on once they got mortgages and children.'

RESOUCES FROM THE THAMES

Tony's craft begins with cutting the rush: *Scirpus lacustris*, also known as flowering rush. Initially he bought in Dutch and Spanish imports, which were expensive. So he revived commercial harvesting on the Thames, which had last taken place in 1939. 'Thames rush is also softer and easier to work with,' he says. As far as he knows, he and just one other

Sickle

ABOVE (top) ***Twisting the rushes forms a strong, smooth coil of even thickness.***

ABOVE ***The rush is pulled quite tightly across and care has to be taken to ensure that the cross-over which forms at the corners as the work proceeds is kept square.***

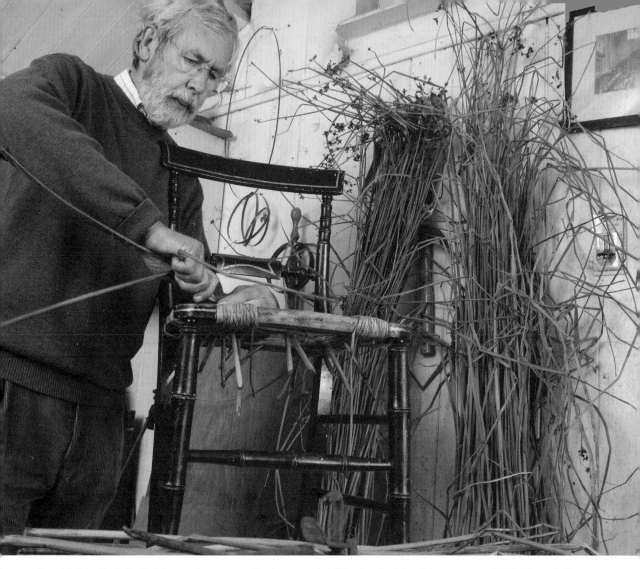

person (working in East Anglia) harvest English freshwater rush commercially.

'Rush goes over very quickly. We need to cut it after the seed heads have set and before they start to get so fat that we couldn't use them,' Tony explains.

Armed with his licence from the Environment Agency, as well as permission from individual landowners who hold the riparian rights, he and two boatloads of

> *Tony revived commercial harvesting on the Thames, which had last taken place in 1939*

volunteers work a 30 mile stretch of river between Abingdon and Lechlade for a week at the end of July and beginning of August.

It is an arduous task. The grey-green rushes grow to 10ft tall and each is cut by hand using brush hooks wielded below the surface of the water. 'Some of us lean out from the boats, others prefer to wade in,' Tony says.

They cut the rush stands along the river on a rotational basis of around seven years, ensuring a sustainable crop. By the end of the week some 5.9–6.9 tons (6,000–7,000kg) will have been gathered. This is stooked and turned daily to facilitate drying, which can take a fortnight or more, before the harvest is stacked in barns to store. Rush is 90 per cent water and the final dry weight will be

ABOVE *The twisting or coiling that takes place is done only on top of the seat and around the framework where it will show.*

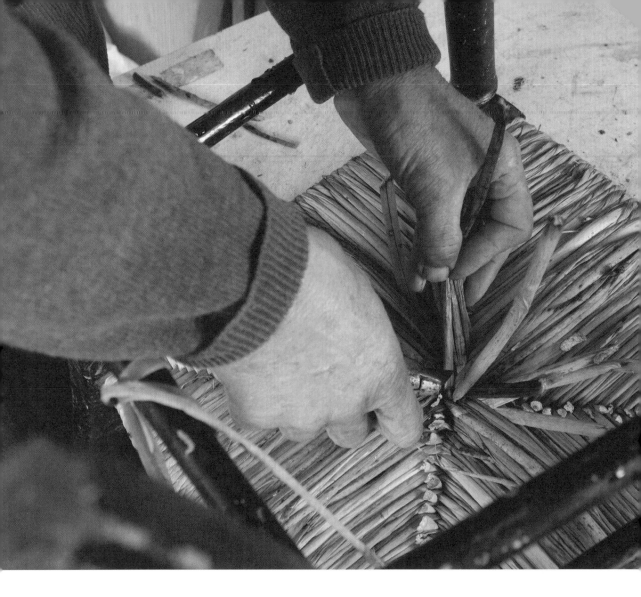

ABOVE *New rushes are added as old ones run out by means of a half hitch. Joins are made underneath and clear of the corners.*

just one-tenth of the fresh weight. Tony sells surplus he doesn't use to other weavers.

WEAVING THE CHAIR

To weave a chair seat, he first sprinkles a bundle 1kg of rush with water to soften it. The tools of his trade are few: a rush lever, a craft knife, a wooden roller and his hands. With the chair placed on a table in his workshop, he cuts out the old rush seating and checks the wooden frame for stability.

If the seat is square, he staples or ties two or three rushes to the left-hand seat rail – the number of rushes depends on the thickness of the cord he wishes to create.

Now weaving begins: twisting the rushes together into a cord, then wrapping the cord over the front rail tight to the left leg, up through the frame, over the left-hand side rail and back up through the frame. Next he takes the cord across the front of the frame to the right-hand corner, where he repeats the twisting and wrapping, and so on at each

> *The tools of his trade are few: a rush lever, a craft knife, a wooden roller and his hands*

orner. Thus the traditional pattern emerges of
our woven triangles that will eventually meet
n the centre of the seat.

As he works, Tony adds in new rushes with a
alf hitch knot, always selecting the right sizes
o keep the thickness of the cord consistent.

'The most skilful part of weaving is
aintaining the tension. It's second nature to
e now. You do it by levering the rush over the
ails, which is also how you get the callauses on
our hands: the first 30 years are worst!'

After he has woven a dozen or so rounds, Tony
tops to push the rows even tighter into their
orners: the dampened rushes are swollen and
hen they dry and shrink the cord will slacken,
o it is crucial to work as tightly as possible. At
his stage, any loose ends (where rush has been
oined in) are trimmed from the underside of the
eat. He puts the off-cuts to good use, wedging
hem with his rush lever into the pockets formed
etween the top and bottom layers of rushes at
he front corners. This maintains shape and gives
dded comfort to the seat.

He continues twisting and weaving, squeezing
p the rows and trimming, until the four woven
riangles meet in the middle. Even now he
edges in a few final cords – 'There's always
oom for one more' – before he eventually ties
ff: lifting a central rush on the underside,
ulling the cord through and knotting it back on
self in a half hitch. Then he rolls his wooden
oller over the seat to 'bed it down'.

Of course, the majority of seats are not
quare, with the front usually wider than the
ack. In these instances Tony has to begin by
quaring up': joining a cord to the left-hand rail
nd weaving around just the front two corners
ntil the gap measures the same as the back
ail. Then he can proceed as for a square seat.

It takes between one and two bundles of
ush to seat a chair and over time the weave
ades to a mellow biscuit colour.

'The average life of one of my rush seats in
veryday use is at least 35 years,' Tony says. 'I
now that because as long as I've been doing
hem I've never had one brought back.'

RUSH SEAT CREATION

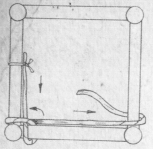

*End tied in as shown, go over front
rail, down and under and up in
centre; then to the left, over itself
and the left-hand rail, down, under
and up in the centre, across and over
right-hand rail*

*Process is repeated working anti-
clockwise, building up corners*

*Twist rush seat like the illustration
above, not like below*

half hitch

reef knot

Joining rush

*Figure-of-eight
weave used to finish
a rectangular seat*

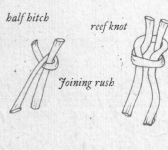

*Chair seats wider
at the front have
two front corners
filled first like this*

The Trug Maker

CARL SADLER

'The word "trug" comes from the Old English "trog", meaning boat,' Carl Sadler says. 'The name refers to its shape: trugs are clinker built, with wooden slats overlapping. They were originally used in different sizes as measures: a bushel, which is eight gallons, a half bushel and so on. People used them to carry flour and grain, or for harvesting fruit and veg. If you bought a dozen eggs, you got them in a small trug, just like a punnet of strawberries.'

These days, of course, the wooden baskets are the must-have for gardeners. Both elegant and practical, they serve to carry everything from cut flowers and secateurs to freshly plucked raspberries.

'It was Queen Victoria who led to their popularisation as garden tools,' Carl explains. On a visit to the Great Exhibition of 1851, the young Queen spotted trugs made by Thomas Smith of Herstmonceux, Sussex, and ordered several for the royal gardens. It is said that Smith was so proud – and untrusting of carriers – that he walked the 60-odd miles (97km) after 60-odd miles from his workshop to deliver them personally. Where a queen led in matters horticultural, others followed and soon gardeners across the country were putting the versatile

People give different numbers or names to the varying sizes, like garden trug, log basket or cucumber trug

vessels to good use.

Carl, whose workshop is in Malmesbury, Wiltshire, is one of the country's leading traditional trug makers, a craft practised before him by his father and grandfather.

'At first I taught rural crafts and studies at secondary school, everything from hedgelaying to looking after pigs, sheep and cattle,' he recalls. 'But the unit was closed down. I had done my first show demonstrating trug making in the 1970s and, since 1989, I have been full time making trugs, hurdles and other rural products, as well as offering services like woodland management and coppice restoration.

'I tend to make trugs in six or seven sizes nowadays, starting at 13in in length,' he continues. 'The largest is 26in long, with two straps around it and no legs. People give different numbers or names to the varying sizes, like garden trug, log basket or cucumber trug – a long, narrow one with a double handle for carrying cucumbers. The most popular sizes I sell are large ones for gentlemen, which are 22 inches long, 13 inches wide and five inches deep, and medium ones for ladies, which are 17 inches long, 10 inches wide and four inches deep.

'Most customers do use them for gardening, but I've also made one for a hotel,

RIGHT *Carl Sadler is one of the country's leading traditional trug makers, a craft practised before him by his father and grandfather.*

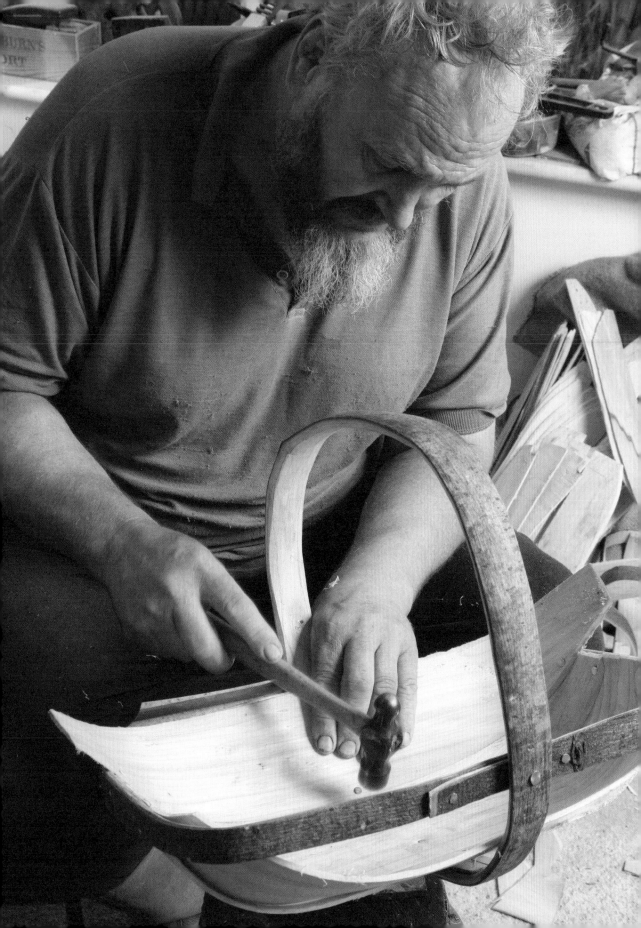

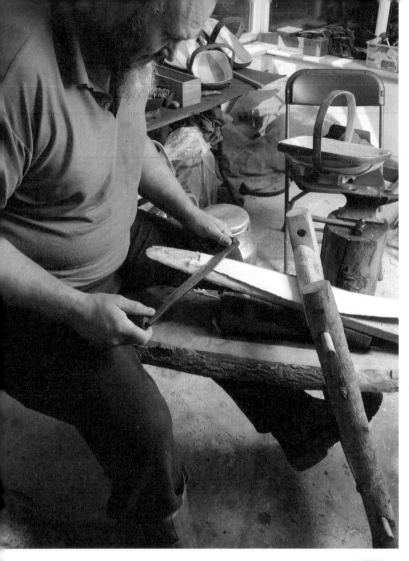

which kept newspapers in it in the hall,' he adds. 'An electrician bought a large one to keep his tools in. It's handy because if he's changing a light fitting or something and drops a screw, it lands safely in the trug. I once made trugs just seven inches long, for bridesmaids to carry sweet peas in at a wedding in Canterbury Cathedral. And I made four-and-a-half-inch round ones for Jamie Oliver. He used one for collecting eggs in his *Jamie at Home* TV programme. I do quite a lot of work for film sets, too. My trugs have appeared in the TV series *Monarch of the Glen*, *Cranford* and *Lark Rise to Candleford*.'

{ *You could teach someone to make a trug in a week, but it would take another three to four years to perfect the craft* }

QUALITY AND LONGEVITY

While trug making blossomed in Sussex following Thomas Smith's lucky royal break, Carl says the tradition is spread across the country, although these days he knows of just four or five full-time makers like himself. Materials can vary according to regional availability and have included ash and hazel. But most well known are sweet chestnut, used for the frames and handles, and willow for the slats that make the bottom and walls of the trug. Carl sources both locally, sharing the willow supplies with a cricket bat maker.

'I cut the timber in the winter before the sap is up and I also steam the sweet chestnut in the winter months, although I make trugs all year round,' he explains. 'To create the frame and handle I first cleave, or split, the chestnut down to the size I want, taking the inside off and leaving the bark on, which helps to protect the outer surface. Then I sit on the shave horse [a

wooden seat with vice] and use a drawknife to further shave the chestnut. Next I steam and soften it in an oven, bend it around a former and leave it for ten days or more. Finally, I nail the frame and handle together with copper nails. Sometimes I'm asked to decorate the handle with pokerwork, but otherwise I leave it plain.'

Carl uses a froe and drawknife to make and shape the different willow slats for the body of the trug. 'The widest slat, at the bottom of the trug, is called the keel. Then you have inners and outers, which you shape up on the shave horse. Slats are an eighth of an inch thick and I do everything by feel and eye. I use copper nails to fix the ends of the slats to the frame because copper doesn't react with the tannic acid in the chestnut; it's just the same as builders did on wooden sailing boats or warships. Iron nails, by contrast, will eat their way through the wood in 15 or so years. I can add feet made from cricket bat willow to the trugs, attached with two copper nails and a copper tack, but I don't usually put them on the strapped trugs.'

Carl says he could teach someone to make a trug in a week, but it would take another three to four years to perfect the craft. 'There are lots of little details to bear in mind. Getting the right wood and knowing just how long to steam and bend it are trickiest. Also, getting the base or keel on the flat, so that it's not at an angle and everything looks tidy, is a challenge.

'A trug with a good coat of linseed oil can last 80–100 years,' he adds. 'Occasionally people bring them in for repair, although I've never had one of my own brought back. People get comfortable with their own trug and nothing can replace it.'

While inferior imports and wares made from plastic have threatened traditional trug making in the past, Carl believes 'the pendulum is swinging back' in favour of quality and longevity. His handiwork is

in demand at country shows and garden centres, and he is always willing to supply bespoke trugs to individuals: in the past he has made walking-stick trugs – sticks with a trug positioned two-thirds of the way up – which people can place in the ground to leave their hands free for fruit picking. He is also frequently invited to give talks and demonstrations at garden clubs.

Despite his busy schedule, he still finds time for his own gardening, he insists – his workshop looks out on half a dozen vegetable beds and a greenhouse full of produce. Naturally, he has a trug to suit every fetching and carrying task.

LEFT (top) *All the tools used by Carl are simple and ancient: a drawknife, a horse, an axe for cleaving, and a hammer and nails. A drawknife produces a thin, but very strong, trug board.*

LEFT (below) *Though some manufacturers now use plywood, Carl sticks to the old way of using sweet chestnut and willow.*

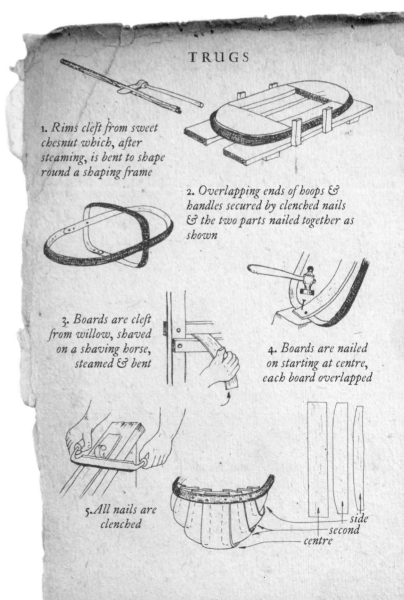

TRUGS

1. *Rims cleft from sweet chesnut which, after steaming, is bent to shape round a shaping frame*

2. *Overlapping ends of hoops & handles secured by clenched nails & the two parts nailed together as shown*

3. *Boards are cleft from willow, shaved on a shaving horse, steamed & bent*

4. *Boards are nailed on starting at centre, each board overlapped*

5. *All nails are clenched*

side
second
centre

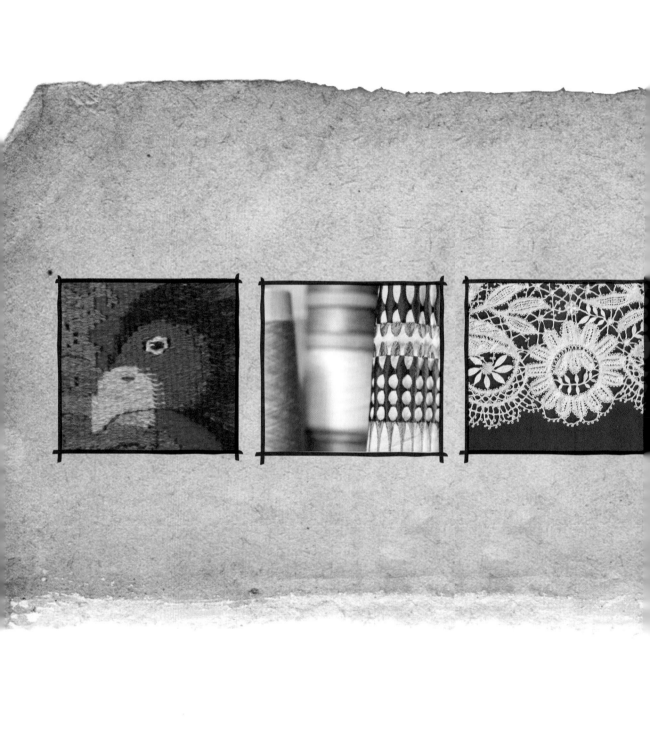

TEXTILE CRAFTS

The Tapestry Weaver

KIRSTEN GLASBROOK

There's a tapestry by Kirsten Glasbrook called 'Let's Fly Away Together'. It depicts a large, colourful lady surrounded by quirky, stylised birds – and neither she nor the aerodynamically challenged creatures are likely to fly anywhere. Yet they seem cheerfully set on their plan. The piece is warmly, wryly humorous, with the sense of a magical tale.

'There isn't a real story behind it,' Kirsten says. 'But most of my tapestries do tell a story. When I was young, I used to tell my brothers tales and they would always come back for the next instalment.'

In her rural studio near Bradford-on-Avon, Wiltshire, Kirsten creates wall hangings and miniatures that adorn homes around the world. Her strong, contemporary images are inspired by songs, dance, stories and myths, as well as personal experiences like walking on a windy day.

'Message' depicts hands holding a snake and a curious archway inviting you through to a moonlit sea. 'Rusalka' is a nod to Dvorak's opera by that name and its reference to the Slavic mythology of water sprites. Then there are the searching tones of 'The Soul Needs More Space Than The Body', full of thought-provoking motifs that nearly squeeze human figures from the scene: a hand holding a labyrinth in its palm,

> { *Kirsten's modern works are a free-spirited surprise. Yet the basic techniques are unchanged in centuries* }

a bird escaping flames, trees, a serpent.

If you are used to the idea of tapestry as the historic wall hangings found in stately homes, Kirsten's modern works are a free-spirited surprise. Yet the basic techniques she employs are unchanged in centuries. Warp threads are set up under tension on a frame or loom, and weft threads are passed over and under them at right angles so that they interlace, creating a cloth and a design at the same time. In the finished tapestry, the warp is hidden and only the weft pattern is seen, having been worked in areas of different colours to build up the design.

Evidence points to Coptic weavers in ancient Egypt as among the first tapestry makers, and early paintings show looms not dissimilar to those used today. Tapestry weaving also became common in western Asia and China, while many historic remnants of garments have been discovered in Peruvian tombs.

In Europe, renowned tapestry centres grew up from the 14th century, in Paris, then the Low Countries. According to tradition the first workshop in Britain was opened in Elizabethan times by William Sheldon in Barcheston, Warwickshire, while King James I set up the celebrated Mortlake shops in 1619. The tapestry looms of William Morris at Merton Abbey in the 19th century

RIGHT ***Kirsten Glasbrook creates handwoven one-off tapestries, using brightly coloured natural yarns and traditional techniques.***

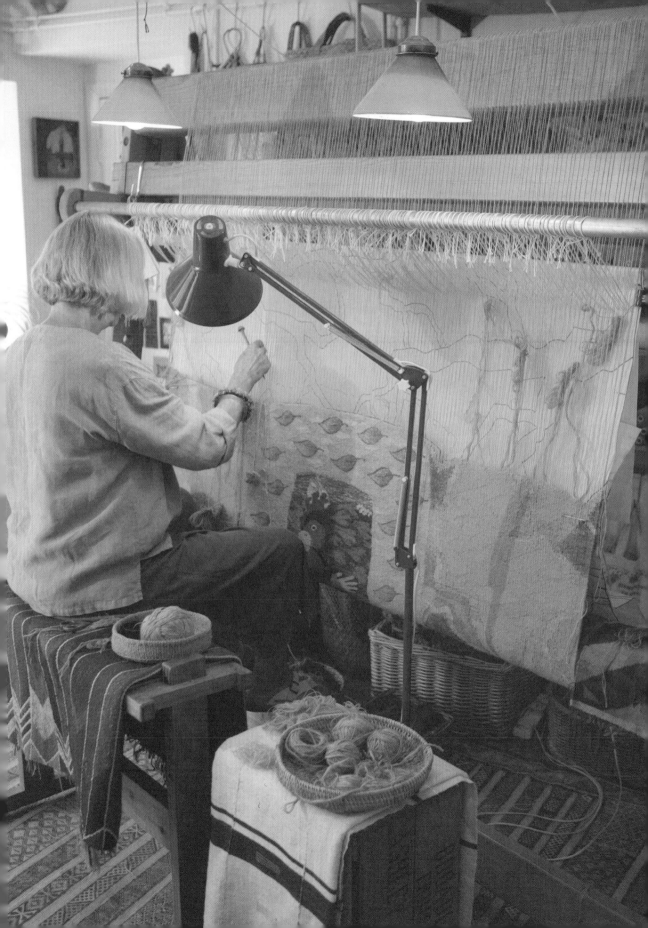

also helped to pass on the craft.

Tapestry provided wall hangings to decorate and add comfort to the big draughty houses of the rich and to adorn churches and public buildings. It was used in canopies of state and as coverings for everything from beds to cushions. Historical designs typically range from hunting and country scenes to coats of arms and mythological motifs.

Some medieval weavers, often inspired by colourful illuminated manuscripts, worked creatively in their own right. But later it became the trend for artists to produce painted designs, or cartoons, which weavers in the large workshops then copied. Today, some studios continue this modus operandi, but individual artist-weavers like Kirsten create both design and tapestry themselves.

Kirsten was born in Denmark and recalls a childhood full of the colour and texture of a family in which the women enjoyed embroidery, knitting, sewing and lace making.

{ *I like the contact with the yarn and as few other tools involved as possible* }

'There were a lot of textiles in my early life, in the traditional Scandinavian way, and I was always drawing. I also did an exchange visit to Scotland and saw hand weaving at some tweed mills. I thought it was wonderful. I went on from there.'

She was apprenticed for three years to John Becker in Copenhagen, one of the most important 20th century weavers in Scandinavia. 'I worked on everything from rugs and cloth to tapestry weaving. In Denmark you can still be apprenticed to master weavers in that way.'

Then she moved to 1960s London and worked for two to three years with Karen Finch, OBE, restoring antique tapestries.

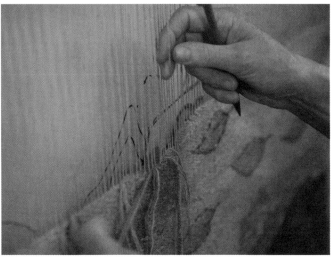

ABOVE (top) *The crank turns the warp beam and is connected to a brake release.*
ABOVE *Tapestries are often woven on upright looms.*

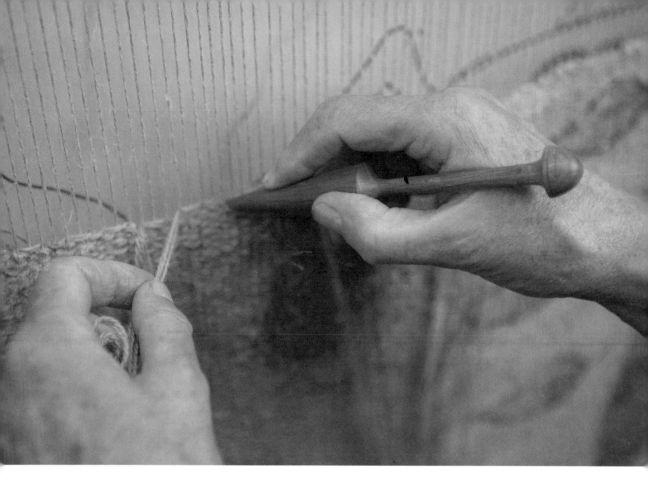

he later set up on her own as a tapestry
eaver, taught and ran workshops, and
rote an acclaimed book on her craft. She
as exhibited widely around the country
nd abroad.

Kirsten's designs begin as sketches in
ooks. 'I scribble down words, little pictures
at I like or things that speak to me. I tend
 work in themes. I had a very long labyrinth
age, inspired by the Minotaur legend.'

Other recurrent motifs include birds,
rpents, fish and hands.

'I was in Peru some years ago learning
om weavers and I found out there that
rds represent the spirit world. They are
essengers from heaven and carry the soul
 the departed to the afterlife, where people
come birds.

'Serpents can be good or evil, and fish are
Christian symbol although they, too, have
fferent meanings in different cultures.

I think I first discovered hands in Egypt:
everywhere you go you see those beautiful
hands and they can evoke so many things,
like protection.'

Kirsten draws a full-size design on a sheet
of paper on the wall. Then she puts this
behind the warp threads that she has tied
and wound vertically on to her upright loom.

She uses cotton (or sometimes linen or
wool) for the warp, which must be strong,
while for the weft she uses handspun nettle
yarn from Nepal 'because it has a hard, clear
surface and good texture'. She dyes yarns
herself and creates many different shades
simply by mixing varying proportions of
the primary colours red, yellow and blue,
sometimes adding a little black for darkness.
Coldwater fibre-reactive dyes are used for
the nettle, linen and hemp, and acid dyes for
the wool.

Her loom gives a weaving width of

ABOVE *The front
and back surfaces
are alike in true
tapestry, with the
exception that
where a change of
weft yarn occurs,
short loose ends
are left hanging on
the back.*

taught. However, she now works from the front looking directly at the design. To pass weft threads through the warp she eschews a bobbin in favour of butterflies: small hanks of yarn wound together with tight heads that slowly unravel as she works.

'I like the contact with the yarn and as few other tools involved as possible,' she explains.

After she has woven a hem Kirsten creates her design, sometimes altering it as she goes – the cartoon is just a guide. Weft colours are used only in the areas where they will appear, not woven across the width of the tapestry (unless the pattern requires it). She employs diverse techniques, including: pick and pick to create vertical stripes; spots and hatching to effect shading; stepping to produce diagonals and curves. Weaving two warps at a time instead of one produces a coarser texture. After each row, she pushes the weft down to keep a tight weave.

> { *I can't imagine life without weaving, I get completely lost in it* }

ABOVE (top) *A mixture of different yarns creates variations in the texture of the tapestry.*
RIGHT *Kirsten employs diverse techniques, including: pick and pick to create vertical stripes; spots and hatching to effect shading; and stepping to produce diagonals and curves.*

2 metres (7 feet) and a variable length, and has two large beams at the top and the bottom. Key to setting up is to ensure that the warp threads are wound on tightly and with consistent tension; how many and their width apart also affects the detail and fineness of the design.

Then Kirsten inserts a large wooden stick through the top of the warp, so that alternate threads are up or down, making a shed or opening through which the weft will be passed. String heddles on a metal bar pull out the second shed. As she weaves, more warp can be exposed from the top beam by winding the completed sections of tapestry around the bottom beam.

It is traditional to weave tapestry from the back, with a mirror providing a view of the front, and this was how Kirsten was

Kirsten usually works from the bottom of the design upwards, but sometimes she works from the side so that when the tapestry is removed from the loom and the design is turned up the right way the warp will run horizontally in the finished piece. The design dictates the approach: it is easier to weave smooth curves horizontally on the warp, for example.

She mostly finishes pieces by weaving a hem, turning it under, stitching it and sewing a strip of cotton tape around the edges on the back to ensure everything is tidy. Weft ends, on the back, are cut short. Larger pieces all bear her woven signature – a 'K' enclosed in a square.

'I can't imagine life without weaving,' she admits. 'I get completely lost in it.'

The Dyer & Felt Maker

JANE MEREDITH

Jane Meredith's flourishing plots of flowers and vegetables beside the River Wye at Byford, Herefordshire, present a picture of a quintessential English cottage garden. Yet there's more than meets the eye here and vivid clouds of billowing wool drying on her clothesline give the clue. Jane grows plants to create vibrant natural dyes, which she applies to fleece for use in spinning, weaving and making felt.

Her rainbow-coloured blankets, throws, floor rugs and clothes are much in demand, and since 2000 she has run popular Plant Dyed Wool workshops to share the secrets of her craft. She also demonstrates mud-resist block printing using her dyes: a technique similar to batik, but using a special mud in place of wax to block print on to fabric before resist dyeing.

'When my three daughters were young I took up spinning and knitting because it fitted in with staying at home to look after them,' she explains. 'I love gardening and I began to wonder if I could dye my wool using plants. So a friend and I began experimenting and it soon became an obsession. Every time I went for a walk I'd pick flowers from the lanes to bring back and try out. In the end, I decided to create my own dye garden.'

Jane describes her garden as a 'hotchpotch, organized chaos' and there's no specific planting scheme. But even the

{ *You never know quite what will emerge and that's the exciting part!* }

briefest wander highlights the diverse palette it grows: skins from onions will produce warm ginger-gold hues, rhubarb stems yield pink, woad makes a deep blue evocative of our ancient ancestors. She derives sunshine from African marigolds, rusty crimson from coreopsis, pale green from spinach, buff-green from nettles, and claret and auburn from madder. Recent additions of polygonum tinctorium give turquoise-blue, while black hollyhocks surprise with green dyes.

'The colours you can get are amazing and they all come from nature, not a bottle,' Jane enthuses. 'You never know quite what will emerge and that's the exciting part!'

She works from fleece to finished product. 'I tend to get my fleeces from people I know and the breeds include Soay, Cotswold, Wensleydale, Castlemilk Moorit, Blue-faced Leicester and Shetland. Different fleeces have different qualities. I particularly like Cotswold wool because it's lustrous, soft and shows up dye well. I like Wensleydale because of its curliness and delicacy; it makes attractive floor rugs.'

To clean and prepare a fleece, Jane first lays it on the ground to 'skirt' it – that is remove dirt and matted clumps. 'I love the muckiness and sheepy smell!' she says. She then immerses the fleece in boiling hot water mixed with a chemical-free washing-up liquid to get rid of lanolin, leaving it to soak until cold. After squeezing it out, she hoses

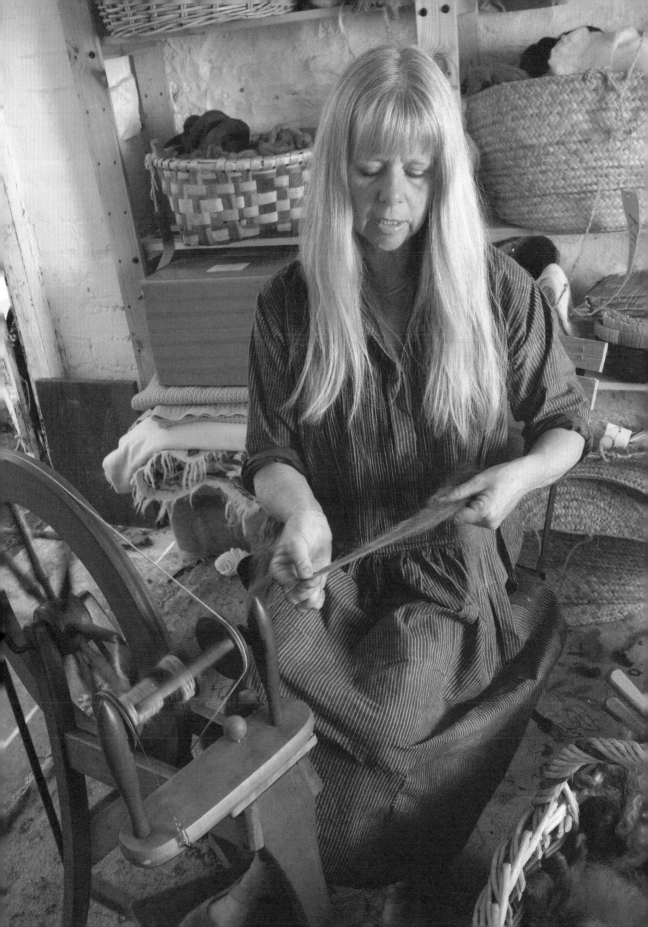

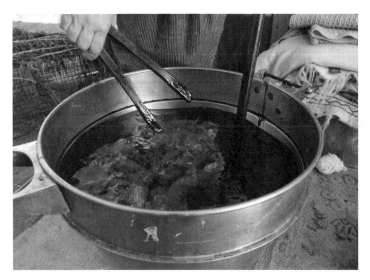

ABOVE (top) *Wodges of wool are dropped into dye baths created from foliage and flowers grown in Jane's garden.*
ABOVE *Carding helps to tease out the fibres, get rid of any bits and generally makes the wool lighter and more airy.*

the fleece with cold water and finally spin dries it. She puts the leftover water from cleaning on her plants. 'It's full of nitrogen and muck that are good fertilisers.'

ADDING COLOUR

To create dyes, Jane collects her chosen foliage and flowers, chops them up and puts them into various large cauldrons of boiling water that she sets up in the garden. Then she drops wodges of wool into these dye baths, leaving them to simmer for half an hour or so, occasionally stirring with a stick.

'I'm quite cavalier in the amounts of flowers I use,' she smiles. 'I do it by feel, though I do refer to books for recipes. Spring, summer and autumn are best for dyeing, when plants are coming into flower

and are at their peak. For instance, you need at least four days of sunshine on woad before picking in order to get its blue colour, otherwise it produces a brown.'

Some dyestuffs – like lichen, which gives an orange tint – can be used directly on wool. Other plants require the wool to be prepared first so that it can absorb the colour. This is called mordanting.

'William Partridge's 1776 *Treatise on Dying* [*sic*] is amazingly precise and methodical,' Jane says. 'It states two buckets of urine as a mordant. I prefer to simmer the wool with chrome, alum, copper or rhubarb leaves! Different mordants have different effects, according to the chemistry with the dyes. For example, if you mordant wool with chrome and dye with onion skins, the result is a light-fast golden ginger. If you use alum, the wool comes out paler and isn't very light fast, but it does fade beautifully.

'I like to mordant with rhubarb leaves because they are natural, but they are also highly poisonous, which I always emphasise at workshops.'

SPINNING

The next process is to hand card the wool: combing it backwards and forwards between two wooden bats studded with metal spikes. 'It helps tease out the fibres, get rid of any bits and generally makes the wool lighter and more airy,' Jane explains. 'I use different pressure to deal with knots in the wool or leave a less even texture, which creates interesting variety.'

Now the wool is ready for spinning and weaving. Jane uses both hand spindle and spinning wheel, simple peg looms and Brinkley looms.

MAKING FELT

If she is feltmaking, Jane leaves the dyeing process for the finished fabric. When creating felt it is important to choose a wool that will contract rather than stay open

and fluffy. 'Among UK breeds wool from Blue-faced Leicester felts tightly, whereas something like Jacob wool stays much looser and spongier. Merino is the finest felting fleece, although that tends to come from Australia of course,' Jane explains.

Felt is probably one of the oldest fabrics in the world, with archaeological evidence pointing to its use in Central Asia in Neolithic times. Over the centuries it has had many traditional domestic uses, from clothing to yurts and bags to saddlery, as well as industrial applications.

During the felting process, the aim is to make the scales on the wool fibres interlock through friction and so create a robust fabric. Jane puts a bamboo blind in the bottom of a felting tray and lays a piece of washed and carded fleece flat on top. She then adds a second layer, placed so that the fibres run at right angles to those of the first layer, and continues to add layers in this manner according to how thick she wants the felt.

'If I want something thin and gossamer-like, I might have just two or three layers. If I want something thick, I'll have six,' she says.

Next, she places nylon netting on top, sprinkles warm soapy water all over the layered piece, flattens it down until no air bubbles are showing – and then rubs. As she does so, the wool shrinks and felts together. Finally, she rolls the felt up in the bamboo mat, first in one direction, then the other, rocking it gently as she goes. The fabric shrinks down further and gets harder and tighter.

If Jane wants to create a design on the fabric, she follows the same process as for plain felt but lays a pattern (possibly coloured) on top of the final layer of fleece before she applies the nylon netting. Then, when rubbing, she must take care not to dislodge the pattern.

'I also sometimes make 3D felt, like a bowl or bag,' she adds. 'Instead of felting flat, I use builder's plastic, which is quite thick, and put fleece around both sides of it. Then I rub it

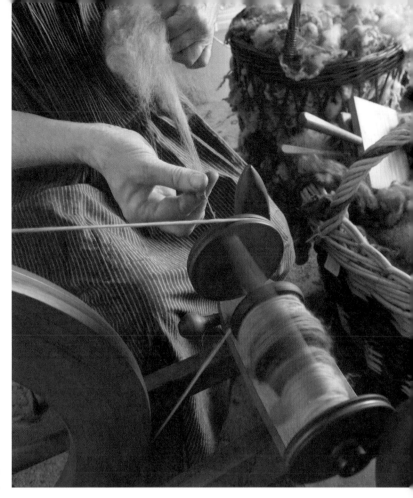

until I end up with a seamless felted piece around the plastic. I cut a hole, take out the plastic, and I have a bowl or bag. I've made a waistcoat by that method before now and people make jackets that way. However, I do like flat felt because I love dyeing the pieces, cutting shapes and patchworking.'

Over the years, interest in Jane's workshops and crafts has grown from strength to strength. 'I think there is a real resurgence in people who want to work with their hands. There's a sort of "back to the land" thing going on,' she observes.

'I do find working with wool therapeutic and I love putting colours together,' she adds. 'Everybody can make something beautiful with wool and that gives confidence. It's such a feeling of power – in a nice way – when you have made something beautiful.'

ABOVE *To begin spinning set the spindle spinning in a clockwise direction while the finger and thumb of the left hand grip the yarn and fibres together just above it to contain the twist.*

Carding board

The Spinning Wheel Maker

JAMES WILLIAMSON

James Williamson has recently retired and estimates that he built more than 2,000 spinning wheels over his 36-year career. 'It began when I was making small turned items for a living and I came across some plans for one,' he recalls. 'In my youthful ignorance I thought: I can do that. I also discovered that there was a need for spinning wheels in the country, because at the time there was just one other fellow making them, up in Scotland, and he had a two year waiting list.'

He set about teaching himself the craft in his Leicestershire village workshop. 'Having made one, I found out how they worked and what was wrong with the design I had used. So I modified it and started offering my wheels for sale. Word of mouth spread and, helped considerably by my wife Anne who was an equal partner in the business, I was never short of orders for wheels.'

Spinning – the art of drawing and twisting fibres into a continuous thread – has been practised since the earliest times. Human hair and grass may well have been among the first materials used, rolled between the fingers or between palm and thigh. The resulting spun yarn was stored on a stick, and from this the primitive drop spindle evolved, weighted with a whorl made from stone, bone or some other material.

> *The harder times were, the more popular spinning became, because people want to try to do something practical*

The first steps in 'mechanising' the process came when the spindle was mounted horizontally in bearings so that it could be rotated by a cord or band encircling a hand driven wheel. Quite when and where the idea originated is a matter of conjecture: probably China or Japan, James believes, and the charkha wheel in India was also early on the scene. In the 14th century spinning wheels were introduced to Britain and, used for wool spinning, became known as wool or great wheels.

Later developments produced the bobbin and flyer mechanism, enabling twisting and winding (previously separate) to be combined in one operation: a bobbin was mounted on the spindle, which was also fitted with a flyer (a U-shaped arm), and the flyer distributed the spun thread on to the bobbin.

In a double band wheel the drive band goes around the wheel twice and turns flyer and bobbin: they rotate at different speeds because their whorls/pulleys are different sizes and so winding on to the bobbin occurs. A single band wheel drives either bobbin or flyer, which rotate in unison, and the spinner applies a brake band to slow one or the other to allow winding to take place.

Another significant development, around the 16th century in Europe, was the treadle,

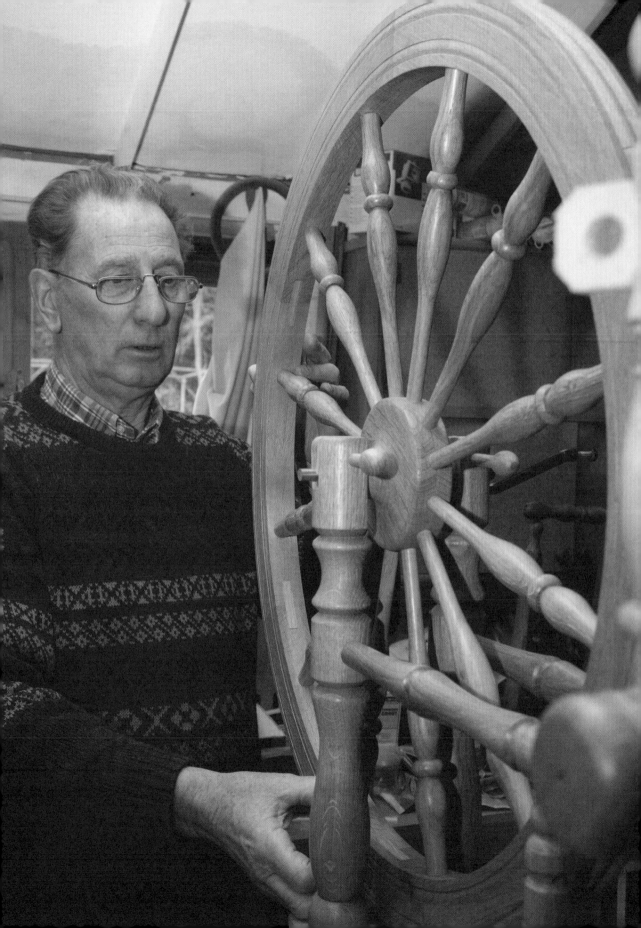

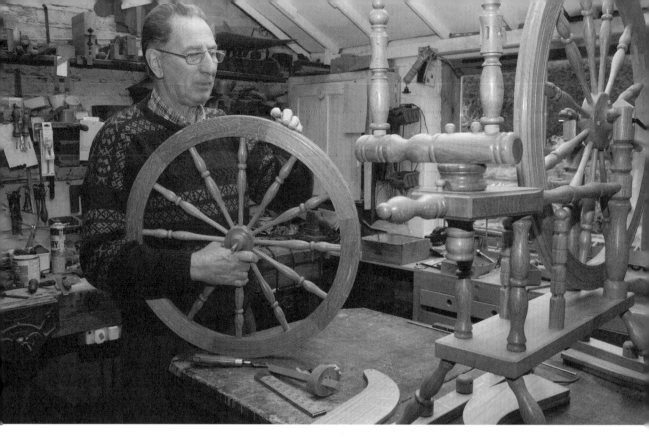

which enabled spinners to operate their wheels by foot, speeding the process even more and leaving both hands free to draft or draw out the fibres.

Many and varied are the finer details of different spinning wheels, and the terminology for components – 'mother of all', 'maidens', 'lazy kate' – all echo the fact that spinners were by and large women, 'on the distaff side'.

In the 18th century demand for large quickly produced volumes of spun yarn led to James Hargreaves' invention of the hand powered multi-spool spinning jenny, Richard Arkwright's patent of the water frame (powered by water and steam) and Samuel Crompton's spinning mule. The commercial hand spinner became a machine operator.

Nevertheless the craft of hand spinning continued as a domestic skill in humble cottages and also as a popular pastime in fashionable parlours of the well-to-do: witness the ornate boxwood, mahogany, rosewood and satinwood wheels of the time.

By the mid 20th century, though, it was the preserve of the few – until a renaissance of interest around the time that James stumbled across the design that set him on the path of his career.

Looking back, he says, 'I have found that the harder times were, the more popular spinning became, because people want to try to do something practical.'

Many of his customers have been private individuals, although some also spun as a business. Around 80–90 per cent of his spinning wheels were sold abroad, with the USA his biggest market.

MAKING A WHEEL

So what are the key stages to making a spinning wheel? He laughs and reveals that on his basic double band treadle-operated Leicester model there are no fewer than 150 different parts.

'What I mainly did was prepare everything for the batch of wheels I was making, then I would do all the turning, make the wheels,

and then assemble them,' he explains. 'I used standard tools for turning and woodworking, and I made different jigs, although I didn't use a lot because I adapted so many shapes to do the same thing. A lot of making a spinning wheel is precision assembly, gluing and pegging all the parts, which needs a great deal of care.'

He used English oak or sometimes European oak, and occasionally yew. 'Where most people fall down is making the wheel, because it is technically quite difficult,' he says. 'You want a true, free running wheel. They call them spinning wheels, but at the end of the day, although the wheel is the hardest part to make, it's not the most important. The flyer is the most important because that does the work. The wheel is just a driving mechanism.'

James finished wheels by signing and stamping them, usually at the back of the bed, and Anne helped with varnishing and quality control.

'I had a reputation for making the widest range of models, around a dozen,' James says. 'They are all double band wheels, but there were such different styles and wheels went from 18 inches diameter to 40 inches.'

Among the most popular was the Leicester, while the Irish Castle was the most complex to make, because it required so many jigs. Based on the traditional Ulster Wheel, it is an upright model with flyer central beneath the wheel, which lends itself to spinning from either side.

He made Great Wheels (which were single band non-treadle) for folk museums, and Chair Wheels based on American models of the 1700s, their name deriving from the similarity of the frame to a chair. He even made a Thurmaston 'Suitcase' Wheel that could be taken apart to fit into a space no bigger than 18 inches square, then quickly reassembled without tools.

'I always tried to ensure a wheel was made specifically for the spinner who bought

it,' James says, citing as an example the importance of placing the flyer on the side of the wheel that is most comfortable for an individual's spinning action. 'Basically in the modern age I was the first to offer wheels that had a flyer on the right-hand side of the body, as opposed to the left. I also provided double treadles, which on larger wheels are ergonomically more satisfying.

'I wouldn't recommend different wheels for different fibres, because any decent wheel will be able to do whatever you want with it, provided you have the technique,' he adds.

Two thousand or so spinning wheels later, James has retired and sold on his business. 'And basically, that's the end of 36 years of experience and knowledge,' he says. 'I don't think there is anyone in the country now making spinning wheels professionally to the extent I did. I sometimes miss it. But I've still got three wheels that my wife, Anne, and I use for spinning: a decorative parlour wheel in the inglenook, a chair wheel and a Leicester. I usually spin wool and Anne has done more specialised spinning including dog hair.'

SPINNING AND WEAVING

Spindle

Spun yarn

Upright spinning wheel

The Lace Maker

CHRISTINE SPRINGETT

I think I might have been a lace maker in a previous life. I'm so at home with the skill and I find it so fascinating that I can't leave it alone,' says Christine Springett.

A bobbin lace maker for over 30 years, she deftly follows a pricking: a pattern of pin holes marked on light blue card fastened on top of a pillow on her knees. She anchors the cotton threads on her bobbins at one end of the design then moves the bobbins in pairs, weaving, plaiting and looping around pins pushed through the pricking into the pillow. 'When you take out the skeleton of pins, the lace maintains its form almost magically,' she comments.

Christine specialises in Bedfordshire lace, which, in its simpler form, produces bold, strong designs in which plaits and denser areas contrast with more open background. At a more advanced level the lace can be finer and certain areas or features are outlined with thicker 'gimp' thread. Simple edgings can be worked with as few as 15 pairs of bobbins, but larger or more intricate pieces may require several hundred.

Plaits, picots (decorative loops), leaves and crossings, cloth stitch trails (sometimes called running rivers) and an edge called 'nine pin' are all typical of Bedfordshire lace. 'I find it a terrific mental challenge because it's not such a geometric grid type of lace as some others. There is a lot more freedom,' Christine enthuses.

> { *When you take out the skeleton of pins, the lace maintains its form almost magically* }

Growing up in the 1950s and 1960s, she learnt to knit, sew, crochet and make her own clothes 'as girls did in those days', but it was lace that always intrigued her. However, it wasn't until 1977 that she was able to join a class to learn the basic skills. Her husband, David, had begun to turn lace bobbins and together they built a business: running lace making courses from their home in Rugby and selling bobbins to lace makers all over the world.

Today they have scaled back a little, running just two courses a year in lace and bobbin making, which leaves time for David to pursue wood turning projects and Christine to create and sell patterns, lace making kits, books and DVDs.

'You couldn't really earn a living from making lace by hand,' she says. 'You just wouldn't get a realistic rate of return on your work. But I enjoy designing and selling patterns.'

The Lace Guild has 4,000 members worldwide (www.laceguild.org) and the total number of people who pursue the hobby in Britain is probably considerably more than that. Their absorbing, therapeutic pastime is a far cry from the days of commercial making.

The lace we know today dates from the 16th century. 'There is a myth that Katherine of Aragon, Henry VIII's first wife, brought lace with her to England, but I don't think it is true,' Christine says. 'I just think that you

RIGHT

Christine Springett has been a bobbin lace maker for over 30 years, specialising in Bedfordshire lace.

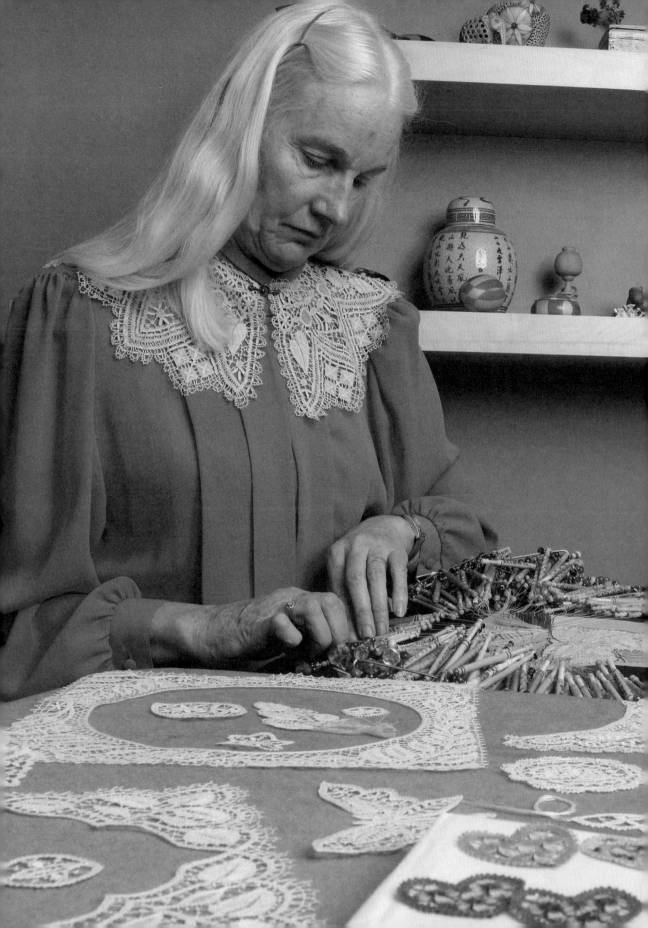

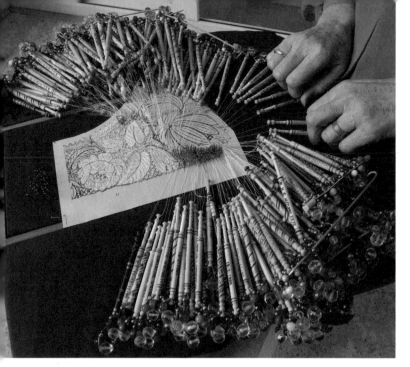

ABOVE *Once it is pricked out with the desired pattern, the light card is pinned firmly to the pillow. The thread is wound on to the bobbins, which hang on pins stuck in the pricked pattern.*

can't stop a good idea spreading and that as countries traded with each other, so each one adapted lace making in its own way.'

Queen Elizabeth I, with her love of enormous ruffs edged with lace, certainly led fashions among the nobility. She is reputed to have splashed out an amazing £3,000 on one regal ruff alone: a reflection of the time and skill it took to make. As popular with men as women, lace not only became a must-have adornment, but also the material of choice for christenings, marriages and even burials.

Italy, France and the Low Countries were renowned for lace making, and perhaps refugees from religious persecution in Europe in the 18th century added to skills already in England. In any case, the craft thrived as a cottage industry, especially in large parts of Devon and the Midlands.

Two main techniques of hand lace making developed, which are still with us: needlepoint, worked with a needle and single thread using a variety of buttonhole stitches; and bobbin lace, as practised by Christine. 'Bobbin lace evolved because it gives the creator more freedom than a needle and thread,' she says. 'It could also be produced more quickly and when people were making

lace for a living speed was important.'

Lace makers would toil for desperately long hours and little payment, including children who attended so called lace making schools in the 18th and early 19th century heyday of the craft. The Industrial Revolution and machines then swept aside commercial lace making by hand, although Queen Victoria continued royal patronage, insisting on Honiton lace for her wedding. The Honiton christening robe she had made for her son, later King Edward VII, has been handed down and worn in modern times, including by princes William and Harry.

The craft may now be a hobby rather than a commercial enterprise, but in England the four main styles of bobbin lace – Torchon, Bedfordshire, Buckinghamshire Point and Honiton – are alive and well. Threads like silk, linen and cotton are most commonly used.

Torchon (the French word for duster indicates it was not considered very fashionable in the 18th and 19th centuries) is the easiest to make and usually the first style that a beginner learns. 'It is a geometric lace and you start and finish with the same number of bobbins,' Christine says. 'When you go on to more advanced forms of lace, you will be adding in pairs of bobbins as you work and you will be throwing pairs out. There is no longer the sure and certain geometry.'

Honiton lace has a long history and is traditionally made with very fine thread. Flower sprigs and sprays are popular motifs. Bucks Point and Bedfordshire were made in the Midlands but not confined to the counties of their names. The former is typified by a fine net ground and diverse motifs that are often outlined with a thicker gimp thread. Bedfordshire lace developed around the middle of the 19th century.

'It had a boldness of design which appealed,' Christine says. 'Thomas Lester of Bedford was the most well known lace designer of the 19th century. His designs for lappets, collars, cuffs and handkerchiefs

famously included giraffes, eagles and parrots as well as the more usual flowers and foliage. At a time when people were

> *If something doesn't look good, I undo it and try again. I'm a perfectionist and lace responds to that.'*

fascinated by the exotic animals in the newly opened London Zoo, his designs made Bedfordshire lace very fashionable.'

For her part, Christine designs both simple and complex patterns, from Christmas decorations to bookmarks and handkerchief edgings. She takes her inspiration from a variety of sources, including antique laces. 'I true them up and improve them, experimenting and keeping a note of what I've done. If something doesn't look good, I undo it and try again. I'm a perfectionist and lace responds to that.'

She draws all her designs on plain paper which lace makers can photocopy on to card to use as a pricking.

MAKING BOBBINS

Just as Christine has studied antique lace for inspiration, so she and David have researched antique bobbins for his wood turning. Unlike many craft tools, bobbins are prized as artistic objects in their own right and have been made in not only wood but also bone and occasionally pewter or brass.

'We have this unique heritage in England of decorating bobbins. Lace makers on the Continent have only plain, functional bobbins,' Christine explains. One reason for the elaborate decoration was, she believes, pure marketing nous: to make a craftsman's bobbins more appealing than those of his competitors. Hence, too, eye catching adaptations like 'cow and calf' or 'mother and babe' bobbins, where one bobbin is

hollowed out and another miniature bobbin is placed inside. There were even souvenir 'hanging bobbins' bearing the names of men taken to the gallows at Bedford Gaol in the 19th century.

'Spangled bobbins, with a ring of sparkling glass beads (called spangles) on their ends, are peculiar to the Midlands,' Christine adds. 'There's a myth that the decoration on the bobbins helped the lace maker to identify which bobbin to move: they didn't. The beads are to keep the threads taut and straight on the pillow, because our pillows have a slightly curving surface.' The ring of beads also stops the bobbins from rolling in an uncontrolled manner.

One story remains true, she admits: bobbins were given as courting gifts and bore inscriptions such as 'Love me True' or 'Marry me Quick'. Certainly, if you are a lace maker, it helps to have a husband who also turns bobbins.

BELOW *To provide extra weight a 'spangle' or 'jingle' is added on to the end of most bobbins.*

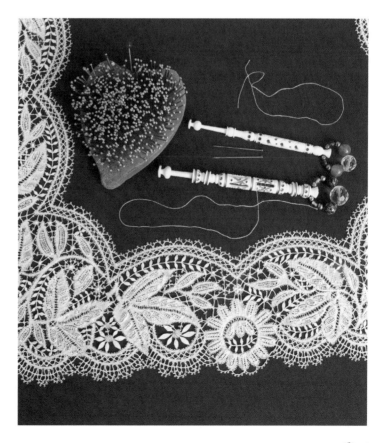

The Fabric Weaver

MARGO SELBY

When she was a child, Margo Selby admits, she found it really difficult to concentrate either at home or at school. But one thing consistently captured her imagination: textiles. When her grandmother showed her how to crochet she was delighted.

'That was my first memory of textiles and how to make them, and I loved it.'

Away from home, things were not so straightforward.

'I found traditional subjects difficult to focus on at school but in creative subjects I had a high level of ability to focus and develop skills and ideas.'

So it was perhaps no surprise that, having finished school, she decided to study textiles at degree level.

'My first degree was in textiles, specialising in woven fabrics. At the end of the course I felt I had come a long way but still had a lot to learn, so I started an MA in constructed textiles at the Royal College of Art. The course very much focused on weaving, which gave me a much broader base of knowledge.'

After her MA, Margo knew that she had her final vocation and she was lucky enough to be offered a two year fellowship at the Ann Sutton Foundation, which conducted research into textiles and was based in Arundel, West Sussex.

'The Ann Sutton Foundation was great as

> { *The process of designing and making a new fabric begins when Margo sits alone in front of her loom* }

it gave me a supported environment in which to set up my business,' explains Margo. 'I was able to produce a project for industry – in other words a fabric that could be produced in a mill. It gave me a real understanding of how the industry works.'

At the end of her fellowship Margo set up working from home in north London.

'Once I had my own studio things went really well, and by 2007 I was able to open my own shop in Bloomsbury in central London. The shop sells the things I make and my loom is set up in the basement.'

She designs and develops all her own fabrics, which are now sold all over the world, but the process of designing and making a new fabric begins when she sits alone in front of her loom.

'All my fabrics start as hand woven ideas even though they are often taken to industrial mills to make limited editions of fabrics which are more accessible. We sell handwoven items in the shop but it is the collaboration between the handcrafted and industrial techniques which have made the business succesful, and allowed interesting woven fabrics to be available to a wider market. While I sell handmade scarves and other handwoven products in the shop, offering mill woven products which are more affordable allows me to sell my woven ideas to a wider audience.'

Margo works on a 24-shaft dobby loom

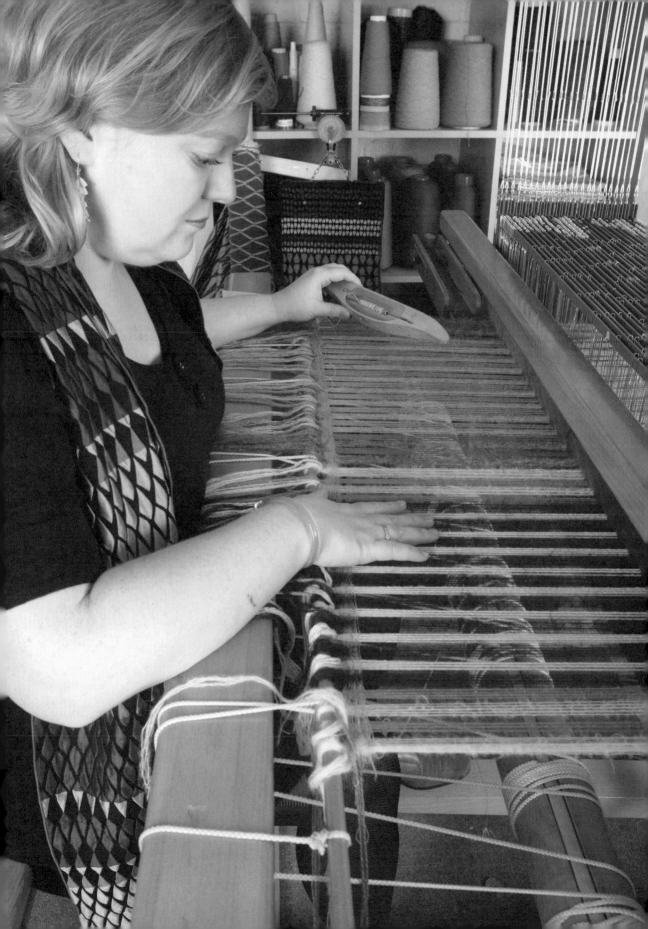

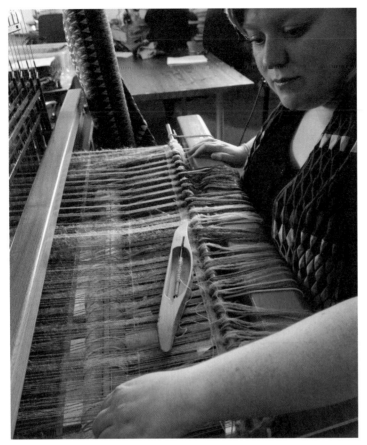

ABOVE *The warp is made of many threads which make up the backbone of the fabric. These are wound on to the loom at an even tension and then meticulously threaded on to the shafts of the loom. This is done in a specific order so that the patterns and structures can be created.*

which, to the uninitiated, is a sophisticated piece of equipment that allows highly complex designs to be woven by hand. But it is essentially much like the kind of looms used a thousand and more years ago.

'It's a one-metre-wide loom and, like all looms, it is complex to set up and operate but it still involves warp and weft, just as an ancient loom would.'

When it comes to designing a fabric, Margo's great passion is colour and texture.

'I'm driven by colour,' she explains, 'but I want the colour and the structure to work together. I create optical patterns of warp and weft that match and complement each other. I create geometric patterns using a technique called "colour and weave". 3-D colour surfaces are created with a double cloth fabric. This means that the cloth is made from two layers of fabric which swap over to form patterns and raised surfaces.

I use lots of silk and lycra, for example. Silk doesn't shrink but lycra does, so I created one fabric that involved the lycra actually physically pushing up the silk after the material had been washed to create an effect not unlike bubble wrap! It became one of my best-known fabrics.'

In the great tradition of craftwork, Margo is a firm believer in producing fabric that is both beautiful and useful.

'I do some fabrics so they can simply be hung to be looked at – rather like a painting – but I prefer my fabrics to have a function. If you think about it, so much that surrounds us is woven – clothes, chair covers, carpets, blankets. They might be great to look at but they are also really useful. There is great pleasure in making the everyday practical textiles in our life beautiful so that they can enhance our lives.'

Her interest in the whole world of design is reflected in her collaboration with other artists, designers and crafts people.

'I've collaborated with interior designers for some of my work – creating curtains and chair covers – and I've also worked with fashion designers to create jackets, shoes and other items. It's something I really enjoy but I also like just being in my studio and making scarves and cushions, small purses and lavender bags.'

To ensure that it reaches the widest possible audience, Margo also sells her work at craft fairs and shows and she has collaborated with museums and art galleries on specific projects.

'I've worked with the Tate Gallery and the National Gallery, and with other similar institutions in America. A museum will sometimes give me a design idea to tie in

with an exhibition, and I develop a fabric that can then be used for all sorts of accessories to be sold in the museum shop.'

Developing a fabric is no easy task. For Margo, it can involve up to five years' work.

'It does take a long time, because my designs are very colourful and complex – I spend hours at my loom coming up with ideas, trying them out and refining them. Once I'm really happy with a fabric it's great to work with an industrial mill to put it into production. It's wonderful to see my ideas brought to life in this way.'

Like the weavers of old, Margo is aware that her craft is essentially a slow, meticulous business.

'Working at the loom I can produce perhaps a metre of fabric a day, which isn't much but there is no way to rush it. And on top of that you have to remember that it can take several days just to set the loom up, particularly if I'm using a lot of fine yarn. Set-up time can be as much as five days.'

So how many new designs does Margo produce each year?

'I make ten or twelve new designs each year and it is important for me to keep developing new fabrics. Some of my new designs will become classics – how well they sell is what really determines how long I keep making them.'

The idea that a handloom weaver is behind a design is definitely a selling point in this age of mass production. Apart from anything else, it is a rare skill. Margo reckons that there are fewer than 30 people doing what she does in the UK, and many of these work only part time or they are 'hobby weavers'.

'People don't realise what a slow, painstaking business designing and handloom weaving a fabric is, and that it takes years to learn how to do it. I'm still learning even though I've been doing it for years. Once you know how to weave, that's just the start – you have to have an idea in your head of how you can make something

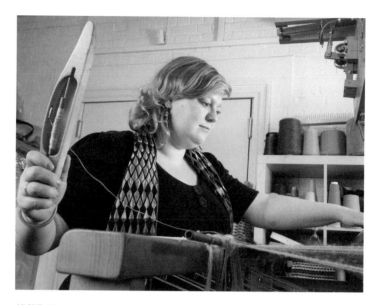

ABOVE *The threads are lifted in different combinations creating a shed. The weft yarn is passed using a shuttle.*

BELOW *Before weaving it is important to check that the tension of the yarn is even across the loom.*

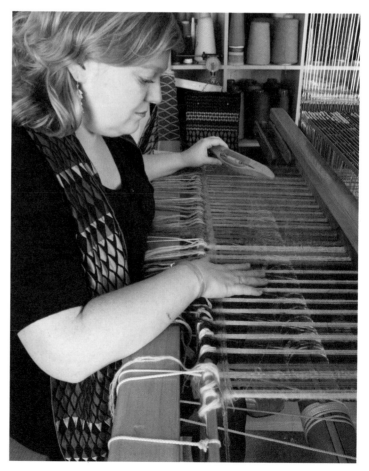

ABOVE *Once the fabrics are woven Margo collaborates with designers of products, interiors and fashion to create a wide range of end uses.*

BELOW *Combining different fibres which shrink and react differently in the finishing creates 3-D fabrics.*

look right before you produce it.

'It's a bit like reading music – my designs start as a complex series of crosses on graph paper, but what looks like a mass of marks to most people enables me to visualise the fabric much as a musician can hear the music when they see the notes on paper.'

Margo loves the long tradition of the craft of which she is a part, but she is also fascinated by new materials and how they work with long-established materials.

'I use lots of different fibres because I'm interested in seeing how they react together – I use silk, lycra, cashmere, mohair, lamb's wool, cotton and viscose. My approach is traditional but also modern – what could be more traditional than weaving on a loom by hand? The key point is that I make and design fabrics I love, and hope that others will love them too.'

Most of Margo's designs are geometric but she also uses a Jacquard loom to create a variety of intricate shapes.

> *I use lots of different fibres because I'm interested in seeing how they react together*

'I worked with a ceramics company called "People Will Always Need Plates" to create a geometric textile design inspired by Trellick Tower.'

Though weaving was once a big industry in Britain it has declined dramatically, but Margo's enthusiasm and success show that there is a market – and a good one at that – for fabric designed and made carefully,

RIGHT *Margo is proud to have combined handweaving technical skills with industrial methods and an entrepreneurial attitude to make weaving and woven fabrics both relevant and accessible in today's society.*

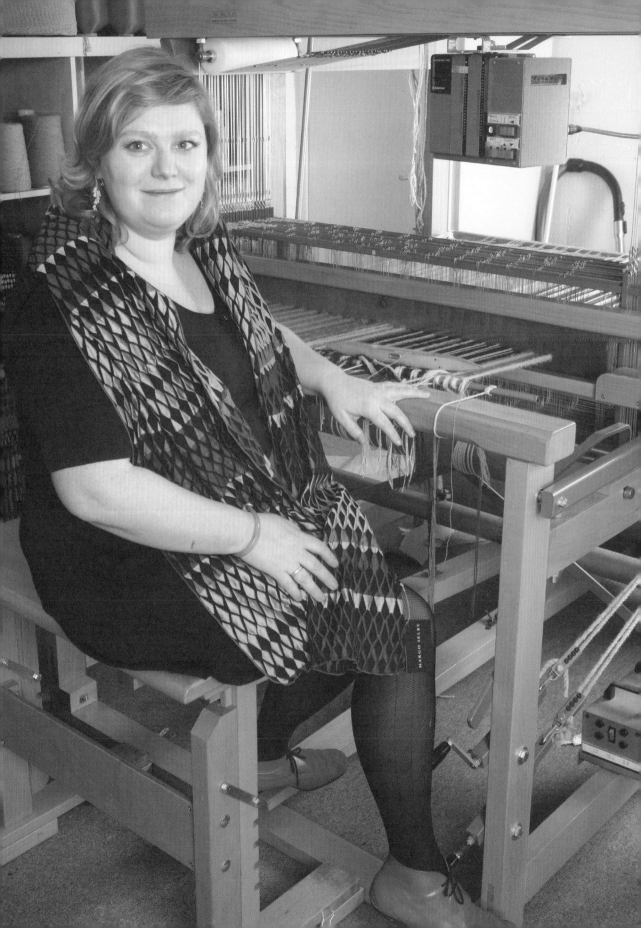

WOODLAND CRAFTS

The Bowl Maker

ROBIN WOOD

Robin Wood makes traditional, functional wooden bowls. That might not sound like anything particularly special but, as Robin points out, the vast majority of bowl turners these days make bowls that are highly sanded and polished – designed to be looked at, as Robin puts it, rather than to be used.

'I want people to eat off my bowls and plates as I do,' he says. 'My most popular bowl is perfect for eating your cereal, but I also make salad bowls and wooden plates and they are made just as they would have been made centuries ago when wooden bowls and plates were simply an everyday item.

'I use whatever timber happens to be locally available – it might be sycamore, ash, alder or elm. It's important to me that the wood should be locally sourced. I'm a traditional craftsman in the sense that I want to relate to the materials I use. When I go to my local timber merchant I buy the whole tree and then gradually turn it into useful things – bowls, plates, spoons and so on.'

Robin came to bowl turning relatively late in life after concentrating on science at school when he was growing up in Cheshire. He still laments what he sees as an absurd academic split between the arts and sciences.

'If you are academic at school you tend to get channelled into science subjects as I

{ *I buy the whole tree and then gradually turn it into useful things – bowls, plates, spoons and so on* }

was and that leaves no room for the arts and crafts side of things. So I got no chance to try my hand at woodwork when I was young, which was a pity. We should mix art and science because we need both.'

After school Robin travelled round the world and did various jobs trying to work out what he really wanted to do. He spent a year in the USA and remembers meeting a number of inspirational people. He also gradually made a list of all the things he wanted from a job, as he explains.

'I wanted a job that would benefit people or the natural world or both and a job that involved mind, body and soul.'

Back in England he took a job with the National Trust at Toy's Hill in Kent, which was the epicentre of the great storm of 1987 when millions of trees were lost in a great swathe across southern England. But it was the storm that made Robin realise where his future lay.

'I started working for the Trust just a few months after the storm had struck and I worked mainly clearing the forest and replanting. I had no experience of forestry work so I suppose I was lucky to get the job at all – I think they liked the fact that I was very enthusiastic! But there were lots of frustrations with the job. I hated the fact that so much timber was wasted – trees were simply bulldozed into enormous piles and

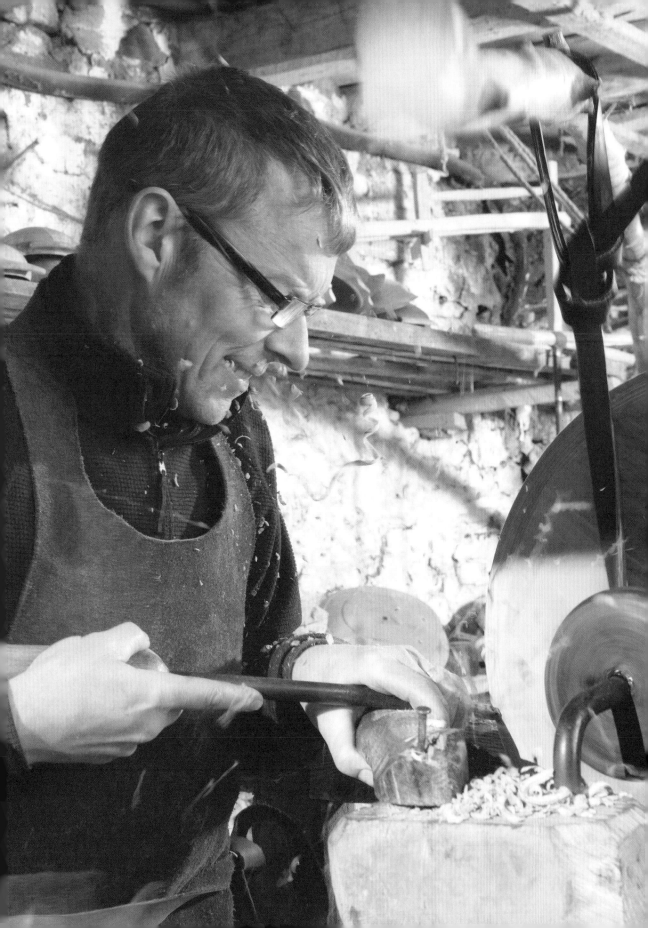

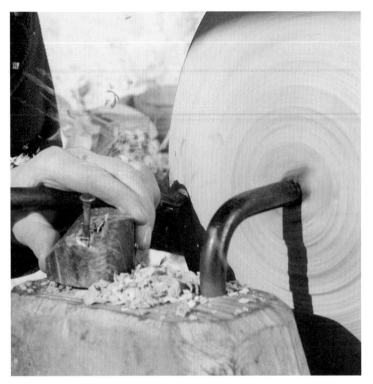

ABOVE (top) *Once centred, the drive cord is wrapped twice around the mandrel and the outside of the bowl is shaped with a hook tool.*

ABOVE *Like the old turners, Robin does not use sandpaper and instead relies entirely on the sharpness of his tools to get a good finish.*

burned. Some of the piles of timber were as high a multi storey building. Some piles burned without stopping for a week or more and when the earth was bulldozed over them they carried on smouldering for months.

'The problem was that there was so much timber suddenly available and there was no one to take it and use it – all the timber yards filled up, people's fuel-wood sheds filled up and then the only thing left was to burn it.

'This was my first introduction to the idea that we had lost the basic ability to use local things rather than throwing them away. There were reasons why the wood had to be destroyed but it was still a sad waste.

'Ironically too, the places where we just left the timber where it had fallen are now far more interesting than where we cleared everything. I suspect we all knew it was wrong to clear all the timber but the locals wanted everything tidied up.'

After Toys Hill, Robin's interest in trees and timber took him to Hatfield Forest in Essex, a medieval hunting forest that remains largely untouched since the Middle Ages except for traditional forms of management – coppicing, pollarding and grazing.

'There hadn't been a great loss of trees caused by storms at Hatfield but when we cut the trees as part of the management regime a lot of timber was still being wasted because, once again, there was no market for it. The timber merchants wanted large diameter wood and we were cutting relatively small diameter wood. It seemed obvious to me that it was important to find a use for the wood. In medieval times nothing would have been wasted – it was all cut for a purpose.

'Then, while I was pondering the waste of all this wood, I discovered someone who had made great use of locally available wood. He was a chap called George Lailey and he was the last person who did what I knew I now wanted to do. George was one of the last to turn bowls on a pole lathe and when he died

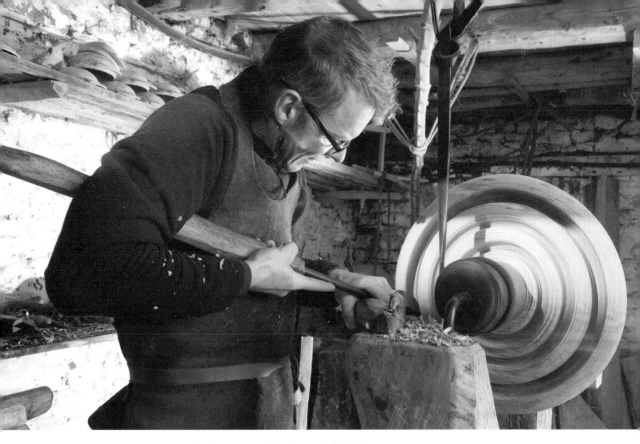

ABOVE *When you are turning large pieces of wood using aggressive tools you need a machine that is going to take the strain.*

ack in the 1950s his tools went to he Museum of English Rural Life t Reading where I was able to see hem. So I never met George but I ead all about him.'

What appealed to Robin about eorge Lailey's work was that, unlike modern bowl turner, he didn't cut ach bowl from a big block by taking ll the wood out of the middle. nstead he cut a groove down the nside of the wood, cut out a smaller lock from inside the large block nd made smaller bowls with each maller piece.

'The beauty of it was that one lock of wood would result in a nest f bowls. Nothing was wasted. Some lectric lathe workers do this now but hey didn't back when I was starting.

'The kind of work George did eally appealed to me and now, just s he did, I can make five bowls out f one block of wood using a pole lathe powered by foot only.' But it was only after Robin had started working on a pole lathe that he really began to understand the full history and heritage of the craft.

THE POLE LATHE

'Using a pole lathe in the woods, which is how a lot of people think it is done, is a relatively late tradition that was confined to the chair bodgers of the Chilterns. In other areas pole lathes had traditionally been set up in workshops. I now have mine in an old National Trust stable. I still use the traditional bendy sapling to drive the lathe but mine is much longer than a bodger's would be. It has to be bigger and more powerful to work with the large piece of timber from which

This was my first introduction to the idea that we had lost the basic ability to use local things rather than throwing them away

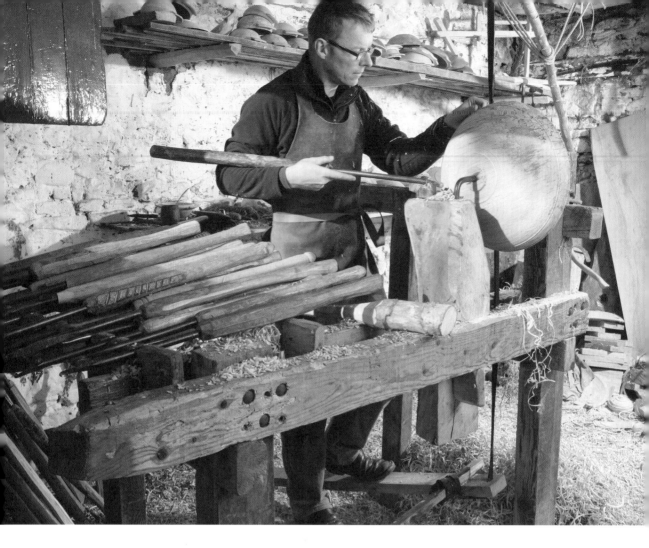

you make a bowl. My pole is 15ft long, 3in thick at one end and about 2in thick at the other.

'The only specialist tools I use are hooks. They are basically chisels with curved blades, but I have about 80 of them all different sizes and styles. I forge all my own tools as well as tempering them just as George Lailey used to. I made copies of the tools George used and came up with variations and new styles to suit my work.

'A turner's hook looks a bit like a medieval instrument of torture. The handles are 15in long and the blades the same length. It sounds like an over sized chisel and that's exactly what it is. But it is a big, heavy tool for a reason; the work

is heavy and the size of the tool helps to ensure that while you are working it doesn't bounce about too much. It also gives you very precise control – I can adjust how deep it cuts to about a tenth of a millimetre.'

Like his hero George Lailey, Robin makes nests of bowls but he also makes copies of Elizabethan porringers, a style of bowl that has two handles. His copies match a porringer dug up in Southwark near where Shakespeare's Rose Theatre once stood.

'My porringer is about 6in in diameter and it's really popular. I also make copies of bowls found on the *Mary Rose*, Henry VIII's flagship that sank in the Solent.'

Because he insists on using whatever

ABOVE *The core is snapped out and the very bottom of the bowl is smoothed using a specially designed curved knife.*

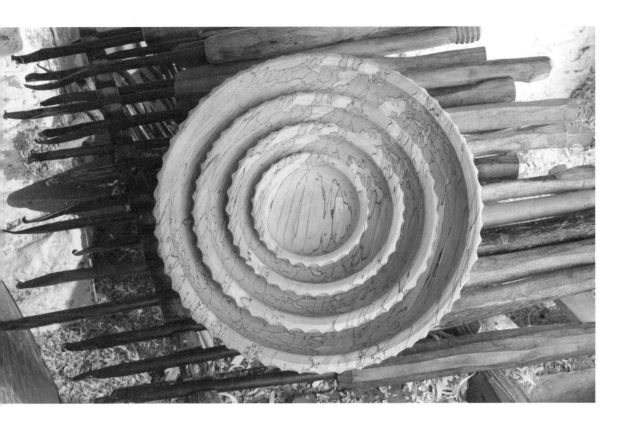

cal timber is available at a particular
me, Robin rarely accepts commissions.

'The problem is that if someone wants
n 11in salad bowl I may only have enough
ood to make a 9 inch bowl and I'm not
oing to import wood from far away to
lfil the commission. But when I can, I do
ake bowls in every size from four-inch
iameter to 22in. A 22in bowl might take
whole day and I reckon I make about a
housand bowls in a year. I've worked at
oughly that rate for 15 years so it's a big
otal! I don't like sending my bowls too far
field – on an aeroplane for example – but
do it occasionally. The truth is that I'd
ather people sourced their bowls locally.'

Despite their superficial similarity to
ther turned wooden bowls, Robin's are
ctually rather special in other ways, as
e explains.

'One of the most interesting things
bout traditional wooden bowls is that
ney are never sanded. Bowls sanded to a
mooth finish can't really be used for food

and traditional bowls were never sanded
for a very practical reason: sanding is
basically not good for the wood of a bowl.
When you cut a wooden surface with a
sharp tool it cuts the fibres cleanly but
the fibres are abraded by sandpaper – in
other words they are scratched and the
scratches fill with dust, which makes the
wood seem smooth.

'However, as soon as you wash such a
bowl the dust comes out of the scratches
and the fibres get all fluffy and nasty.
When a bowl is turned and left without
sanding this doesn't happen. The wood
has ridges formed by the cutting process
rather like a hand thrown pot. My bowls
age beautifully and get smooth with use.

'Wooden bowls were in use in England
from roughly 600 to 1600CE and, contrary
to popular opinion, they were not just
used by the poor. The great ship burial at
Sutton Hoo, for example, included wooden
bowls made for a great king. Finely made
wooden bowls were a status symbol.'

ABOVE *Depending on the*
weather and the wood, the
bowls are left to dry for 3–
6 weeks, once the turning
process is complete. They
are then finished with
hot natural vegetable oil
which seals the wood.

Chisel

The Broomsquire

ADAM KING

A few years ago at the height of Pottermania, children would drag their parents to watch broomsquire Adam King demonstrating his craft at country shows. 'When the kids saw the besoms I make, they recognised them as Nimbus 2000s,' he says. 'Sales of my children's besom brooms really went up, though I'm sure half the kids didn't even know you are supposed to sweep with them.'

Perhaps, once the younger generation has finished whizzing about backyards in make-believe games of Quidditch, they will graduate to the ranks of gardeners who appreciate the practical merits of his rare craft, especially as autumn leaves begin to fall.

'A traditional birch besom is much more effective than a conventional modern yard broom and it won't damage your lawn like a rake,' Adam says. 'It gets between the grass and flicks leaves up rather than sliding over the top. As you sweep, you flatten all the unsightly wormcasts, and you can get into corners that other brooms can't. You can do delicate things, too, like lifting leaves off gravel without shifting the gravel. The generous length of brush means besoms like mine can last up to ten years. Those you find in garden centres are usually cheap imports that quickly fall apart.'

Adam is a third generation woodworker born and raised in the Chilterns of Buckinghamshire, an area historically renowned for its beeches and furniture industry. His grandfather was a chairmaker and his father has worked all his life in rural crafts; Adam learned how to turn chair legs on a pole lathe when he was just five years old.

'I was demonstrating at craft shows from the age of seven or eight,' he recalls. 'My dad taught me the basics of besoms, too, though he never made them on the scale I've done.' At 18, Adam set up his own business and says that today he knows of probably only a couple of other full-time broomsquires in the country, though there may be more.

His work follows a seasonal round. He cuts birch on Stoke Common, a short drive from his garden workshop in High Wycombe, from December to March when the sap content is low and leaves have fallen

'It's an SSSI site that the City of London is restoring back to heathland. So I'm doing them a favour by cutting the birch down and they're doing me one because I want the birch for the heads of my brooms,' he explains. 'Ideally the birch I cut is three to four years old, when it's about 5ft tall. It's still nice and young then and quite stiff. Once it grows into bigger trees, it gets too floppy for brooms.'

He stacks the birch in his purpose-built store at the bottom of his garden, a large

> *Adam learned how to turn chair legs on a pole lathe when he was just five years old*

RIGHT *A besom broom is still the most versatile broom for general outdoor use. Adam King set up his own business when he was 18 and he has been making besoms ever since.*

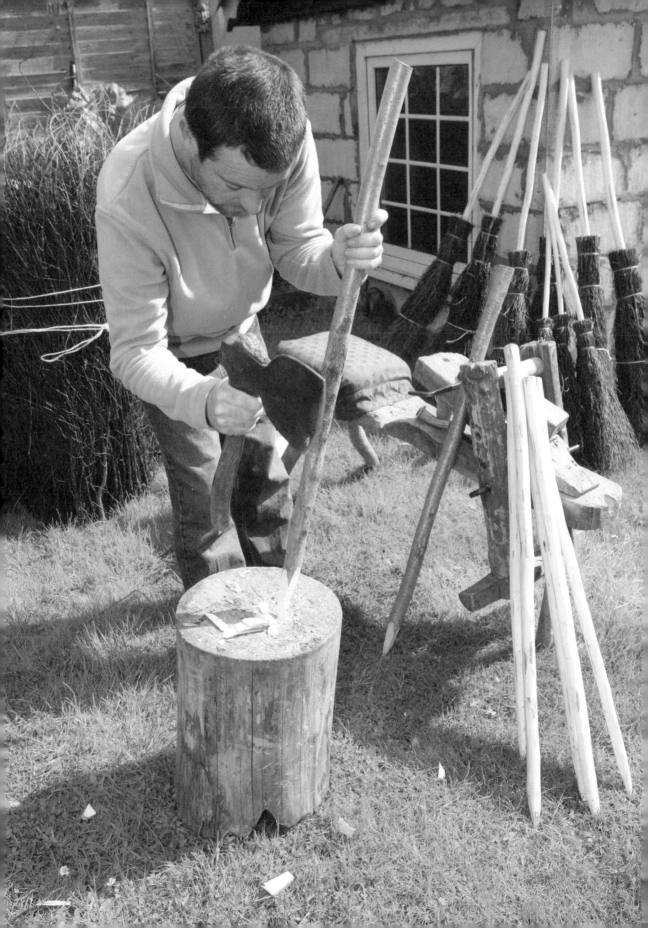

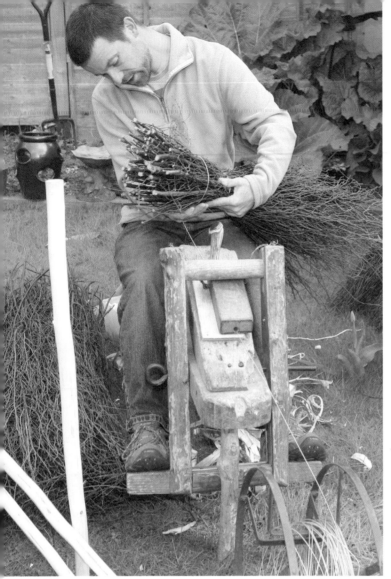

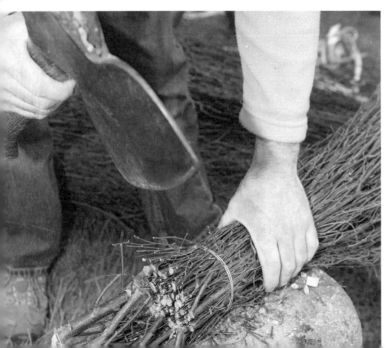

shed with overhanging roof and gaps to allow air to circulate, helping to prevent the wood from rotting. It takes a year to dry and season the birch before it is ready for use.

'I work outside in the fresh air because the birch dust can be bitter tasting,' he says as he sits astride his 50-year-old broom horse: basically, a traditional hands free vice he operates with his feet, pressing on the base pivot to bring down the wooden gripper. He rolls a bundle of birch into a round broom-head shape, fastening it in two places using wire threaded from a clamp beneath the horse, before trimming the ends square with an axe on the chopping block.

It's back on to the horse to strip the bark from the locally cut hazel he uses for the handle. Once he has fashioned the end to a point with his drawknife he pushes it into the broom head, inverts the broom and vigorously bangs the handle on the chopping block so that the head slides down. A wooden peg hammered through the handle between the two wire ties prevents slippage or twisting.

It takes around 25 minutes to complete a 5ft broom for adults and a mere ten minutes for a children's 32in version.

Prior to the arrival of modern brushes there would have been a broomsquire in most villages and it was the sort of trade that would have been handed down in families.

'Different regions had their own styles of besom, making use of the best available binding materials for example,' Adam says. 'I use wire, but originally besoms would have been tied with withies, be it split ash or split hazel, or down in Somerset they would have used willow. Birch is the traditional material for the heads in the Chilterns and most of the UK, although moorland heather was used in areas where birch is less common, such as Scotland. The advantage of birch is it remains very supple even when it's totally seasoned.'

Besoms – their name derives from the Old English 'besma' meaning 'bundle of twigs', Adam explains – were for centuries the workaday

tool of the housewife. They were also believed to have supernatural and symbolic associations. The ancient pagans used birch twigs to sweep away the spirits of the departing year and besoms were later hung above doors or kept in porches to ward off evil spirits. In folk tradition, witches flew on broomsticks that were sometimes smeared with magic ointment.

Adam has sold besoms to practising white witches, mainly at Glastonbury Festival. 'They often want certain modifications. For example, they prefer ash handles because in pagan mythology ash was the wood of knowledge. Birch itself was a wood of purification, which is why the witches sweep out their circles with it before casting their spells. They usually don't want the broom head trimmed, either, because it reduces its power.'

He also does a good trade in handfasting brooms, used in pagan wedding rituals. 'I bind these with willow rather than wire, because people want them made completely from natural materials. I pyrograph names and dates onto the handles, too.'

Adam sells his besoms at craft and agricultural shows, and in response to orders through his website he posts his work out to anywhere in the UK, conjuring a rather exciting image of flying broomsticks.

As regards a fourth generation to carry on his craft – he also carves Welsh lovespoons and wooden jewellery – he says his three small children are too young yet to be making career choices. However, he has in the past taught others to make besoms. 'Most people could learn to make a basic broom fairly easily. The mechanics and skill of it are not as great as in many crafts. But it does take a lot of practice to consistently make good ones without bits sticking out and handles askew.'

LEFT (top) *A bundle of birch is rolled into a broom-head shape and fastened with wire threaded from a clamp beneath the horse.*
LEFT (below) *The ends of the broom head are trimmed square, ready for the handle to be inserted.*

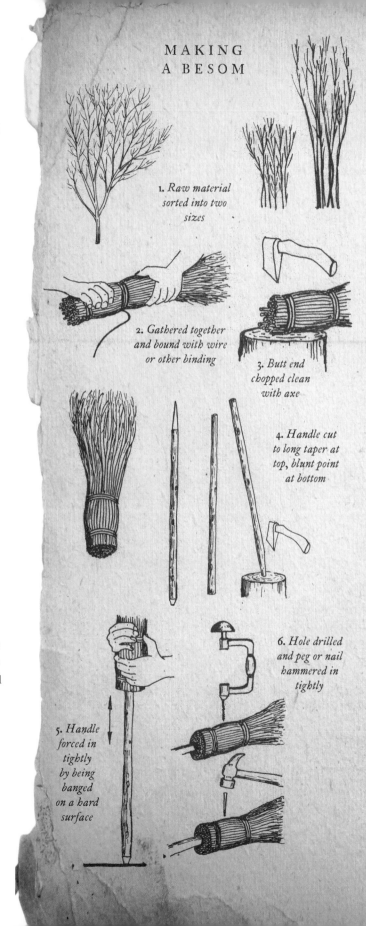

MAKING A BESOM

1. *Raw material sorted into two sizes*

2. *Gathered together and bound with wire or other binding*

3. *Butt end chopped clean with axe*

4. *Handle cut to long taper at top, blunt point at bottom*

5. *Handle forced in tightly by being banged on a hard surface*

6. *Hole drilled and peg or nail hammered in tightly*

The Hurdle Maker

BERT MANTON

Bert Manton trained as a science teacher before switching to teach crafts, but then a chance meeting led him to become one of Britain's last traditional wattle hurdle makers. Wattle means woven and a hurdle is a moveable fence.

'It all started when, as part of my craft teaching, I made a copy of an old pole lathe – the sort of lathe once used to make chairs deep in the Bucks beechwoods. At the time, an inspector was visiting the school where I worked and when he saw the lathe he suggested I visit a chap called Fred Lambert who had written a book on coppice crafts.

'After meeting Fred my life changed completely. This was back in 1976, but two years earlier I'd met a chap called Charles West who was the fifth generation of a family of Dorset hurdle makers. I met him at the Royal Show where he was demonstrating hurdle making and I said I would love to learn how to do that. I remember he said to me, "Well you won't learn while standing there!" After that I went to see him regularly and learnt how to make hurdles. All his tools and his notes – which I helped him write – went into the Dorchester Museum when he died. I started making a video about hurdles with him and only finished it recently. That will go to the museum too. Charlie had started work back

in the 1920s so he was probably one of the best people in the country to learn from.'

Bert has never stopped making hurdles since those early days back in the 1970s, but he is also in involved in teaching hurdle making, as he explains.

'It's teaching and demonstrating really. The great thing is that there is more interest in hurdle making today than there was in the 1970s when it was in danger of dying out, but I don't make hurdles on a commercial basis.'

Based at Woodford Halse near Banbury in Oxfordshire, Bert's courses attract people from all works of life and many turn up because they have been bought a course as a present.

The process starts in woodland and it is a perfect example of how traditional crafts can fit into modern ideas of sustainability.

'You need a wood of coppiced hazel and the hurdle maker uses hazel that's grown on an eight year cycle because at eight years a coppiced tree will produce just the right abundance of rods or new growth. We cut these and make the hurdles from them, but the beauty of it is that a hurdle will last about eight years so when the new growth is ready after eight years we are just ready and in need of it! It all fits very nicely.'

Hazel is traditionally harvested in winter, usually between September and March when the sap is not in the tree. This would have

> *There is more interest in hurdle making today than there was in the 1970s when it was in danger of dying out*

RIGHT *Bert Manton is one of Britain's last traditional wattle hurdle makers. Not only does he make them but his wealth of knowledge and experience makes him an expert teacher in hurdle making.*

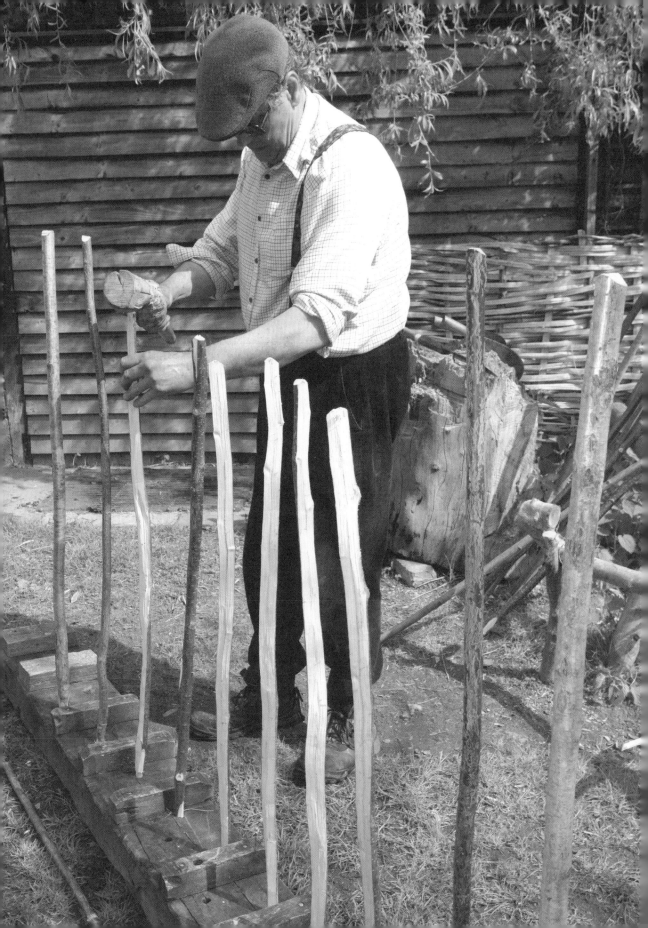

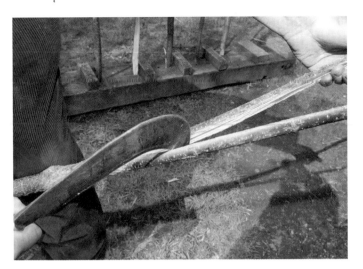

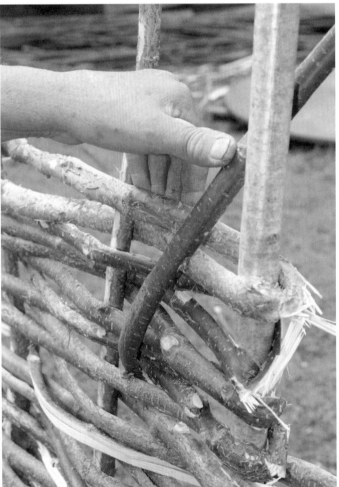

been a quiet time for anyone working on the land in the pre-industrial era so it also provided work just when it was needed. But the real hurdle making starts after the harvest.

'After you've gathered in your hazel rods your first job is to make a frame which is then pegged to the ground. Traditionally a slightly curving tree would be cut and laid on the ground and then holes would be drilled along its length. Into these holes you put the upright hazel rods – the first stage in making the hurdle. You make the hurdle on a curve because it straightens as it dries out. If you start off straight the hurdle will twist.

'The upright rods are called sails, or zales if you're from Dorset. You use ten uprights for a sheep hurdle and the ones at either end are round or whole hazel rods while the middle eight are split hazel rods. The sails are fixed about 6in apart. Once the uprights are in position you start to weave with round rods – this is known as picking up the bottom – from side to side through the sails. But this has to be done is a special way to stop the bottom falling out of the hurdle.

{ *when hurdles were in everyday use a good maker might produce up to ten ina day* }

'We use spur rods to stop the bottom falling away. It's hard to explain exactly how they are used but they double back from the end sails to lock the bottom rows of round hazel in.'

For Bert the great pleasure of hurdle making is that it is an environmentally sound skill that reflects perfectly the modern desire to use what is locally available.

'We are able to use whatever hazel we have to hand – thin stuff as well as the better rods can all be used. Charlie West always said tha

ABOVE (top) *The hurdle maker's billhook has a sharp curve or throat, and a sharp point.*
ABOVE *Twisting and bending at the same time ensures that the fibres are bunched up and remain unbroken.*

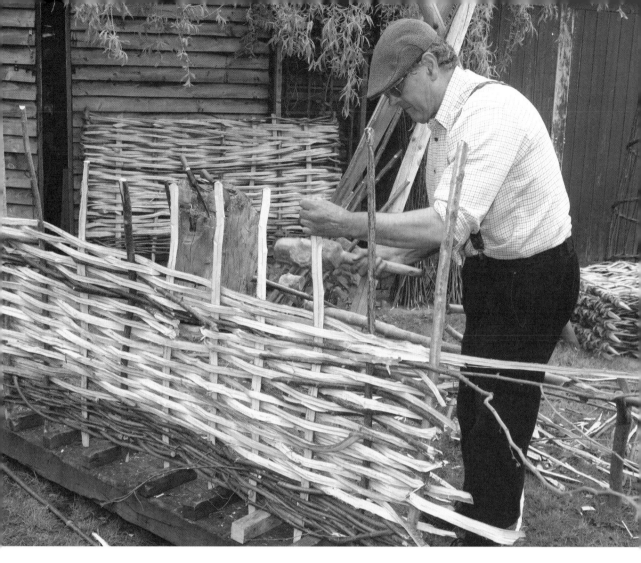

he definition of craftsman was that he could
se whatever materials were to hand to make
saleable product.

'When we have woven the split rods back
nd forth across the sails we eventually reach
most to the top. This is where we finish
ith a 'daddy rod' – this is one of two round
ods woven in to keep the top nice and tight.

'Another special feature of a sheep hurdle
that the end sails are slightly longer than
e rest so they can be overlapped with
her hurdles. Traditionally hurdles were not
xed in the ground but tied together using a
ackle – a twisted piece of hazel. Properly
ed together, hurdles will stand up well and
u'll notice on a traditional sheep hurdle
at there is a hole in the middle – this is

called the twilly and it was used to push your
hand through the make it easy to carry the
hurdle. The twilly is made with round rods so
there are no sharp edges – as there would be
on split hazels – to catch your hand.'

Although he no longer makes a large
number of hurdles for sale Bert still makes a
few for himself.

'I might make a dozen sheep hurdles in a
year these days. I could make a lot more, but
not nearly at the rate the old timers used to
make them – when hurdles were in everyday
use a good maker might produce up to ten
in a day. I once made four in a day and was
exhausted so how those old boys did it I
don't know! Old Charlie West and his dad
working together once made 27 in one day.'

ABOVE *The hurdle
is made on a
curve because it
straightens as
it dries out. The
uprights are held in
position in a heavy
'mould' during
weaving.*

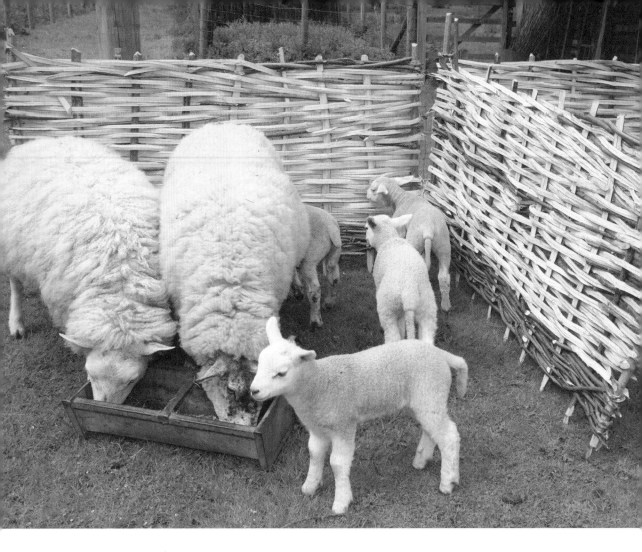

Hurdles were made in many parts of Britain before modern materials began the long slow process of making then obsolete. And there were regional variations as Bert explains.

'There were many different traditions. The sheep hurdles I make are typical of the southern style, for example. In the Midlands hurdles were very different – they made a five-barred gate hurdle. This used willow or ash and it was designed to be driven into the ground.

'The amazing thing about wattle hurdles is that they are so simple. There are no nails, no wire, no screws and just one tool – a billhook. True hurdle billhooks are hard to find these days, but the real skill is in splitting the hazel rod. If you've never done it before there's a good chance it will run out – by which I mean the split won't run all the way down the rod but keep breaking off.

'Old Charlie used to say to me that the most important thing is to work your hurdle all the time by which he meant you've got to keep checking that everything is going in straight and true.'

{ *The amazing thing about wattle hurdles is that they are so simple. There are no nails, no wire, no screws and just one tool* }

MAKING A WATTLE HURDLE

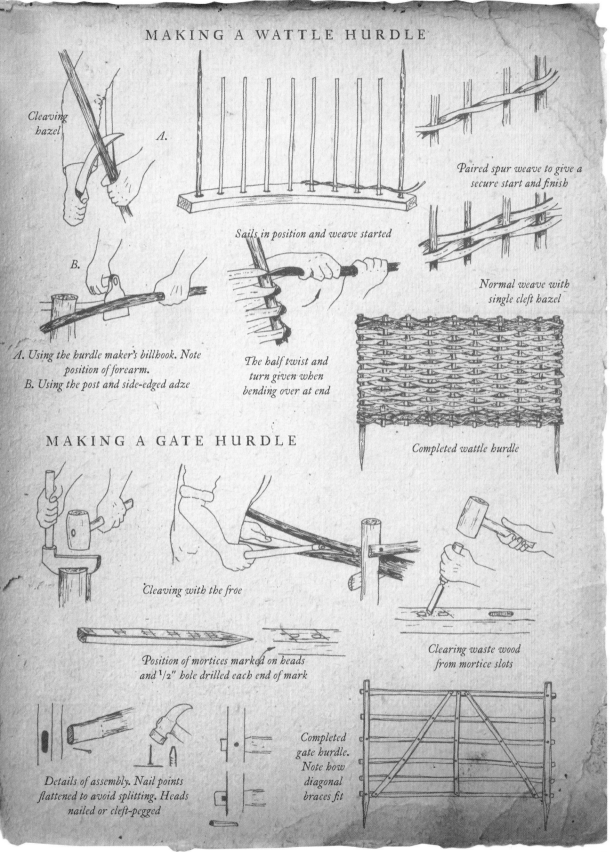

Cleaving hazel

A.

Sails in position and weave started

Paired spur weave to give a
secure start and finish

B.

Normal weave with
single cleft hazel

A. Using the hurdle maker's billhook. Note
position of forearm.
B. Using the post and side-edged adze

The half twist and
turn given when
bending over at end

MAKING A GATE HURDLE

Cleaving with the froe

Clearing waste wood
from mortice slots

Position of mortices marked on heads
and ½" hole drilled each end of mark

Details of assembly. Nail points
flattened to avoid splitting. Heads
nailed or cleft-pegged

Completed
gate hurdle.
Note how
diagonal
braces fit

Completed wattle hurdle

The Bodger

GUY MALLINSON

When Guy Mallinson decided to leave the rat race of London behind him, he set off for deepest Dorset and a seven acre wood. From here he now runs woodworking courses as well as making extraordinarily beautiful furniture and other items using techniques that are both simple and sustainable.

Guy grew up in London but from his earliest days at school he realised that his passion was for making things from wood. After leaving Bryanston, his school in Dorset where his passion for woodwork was encouraged, he set off for Parnham House where he learnt cabinet making under the watchful eye of John Makepeace on one of the best known furniture making courses in Britain. Then he worked for the furniture designer David Field before attending the Royal College of Art, where he discovered that most of the students, though talented furniture designers, had no hands-on experience of making things themselves.

Guy went on to run a highly successful London furniture company making commissioned pieces for a mix of Arab billionaires and huge multinational corporations, including Disney.

But the lure of the countryside was strong and he eventually decided to kick over the

> *One of the most remarkable things about green wood furniture is that such fine pieces can be produced using few and very basic tools*

traces and move his own furniture making business and school to the remote West Dorset village of Holditch, near Forde Abbey. Here he has created a unique camp in the centre of his wood, where wigwam-like tents heated by open fires allow year-round outdoor working, protected from the worst weather.

Though Guy trained as a cabinet maker, he was fascinated by the far more environmentally friendly and sustainable techniques of green wood working. With cabinet making, timber is dried, sawn into planks and transported hundreds, perhaps thousands, of miles before being used. As much as 50 per cent is discarded. Green wood working, by contrast, uses local timber and low-energy techniques and almost nothing is wasted. One of the most remarkable things about green wood furniture is that such fine pieces can be produced using relatively few and very basic tools.

Guy explains the difference between cabinet making and green woodworking, which has become his passion.

'I trained as cabinet maker and the skills have stood me in good stead but green woodworking has some huge advantages over conventional woodworking – it allows you, for example, to work with the wood using its natural strength. This is less of a

RIGHT *Guy Mallinson has turned his cabinet making skills to the crafting of green wood in a magical woodland workshop in Dorset.*

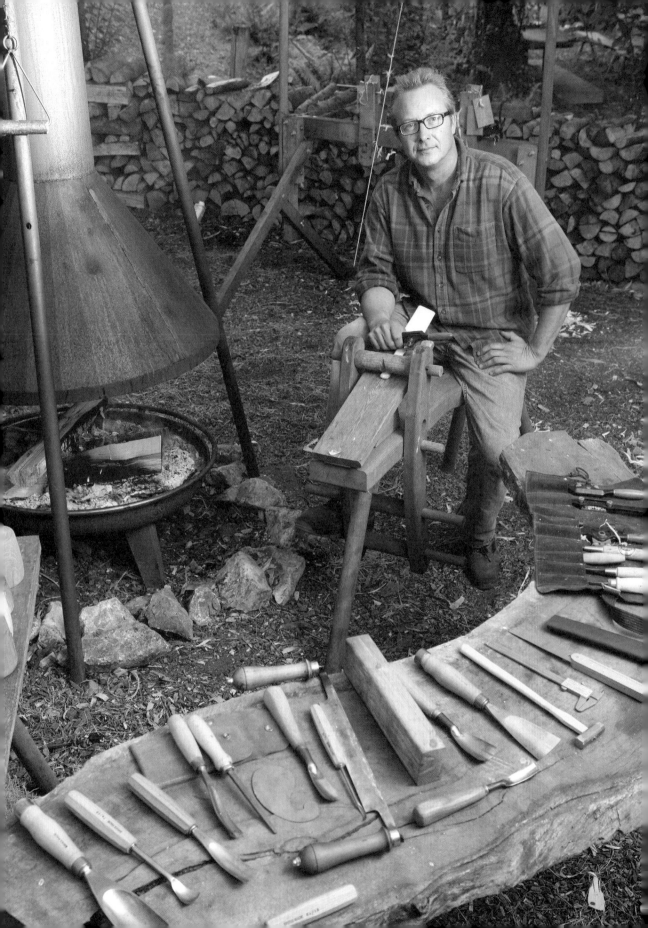

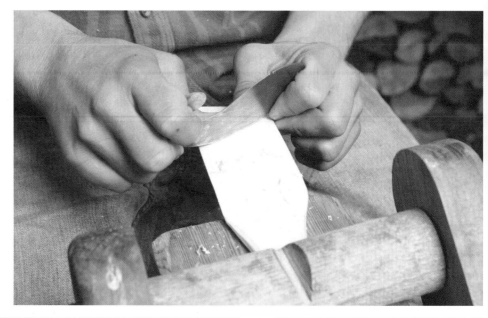

RIGHT *The burr on a cabinet scraper is used to finish a sycamore spatula on a shaving horse.*

BELOW *Guy uses a roughing out gouge on a billet rotated by the foot-powered pole lathe.*

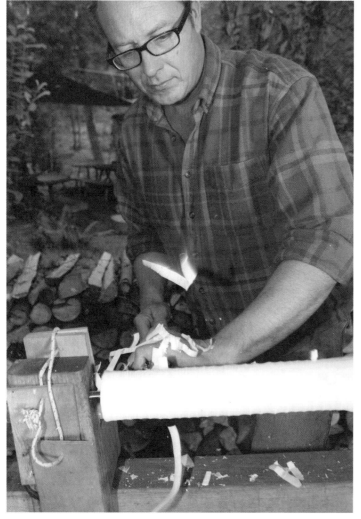

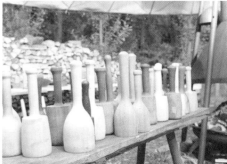

ABOVE *A collection of mallets of various weights and sizes made from elm, hornbeam and apple.*

factor in cabinet making, where one works with seasoned timber (dry wood) cut into planks.

'Green wood, which still has its sap and therefore appears almost wet, is so much softer and easier to work. The techniques for working it are also very environmentally friendly, being low energy and low waste. Our pole lathes rely entirely on human power (in the form of a foot treadle) and much of the rest of the work we do is based around simple gouges and chisels, drawknives and a most marvellous piece of equipment called a shaving horse. This simple device allows you

> *The techniques for using green wood are very environmentally friendly and low waste*

to grip any piece of wood tightly while it is worked on.

'But the process really starts when we select our trees.'

Guy tries to make sure that he goes with the forester when timber is being felled because he has very particular requirements.

'We're looking for the straight stem below the branches – branches disrupt the grain and thereby weaken the wood. A good straight stem will give good grain, which is vital to our way of working, using the natural strengths of the timber.

'Once the tree has been cut into lengths and delivered, I stack it in such a way that it doesn't dry out too quickly. When we decide

LEFT *The pole lathe has the advantage of being simple and portable, an important consideration for many woodland craftsmen.*

BELOW *Carving a sycamore bowl with a gouge and mallet. The mallet is made from dense apple wood that resists splitting.*

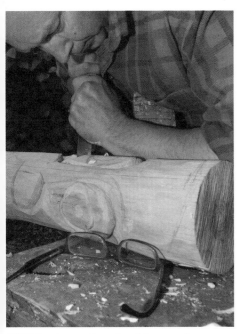

ABOVE *Paring end grain with a carving gouge on a totem pole. There are two distinct types of gouge: one shallow, the other deeply hollowed.*

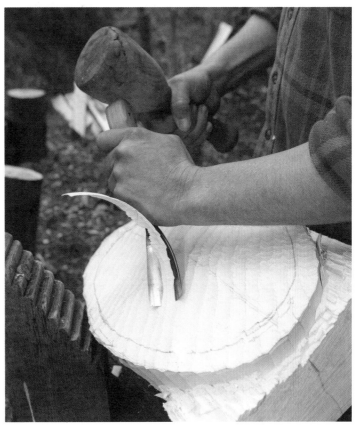

to make something we select a good suitable log for the job in hand and use a froe to start the process of turning raw wood into a finished spatula, chair leg, skittle or whatever you would like.

'The froe, which is rather like a wedge with a wooden handle fixed at right angles to the blade, is hit with a club (rather like a rough mallet, made by us from hornbeam) to split the chunk of wood. This process of splitting is called cleaving. A side axe is used to get the raw wood close, but not too close, to the shape we want. We then move to the shaving horse and use the drawknife to take the rough block of wood down close to the final shape we need. If the piece needs to be turned, it moves to the pole lathe.

'A cabinet scraper – a metal half-moon-

BELOW *Elm is preferred for seat making as it is best able to stand up to the many processes used in chair making. This post and rung ash chair has a wych elm woven bark seat.*

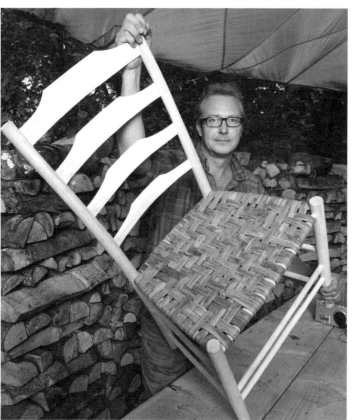

shaped disc with a burred edge – is often used instead of sandpaper for final smoothing.'

It all sounds pretty straightforward but, as Guy explains, only experience can give you the ability to get it right and different people learn at different speeds.

Running courses is a vital part of the mix that allows green wood furniture making to be a financially viable way of life for Guy. He runs courses for all ages and levels of ability, from those with high skill levels to complete beginners.

Typically, beginners will start by making a simple wooden spatula or a bowl and

progress, if they have the time and talent, to making beautifully crafted chairs that will last several lifetimes, despite being held together without glue and entirely using the natural tendency of green wood to shrink predictably, to a different degree in each of the three dimensions, to lock the joints.

'Our students have the pleasure of making something and taking it away – whether it's a rolling pin or a garden gate. And we don't waste anything: wood that has flaws or knots is put on the fire and keeps us warm.'

Where high tech will do the job better Guy is not in the least precious. He uses computer software to design 3D objects on his laptop; and where a battery drill will do a better job than a brace and bit, he's happy to use it.

'We're really green but we don't take it to extremes! And though green wood courses are central to what we do, I will never give up accepting commissions for specific pieces – the prospect of designing something new is always enticing!'

ABOVE *Part of the woodland teaching workshop with central fire pits and log walls.*

Drawknife

The Stick and Crook Maker

BILL LOWE

After 22 years in the RAF, followed by a stint as a pub landlord and a number of years on the railway, Bill Lowe found himself signed off from work after a car accident. It was the late 1990s and just before the accident Bill had visited a country show where hand carved decorative walking sticks were on show.

'I saw these marvellous walking sticks and thought I'd like to have a try at that. I'd always enjoyed working with wood but I had never really had the chance. After the accident I had a bit of time and I thought I'd learn how to do it properly so I joined the British Stickmakers' Guild. I read their magazine and was hooked.'

Some time later Bill's wife suggested he go on a three-day stickmaking course at Grantley Hall near Ripon, in Yorkshire and it was here that he met Leo Gowan, one of Britain's best-known stick makers.

'I got on really well with Leo,' explains Bill. 'And after that course I came away with an antler thumbstick I'd made myself. I was delighted. Later I contacted a local branch of the British Stickmakers' Guild and joined a group in Warrington. On my first visit to the group I was amazed to see around 50 people there and it made me realise how popular stickmaking really was.'

Each stick is a labour of love for me and the process is inevitably slow because the materials have to be treated properly!

Stickmaking gradually became Bill's passion and as he learned new techniques his confidence grew. A further car accident put paid to any hope he might have had about going back to work full time so he decided to make stickmaking his life.

'I read everything I could get my hands on and worked on sticks whenever I could because the best way to do it is to do it!'

As with so many country crafts the key to good stickmaking is using the right materials, as Bill explains.

'One of the most popular materials for stickmaking is ram's horn – for purists – or buffalo. I buy my buffalo horn from a man in Scotland who imports it from India and though I still use ram's horn it's becoming difficult to get. I cut my sticks in the local woods but also sometimes buy them in. I don't worry too much about the stick because the bit that needs the real work, the interesting bit, is the top of the stick, the bit you hold in your hand.

'But for the shaft the staple timber is hazel, which is ideal because it tends to grow straight anyway and just needs smoothing. Where a stick needs to be straightened I use an old flue, a simple metal tube really, and a steam wallpaper remover.

'I put the sticks in the flue, seal one end and blast steam in at the other end for maybe an hour or so using the steam wallpaper

RIGHT *Bill Lowe has been designing and creating unique sticks since 2001. Turning a hobby into a passion, Bill creates beautiful and practical works of art which are both personal and of high quality.*

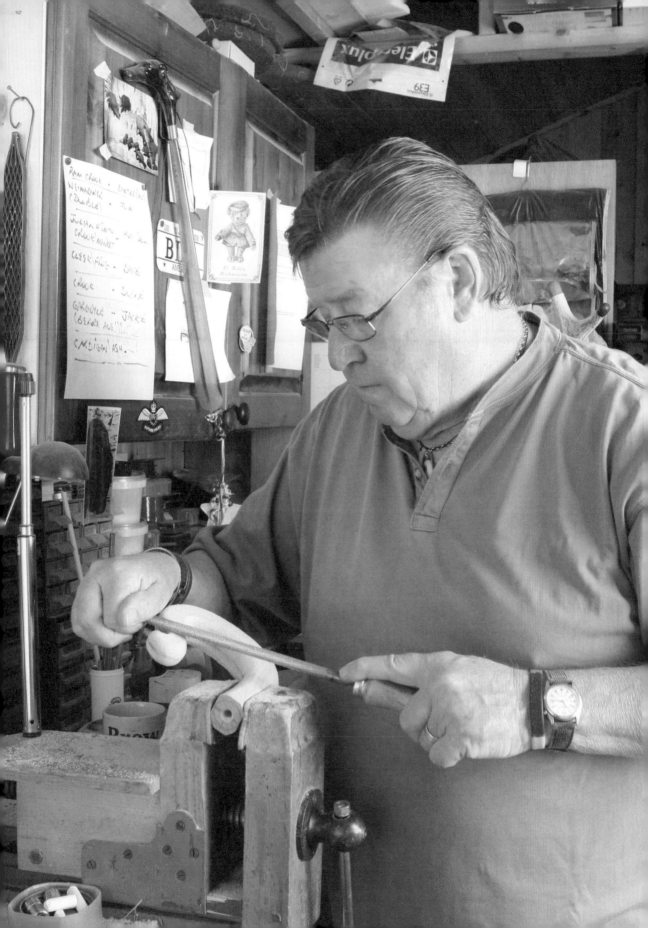

1. For *bent sticks* select straight-grown ash, chestnut or hazel. Cut 12" longer than is required. Cut a notch in the stick 1" from end for cord.

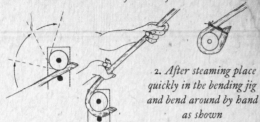

2. *After steaming place quickly in the bending jig and bend around by hand as shown*

3. *When set, cut cord. Bend will spring to normal shape. Cut off notched end and clean up handle*

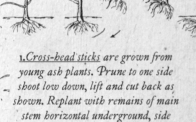

1. *Cross-head sticks are grown from young ash plants. Prune to one side shoot low down, lift and cut back as shown. Replant with remains of main stem horizontal underground, side shoot pointing vertically upwards*

2. *Prune off large side branches during growth to retain a single upright stem.*

3. *Lift from ground when diameter of stem at base is 1½". Clean off all root branches and then tidy up to obtain a natural-shaped handle*

TIPS

Fitted to protect the end of a stick, these can be made from brass or steel tube about 1" in length. Fit and secure with suitable adhesive and/or steel pin

remover. After that any stick can be bent as much as you like – even into a U shape.

'Apart from hazel, holly is good and ash but whichever wood you use you need to season it for about a year before you use it. I cut mine in December when there is little or no sap.'

And if there is flexibility in the timber that can be used for the shaft of a stick there is an even wider variety of available materials for the handle.

'You can use ram's horn, as we've seen, but also oak, deer antler, walnut – whatever you like. Walnut and oak are difficult to carve but that's part of the enjoyment. Purists attach the handle to the stick using a dowel – you drill a hole in the head of the stick and a corresponding hole in the bottom of the handle and glue the dowel down into the shaft and up into the handle. I prefer to use a threaded bar which effectively screws the head on to the stick.'

The important point about sticks is that, like anything hand made, each is unique. The skills involved in carving the handle are time consuming, which means this is a craft that operates very much at the opposite end of mass production, as Bill explains.

'I make perhaps a few dozen sticks in a year – it's not a large number but then to some extent each stick is a labour of love for me and the process is inevitably slow because the materials have to be treated properly!

'Take ram's horn for example. If you want to use it you have to season it first for about a year. Then you have to boil it before flattening it in a metal press. Finally you use a former and heat the ram's horn to make it circular and ready for the top of the stick.'

That laborious process is matched by the time and effort it takes to carve a hardwood handle to a specific and sometimes highly naturalistic design.

'One of my most popular sticks has a dog carrying a pheasant carved on the handle. A job like that might take 30 hours.'

The need for superb eye and hand coordination hasn't changed in centuries but Bill allows himself a little leeway when it comes to using power tools for the intricate business of turning a block of wood into a recognisable animal.

'With carving I tend to use a dremell – a mini drill on the end of a flexible electric cord. It's a bit like a dentist's drill. I have hundreds of bits for different work and they just fit on the end of the cord. I also have a buffing machine and usually finish the thing off with fine sandpaper.'

With ram's horn becoming increasingly difficult to obtain Bill sometimes uses cow's horn instead, but this needs special treatment, as he explains.

'Cow's horn is easier and quicker to use than ram's horn but it does present a number of challenges. You have to cut out a middle section of the horn and fill the resulting hole with a special resin. I like to fix a pewter medallion to the ends of my cow's horn handles with perhaps a picture of a dog or a pheasant on it.'

Bill knows he is never going to make a fortune from stickmaking but the regular summer show season keeps him happily occupied.

'I started selling my sticks at local shows in 2001 and have never looked back. I do several shows each year and demonstrate stickmaking while also offering sticks for sale. I might sell 20 or 25 in a year.

People do ask for unusual things – someone asked me for a gargoyle handle recently so I copied the gargoyles on our local church. But I also work from photos to produce portraits – but that's the great pleasure of stick making, you never know what you'll be asked to carve next!'

{ *That's the great pleasure of stick making, you never know what you'll be asked to carve next!* }

BELOW *For Bill, stick making has proved to be an artistic outlet that combines craftsmanship and creativity to produce wonderful results.*

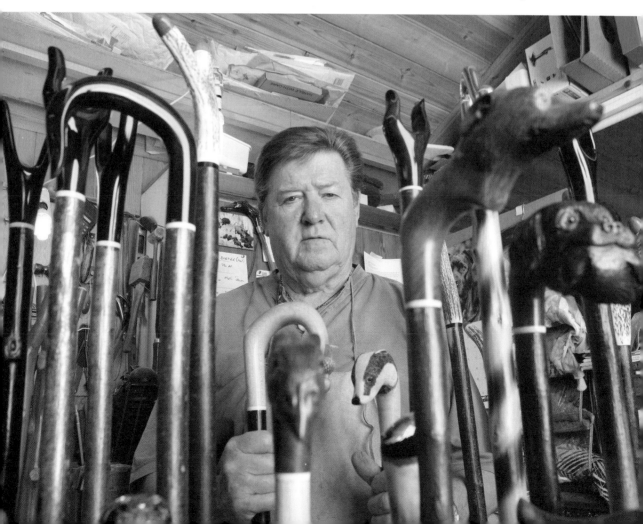

The Hedgelayer

PHIL GODWIN

'**E**very hedge is different, which makes the work more interesting and more of a challenge,' Phil Godwin says. The self-employed hedgelayer travels around farms and estates in the Cotswolds and his skills are in great demand.

'Mainly I'm laying hedges to give them a new lease of life,' he explains. 'Around here, you get mostly hawthorn, or quickthorn as it's called. People plant it to get a quick barrier and, being thorny, it is a stock deterrent. There's quite a lot of hazel as well. Hazels and thorns don't grow into big trees: they have a limited height scale, and then they die off and fall over. So if you chop them down and lay them, it thickens them up in the bottom and encourages them to grow again.'

Phil took a farm job as soon as he left school in 1976 and his boss showed him how to lay a hedge by hand in his first winter. 'The only way to learn was to get on and do it, so he watched me lay one then left me to it,' he recalls. 'Basically, I've been doing it every winter since except the first year when I became self-employed and was fencing instead.'

Phil took the plunge into self-employment after being made redundant some 20 years ago. Now he works as a traditional hedgelayer in winter and in summer he works for a contractor cutting and trimming hedges and verges for the local council with tractor-mounted flail.

'Many people think mechanical flail trimming isn't as good as traditional methods, but I think that if you use flails for the right purpose – trimming rather than cutting – then you can make a nice job of it,' he says. 'However, there has definitely been a revival of interest in traditional hedgelaying in the last ten years or so as people have become more conservation minded.'

> *There has been a revival of interest in traditional hedgelaying in the last ten years as people have become more conservation minded*

If the landscape is our most important historical document, hedgerows provide rich lines of text from which we can read tales of the British countryside. Hedges have been a part of our scenery since the Bronze Age and the Saxon word for hedge, 'haga', has been perpetuated in place names such as Hayes, Hawes, Haigh and Haughley. Some hedges seen today, dated in part by the number of species of trees and shrubs they contain, may be 500 years old or more. However, the majority derive from the Enclosures of the 18th and 19th centuries: it is estimated that between 1750 and 1850 some 200,000 miles of hedges were planted.

In recent times there has been great concern over the loss of hedgerows due to road building, housing development on the edges of towns and villages, larger field sizes on farms, replacement by fencing

RIGHT *Phil Godwin works as a traditional hedgelayer in winter, while in summer he works for a contractor cutting and trimming hedges and verges with a tractor-mounted flail.*

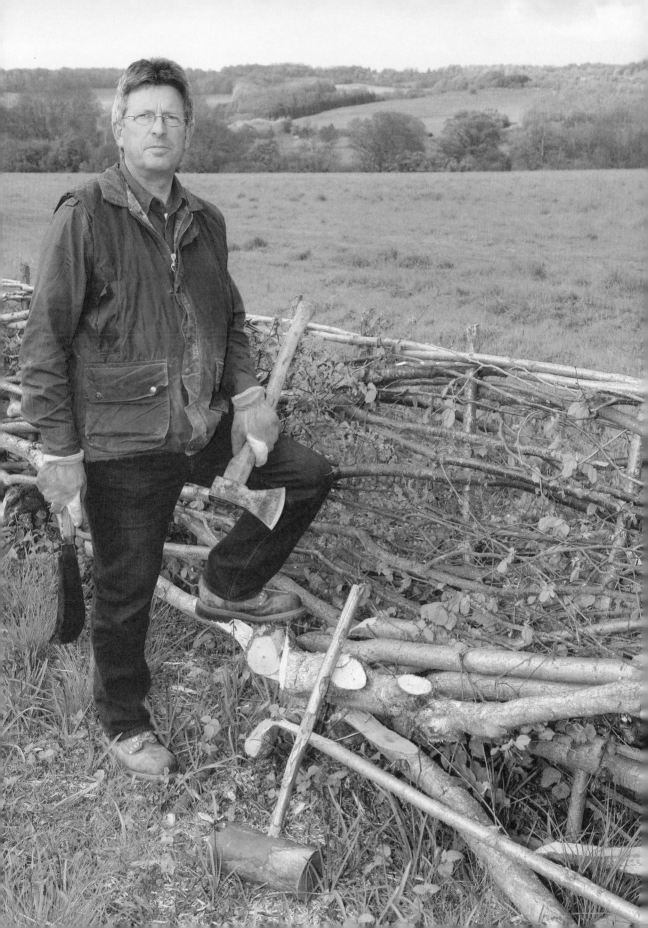

and, simply, neglect. The Government's Hedgerow Regulations (1997) and environmental stewardship schemes on farms are helping to save and promote managed hedgerows, which is all good news for people like Phil. It is a striking fact that, according to the Campaign to Protect Rural England, hedges contain 15 per cent of our native stock of broad-leaved trees, 600 species of flowering plants, 65 species of bird, 20 species of mammal and 1,500 species of insect.

'One estate where I have been laying hedges has set aside land where fields aren't cropped or sprayed. It all helps encourage wildlife,' Phil says. 'In fact I see a lot of wildlife when I'm working: red kites, buzzards, deer and all sorts. It's a nice part of the country, with hills and valleys. I really enjoy working outside in the fresh air and I must admit it's also nice when walkers stop and admire what I'm doing.'

The basics of traditional hedgelaying are the same around the country. Tools of the trade are a billhook,

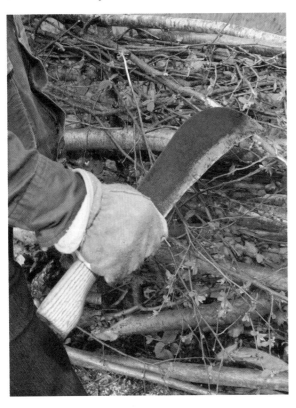

ABOVE *Billhooks vary considerably from place to place, each locality seeming to have its own preferred type.*

slasher, saw and axe – and occasionally Phil uses a chainsaw. 'They were invented to make life easier,' he says pragmatically. 'The wildlife soon get used to the noise and carry on like usual.'

{ *Let's put it this way: I didn't need a lot of rocking when I came home at night. It was tiring work!'* }

Kitted up in leather gloves, protective trousers and steel toe capped boots, he first clears out the ground beneath the hedge to be laid. Then he trims selected bush stems – sometimes called plashers or pleachers – of any unwanted branches and cuts them partly through at an angle, a few inches above the ground. Next he bends the stems diagonally, staking them in place to form a barrier.

'Most of the time I use hazel for stakes, sometimes ash, depending on what I have at the time,' Phil says. 'This year, most of the hedge I've been working on has been hazel with some thorn, so I've been cutting stakes out as I go. I use a mallet I made myself out of a piece of sycamore for hitting the stakes into the ground. I don't like using metal mallets because they split the stakes.'

The cut stems in the hedge remain alive and continue to grow while new ones also shoot up, creating a healthy lattice of diagonal and vertical growth. Hedge tops can be finished firmly and neatly by heathering, twisting or plaiting heathers (also called binders) to hold the different parts of the hedge together.

'I like a hedge to be about 10ft in height when I start on it. When it's laid, it is down to about 4ft,' Phil says. 'Sometimes people worry that birds won't like that, and because you're doing it in winter, they won't have berries. But the hedge quickly grows up again and there are plenty of other hedges nearby where birds can feed.

'One hedge I was working on was more like a copse, ten paces wide and nearly as tall as some overhead electric wires,' he adds. 'I approached laying it in the same manner, but I had to be a bit strong when the wind caught it because it was top heavy. Let's put it this way: I didn't need a lot of rocking when I came home at night. It was tiring work!'

THE BASICS

The basics of hedgelaying may be constant, but more than 30 different styles have been recorded around the country. Variations arise according to the purpose of the hedge, the livestock it is to contain (if any), terrain and local plants.

'Pembroke', for example, is a type of 'flying hedge': a low hedge on a high bank that is well suited to gale swept coasts; the hedge is angled towards the prevailing wind. 'Midland' or 'Bullock' is intended to contain cattle and is constructed sloping towards the animals to withstand heavy leaning. The 'brush' or prickly ends of stems are pushed to the livestock side, and strong binding is woven around the central row of stakes along the hedge top so that bullocks can't twist it off with their horns.

'I can do Midland and, when I used to do competitions, I did South of England style, which is basically stakes down the middle and then pulling the hedge in from either side,' Phil says. 'But for work I do the Phil Godwin style, which is a mixture of the two.'

He always adapts according to the situation. 'If a hedge hasn't actually been planted for laying, it can grow in a pretty random way and it wouldn't work to clinically follow a certain style. You have to make your line up with whatever is there. Or if the ground slopes up hill, you start at the top of the hill and work your way down, so that the hedge is always laid with stems growing up hill, in the direction of the sap rising.'

Phil works for as long as winter daylight allows. 'Ideally you've got to lay 20 yards a day to make any decent money. But it varies. Some days you can lay a chain, or 22 yards, quite comfortably, other times you are struggling to do 5 or 10 yards. Wind and rain affect progress, too. People often think hedgelaying looks good, but after a few weeks of coming home freezing cold at night they change their minds!

'If you're going to lay and leave a hedge, you only need go back again in about ten to 20 years,' he continues. 'If you lay and trim, you can return the next year, but just to take the long ends off. I definitely like to go back in spring to see hedges I've laid come out in leaf. What I do is hard work, but you have something to show for it and I take pride in that.'

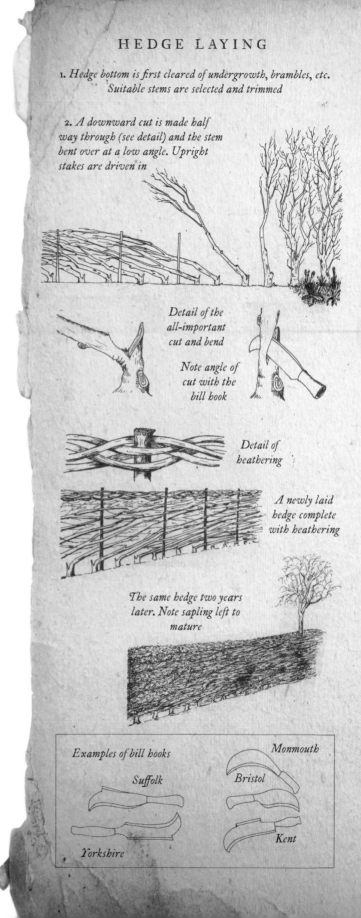

HEDGE LAYING

1. *Hedge bottom is first cleared of undergrowth, brambles, etc. Suitable stems are selected and trimmed*

2. *A downward cut is made half way through (see detail) and the stem bent over at a low angle. Upright stakes are driven in*

Detail of the all-important cut and bend

Note angle of cut with the bill hook

Detail of heathering

A newly laid hedge complete with heathering

The same hedge two years later. Note sapling left to mature

Examples of bill hooks

Monmouth

Suffolk

Bristol

Yorkshire

Kent

The Clog Maker

JEREMY ATKINSON

'Clogs used to cost a day-and-a-half's wages. Mine still do. However, you can now buy a pair of shoes for an hour-and-a-half's wages and therein lies the problem. The craft is out of time, it's a leftover.' So says Jeremy Atkinson, who specialises in hand making traditional 19th century styles of clogs at his workshop in Kington, Herefordshire.

Yet the master clog maker is upbeat and says there are always customers willing to pay for comfortable, durable, made to measure footwear with individual character. The National Theatre, pantomime productions and local drama societies have also beaten a path to his door.

'There are only two traditional clog makers left in the country, people who are really doing everything by hand rather than using machines or simply assembling the different parts,' Jeremy continues. Just over a century ago, in 1901, 6,276 clog makers were recorded in England and Wales. That's a huge difference, but the skill might not die out.

'I started to learn the craft in 1977–1978. I had trained as a teacher but there were few jobs and I was disenchanted with the way society was going. A lot of people felt that way, it was the time of Schumacher's *Small is Beautiful*. It's come round again now. Anyway, I learnt clog making from Hywel Davies in Tregaron. I've taught Geraint Parfitt, who works at St Fagans [National History Museum near Cardiff], which is committed to sustaining such crafts.'

Jeremy, with the aid of a Churchill scholarship, travelled in France and Spain to learn European traditions. One of the origins of wooden soled footwear in Europe is believed to have been the Roman bath shoe which protected the wearer's feet from hot tiled floors. From this came the patten (a wooden overshoe) and, in turn, the clog made of wood and leather.

Clogs were utilitarian rather than fashionable footwear, although more decorated 'Sunday best' styles did develop. Well into the 20th century, factory and farming folk wore clogs for working and it's easy to appreciate why: wooden soles raised the wearer above mucky wet roads or factory floors and, due to the poor conductivity of wood, they prevented heat from escaping or intruding.

Clog blockers, working in gangs, would cut wood and roughly shape it into blocks sized as men's, women's or children's. These blocks were then hand carved by the clog maker, who also added the leather upper.

Different woods were used in different areas, reflecting both availability and needs.

The Welsh carved alder, birch and sycamore. The English, Jeremy says, tended to use Welsh and West Country alder, Lincolnshire willow and Scottish birch. 'A clog maker's son in Cumbria told me that

> There are only two clog makers left in the country, people who are really doing everything by hand rather than using machines

RIGHT *Jeremy Atkinson specialises in making traditional 19th century style clogs, completely carving by hand following a centuries-old craft*

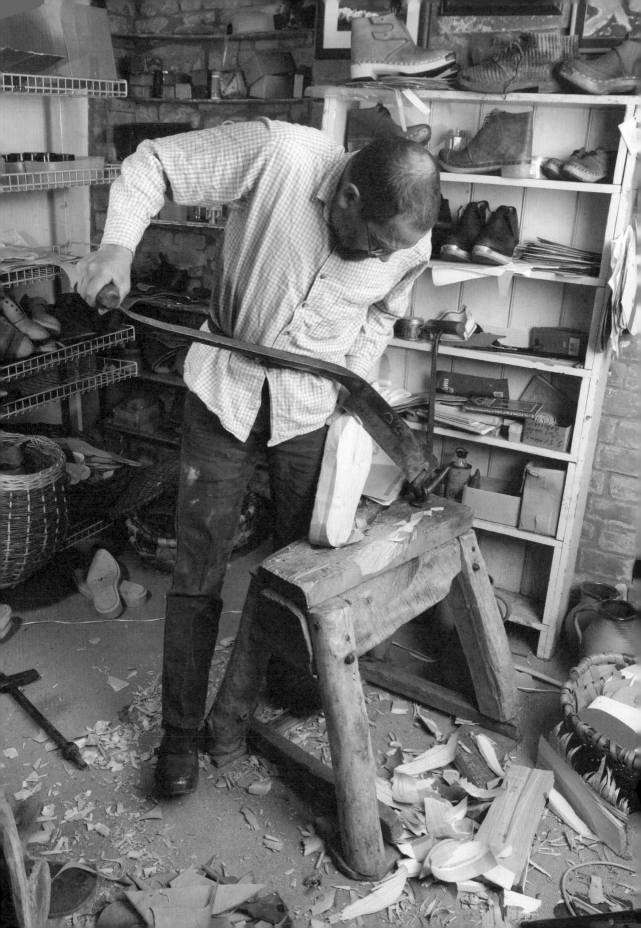

they used Scottish birch for clogs worn in mines because it resisted the acid conditions better than alder did.

Willow, birch and alder are relatively soft and easily carved dry. Sycamore should be carved green; it's a very stable wood and too hard if worked dry, although with today's central heating it is best to allow it to lose much of its moisture before lasting and nailing on the leather upper. With multi-cutter machines being introduced in the 1970s, sycamore ceased to be used since it blunted their blades due to its silica content, thus leaving beech, although some small individual machinists have gone back to sycamore now.'

Different styles developed to suit the wearer's occupation. A blucher boot was low cut so that a miner caught in a rock fall could slip out of his trapped clogs. Flap and buckle type

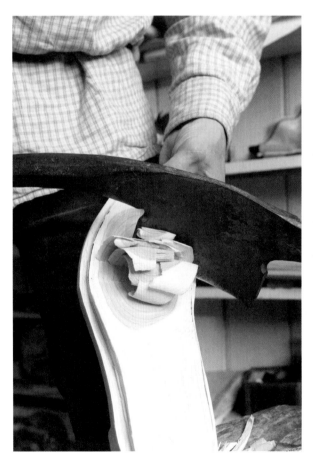

ABOVE *The shaping of a billet of wood to suit the form of the human foot is a skilled business, taking many cutting strokes with different sweep blade knives.*

clogs lined with felt were ideal for keeping out water and cold on the fish wharves.

Sole styles varied, too. 'London' or 'square toe' were favoured in industries where a lot of kneeling was required, such as mining. 'Ducks' with extended toes allowed more cast, or curve, to be built into the sole – better for a hilly landscape and popular in many northern areas. But it wasn't all work and no play: soles of dance clogs were traditionally made of ash, because they gave better clarity of sound, and some clogs had truly elegant shapes.

{ *Although the foot outlines of different people can look the same, some people have hard feet, while others' are soft and malleable* }

In the end, the arrival of the industrialised 19th-century hobnail boot and increasing machine manufacturing of clog soles in the 20th brought decline in the handcraft. Those who continued tended to be itinerant, moving from place to place making 'specials' as required. 'If you had a peripatetic craftsman, he wasn't training anybody,' Jeremy says. 'The craft withered away from there in terms of made-to-measure.'

MADE TO MEASURE

Jeremy makes most of his clog soles using sycamore, which he selects and cuts himself. 'I want the sycamore vertical, as if it leans a lot, the side of the trunk under tension doesn't cut well; and it needs to be black knot free and between 7 and 10in in diameter. I rather like green knots though; I think it makes the soles more shock resistant. The pictured soles are cherry which is a good carving light wood though more inclined to split whilst drying.'

He not only takes conventional shoe measurements, but also feels a customer's feet. 'Although the foot outlines of different people can look the same, some people have hard feet, while others' are soft and malleable. The clog needs to work for each individual.'

'The biggest skill is being able to control the knives,' he continues. 'I use three main swivel blade knives. You've got to learn the moves and the moves are a bit like Aikido. It takes a lot of practice and also strength. The knives must be razor sharp and you work towards the

He can cut soles to suit particular dancing styles and leather can be dyed different colours

entre of the grain, otherwise you split it.

First you've got the blocker or stock knife. It as a very cranked handle, which isn't in line with he blade, so when you are working on a big pair f clogs you don't get the handle in your face. It's wkward but you get power. You use the stock nife to cut the base and sides of the sole and oughly shape the inside.

Then you've got the hollower, to hollow out the ole. Finally, you've got the gripper bit, to cut the roove, or rebate, for the upper to sit in. It's the nost difficult knife to use because you have to ynchronise the movement of both the knife and he sole: luckily it's also the least dangerous.'

The soles are tidied and smoothed inside sing a small curved knife called by its Welsh ame, twca cam, and a paring knife cleans up the ebate.

For the uppers Jeremy generally uses 1⁄12in– 6in thick, waterproof crust-dyed chrome leather, ut to a pattern and sewn together. He gently ulls each upper, (sometimes softened in hot vater) over a wooden last to mould it. He nails he upper to the rebate of the sole, covers the join by a strip of leather called a welt, then toe tins, clasps, or buttons can be added according to the style and options. After a couple of days he can remove the last and the shape is retained.

As an alternative to crust dyed chrome, he has traditional waxed kip water buffalo leather. If he used hot water to soften this, 'it would turn to cardboard'. Instead he heats a gloriously named half round bottom glazer and rubs it over the leather to melt the wax before lasting.

'I don't think much of plain veg tan for uppers, either shoes or clogs,' he says. 'It's stiffer than chrome and isn't particularly durable or waterproof. I haven't bothered to use it for 20 years. It looks nice when new but that's about its only advantage.'

Each pair of clogs that Jeremy makes is bespoke. He can cut soles to suit particular dancing styles and leather can be dyed different colours. Designs can be burnt into the crust- dyed chrome leather with a pyrograph, while traditional crimping – cutting patterns with a tool called a race – is used on the waxed kip. His range includes Clasp, Flap and Buckle, Welsh Slippers and Bluchers. But for his part, he favours a Laker boot with a broad duck toe and buttoned flaps. 'They're really comfortable and I'm lazy about doing up laces. A customer asked me to make this design – it's a modified Derby – and I called them after him. They've proved popular.'

The Rake Maker

JOHN RUDD AND GRAEME RUDD

Back in the days when farm implements were all made locally and from local materials, enormous ingenuity was often required to make a serviceable tool from limited resources. But in turn this often produced a situation where, over centuries, tools developed that were so well suited to the task in hand that they have never been superseded even by tools made with the latest hitech materials.

A case in point is the garden rake. It might seem that a metal rake would work better and last longer, but in fact wooden rakes – probably made in exactly the same way for centuries – are actually more comfortable and efficient to use than modern metal ones. Traditional wooden hay rakes are now very rare indeed, but there is one family who is still making them to a design that would be recognisable to an 18th-century farmworker: in the tiny hamlet of Dufton, near Appleby, in Cumbria, the Rudd family have been making wooden hay rakes for over a century. Working in the late 17th-century workshop that was used by his father and grandfather, John Rudd, now in his late sixties, and his son Graeme currently make some 14,000 rakes a year, still using the tools and techniques that were used when the business was started by John's grandfather in 1892.

Hay rakes are made from three timbers: ash, ramin (a hardwood imported from the Far East) and silver birch. The ash and ramin are used to make the head and shaft of the rake, respectively; the 16

teeth are always made from silver birch. Traditionally pitch pine was used for the handles, then earlier this century Colombian pine started to be used; but good supplies of straight-grained wood began to dry up and John moved to ramin. Rake handles are a standard 6ft long, and the whole thing is hand-made except for a machine that pushes the teeth into position: this is purpose-made and therefore unique.

John says he has been making rakes since he could walk: 'I'd have been about ten, anyway!' he says with a smile. 'It was what the family did, and I learnt it the way most kids learn to play football; but even then I knew we were doing something special. I doubt if anyone else in the country still

RIGHT John Rudd and his son Graeme currently make some 14,000 rakes a year, still using the tools and techniques that were used when the business was started by John's grandfather in 1892.

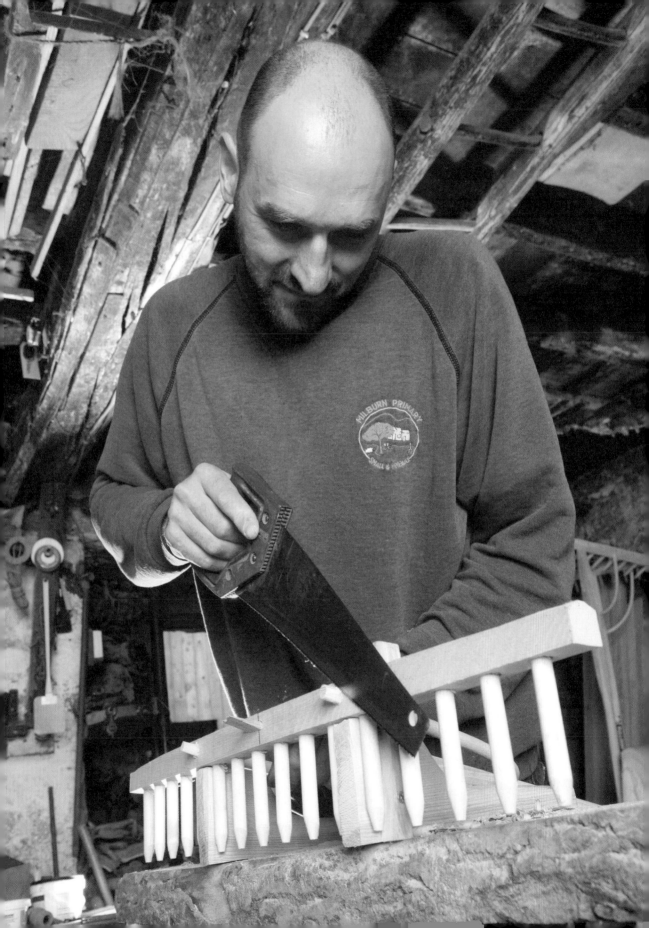

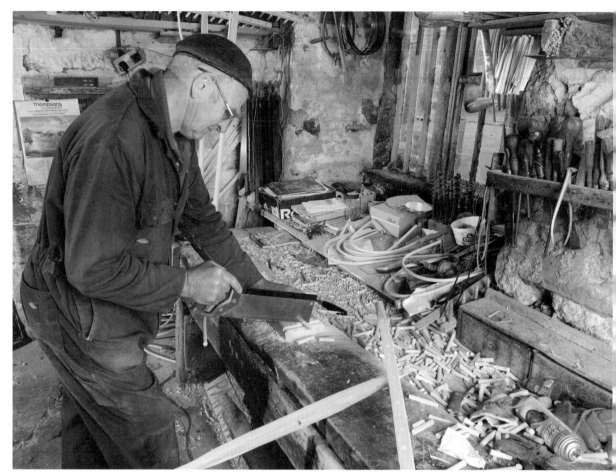

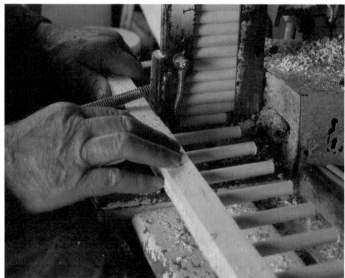

ABOVE *The tines are made from silver birch, which is used for its strength.*

ABOVE (top) *Each rake goes through at least 20 hand operations before it is completed.*

{ It was what the family did, and I learnt it the way most kids learn to play football; but even then I knew we were doing something special }

makes them the way we do.'

So how are these splendid rakes made? Surrounded by wood shavings, John was happy to explain: 'First you shape the 6ft long shaft; this needs to be straight and smooth, obviously. Next a small wooden ash hoop, about ½in in diameter, softened by boiling for ten minutes and then shaped into a semi-circle, is used to hold the head

on to the shaft – as it dries out and hardens, the hoop grips like a vice, but it is also nailed. A traditional rake involves the use of just four nails – three in the hoop, and one into the shaft.

'Birch has always been used to make the teeth because it is plentiful locally and hard wearing, and the latter is, of course, essential since the teeth do all the work.

'My grandfather told me that birch used to be made into clog soles, so it must have been pretty solid stuff. With care, a rake will last 20 years. I don't know how long it takes to make one because we make lots of hoops and heads and shafts, and then fix them together. But we might make a few hundred in a week.

'Originally most of these rakes would have been used for hay, but these days people use them on farms, in their gardens, and even as shop window ornaments; and a lot of people buy them because they like the look of them because they are hand made. But they are also popular for raking over bunkers on golf courses. I see our rakes used on the greens in top golf tournaments and sometimes in period television dramas, which always gives me a good feeling'.

> *I see our rakes used on the greens in top golf tournaments and sometimes in period television dramas*

John sells most of his rakes to a wholesaler in Sheffield, and from there they go all over the world. 'It's wonderful to make something by hand that's so popular,' he says. 'Of course, it's also useful and it's part of a long tradition.'

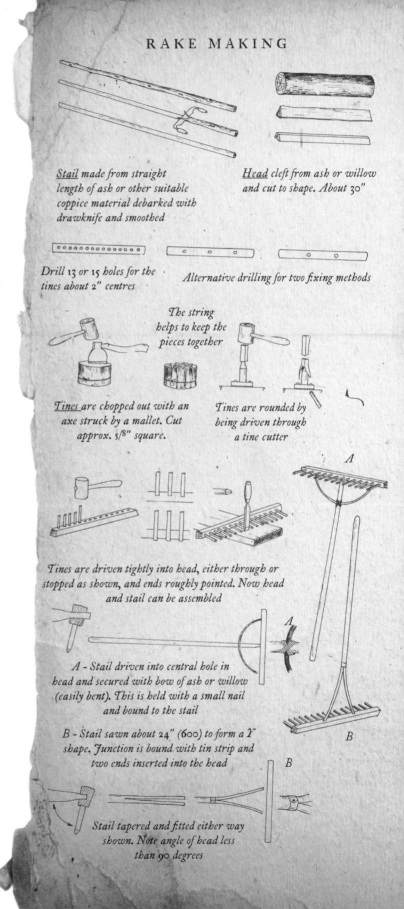

RAKE MAKING

Stail made from straight length of ash or other suitable coppice material debarked with drawknife and smoothed

Head cleft from ash or willow and cut to shape. About 30"

Drill 13 or 15 holes for the tines about 2" centres

Alternative drilling for two fixing methods

The string helps to keep the pieces together

Tines are chopped out with an axe struck by a mallet. Cut approx. 5/8" square.

Tines are rounded by being driven through a tine cutter

A

Tines are driven tightly into head, either through or stopped as shown, and ends roughly pointed. Now head and stail can be assembled

A

A - Stail driven into central hole in head and secured with bow of ash or willow (easily bent). This is held with a small nail and bound to the stail

B - Stail sawn about 24" (600) to form a Y shape. Junction is bound with tin strip and two ends inserted into the head

B

B

Stail tapered and fitted either way shown. Note angle of head less than 90 degrees

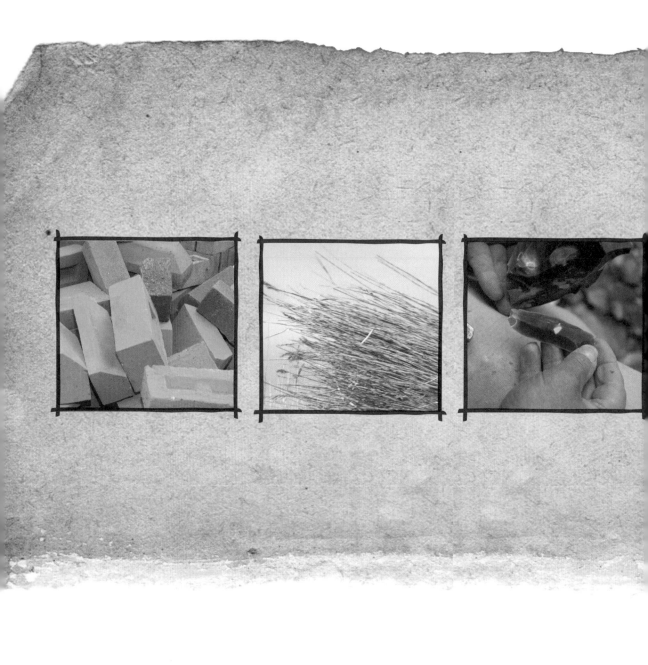

BUILDING CRAFTS

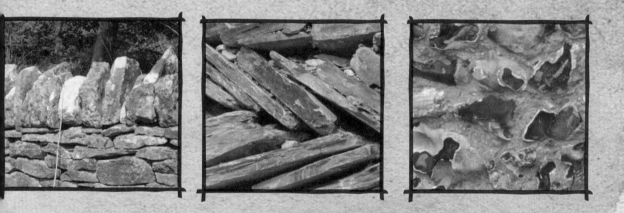

The Brick Maker

COLEFORD BRICK & TILE

'We generally say: if you can draw it, we'll make it,' says Tim Walton, works manager at family owned Coleford Brick & Tile. 'We are very versatile and can hand make whatever type of brick someone wants.'

The company, down a country lane in the Forest of Dean, Gloucestershire, was established in 1925 and originally supplied the majority of its output to the prolific local coal mining industry.

'Wherever there was coal there was clay in between the coal measures. So most coalmines had brickworks attached,' Tim says.

In modern times mining in the area has ceased except on a tiny intermittent scale by independent 'freeminers'. And so now Coleford Brick & Tile supplies individuals and organisations like Cadw, English Heritage, The National Trust and British Waterways. Commissions come from both new-build projects and restorations of historic properties where the ability to match what is there is crucial. In addition to standard and bespoke shaped special bricks, the company hand makes pavers, floor tiles and cobbles. Colours range from yellow to deep purple, and textures vary from smooth to rustic 'aged' surfaces.

'We get a lot of orders for public buildings,

{ *Hand throwing bricks is quite hard physical work and in a good week we make about 35,000. In a year we make 1–1.5 million* }

universities, and refurbishments where people need funny sized bricks and unusual colours,' Tim says. 'There are perhaps eight or ten companies in the country making bricks by hand, but a lot supplement what they do with machines. We specialise in everything being handmade.'

Recent work has included supplying over 200,000 hand thrown bricks and specials for the transformation of Stratford-upon-Avon's Royal Shakespeare Theatre. From initial enquiry, through visits with sample panels of brick, to order took two-and-a-half years. The result was the creation of a new, bespoke Stratford Blend of individual bricks ranging from rust red to mauve hues.

The Romans brought the craft of brick making to Britain and their handiwork can still be spotted incorporated into later Saxon and Norman churches, providing testament to its durability. However, when the legions withdrew from our shores early in the 5th century, the art of building in brick was almost lost, as timber, cob, stone and flint became preferred materials of construction. Then the 15th century ushered in a revival, and the Tudor period gave us magnificent red brick edifices like Hampton Court Palace Brick was now the must-have for the status-conscious wealthy classes.

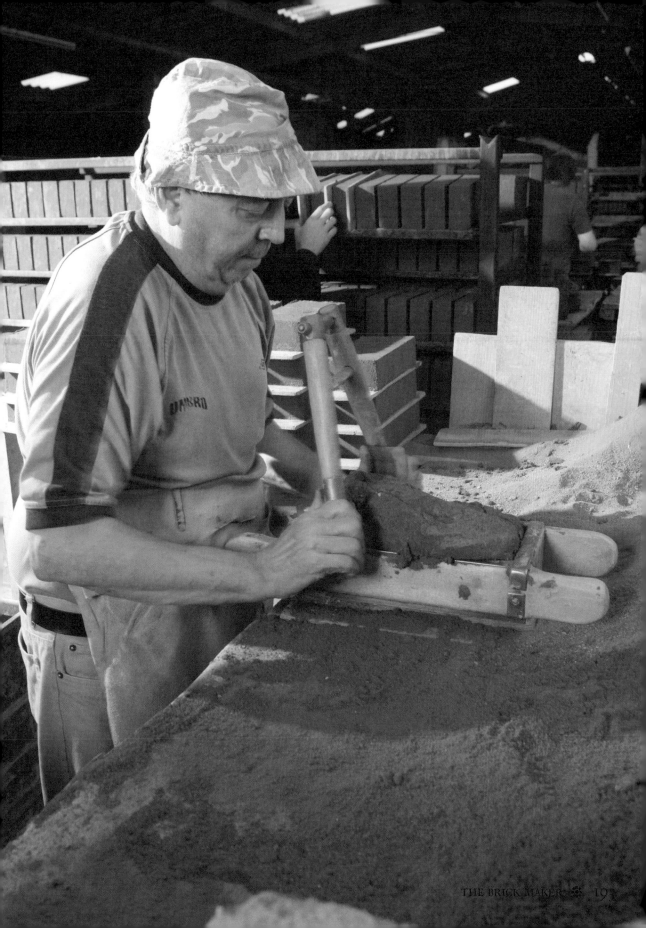

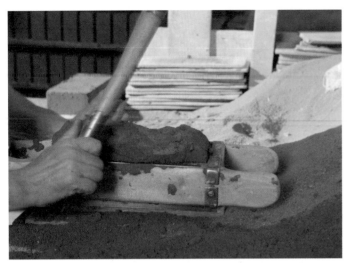

ABOVE (top) *The traditional throwing process still produces the most attractive result, with each brick individual to the next.*
ABOVE *Each wooden mould will make up to 10,000 bricks before it needs replacing.*

SPECIALIST BRICK MAKERS

Today most bricks may be machine made, but Coleford Brick & Tile is proud to keep alive the skills and individuality that hand throwing provides. 'Around 20 people normally work here, all local people,' Tim says. 'Hand throwing bricks is quite hard physical work and in a good week we make about 35,000. In a year we make 1–1.5 million. Of course a modern machine brickworks probably does 2 million in a week. But we are specialist.'

He explains on a walk around the site how a brick is made. Outside, a small mountain of local clay sits waiting. 'The clay seam is dug every five to six years and we stockpile it. The raw material is fed into a hopper, up a belt into a pug mill, which does most of the action on the clay. We add water and barium into it there: barium stops efflorescence – it stops the salts coming out. The pug mill is a bit like an old-fashioned corn mill and it squeezes the clay out through grids.

'Then it goes through two high speed rollers turning in contra fashion and knocking the material down so that it isn't lumpy,' he continues, pointing high overhead. Eventually the clay is fed down through a vast pipe to emerge like a sausage, quickly broken off by a waiting worker into 'clods' ready for use.

'The clods are about 25 per cent moisture. Each brick has about a pint and a quarter of water in it,' Tim says. 'You need the right consistency of clay, neither too sloppy nor too firm.'

The clods are taken over to a brick maker like Jimmy, busy at his bench. Jimmy, now in his 60s, has worked for the company for more than 40 years; he makes three bricks a minute with a steady rhythm that would leave a novice gasping. First he rolls the clod in sand to prevent sticking and throws it into a wooden mould with enough force to expel any pockets of air. Then he cuts off excess clay from the top using a wire. He sprinkles the freshly exposed surface of clay with more sand, places a wooden board on top

nd swiftly turns the mould upside down, eaving the brick shape sitting neatly on he wooden board.

Each wooden mould will make up to 0,000 bricks before it needs replacing. The ase may be raised in the middle to make he indentation in the brick known as the og, which will be filled with mortar when he brick is laid. Designs or motifs can also e raised in relief on the base of moulds.

After Jimmy has done his work, the ricks are stacked in a dryer for three ays before being loaded into a gas fired huttle kiln. 'We put about 12,500 bricks at a time, with standard bricks in the wer part and specials or non-standards h top, which is the easiest way to stack,' im says. 'We fire at 1,060–1,100° in an 0-hour cycle. It takes around 24 hours for e bricks to cool as we gradually open the oors of the kiln.

'The different colours are achieved by e natural sand firing to a colour, or we ld in stains to the sand, or we change the atmosphere of the kiln. A red brick in an oxidising kiln becomes a brown brick in a reduction kiln: oxidation and reduction are two different types of firing.

'Overall there is about 18 per cent shrinkage in making a brick. So, for a standard 215mm length brick you need a 255mm length mould. Half the shrinkage is from the dryer taking water out and half happens in the kiln.'

Back outside in the yard, against a canopy of woodland, pallets stand loaded with finished bricks of diverse shapes and sizes, offering an image of 3D multi-coloured giant jigsaw puzzles waiting to be assembled. Coleford Yellow, Cotswold Buff and Gloucester Grey catch the eye at the lighter end of the spectrum, and hues deepen through Mixed Tudor Red and Elizabethan Multi, to Mixed Purple and Mixed Antique. And should even such a wide range not include something you want, Coleford Brick & Tile will blend something especially for you.

ABOVE *After the bricks are formed they are individually stacked by hand in preparation for their period in the dryer.*

Brick mould

The Dry Stone Wallers

DES HALL AND ROGER CLEMENS

Dry stone walls are constructions of uncompromising beauty, typically found in upland areas where planting thick hedges would be too difficult. They run like character lines over the much loved faces of the Cotswolds, the Lake District and the Pennines; and fret across hardy areas of Scotland, Wales and England's South West. When wind and rain sweep in, they provide invaluable shelter to animals and farmers, and in all seasons their surfaces and crannies are havens for flora and fauna.

Built as boundaries or stock barriers, such walls have always been made with whatever local rock was to hand. Purpose (to keep in cattle or sheep, for example), the lie of the land and individual builders also influenced styles of construction. Usually it was farm labourers or estate workers who set to, although the boom time of enclosure in the 18th and 19th centuries saw a rise in professional wallers. Their techniques are continued to this day.

Made without mortar, walls rely upon the careful placing of stones plus their own weight to keep them standing: a good one will last more than 100 years; some are known to be over 1,000 years old. Most often the construction is a double wall (single 'dyking' in Scotland is a notable exception) raised on a footing of a single course of large stones laid flat in a shallow trench. The space between the two faces of wall is packed with small stones, known as the 'fill' or 'hearting'.

Wallers peg guide strings, then build up successive courses of shaped stones – largest first – making sure that the joints between stones in one course are covered by stones in the next, just as in bricklaying. Stones are generally (but not always) laid with their length running into the wall rather than along it, helping to lock them into place. 'Throughs' (long stones stretching across both faces of the wall) are placed at intervals in certain courses, to 'tie' the sides together.

Key to the waller's art is the 'batter', a gradual taper inwards of the two sides of wall. Experienced builders may judge this by eye; most use a tapered batter-frame or profile with guide lines. The batter adds strength to the construction and also sheds water.

Finally, the wall's last course is levelled off and copestones are added: usually tall, flat, thin stones that stand upright. Decorative they may be; their weight and function as throughs add stability.

Features like stiles and 'smoots' (little holes to allow wild animals through) may be incorporated and there are many regional variations on the general principles of dry stone walling. Speak to any professional waller and he has his own personal tale.

{ *A good wall will last more than 100 years; some are known to be over 1,000 years old* }

RIGHT *Des Hall, who works with his son Michael, has been making and repairing dry stone walls for farmers and private individuals in the Cotswolds for 45 years.*

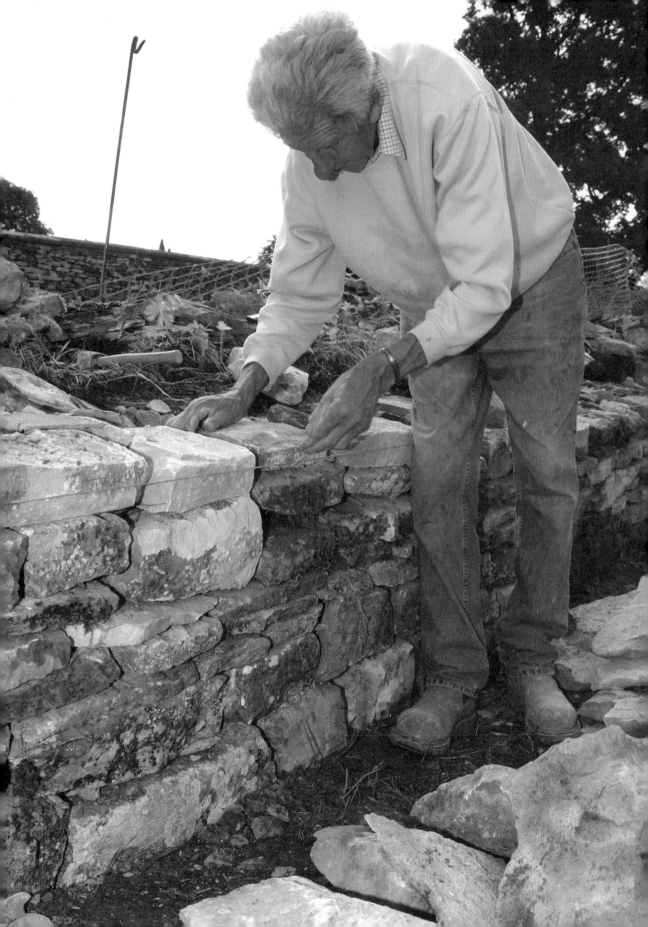

COTSWOLD WALLS

Des Hall, who works with his son Michael, has
been making and repairing dry stone walls
for farmers and private individuals in the
Cotswolds for 45 years: the 790sq mile Area
of Outstanding Natural Beauty is famously
criss-crossed by 4,000 miles of walls.

'The stone here is oolitic limestone. You can
get white, and there's grey and brown, both
of which are very hard,' Des says. 'We always
use the hard stuff, from quarries. Years ago
farmers would just plough it up – that's why
some people call them rubble walls.

'In the fields walls are often laid randomly,
not in neat courses. But if you're working
on a private estate they usually want walls
done in courses, with stones all picked out
according to their sizes – we don't sort them,
we do it by eye – and everything dead level.

'I dig a footing of about 6in deep and
put big stones in the bottom. A normal
Cotswold stone wall is about 3ft high and
about 20ins to 2ft across the bottom. With
the batter, you normally finish at about 16
to 18in across the top.

'If it's new stone it's all got to be worked

{ *One waller who worked
with me would hide a
penny every time he had
done about 10 yards* }

by cutting it into reasonable sizes and tapping the ends off to get it as square as you can, before you lay it. I've got an old-fashioned walling hammer, made by my cousin years ago – he was a blacksmith; and I also use smaller hammers. I chuck the "rubbish" into the middle [of the wall's two faces].

'In the Cotswolds sometimes people lay stones lengthways along the wall, but you always lay them with a bit of a slope on them and they are all pinned individually to let the water run off them. One waller who worked with me would hide a penny every time he had done about 10 yards.

'We finish off with the copings, or "cock-and-hen": using the biggest stones we can find, up to a foot high and 6in thick. It's mostly the weight of the copings that holds the wall together. A lot of people want mortared tops these days, to prevent the stones from being pinched. I don't personally like it because I think the sand and cement tends to draw the stone and it shatters quicker.

'It takes a ton of stone to do a square yard of wall and you can average 2.5–3.5 yards a day. I work all year round and it's very, very cold on those Cotswolds in the middle of winter. But I've never worn gloves: I like to feel the stone, feel what I'm working with. It's a good old job and I've enjoyed every minute of it. I'm 70 this year and I shan't ever retire.'

CORNISH HEDGES

By contrast Roger Clemens, from St Ervan in Cornwall, builds Cornish hedges.

'The hedges are actually two stone walls kept apart by a filling of soil,' Roger explains. 'We call them hedges because they are alive with flowers and wildlife, and birds like wrens nest there. We've about 30,000 miles of Cornish hedges in Cornwall and over the last 35 years I've built 160 miles of them.

'When I left school I worked on a farm and went to agricultural college, but I most enjoyed making stone hedges. I've done a

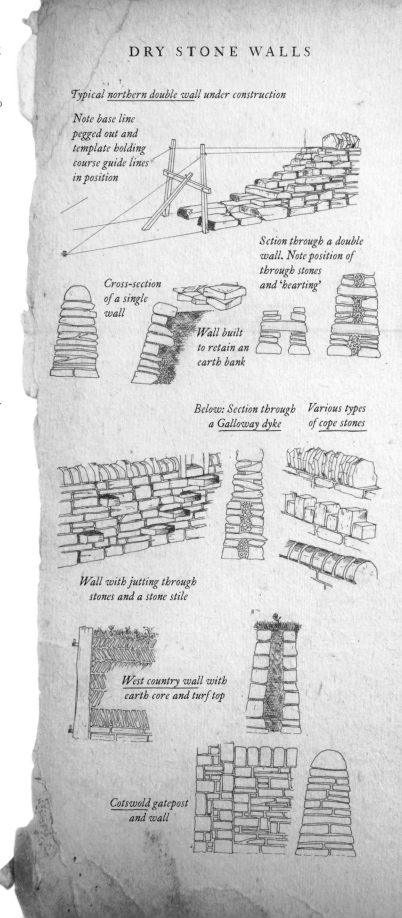

DRY STONE WALLS

Typical northern double wall under construction

Note base line pegged out and template holding course guide lines in position

Cross-section of a single wall

Wall built to retain an earth bank

Sction through a double wall. Note position of through stones and 'hearting'

Below: Section through a *Galloway dyke*

Various types of cope stones

Wall with jutting through stones and a stone stile

West country wall with earth core and turf top

Cotswold gatepost and wall

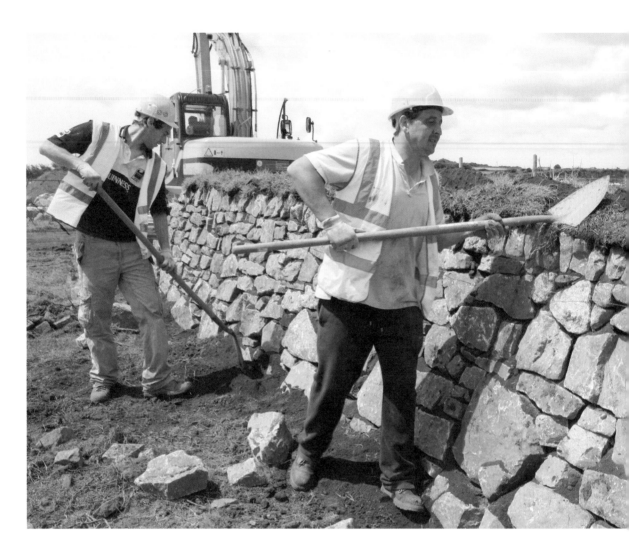

lot of work for Cornwall County Council, including 5 miles [8km] of hedge along the A30. My son Martin runs the business now with a team of nine, though I still help out.

'The oldest hedges of west Cornwall are more than 4,500 years old. Some were wide enough for a horse and cart to go on top; others were only 2 feet wide. They were originally stock barriers; some we now build along roads are sound barriers.

'The stone that's used varies. In north Cornwall you get hard slate, which, if you cut it, is grey on the inside and can be brown on the outside; in mid Cornwall it's soft brown slate. On Bodmin Moor and west Cornwall around Land's End it's all granite. The Lizard has serpentine.

'You generally lay the bigger stones on the bottom and it's important to build the correct shape. The face should be concave. Most hedges bulge from near the bottom where the rain goes into the soil: if the face is curved inwards, the pressure downwards holds the hedge in and gives it strength.

'We build the hedge as a unit, laying each course and compacting the soil. You don't build two stone walls and fill it in! We use a frame and lines as a guide, although I can build without them. I also use an old long handled Cornish shovel: people employed this as a template, turning it up against the hedge to check the shape matched the shovel.

ABOVE *Most Cornish hedges are topped with turves of grassy earth and are given a liberal covering of soil.* RIGHT *Roger Clemens and his son Martin build Cornish hedges and have used their skills on a variety of schemes such as road improvements, housing development, pipelines, windfarms, schools, the Eden Project, Hampton Court and the Chelsea Flower Show.*

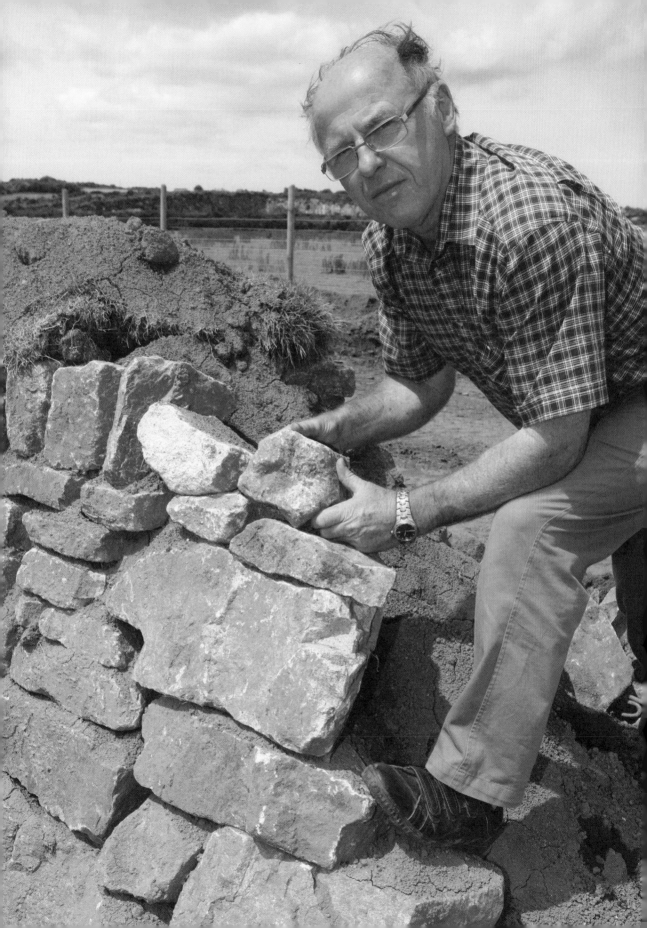

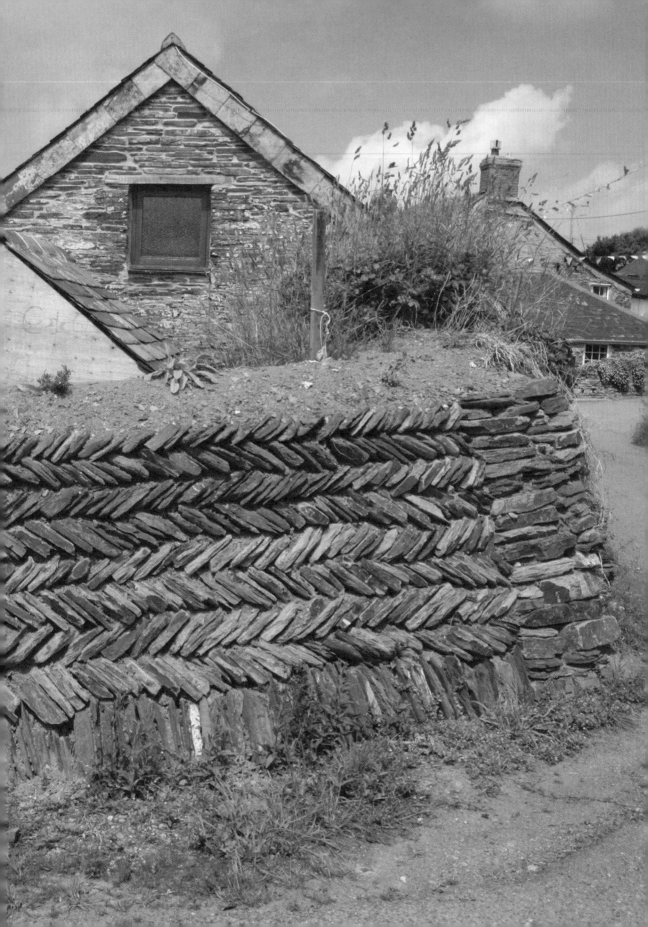

'Tops of hedges look best if your final row of stone is different from the rest. You can use granite or slate laid flat and then an upright row of "soldiers" or "pitchers". We also do a herringbone pattern, with one row of stone or slate sloping left and one row sloping right. Put a turf cap on top of that and when the vegetation grows over it binds everything together.

'If you've got a lot of smaller stone or slate, you can do a whole hedge in herringbone pattern – called the Kersey way in the Padstow to St Ervan area.

'Years ago, I built 4 yards a day, but for big jobs we've adapted the method of construction to use a machine and now four men and a machine can do 33 yards a day. If access is difficult, there's still a lot of carrying by hand, though. I recently carried 47 tonnes of stone from a dumper to a site in seven days! I'm 68 now, so I've really got to start acting my age.'

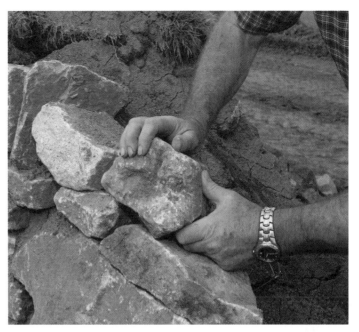

> The oldest hedges of west Cornwall are more than 4,500 years old. Some were wide enough for a horse and cart to go on top; others were only 2 feet wide.

RIGHT *Few tools are used and Roger and Martin rely on their eyes and hands, the eyes sharp enough to pick out just the right piece of stone to use next.*

LEFT *On a firm foundation of larger stones, slate or similar material is laid side by side, on edge, to form a herringbone pattern.*

The Flint Knapper

PHIL HARDING

According to Phil Harding, flint knapping is the world's oldest craft. Originally trained as an archaeologist – one of the few jobs that allows him to exercise his flint-knapping skills – Phil happily admits that he is obsessed by flint and all its uses: 'Knapping is the process of working flint,' he explains with enormous enthusiasm. 'You don't cut flint you knock or push flakes off it, but it's such a wonderfully useful material. It's pure silica, brittle and yet strong. For centuries it's been used as a building material anywhere and everywhere it is found.'

Norfolk is the great centre for flints, and in prehistoric times flints were mined at Brandon (actually just over the county border in Suffolk); here visitors can still visit Stone Age flint mines at Grimes Graves. In the 17th, 18th and 19th centuries the same area supported an important industry of gun flint makers, the sort of flints used in old muskets and pistols to provide a spark for the powder: 'You could say,' says Phil with a grin, 'that the defeat of Napoleon at Waterloo was entirely the result of the flint knapping that took place at Brandon. Without the flint knappers the main weapon of warfare of the time would not have existed.' Today flints are still worked for guns used by historical societies such as the Sealed Knot, an organisation that re-enacts old battles

'Dozens of men worked at Brandon making gun flints,' says Phil, 'and it's a highly skilled business. They made blades – that is, long strips of flint from which three or four individual gun flints could be taken. And as they made each flint they would know by just looking at it whether it would do best in a musket, a pistol or whatever.'

Phil has made many gun flints. He also makes replica flint tools as part of his job as an archaeologist: 'My work has included making Stone Age flint tools, axe heads and arrow heads for testing by various researchers and archaeologists; however, most knapped flints are today used for building work. I remember I did about a thousand for West Dean College in Sussex. Each quoin (a sort of corner piece for a building) had to be just right, and it's not easy work. I think I managed to do about a dozen a day, which is slow going when you've got a thousand to do!

'Whatever you are planning to do with flint, half the battle is choosing your flint in the first place. The best quality flint comes from East Anglia, but I've had bad flint from East Anglia and good flint from other areas where the flint was said to be consistently poor. Poor flint is flint that has

> *You could say that the defeat of Napoleon at Waterloo was entirely the result of the flint knapping that took place at Brandon*

RIGHT **Phil Harding knapping a flint cut into a brick shape. Knapping flint with right angles takes great skill.**

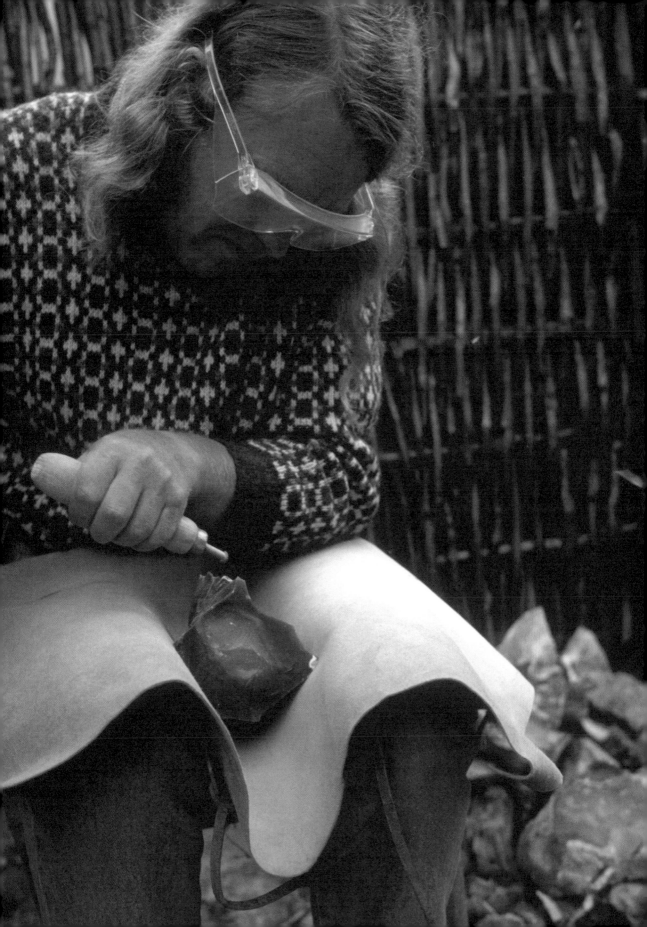

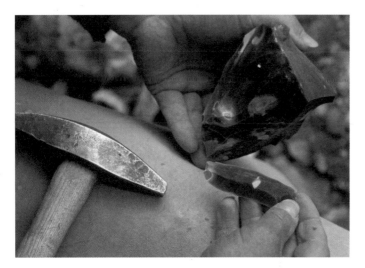

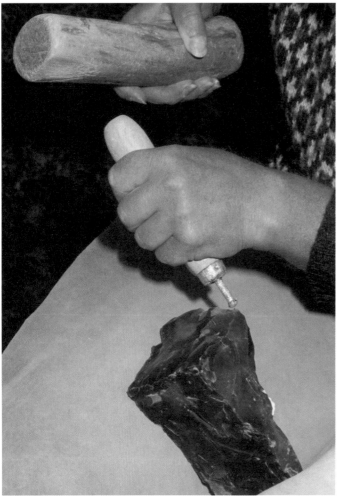

been exposed to excessive cold or excessive heat. That doesn't mean that a piece of flint will be poor just because it's been left out on one frosty December night; when we say a piece of flint is "frosted" we mean that it was probably exposed to extreme cold during the last Ice Age about 10,000 years ago – it would have been damaged if it was lying on or near the surface during the glaciation.

'Flints left in heaps in the summer sun also deteriorate because, despite the fact that they are hard, they do contain moisture, and if they dry out they become difficult to work – that means they won't knap or cut crisply. Frosting on the other hand creates fracturing and a badly frosted flint will probably shatter as you try to work it.'

GEOGRAPHICAL VARIATIONS

Wherever you find chalk you find flint, so there are rich pickings right across the South Downs through Sussex, Hampshire, Wiltshire and Dorset. Flint also occurs through the North Downs and up through the Chilterns and east to Norfolk. It peters out at Flamborough Head.

'In parts of Norfolk, flints were often used whole,' says Phil. 'The builders would simply take a wagon to the beach, load it up with fist-size spheres of flint (these would have been washed into shape over centuries by wave action) and then simply build them into the mortar walls. The flint wasn't there just to fill the wall, it was what gave the wall its strength. With bigger pieces of flint the idea is to create one flat surface – that's the surface you would see – and the irregular shape of the rest of the flint would be used to lock the flint into another flint within the wall. A flint that can be used like this is said to have a good "tail". The classic example would be a concave piece of flint being bedded into a convex piece of flint.

'When you take an old flint wall down you often see how the builder has linked much of the flint together like this. The

ABOVE (top) **Hard hammer techniques are used to remove large flakes of stone.**

ABOVE **Phil uses a 'punch' to knap a Norfolk flint. Prehistoric man would have done the same job using deer antler.**

irregular shape of the flint within the mortar is obviously a good idea, as it grips other bits of flint and the mortar. Mortar for flint work has to be soft and dry – soft because the flint will move, shrinking in cold weather and swelling in hot; and not too wet because, unlike brick, flint won't absorb much moisture and wet mortar will simply ooze out of the wall.

'Only in rare instances will a flint be made to look like a brick. I have seen this sort of thing, but it's very difficult to do because you can't easily knap a flint at 90 degrees – 70 or 80 degrees is usually your maximum. And, of course, to make a brick, you're knapping at, or very near, 90 degrees.'

VARYING TECHNIQUES

The greatest flint knappers were probably the prehistoric Danish people and the Egyptians – but I reckon I could match the work of the best British prehistoric flint workers! The technique for flint knapping varies. Ancient man used a deer antler to knock flakes off the flint, and this works because the antler is softer than the flint so it is less likely to shatter it – and it doesn't matter that it's softer because you are working at angles of less than 90 degrees and the flint is very weak at these angles. In fact we still use deer antler today, though equally we'll use what we call a "punch", a sort of blunt chisel which is hit with a mallet; but you can also use a stone, or flint on flint.

'The real skill is being able to visualise how the flint will look when it's finished, before you've started. What you have to remember is that no two pieces of flint are the same and when you approach each one you have to tackle it in a different way. You assess the angles before you start, because taking off a series of flakes of flint can easily wreck the whole piece if you don't know what you're doing.'

ABOVE *Knapping for building purposes is a skill that is still practised in the flint-bearing regions of southern England.*

The Stone Mason

ANDY OLDFIELD

'I love old buildings,' says stonemason Andy Oldfield, who works for the National Trust at one of Britain's most spectacular Elizabethan houses, Hardwick Hall in Derbyshire.

'I was taught the skills of the stonemason by Hardwick's master mason Trevor Hardy, and I'm now what's called the leading hand – I'm second in command as it were to Trevor. Working at Hardwick is a challenge and a privilege because the work we do repairing and conserving the stone will last for generations.'

After what he describes as something of a mid-life crisis, Andy retrained as a stonemason at the age of 31. Before that he'd worked in a succession of different jobs – everything from factory hand to laser engineer. But nothing captured his imagination in the way that stone carving did.

'I loved it from the first day of my apprenticeship,' he says.

Like most apprenticeships the work of the stonemason starts with the basics, as Andy explains.

'It's quite simple really. You go to the quarry and get a rough block of stone. You then have to turn that rough block into a fairly precise cube. It's a process known as "boning in". You make a flat surface on one side of the stone, using a simple chisel and

> *Once you are able to make a perfect cube you have all the basic skills necessary even for complex carving*

mallet combined with special wooden blocks that are effectively depth guides to stop you taking too much stone away and to ensure that your finished surface is level.'

Andy insists that the basis of his ancient craft is actually fairly straightforward. Once you are able to make a perfect cube – no easy task – you have all the basic skills necessary even for complex carving.

'Making that cube is the way you cut your teeth,' he says. 'There are four parts to the process. Pitching involves removing the first big areas of waste stone from the block. That's just the stone you don't want. Punching the waste off is the next stage – it's the same idea as pitching but you are taking off less stone. Next comes clawing the waste off – it's a finer technique for removing stone. Last and most delicate of all is chiselling the finish. Chiselling produces the end result.'

Once you have mastered these skills, says Andy, you can apply them to all architectural masonry work. Tools may differ in size for various jobs but the basics remain the same.

The stonemason's apprenticeship formerly lasted around seven years, but it is currently two to three years. Much of Andy's early training involved work on Hardwick Hall itself and Hardwick, as he explains, poses particular challenges:

RIGHT
Andy Oldfield mixes the ongoing work of maintaining the stonework at Hardwick Hall in Derbyshire with private commissions for decorative carving.

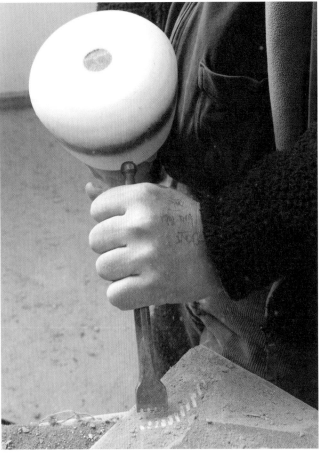

'Hardwick is a sandstone house in an exposed position on a hill. Over the centuries – the hall was built in the 1590s – it's had a lot of wear and tear. We work continually on it, and we can spot immediately where good repairs have been done and where some not so good repairs have been done. We try to conserve wherever we can, which means using what is already there, but soft sandstone in an exposed position wears away quite quickly so we often have to take out worn sections of the stonework and replace them. Making a new piece to fit perfectly is very satisfying.'

The stone to build the hall and its predecessor, the 'old hall', all came from the estate itself. Sandstone is still quarried there to this day, but only for the purpose of supplying Andy and his team with the means to keep the house in good repair.

Much of the work on the stone parts of the house centres on the strapwork around the turrets, the stone mullions and transoms of the windows (and there are a lot of windows), but the basic principle is that the house is repaired and conserved on a 30-year cycle. 'That's how long to it takes to work right round the house and get back to where you started!'

Andy is also responsible for carefully recording the state of the stonework at the hall. 'We map, log, record and restore as we go.'

He is immensely proud of the long tradition of craftsmanship of which he is part. The materials from which the stonemason's tools are made may have changed here and there over the years, but in terms of their basic design, they would be instantly recognised by a medieval stonemason.

'Stonemasonry tool skills go back a thousand years and more,' he explains. 'In addition to the skills needed to work stone, there is the knowledge of stone itself. Different stones have very different qualities. Sandstone, for example, is relatively easy to work because it is soft, whereas granite is difficult because it is very hard.

'That's why granite chisels tend to be made

ABOVE (top) *Any stone used for renovations on Hardwick Hall is quarried on site.*

ABOVE *The serrated-edged claw takes away waste stone in a more controllable way than a flat-edged chisel.*

FAR RIGHT *The initials 'ES' adorning the Hall are for Elizabeth Shrewsbury ('Bess of Hardwick'), the richest woman in Elizabethan England after the Queen herself.*

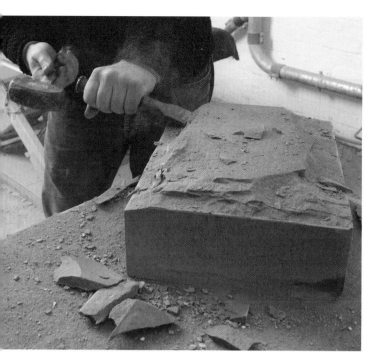

in a far more resilient way,' says Andy. 'But for all stone, however hard or soft, you start by trying to remove a lot of stone, and work down through the layers to where you want to be.

'Once the stone is down to its basic shape the finer tools come into play. Decorative carving is difficult, there's no doubt about it. We use fine tools and round nylon mallets – the heads of the mallets are round because it means they can be used from all angles. It's the same striking surface all round. Stonemason's mallets were once made from fruit wood, but nylon lasts much longer – perhaps as long as ten years.'

Away from his work at Hardwick Hall Andy accepts commissions for carvings. He's booked up for years ahead, and it's a part of the job he loves.

'I really enjoy figurative carving and I'm asked to do animals and people for all sorts of settings. I usually advise about the best kind of stone to use according to where it will be displayed – it might be a lovely tight-grained Portland stone for a commission that will be kept inside, but something completely different for an exposed, outdoor position.'

The Thatchers

MATTHEW WILLIAMS AND DAVID BRAGG

Although it survives in parts of East Anglia, the tradition of long straw thatching had all but died out in Oxfordshire and surrounding counties until Matthew Williams and David Bragg set up Rumpelstiltskin Thatching, a company devoted to restoring the ancient tradition of long straw thatching to the region.

Matt sparkles with enthusiasm when he explains the company's mission and the thinking behind it:

'Until the canals and railways made transport cheap and easy, all thatchers used local materials and only local materials. Oxfordshire houses would have been thatched with long straw – not water reed, which only came in because transport became cheaper and because people thought stuff from farther away was better than local stuff, which, as it turned out, was largely nonsense.

'We hear about water reed thatch lasting up to 80 years. That might be true in optimum conditions with the best reed there is, but we've seen water reed that's lasted maybe eight or ten years. The problem is that huge amounts of it are imported from Poland and China, where it is often grown in polluted water. That makes for poor quality

reed, which won't last. And imagine the waste of energy in transporting that inferior material half way round the world.'

Matt and Dave are eager to emphasise that long straw thatching is truly green.

'When we use wheat straw we're using something that's just a by-product of food production,' says Matt. 'We have eight acres of local wood that we coppice for our hazel spars and we're negotiating with local farmers to get them to grow the sort of wheat we need (the older varieties) so we don't have to transport it miles across country.

Straw thatch is, if you like, the ultimate green material – it's a superb insulator, it uses a by-product of an important food crop and it looks great!

'Straw thatch is, if you like, the ultimate green material – it's a superb insulator, it uses a by-product of an important food crop and it looks great!'

It is not only thatch's green credentials that the men are passionate about, they are also advocates of traditional thatching techniques and honouring local styles. They are keenly aware that Oxfordshire houses look better with long straw thatch, because that is what they were built to carry. Regional styles developed because the local climate and architecture demanded that thatchers adapt their methods and materials to suit the particular conditions. So only the correct local style properly matches the buildings.

'We want to restore the traditions that

RIGHT *Matthew Williams and David Bragg have revived the traditional methods of long straw thatching in Oxfordshire.*

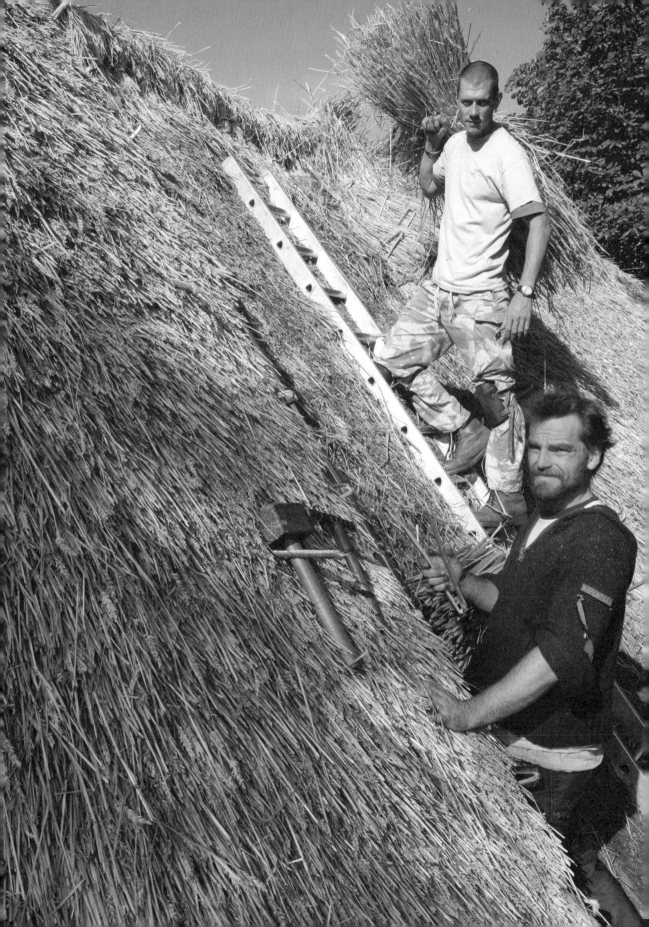

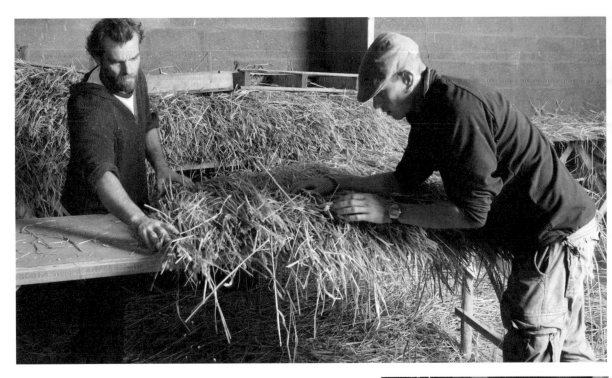

ABOVE *The process of drawing straw from the bed takes as long as fixing it to the roof.*
RIGHT *Yealms are tied into packs of three for ease of handling.*

> *Long straw had traditionally been the dominant thatching style throughout the Midlands and the south of England*

existed in this part of the world before water reed and the fashion for combed reed came in from miles away. A good, well fixed long straw thatch will last maybe 30 years, which is good by comparison with all but the best water reed. But, just as important, it looks right for this area because many of the cottages and houses we work on were designed to take long straw thatch. Even though good water reed may last as well, it demands the removal of ancient layers of thatch and therefore the loss of a part of our cultural heritage. The local long straw style lasted as long as it did – until the 1960s – simply because it worked.'

In their pursuit of authenticity Matt and Dave have learnt to look deep into the past when they start work on a roof.

'We can read an ancient roof because under the top coat of thatch on a very old house you might find straw that dates back

500 years or more,' says Dave. 'When we get down to that level we see ancient varieties of wheat straw and occasionally rye that might have been used in a year of bad harvest. Whatever was used it had to be local because transport was slow and very expensive.'

Early on in their thatching careers both men noticed that the lower layers of thatch that had survived longest had been put on in a very different way from the method they had been taught.

'Other thatchers in the area told us that doing things the old way was just too difficult,' says Matt, 'but having seen the unbroken long straw tradition that survives

in East Anglia we learnt by seeing how old thatch had been put on, and slowly abandoned the combed reed techniques we'd been taught.'

Dave and Matt both studied thatching at Knuston Hall, one of the few thatching schools in the world, where long straw thatching is still taught but few trainees take up the opportunity. Here they discovered that long straw had traditionally been the dominant thatching style throughout the Midlands and the south of England. But even within long straw thatching, different counties and areas had their own distinct and decorative styles.

'It was so fascinating and it made us determined to stick to the Oxfordshire style, which was relatively straightforward and unadorned – but it is the right style for our area.'

Much that has to do with thatching is counter intuitive, says Dave. For example, hot dry weather is actually bad for thatch.

'It lasts much longer if it's constantly wet!' he says with a smile. 'When it's wet it doesn't get brittle, which is what happens when it is too hot and dry. That's why the south-facing, sunny side of a roof always wears faster than

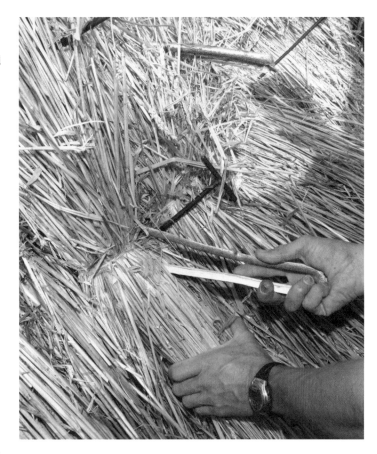

ABOVE *One of the 7,000 spars being used to attach long straw to this roof.*

BELOW *The shaggy eaves and gables are cut to a sharp finish with a traditional knife.*

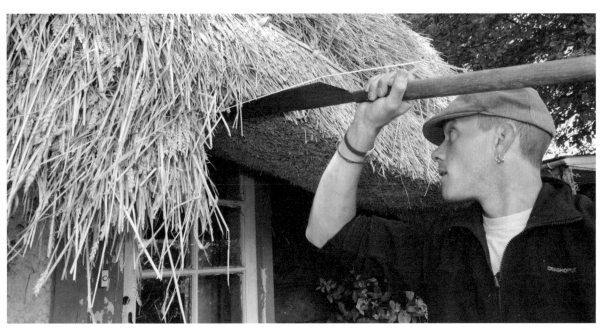

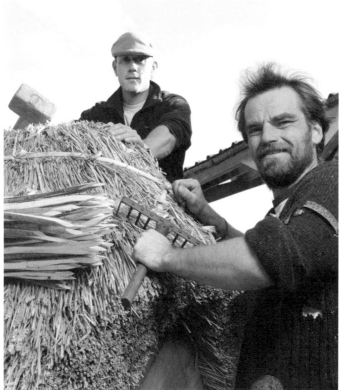

ABOVE *Sheaves of straw are stooked in the field and left to dry for two or three weeks They have been harvested by a traditional reaper-binder.*

LEFT *The roof is topped off with a traditional flush-fitting ridge and raked through to remove loose straws.*

Leggat

the north side.'

The process of thatching a roof is as traditional as the materials used. With water reed thatching, the whole roof is stripped when the roof needs to be replaced. With long straw, the historically fascinating layers are left in place, as Matt explains:

'We take the old roof down until it's perhaps 45cm or 60cm (18in or 24in) thick. We then consolidate what's left till it's the right shape for us. We firm it up and fill in the dips. We then take what we call the boltings – bundles of trussed straw; we open them and lay them out on a bed. As the straw is laid down it is wetted but not too much. The water makes the straw pliable; it makes it relax, if you like. Leaving it wet also helps the sugars in the straw to ferment, we believe, so that when it's on the roof it doesn't allow damaging fungi to grow – fungi love sugar. With the sugars gone the straw becomes acid, which the bugs don't like. Once on the roof the straw actually gets stronger as it ages – it becomes ropey and tough.

'After the straw has been placed in the bed it's pulled out and gathered into yealms or handfuls and these are carried up on to the roof. Starting at the eaves, each course of straw is pegged into the roof overlaying the previous course, working gradually up to the ridge. We do the whole of one side of the roof then the other, then the heads – the straw left sticking up above the ridge is pushed over from either side to create a waterproof finish.'

Despite more farmers moving to organic production, long straw varieties are still rare due to unhelpful legislation on the varieties that are legally permitted to be grown. Growing their own may ultimately be the solution; Matt and Dave already produce their own hazel for the spars.

BELOW *'Oversailing' straw is wrapped over the apex and secured with spars in preparation for ridging.*

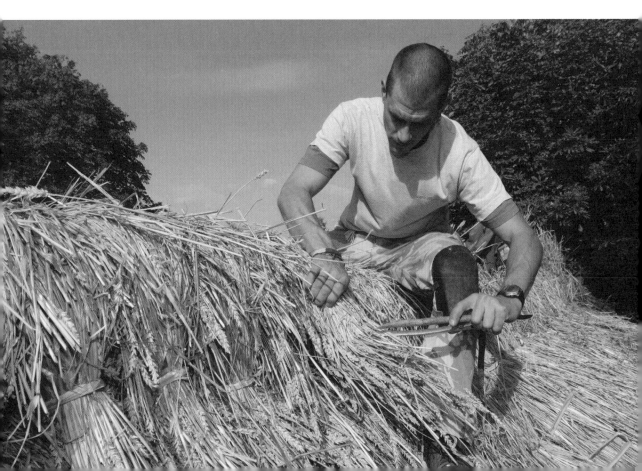

'We also have our own reaper-binder and threshing machine – they're more than half a century old but still work,' says Dave with a smile. 'We can't use straw that's been through a combine, because it destroys the straw, but the reaper-binder is perfect: it cuts the wheat and bundles it perfectly for us to leave in stooks in the field. We have to cut early so the crop is still green, because that leaves the straw still strong and pliable.'

Another problem for master thatchers like Matt and Dave is that absolutely anyone can set up a thatching business: there are no regulations that say you have to have a specific qualification. This makes it difficult for the potential customer to judge which thatcher really knows his stuff, and Dave and Matt regularly see poor quality work.

Starting Rumpelstiltskin Thatching was no easy task as there were no examples of long straw thatching for potential customers to see.

'People were understandably suspicious of us wanting to use this traditional method when they didn't know what the roof would look like or how long it would last.'

They were so confident in their methods though that they thatched their first few long straw roofs at prices that their clients couldn't turn down, knowing that they would be delighted by the results and word would quickly spread.

Matt and Dave have a simple explanation for the company's unusual name:

'If you remember the children's story, you'll know that Rumpelstiltskin was the only person who could spin gold from straw. That's what we like to think we're doing!'

> *People were suspicious of us wanting to use this traditional method when they didn't know what the roof would look like or how long it would last*

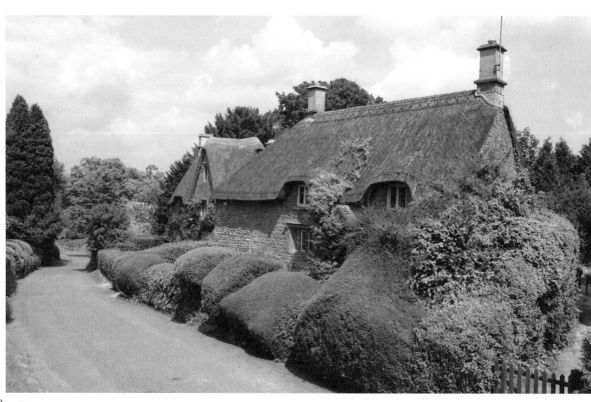

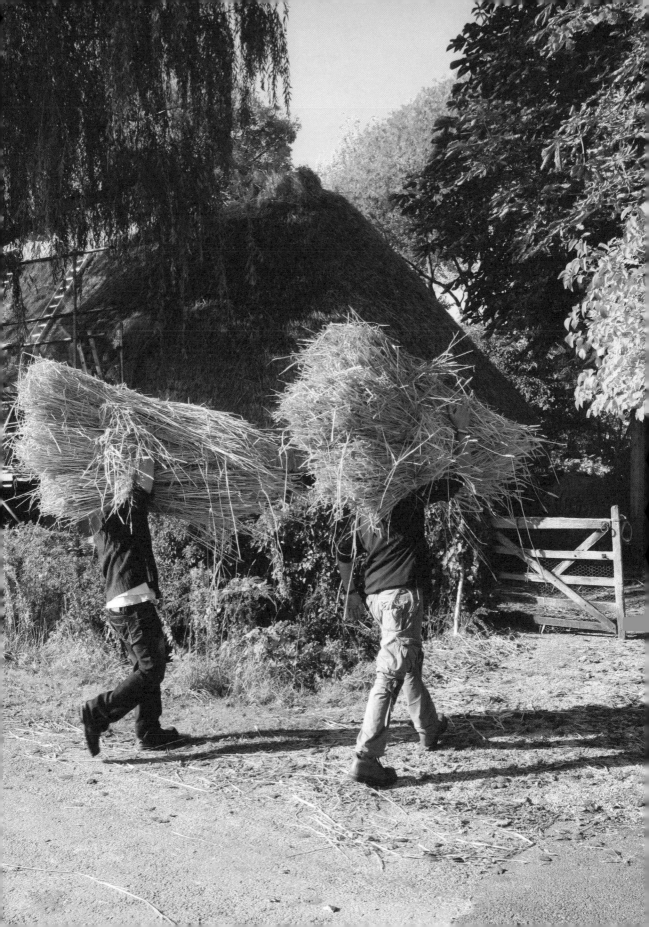

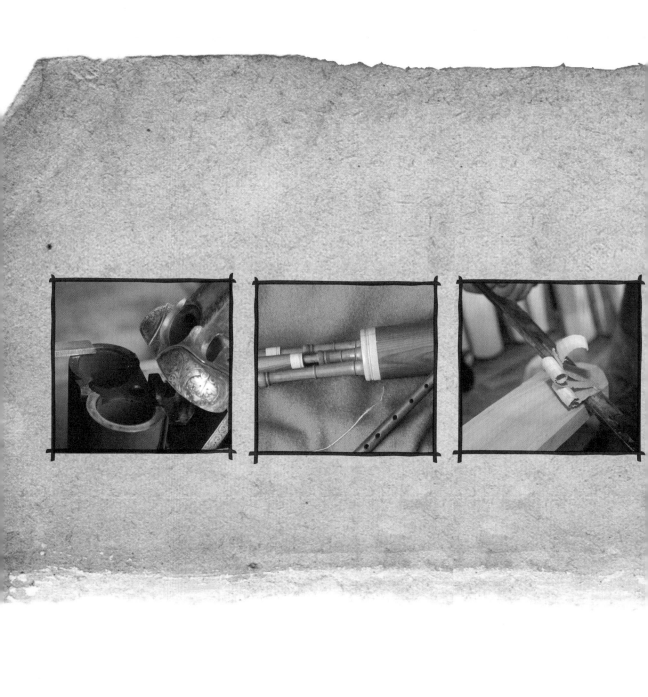

CRAFTS FOR SPORT AND RECREATION

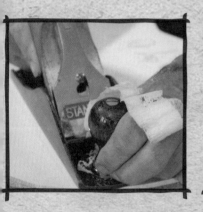

The Bowyer/Fletcher

CHRISTOPHER BOYTON

Archery is hugely popular, but few today use the sort of longbow that made England's bowmen the terror of Europe in the Middle Ages. One man who still makes traditional longbows is Christopher Boyton. His fascination with the subject of bows and bowmen began early, as he explains.

'I started making bows as a child. It was all to do with the romance of the thing – Robin Hood and all that. But I also read every book I could find on bows and bow making – especially bows used by American Indians.

'It really started in a more serious way when I was 19. I was on holiday and decided to try to make a bow using timber from a nearby wood – with the landowner's permission, of course. I made the bow from a bit of ash and as you can imagine it was a hopeless failure!

'Soon after that I got to know a chap called Tony Harris of the Medieval Society – he made all sorts of interesting stuff for TV. He sold me a bow stave of yew – a stave is a block of wood ready to be made into the completed bow. This was back in the 1970s and it cost £8 – a lot of money back then. He also gave me a set of instructions on how to make a bow so it was money well spent! I soon went back and bought five more staves.

'After making half a dozen bows I thought I'd better start trying to shoot them – I am one of the few bowyers who got interested in making them first and in using them second!'

Christopher's enthusiasm was given an additional boost when he met one of the greatest exponents of the art of bowmaking.

'I was lucky enough to get to know Richard Galloway, a Scottish bowyer who made, among other bows, a range of bows for Slazenger. He was a real inspiration. I spent ten years visiting him twice a week from my home in Brentford, West London, to the boatyard at Southall in Middlesex where he then lived on one of the last remaining Thames sailing barges. He taught me a huge amount and he recruited a gang of archers – big strong blokes – to test his longbows. He made superb replicas of the kind of bow used in the Middle Ages. I used to help with the bow testing and we were the first in modern times to shoot medieval length arrows – 32in or longer compared with the modern length of 24–28in.'

Christopher has become a mine of fascinating information about the history of bows, their construction and use. In the Middle Ages young apprentices in London were compelled to practise archery outside the city walls every weekend and the bow and its use were central to daily life. Terms used in other trades entered the bowyer's

> *I am one of the few bowyers who got interested in making them first and in using them second!*

RIGHT *Chris Boyton is a renowned British archer, bowyer and manufacturer of traditional longbows.*

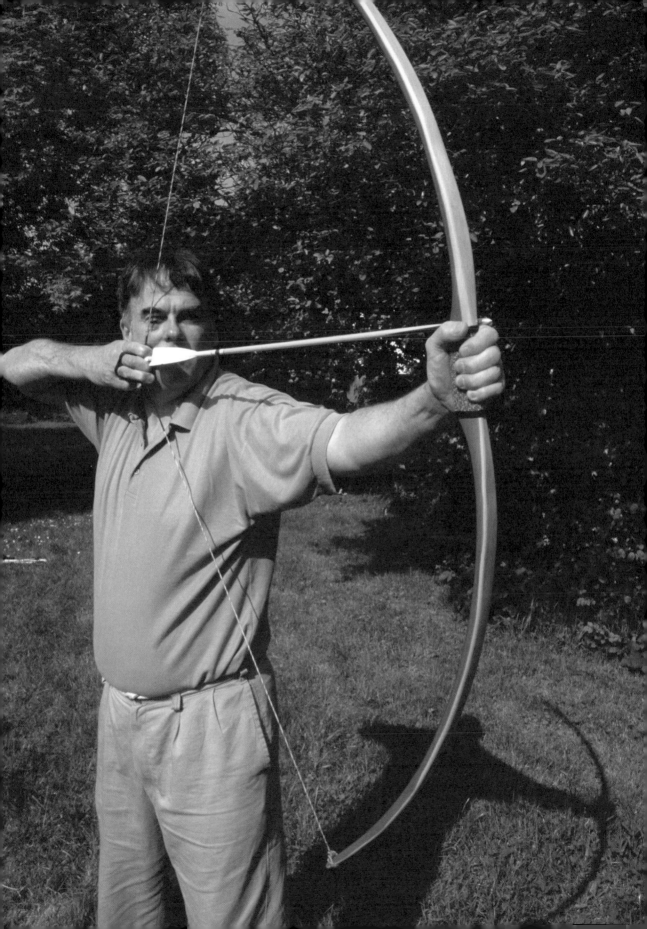

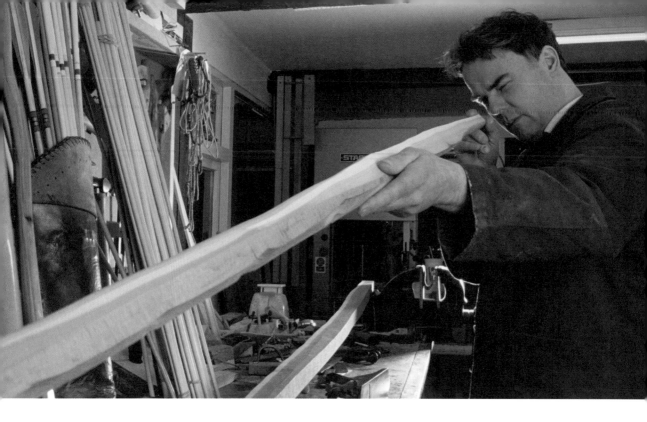

ABOVE *Excess timber is removed by paring down the seasoned wood with an axe to square off the sides.*

vocabulary, as Christopher explains:

'The medieval bowstring was pulled back to the ear, a distance known as a Clothier's Yard because that was how cloth was measured in the Middle Ages. A yard was the length between an outstretched hand and a hand held against the ear – the precise position the bowman would achieve before shooting his arrow.'

Christopher is at pains to point out that Richard Galloway was in some ways a hard task master. He set his young would-be apprentice challenges so that he could find things out for himself. But Christopher's enthusiasm and innate skills with wood stood him in good stead.

'I'd been really good at carving since I was a child and I found those early self-taught techniques were really useful when it came to making bows.'

MAKING A TRADITIONAL LONGBOW

'To make the sort of yew bow that would have been used in Medieval England you first have to find a really good tree. That has

become increasingly difficult because there aren't so many bow quality yew trees around. Medieval bowmen would have had the pick of a seemingly endless supply of trees. Once you've found a nice smooth round tree you fell it and remove the bark – some people remove the bark later on but I always take it off at this stage to discourage insects, such as woodworm, that like to hide under the bark.

'You split the log which, by the way, must have been cut long – about 7ft. You split it into quarters or eighths using wedges. The cleft wood is then left to season. You leave the timber for at least two years partly so it gets harder but, more importantly, because as time passes it becomes more stable. The longer you wait the more stable the timber – I've used wood that has been seasoned for 50 years!

'The next stage involves removing the excess timber from your seasoned wood. If the wood has become twisted during seasoning, which does happen, we straighten it using a heat process. Traditionally the wood would be smeared with animal fat, heated using charcoal, bent and clamped.

'As the paring continues the block of wood begins to resemble the traditional bow shape. Using a jack plane it is then tapered and cut to length. You want it about one-and-a-half inches wide at the middle tapering to about half an inch at each end.'

Once the bow's width has been tapered it has to be reduced in depth, which is where things get tricky:

'All timber has an inner heartwood and an outer layer of sapwood. The skill of the traditional bowyer is to use spoke shaves, drawknives and rasps to reduce the depth of the bow in such a way that the backface of the bow still has a thin layer of the sapwood on it while the inner face has just the heartwood. In other words the bow is made from the outer part of the yew log where sapwood and heartwood meet. The layer of sapwood must be around 3/16 in thick on the finished bow to work best. The reason is that the sapwood on the back of the bow is very springy so, under tension (when the bow is drawn), it is being stretched and that combined with the strength of the heartwood produces a formidable weapon.'

Aimed at 45 degrees, a powerful Tudor bow used by a good archer would have been able to propel an arrow from around 200 to 400 yards, depending on arrow weight. Tudor arrows had heavy forged iron tips so if you were hit in an unprotected area of the torso the impact might well be fatal.

'With all that work on something that was going to be shot and probably lost, arrows and warfare were expensive. And that old chestnut about arrows shot into a target being split by other arrows – it really does happen sometimes but more by chance than deliberately,' says Christopher Wryly, before returning to the steps in making a bow.

'The point about shaping the bow from the rough initial piece of wood is that it is all done by eye. Once the bow is the right shape the square edges are rounded off and the bow is polished – highly polished. On

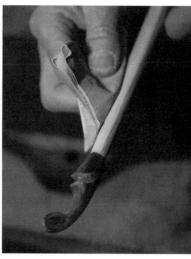

bows found on the sunken Tudor warship *Mary Rose* you can still see the marks of the rasp and scraper so they weren't polished but that was because they were seen as a purely functional bit of kit. I use a rasp to round the bow off.

'Next step is to make the notches, or nocks – the places at either end where the string will be attached. Some old bows had two slots in the side of the wood for the string but for greater strength they usually used a slim inset of horn with a groove cut in it. The horn is drilled out, the end of the bow filed to a point and the horn tip is then glued on.

'The string used in the past would have been hemp, but these days if you wanted to use hemp you'd have to grow it yourself which might be tricky as it is the same plant from which you get cannabis! The closest I've got is hemp thread which is not quite the same. Flax was also used and silk was used to attach the feathers to the shaft of the arrow.

Christopher started making bows in 1974 and his reputation is such that he was asked to help catalogue the Tudor bows found on the sunken warship *Mary Rose*. He was delighted to discover that the bows are almost identical to some of the bows he makes today.

ABOVE (left) *The bow is tapered using a jack plane.*
ABOVE (right) *Once the bow is the right shape the square edges are rounded off and the bow is polished.*

The Bagpipe Maker

JULIAN GOODACRE

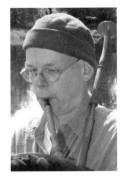

Julian Goodacre has been making bagpipes for nearly 30 years. He is entirely self-taught and, remarkably, has recreated a number of ancient styles of bagpipe using little more than carvings of early bagpipes in old churches.

But there is nothing dry and academic about Julian's work. Indeed he is the first to say that he is a not academically inclined at all – he cheerfully admits that he has never learnt to read music, for example, yet he has an almost encyclopaedic knowledge of bagpipes, their history and their music.

'I make a whole range of bagpipes, some from copying instruments held in museums, others, such as my Leicestershire smallpipes, from looking at period illustrations. Or my Cornish double pipes which I recreated from a carving in a church on Bodmin Moor. By recreate, I mean that none of these pipes had survived and thus there was no knowledge of how they were made.'

An Englishman from Leicestershire who also makes the famous Highland pipes, Julian now lives in Scotland. But his most popular pipes, from a sales point of view, are his Leicestershire smallpipes. He explains that we will never know what the original pipes may have sounded

> By recreate, I mean that none of these pipes had survived and thus there was no knowledge of how they were made

like because, like Cornish double pipes, he has had to recreate them using only illustrations.

The lengths to which Julian will go to try to make interesting sets of pipes can be judged by the fact that he once travelled to Nova Scotia to look at a 17th century Highland bagpipe chanter that belonged to the legendary blind piper Iain Dall MacKay (c.1656–1754).

'The chanter was no longer playable – it was very fragile,' says Julian, 'but I was allowed to measure it and now I make exact copies'.

So how did this fascination with bagpipes start?

'I have always been very practical. After school I'd had various jobs, working in shops and in a paper mill, and then I became an agricultural engineer in Galloway.

'I got interested in English bagpipes through playing the penny whistle. I taught myself to play it which was a revelation to me as it made me realise that you don't need to be able to read music to play music. I set off travelling round Africa and the Far East playing the whistle and teaching myself how to make them out of old tin cans.

'I came back to Scotland in 1981 with a burning desire to rediscover English bagpipes. At that time there were a few

RIGHT *Julian Goodacre has taught himself to design, make, play and compose music for a unique range of bagpipes. Julian has even hand-made each individual chisel handle.*

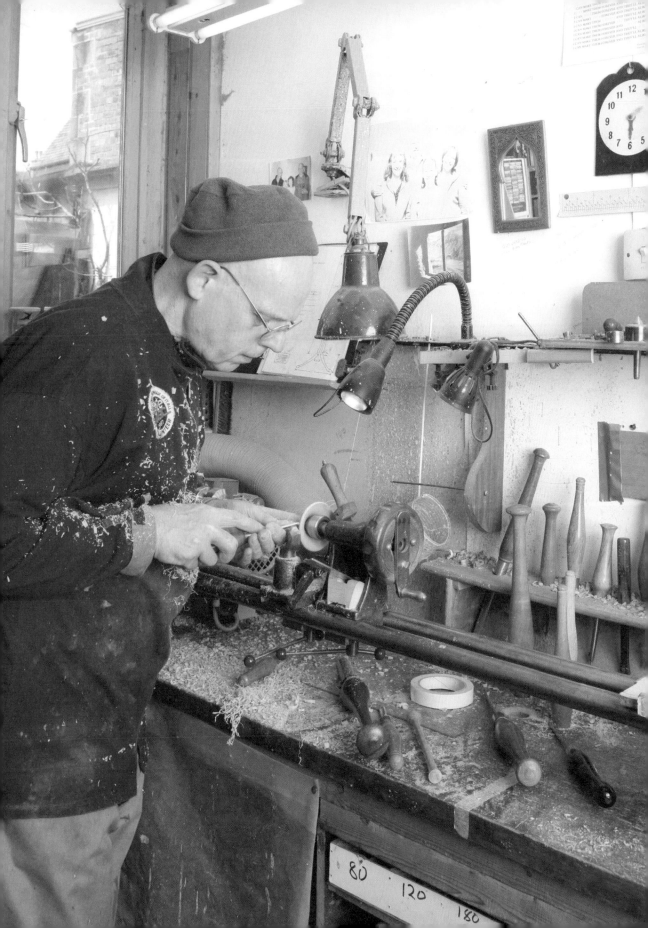

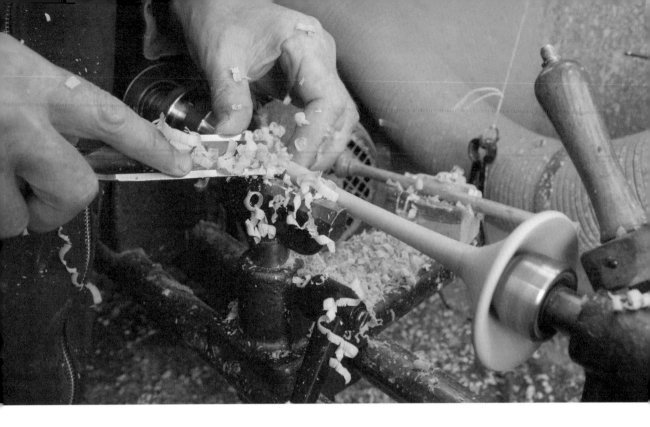

ABOVE *The delicately designed Leicestershire small pipe chanter is as thin as a pencil when finished and the final stages require deft chisel control.*

makers in England getting interested in this. I had no formal training in woodworking but I quickly got the hang of it and now I make a whole range of pipes, play them and record with my two bands. I have recorded four CDs so far.'

For Julian, one of the most important aspects of his work is that he should know the source of the materials he uses to make his remarkable instruments.

'I really like using wood from trees that I have known – for one set of Leicestershire small pipes, for example, I used wood from a cherry tree that grew near where an aunt was buried. And at the launch party for my CD I played a set of pipes from an apple tree from a relative's garden. We also drank apple wine that had been made from the apples from that tree!'

Julian combines his interest in the tradition of bagpipe making with an individual flair. 'I like fruit woods for my pipes because it is close-grained and stable – plum,cherry, apple and mulberry, if I can get it, are ideal. I use walnut for bellows

on all my sets of Border and Scottish smallpipes from a tree planted by my father in the 1940s.

'Bagpipes have been played in England since the 13th century. The earliest written reference is from 1285/6, at least 150 years before references to bagpipes in Scotland. The Highland Bagpipes have only been around for about 400 years.'

'Pipes may well have varied from region to region. Take my Cornish pipes for example. These are based on a carving on a bench made in 1510 – they are fascinating. The sound is much deeper than on other small pipes and as they have two chanters you can play chords and counter-melodies. Pipes vary musically in other ways too – Scottish smallpipes are now made to play in the key of D or A, English pipes in D or G and early music people like them in C or F.

'I started the practical business of making my very first set of pipes by buying what turned out to be a terrible set of pipes. When I realised how bad they were – I shan't say who made them! – I slowly

replaced every part with bits made by me. It was my first re-creation. That first set took me several months but within two years I had developed a range of three different types of pipes.

'Smallpipes have chanters with a parallel internal bore, and, like the orchestral clarinet, have a low rich and relatively quiet sound. Most people will have heard the Northumbrian smallpipes – the one type of English pipe that I have never made. Highland pipes and my English Great Pipes have a chanter with a cylindrical bore which makes them sound loud and higher pitched.

'I have had to make many of my own tools,' says Julian. 'My engineering background helps with that. I make the reeds for the instrument from yoghurt pots. Not very traditional I know, but they really last and produce a wonderful sound. Traditional reeds don't last so long and are affected by humidity and temperature.'

Julian has made more than 650 sets of pipes in the last 27 years and has anything up to a two year waiting list.

'My most popular pipes are the Leicestershire smallpipes – they are also the cheapest. Many people have taught themselves to play on these pipes. They are really quite simple, playing just nine notes with a semi-tone below, but a virtuoso player can produce wonderful music on them. For many, the limitation of playing with just nine notes becomes a liberation!'

'Pipe making involves so many skills – there's leather work, woodwork and wood turning as well as tuning and, of course, playing. It even involves musical and social history. And there's geographical interest as distinctly different types of bagpipes are made in most regions of Europe. I now lecture on smallpipes around the world and, with my brothers John and Pete, play in the Goodacre Brothers. We also publish our own books on pipes and piping history. And all over the world people are fascinated – I've sold pipes in America, Japan and even in the Andes!'

> *Pipe making involves so many skills – there's leather work, woodwork and wood turning as well as tuning and, of course, playing. It even involves musical and social history*

BELOW *Hand-sewing the bag is a laborious and time-consuming process; the finished bag must be completely air tight.*
BOTTOM *The heart of a bagpipe is its reeds; traditionally made from cane. Julian's are made to his own design from the long-lasting plastic of old yogurt pots.*

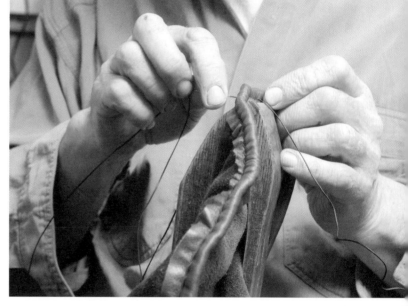

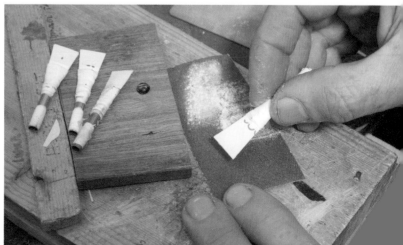

The Cricket Bat Maker

TIM KEELEY

The game of cricket has come a long way since medieval shepherd lads used the gate hurdle of their sheep pens as a wicket. A look around Tim Keeley's workshop at Ashburnham, East Sussex, drives home just how much bats have progressed too: his smooth, burnished high quality sporting weapons are a far cry from the primitively shaped sticks or tree branches of old. Hundreds of them, in various shapes, grades and stages of completion, silently promise summer glories of balls hit for six.

Tim is master cricket bat maker for world renowned John Newbery Ltd, whose customers range from junior would-be 'Freddie' Flintoffs to professional players at club and Test level. The company traces its heritage back to the early 1900s when the Newbery family first handcrafted bats. Tim honed his skills alongside the late legendary master bat maker John Newbery.

'We are a small niche company making top end products,' Tim says. 'Our philosophy is that quality, performance and style come first. In the last few years the market has grown – 20 years ago there were around half a dozen big companies, now there are about 50 little companies all competing. Cricket is really popular.

'We are constantly developing differently shaped bats to suit different needs. At the

> *Shaping and balancing is done by eye, a skill built up over years of experience*

moment there are trends for lovely thick edges and weight distributed to the bottom of the bat, the middle of the cricket bat has bigger sweet spots and curves in different areas. There are different grips, different feels and weights.'

Newbery bats begin life as carefully selected willow trees. 'We've been planting trees for the last 20 years, on local farms across the South of England,' Tim explains. 'People laugh when we say that, but the clock is ticking and we've got trees coming through. Those we're cutting down now are 15 to 20 years old – they are about 60 inches in circumference when they are ready. We also source wood from a willow dealer in Chelmsford.'

The wood is cut into rounds that are 30 inches in length, and these are split open to give eight or nine clefts. With three or four rounds per tree, that makes 20–30 bats from an individual felling.

'We saw the clefts into pre-cricket bat shapes, dip the ends into hot wax and put them into the drying kilns. They will be ready in about three months' time,' Tim says. 'The wax stops them from splitting and they lose half their moisture weight. Afterwards, we grade them out, from nice tight, straight grains that are top quality to some that have a little bit of red on them or a little blemish. Generally, cricket bats made from willow that's grown slowly and has a nice tight grain hit the ball farther and they become the elite,

RIGHT *Tim Keeley, of renowned bat maker John Newbery, has been making bats for more than 30 years.*

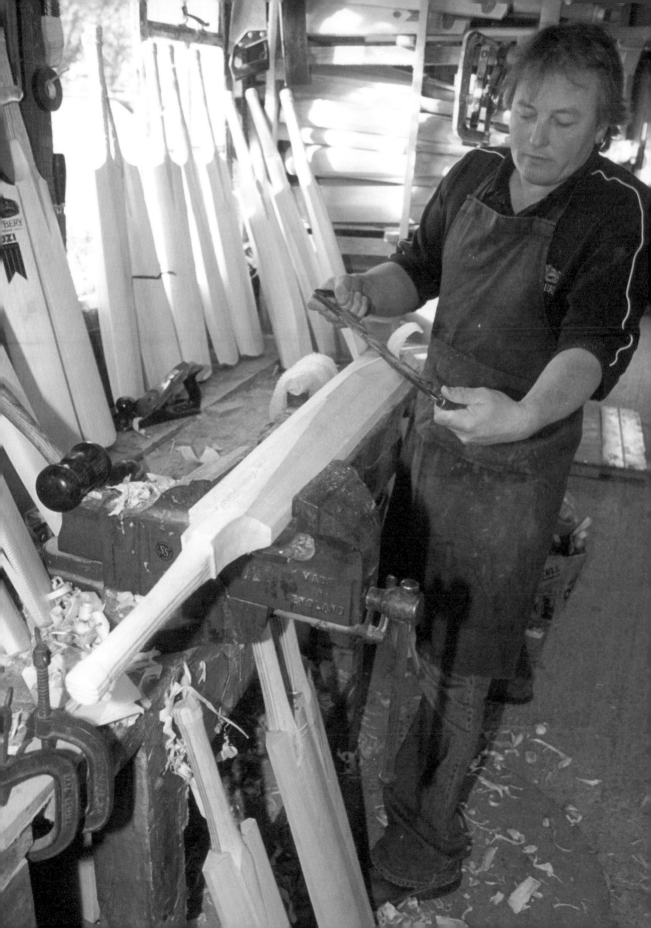

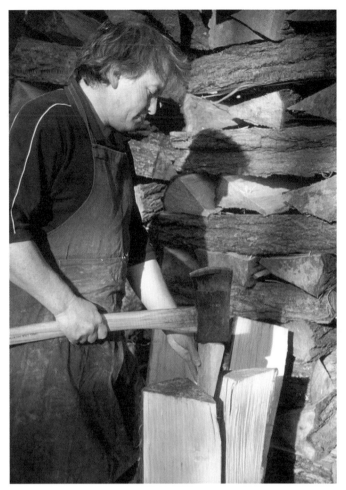

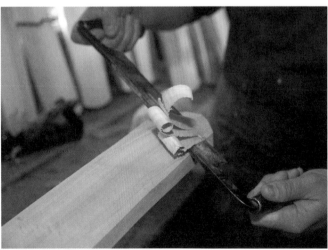

ABOVE (top) *The cleft is prepared to a rough cricket bat shape with a convex face, ready for pressing.*

ABOVE *The blade is shaped by 'pulling off' the willow with a drawknife.*

niche, expensive bats on the market. We produce bats in three grades.'

The atmosphere during the making process alternates from the voice drowning noise of CNC (computer numerical control) machines, spindle moulders and backing machines, to the relative peace of hand tools – drawknives, spokeshaves and block planes – being wielded. Shaping and balancing is done by eye, a skill built up over years of experience.

'The long, straight fibres in a bat are quite soft and they would really dent without pressing. We compress the fibres down at a pressure of three tons per square inch to give them resilience and give the bat its performance.'

A handle is spliced and fitted into the blade with strong wood glue. Newbery's 'treble spring handles', incorporating three strips of rubber to cause spring when a ball is struck, have been specially developed to give greater 'whip'.

'The next process is to skim the shoulders and toes, then hand shape the bat to give it a nice balance and feel. We do half a dozen different models, or any shape somebody wants, with a variety of depths and weights to suit, from 2.5ozs to more than 3lbs. It's a bit of an art form to distribute the weight and make sure the pickup is correct. Sometimes the bats are pressed again, to help put an arc of a bow in them which gives a nice feature.'

The bat is then sanded and polished, progressing from coarse sanding to fine sanding, before it is waxed to a lovely sheen using a linen buffing machine. After polishing, Irish linen string is bound on to the handle to help hold it together, preventing the rubbers from becoming de-laminated and effectively 'tuning' the flex of the handle. One or two rubber grips are added to enhance the bat's balance and feel, then finally 'cosmetics' – logos, names, colours – are put on.

'Our range of bats is a result of research and work between us and professional players,' Tim says, adding, 'I can't name individual players, of course.

'Coming up with names for models is quite difficult, but at the moment the theme is speed

and power,' he continues. 'Our Mjolnir bat is named after the Norwegian god Thor's thunder hammer. We put it on the market ten to 15 years ago and lots of professional and local club cricketers have used it. They select it for its high quality willow, classical English shape, pickup and huge profile in the hitting area to give great performance. You can tell it has nice tight grains on it and that it will be a good cricket bat.

'I developed the Uzi when 20/20 cricket became popular. An Uzi is a machine gun from America and it seemed a suitable name because I wanted a rapid-fire bat. I dropped the shoulders down a little bit, lengthened the handle and thickened up the edges for a bit more power. We've another new 20/20 model called the TT, with less weight on the shoulder and a bit more weight in the middle, a bat that will pick up a little quicker for the faster game in 20 overs.

'Our Chic model is the first bat specifically designed for female cricketers,' he adds. 'It's made of light, top grade willow, has a slightly reduced size and thinner handle, but still has a powerful middle.'

Tim no longer plays cricket, having turned to golf in recent years. 'But cricket goes on in my mind constantly. I enjoy meeting professional cricketers and trying to make the best products I can. When cricketers do well and they are using your bat it's a great feeling of excitement and goose-bumps.'

He is also keenly interested in the history and development of the game. 'It first started in the Kent/Sussex borders when farmers used sticks from the hedgerows,' he says. One theory claims that the sport's name derives from the Saxon *cryce* meaning 'stick', and another that it comes from the Old French *criquet* meaning 'goal post' or 'wicket'

By the 18th century matches in London were attracting huge stake money, while the famous Hampshire club of Hambledon beat off all-comers for an incredible 30 years. But it was the Marylebone Cricket Club (MCC), founded in 1787, which overhauled the rules and became regarded as the sport's governing body.

Bats have kept pace with the ever more skilled and technical advances of the game. And that challenge continues to occupy Tim. 'You might think that every possible design would have been made by now, but there are always new trends or fashions, or a cricketer comes along with a bat and says he wants something different done to it and suddenly a whole new profile forms. I think the shape of cricket bats will always keep changing.'

ABOVE *A handle is fashioned from cane laminated with rubber (to take the shock out of striking balls). This is spliced and fitted into the blade with strong wood glue.*

The Guitar Maker

PAUL FISCHER

'Musical instrument making is a very traditional profession and a lot of traditional professions don't go forward very fast,' master luthier Paul Fischer says. 'Even when I started in 1956 we were looking at instruments of the 19th century and before, and reproducing them. But if you consider the history of the classical guitar, roughly every 100 years the instrument has gone through a process of evolution and something good or something new has come out of the experiment.

'For example, before about 1850, it was a parlour or salon instrument and was never played in concert halls, because it was too small and the sound wasn't loud enough. Then [Andres] Segovia started introducing it to a wider audience and the guitar has gone through another stage of development, right up to the end of the 20th century, which is where I and others come in.

'The demands on the instrument now are for it to be played not only in concert halls but in guitar concertos – well, you can imagine a whole orchestra can easily drown a guitar,' Paul continues. 'There is a limit to how much extra power we can get from the instrument, but we can at least refine the quality of sound so that you can hear the voice of the guitar separate from other instruments.'

A browse around Paul's Cotswold studio

{ we can refine the quality of sound so that you can hear the voice of the guitar separate from other instruments }

indeed reveals a craftsman at the cutting edge of his profession. A variety of woods, stored in humidity controlled conditions, are testament to many years of experimentation, and there are modern materials like Nomex, too. Some makers even experiment with carbon fibre.

'In the world of high quality instrument making we use very expensive and occasionally very scarce woods, some of which are now banned and we're desperately looking for alternatives,' he explains. 'For certain components of construction I'm using Nomex, which is becoming quite popular, partly because it makes a better instrument. Nomex is a paper and its structure looks like a honeycomb. It's used in the wings of aircraft because it is very strong and very light, qualities that are useful to guitars, too.'

Paul has clients in more than 20 countries, including top performers. But he didn't always focus his energies on classical guitars. 'I first trained in harpsichords, clavichords and spinets, then moved into what we call fretted instruments: guitars, lutes, citterns and pandoras. It all began at school in Oxford when I was aged 15 and the music master asked if anyone wanted to be an instrument maker. I hadn't thought about it at all, but it sounded a brilliant thing to be doing. I've loved it ever since.'

He became apprenticed to a friend of the music teacher, Robert Goble, the renowned

RIGHT *Paul Fischer began his instrument making career in 1956, and is now the foremost British classical guitar maker, with clients in more than 20 countries.*

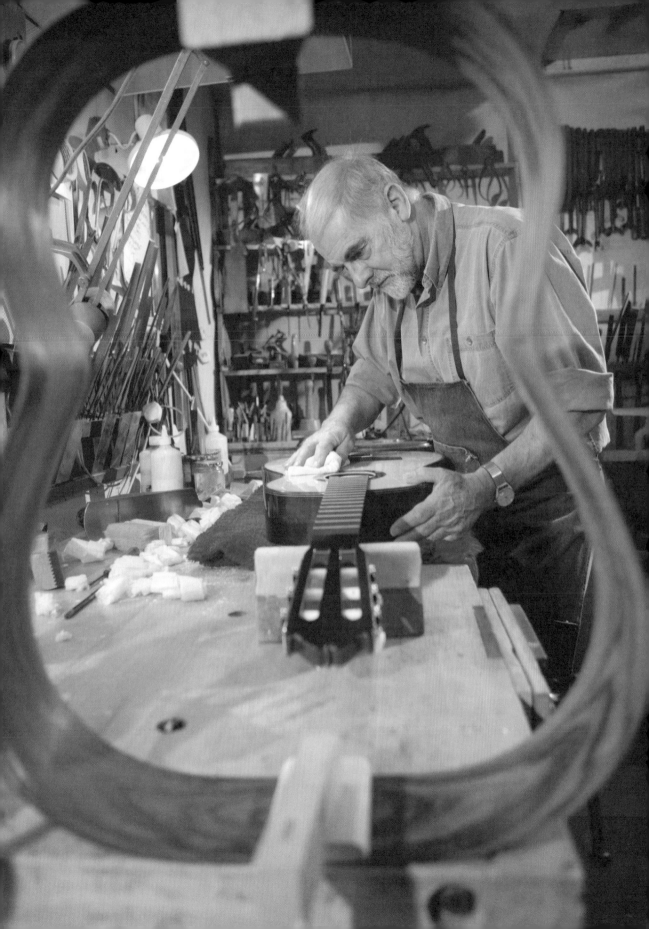

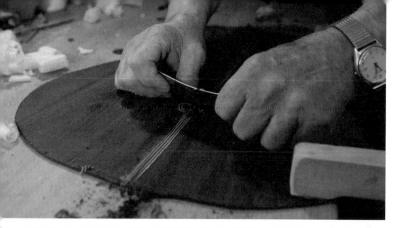

ABOVE (top)
Traditionally, the rosewood back of a guitar is made from high-quality timber that has been carefully seasoned to remove moisture and ensure structural stability.
ABOVE
A rosette is the mosaic decoration inlaid into the soundboard.

maker of harpsichords and early keyboard instruments, and he studied at Oxford College of Art and Technology. 'Goble had studied with Arnold Dolmetsch, one of the members of the Arts and Crafts movement, and I received a very thorough training in making musical instruments.'

In the 1970s Paul pursued his interest in guitars by working as chief instrument maker and manager for luthier David Rubio, at Duns Tew, Oxfordshire. 'I taught Rubio about harpsichords and I learned from him how to make guitars and lutes. He had a real understanding of the raw materials. In instrument making you need to understand the wood and even how to cut the tree in a particular way to produce the right grain. The wood has to be the right weight and colour. I reject probably 30 per cent of everything I get.

'It surprises many people that the guitar is one of the earliest musical instruments,' Paul adds. 'It originated in Babylonia, or at least the first evidence we have suggests it began in that region, in what we now know as Iraq.

There are stone reliefs of people playing the guitar and even at that stage it was quite highly developed with frets and they had worked out a scale. The normal plucked instrument of the time would have been the lyre, which has only five or six strings, meaning you have only five or six notes. By adding a neck and the frets you increase the range dramatically.

'At the time I worked with Rubio, English guitar making didn't have much of a reputation. It was always assumed that only the Spanish could make guitars. So, to sell his work, Rubio changed his name. "Rubio" was a nickname [he was born David Joseph Spinks] acquired from his time learning flamenco in Spain: El Rubio means pale or blond.'

The ploy – and their talent – succeeded. 'Rubio struck up a good relationship with Julian Bream and John Williams, which helped to establish him and English guitar makers in the world. I made a large proportion of the guitars that came out of the workshop – you'll see my initials as well as the David Rubio label – and we made instruments for many leading musicians.'

In 1975 Paul set up his own studio, in order to develop instruments independently. By now he had met the physicist Dr Bernard Richardson, whose experiments using holographic interferometry incorporating laser technology mapped the movements of wood in instruments as they are played.

'That has helped me to really understand what makes instruments tick, the physics and acoustics, rather than simply copying other people's work. As a result I developed the "taut" system in the 1980s, which meant tightening up the soundboard, the most critical part of any wooden instrument. By applying the benefits of Bernard's work and understanding the engineering, I could also make the top of the instrument lighter, thinner, stiffer and stronger – which is where Nomex comes into its own. By using the "taut" system or Nomex we create a

soundboard of low mass and high stiffness, so maximising the distribution of string energy (sound). The instrument is louder, with better balance and a more refined tone.'

USING THE RIGHT MATERIAL

In the 1980s a Winston Churchill Research Fellowship took Paul to Brazil, to look into dwindling supplies of Brazilian rosewood and to find out about alternative timbers.

'Brazilian rosewood is acoustically brilliant and for centuries it has been considered the finest wood available, but its use has now been banned. As it happens, I have enough in stock for the rest of my life, although I require a Defra licence to export any guitars I make with it. Most classical musicians are conservative about change, but there are very fine alternative woods that work equally well. For the back and sides of guitars I love Brazilian kingwood, bird's eye or quilted maples, sapele pommele, macassar ebony or satinwood. I use spruce and western red cedar for soundboards.

'The materials in the neck have to be strong enough to resist the pull of 100lbs when all the strings are up to pitch. I use mahogany when I can: it's scarce, but I recently retrieved some from an early 19th century square piano that was beyond restoration.

'In guitars there is hardly a woodworking joint and you never ever, of course, use screws or nails. What you do is all very, very fine wood- and cabinetwork, and it is the accuracy of this that gives the structure and strength. I usually start with the soundboard because there are quite a lot of gluing-up processes and I can move on to something else while each stage is drying. I make all the major parts in turn, back, sides, neck and so on, using traditional woodworking tools, plus special instrument makers' tools and some I have manufactured myself. Then, within one day, I assemble everything. Once it is a complete unit, I begin the finishing process, scraping, glass papering, varnishing and setting up,

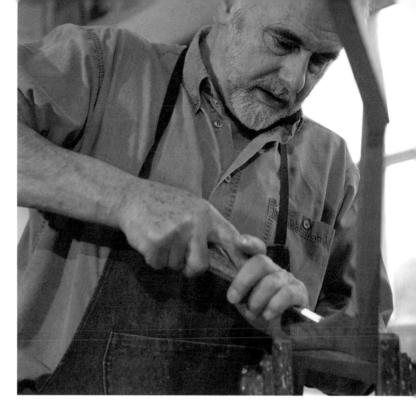

which means preparing all the smaller parts like bone nut and saddle, fitting machine heads, putting the strings on and tuning.'

Paul has made over 1,100 instruments in his career and when he test plays each guitar he refers to their colour tones with evocative words like plummy, rich or romantic. 'One instrument I made was such a deep, warm, wonderful sound that I described it as dark chocolate: it's an unmusical phrase, but it described it exactly.'

Over the years, he has trained other instrument makers at his workshop and he gives master classes and lectures on guitar making: not simply to share his expertise but to raise the profile of his profession.

'Guitar making is in the same league as any of the fine crafts and even art, but makers are reluctant to speak up about what they do and, sadly, they still aren't appreciated as much as they should be. When I began there were just three mediocre makers in the country; now we have probably 20 or 30 very, very fine makers. We make instruments as good as anything in Spain, if not better than most. We need to put our heads above the parapet and let people know of our achievements both at home and internationally.'

ABOVE *The materials in the neck have to be strong enough to resist the pull of 100lbs when all the strings are up to pitch.*

The Gunsmith

GRAHAM BULL

Gunmaking is one of Britain's 'younger' crafts, an industry essentially kickstarted by Henry VIII when he encouraged gunmakers from Europe to settle in London. Prior to this, the king had been forced to rely on imports from the continent – not a sustainable solution as the gun began to outcompete the bow.

Things soon picked up and in 1637 the Worshipful Company of Gunmakers was founded to promote and regulate the emerging trade, a role it still fulfils today: including testing, or 'proofing', the soundness of a gun's barrel and action by firing it with an over-pressure charge of powder. If the gun survives, it is passed as safe to shoot and it is stamped with a proof mark.

As guns became increasingly important on the battlefield, workshops developed in the provinces, especially Birmingham. Here thriving metalworking industries provided a ready supply of men and materials, and local gunmakers were granted Government ordnance contracts in the 1690s. The Birmingham Gun Barrel Proof House, which shares the work of proofing with London's Worshipful Company, was established by Act of Parliament in 1813.

There has been much technical innovation since the first 'fire sticks', which were basically tubes of iron where a charge was introduced from the muzzle and lit by a heated iron or match thrust through a touch-hole on top of the barrel: literally hand cannons. Breech loading, often attempted but only successfully accomplished in the early 19th century, proved more efficient and quicker. Operating mechanisms (the 'action'), rates of fire, the number and length of barrels, bore size (inside diameter of the barrel), shot and methods of re-loading have all progressed to suit different needs. Greater long-range accuracy has been achieved through 'rifling': grooving the inside of the barrel to impart spin and stability to the shot.

In the military arena, production of guns is now on mass standardized scales. But in sporting circles shotguns and rifles continue to be made and restored according to traditional methods where individuality is prized.

Guns bearing the names of famous English makers like Purdey, Holland & Holland, Boss and Westley-Richards exchange hands for thousands of pounds. Not only are they functional, many are works of art, their polished metal furniture (the plates covering the gun's mechanism) beautifully engraved with scrollwork, hunting scenes, or perhaps the original owner's favourite gundog.

Graham Bull joined the gun trade as an apprentice 42 years ago when he was 16 and has been a craftsman at John Foster Gunmakers, Stockton-on-Tees, for the last 27 years. 'As a child I was fascinated by guns:

> The design of English sporting guns has changed very little over the last century, although there has been some refining

RIGHT *Graham Bull has been a craftsman at John Foster Gunmakers for 27 years.*

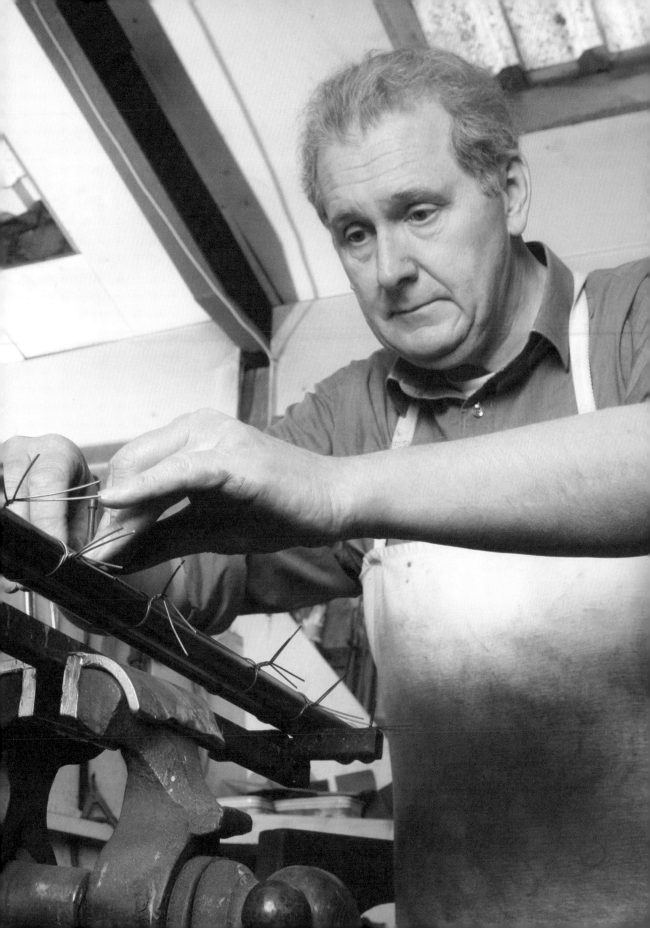

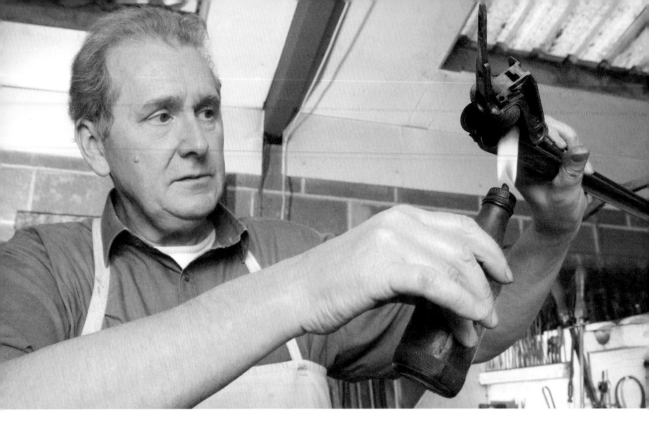

ABOVE *Graham uses the traditional method of 'blacking down' with a paraffin lamp to check the fit of action and barrels, putting a layer of smoke on one surface, then when the joint is closed the smoke rubs off on the high spots.*

not so much for shooting, but for their shape, style and appearance,' he says. 'My father was a joiner, and my grandfather and great-grandfather were woodcarvers, so I'm the first metal worker in the family. But I still use tools I inherited from them when I am working on [gun] stocks.'

Indeed his workshop at John Foster (gunmakers since 1965) is awash with every type of tool for metal and woodworking, from files and saws to chisels and gouges.

'Most of our work is renovation, rebuilding and repairs,' he explains. 'The cost of building new guns is so expensive. Our customers are a mixture of trade and individuals who do game shooting and clay shooting, although some buy for investment, too.

'I can be working on guns that were made 100 years ago or ones that were made just five years ago. The design of English sporting guns has changed very little over the last century, although there has been some refining. There are basically two styles of sporting gun: the box lock, with most guns based on the Anson and Deeley patent [1875], and the Holland &

Holland style sidelock from the 1890s. The sidelock is more expensive to make because it has more parts.'

Graham goes on to explain in enthusiastic detail Anson and Deeley's 'hammerless action' and simple, elegant lockwork contained within the body of the gun; contrasted with the sidelock, where lockwork (hammer, sear, mainspring etc) is mounted on the backs (inside) of a pair of lock plates fitted to the sides of the body. 'They both go bang and shoot things, but one is more down to earth, shall we say. It's like the difference between a Morris 1000 and a Rolls-Royce, if you like.

'However, most clay shooting is now done with the more recently developed 20th century over and under guns,' he adds.

Through his training and experience, Graham has the versatility to work on all the main components of gunmaking – barrels, action and stock – rather than specialising in one area, as was often the case in the trade.

Before modern steel was available, twist or Damascus barrels were made from different irons, including old horseshoe nails, he

explains. 'The nails would be put in a cloth bag in some acid so they would rust together. Then they would be heated in a forge and hammer welded into a strip, which in turn was wrapped like a ribbon around a former and then hammer welded into barrels. It was a long, complicated business. Today gunmakers must buy steel to the required specification and bore from a solid bar. We buy our barrels in ready formed blanks to work on.

'Sometimes people bring us guns for alterations to the chokes – the choke is a constriction in the ends of the barrels that controls the spread of the shot or "pattern": the tighter the choke, the denser the pattern. So to give a better spread we open them out. These days we use honing machines for this and for boring out any pits or marks, rather than the traditional boring methods, which was a skill in itself.

'We also specialise in sleeving, whereby we cut the old worn or damaged barrels off at about 3½in and fit new barrel tubes into them. So you effectively have a new barrel but without replacing what we call the back end, the expensive part which goes into the body of the gun and takes all the work in fitting. Work on barrels of this kind means a gun has to be re-proofed.'

The action, or operating mechanism, is at the heart of a gun, joining together barrel and stock – hence lock, stock and barrel. It connects triggers to the firing mechanism and the safety catch which prevents the gun going off accidentally, and allows the gun to be opened to eject cartridges and load fresh ones. An outside specialist supplies Graham with a basically machined action in the style he requires, then he painstakingly makes and puts together the inside work.

'It's very important to get the joint between action and barrels right because you don't want gas to escape from the cartridges. Also, if everything isn't fitting exactly the gun will come loose and wear,' he says. Walnut is the traditional wood for shotgun stocks because

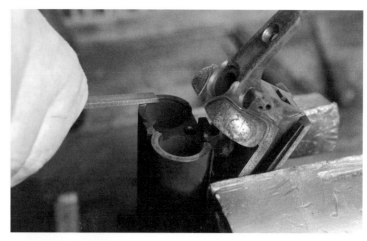

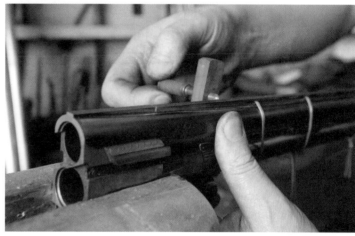

of its weight, strength and attractiveness. When Graham makes a new stock, he tailors the length, cast and drop to the customer's requirement. Balancing may also be requested: making the stock heavier or lighter by boring out holes in the butt end, adding in weights or leaving the holes empty; checkering (criss-cross decoration) covers any plugs.

'You need a particular aptitude for gunmaking,' Graham says. 'You can't rush things, and it's not something you really cut off from when you go home, it's addictive.

'When I'm working on a very old gun I sometimes feel I'm competing with a man who has been dead for, say, 90 years,' he adds. 'I've got a gun in my hands that has lasted a century and I think: this guy knew what he was doing, so I'd better make a good job of it, or he might come and haunt me!'

ABOVE (top) *The high spots are filed away to get as much of the faces touching as possible.*
ABOVE *Lining of ribs prior to soldering.*

The Whip Maker

DAVID THORNE

David Thorne turned to making handcrafted bespoke hunting whips in 1987 as an alternative to farming. 'The family sheep and arable farm was 100 acres, which is something and nothing these days. We couldn't make a living,' he recalls. His childhood hobby of crafting walking sticks and whips offered better prospects, he thought. Then changes in the law ushered in by the Hunting Act 2004 seemed to threaten his living again.

'In fact, I'm as busy as ever,' he says. 'I sell around 350 whips a year to individuals and hunts, in this country and overseas, Ireland, Italy, the USA.'

David crafts at a bench laden with leather, deer antler and other materials of his trade in his workshop in Lapford, Devon. 'Traditional hunting whips are different from general equestrian whips because they have a hook handle that's used for opening and shutting gates,' he explains. 'I make them with deer antler handles and leather-covered fibreglass shafts. Generally, hunt servants carry a white whip and for those I put white nylon braiding on the shafts. For kennel whips I generally use ground ash.'

He travels to Scotland twice a year to source red deer antler. 'In May–June it is shed naturally and picked up by stalkers. In November–December it comes from deer shot on the estates. I get some antler locally in Devon, too.'

Back in his workshop he likes to make as many whips as he can from January to April, in time for selling at country shows around the country throughout the summer. He works long hours: grinding and shaping antler into a handle, then filing and sandpapering; cutting a length of fibreglass for the shaft, measured to suit a man, woman or child; then gluing the shaft into the handle before wrapping it in waxed brown paper to achieve a tapered effect.

Next he cuts a strip of brown English panel hide leather and neatly stitches this over the shaft before slipping a silver or nickel collar up to the handle: collars can be inscribed with initials and dates as customers wish. Finally, he binds the end of the whip and attaches the loop and a thong if required.

'I use the brow-point, or fighting-point, of the antler where it joins the stag's head, because of the shape and because it's the

RIGHT *David Thorne started his business making a wide range of hunting whips in 1987 and is entirely self taught.*

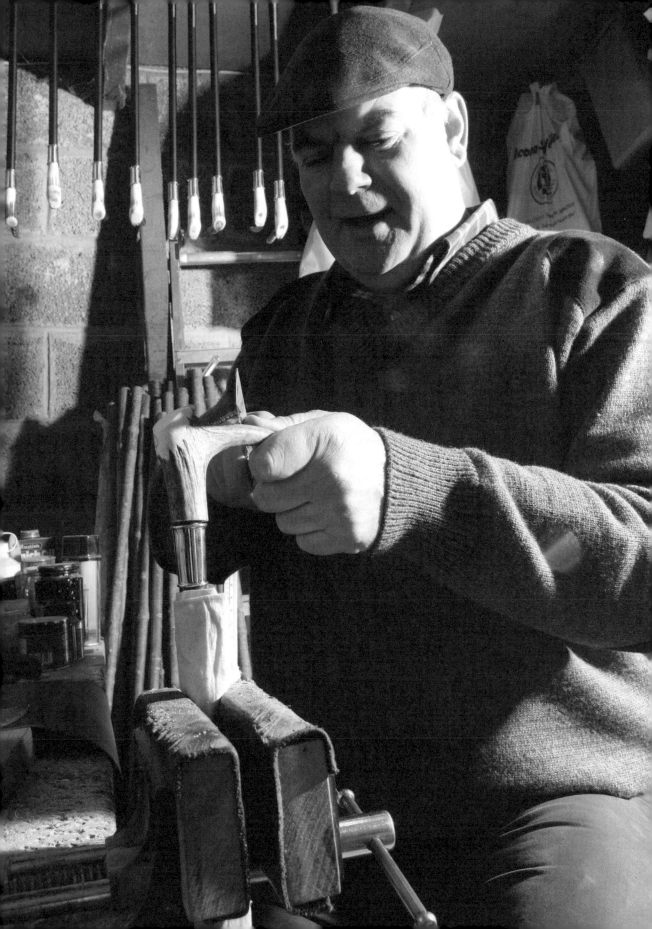

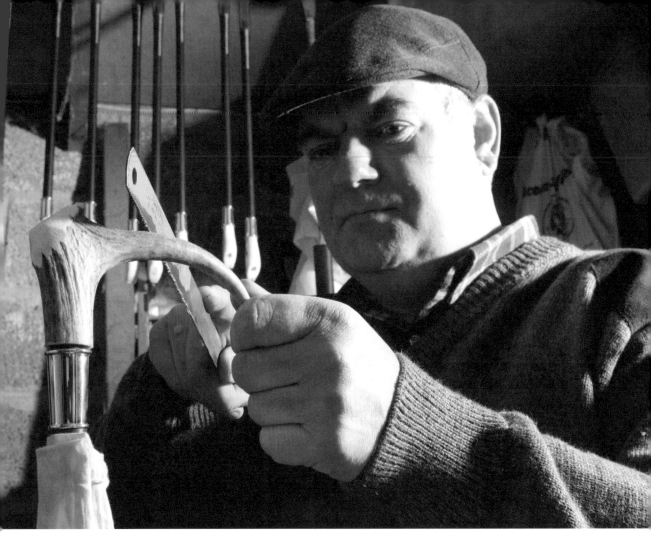

ABOVE *Traditional hunting whips have antler handles of a high quality, sourced from native red deer within the UK.*

strongest part,' David says. 'I generally like darker antler because it gives a better look to the whip. Usually, the darker the antler, the older the stag, although that's not always the case. Years ago, Indian antler would have been used in whips because it has no marrow in the middle and is hard. But nowadays the raw material isn't exported and you can't get it, so I use red deer antler.

{ *Some are as much as 100 years old, with plaited leather covering whalebone shafts* }

The secret of a good handle lies in its angle. 'It has to be 90 degrees or less so that when you pull on a gate it won't slip off.' He often adds a brass stud to the end of the handle, to aid grip when pushing open wet, slimy gates, and he carves indents into the antler to improve grip in the hand. 'A whip is a working tool; it's an extension of your arm. It should balance right and do its job.

'Sometimes I buy old fishing rods at a local sporting auction and recycle them as shafts. They are ideal for whips that need a bit more flexibility,' David adds. 'And I occasionally get unusual requests. An Italian gentleman wanted two whips covered in crocodile skin and fitted with gold collars. He sent me a parcel containing a complete crocodile, bar the head. It was two feet long and had been specially reared for the skin, which was a real rich burgundy colour. There was quite a lot left over, which I sent him back with his two whips.'

Closer to home David sources ground ash for kennel whips from a local grower. 'Ash generally grows straight and he specialises in hook handle plants that are grown so that you get right-angled handles on them. They are really grown for walking stick making and I go and pick out the best ones for me. Occasionally I even make whips from blackthorn, although that doesn't grow very straight. The Irish like blackthorn and a lot is grown there.'

In addition to crafting new whips, David repairs old ones. 'I get nearly 150 a year. They've usually got sentimental value, having been handed down the generations and people still want to use them. Some are as much as 100 years old, with plaited leather covering whalebone shafts – whalebone was often used in the past.

Sometimes I can only salvage the best bits, like the handle and collar if there are initials on it, so the customer gets something back from the original.

'I don't know of anyone else in the country handcrafting hunting whips on the scale I do,' David reflects. A keen supporter of traditional countryside pursuits, he regularly follows hounds and says, 'I wouldn't say I've got anything to worry about the future of my craft at the moment.'

BELOW *Hunt servants' whips have a white nylon braiding on the shafts, which are made of fibreglass for added strength.*

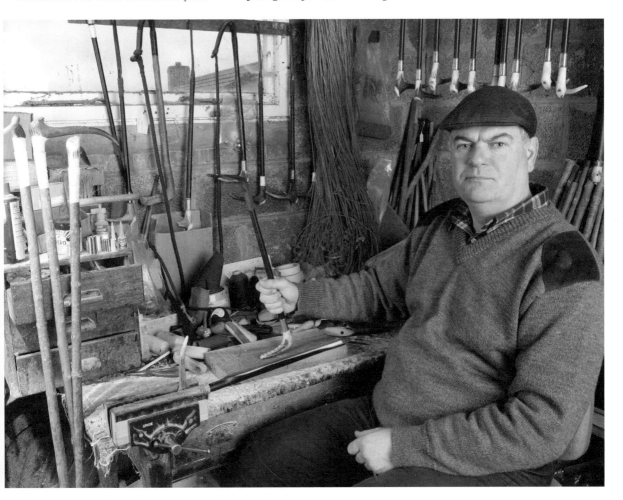

The Gig Boat Maker

DAVE CURRAH

Dave Currah's boatshed, in a corner of a field above West Looe in Cornwall, is a busy scene of timber and tools. A boat, 32ft (9.75m) long and with a specifically prescribed by the Cornish Pilot Gig Association – 32ft (9.75m) and 4ft beam, almost completely fills the space. It's a fit that's both snug and precise, which is just as well because Dave builds Cornish pilot gigs and the size of these shallow-draught boats for six oarsmen and a cox is strictly prescribed. He has completed more than 35 in his time and he approaches each new one with as much meticulous care as he did his first, built with his father Jim back in 1992.

Today gigs are used in racing, but their origins were as working vessels. 'Other areas probably had similar boats but not exactly the same as here in Cornwall, because different shapes and draughts were made to suit local conditions,' Dave says. 'I think gigs just evolved, built faster and lighter each time. The main thing that marks them out is their length, to get six men in with a cox.'

From the late 18th century, gigs served throughout Cornwall and the Isles of Scilly to row pilots out to ships entering the English Channel and Bristol Channel. Whichever pilot got aboard first would navigate the vessel safely into harbour – and the men on the gig got a cut of the fee. It was a highly

> Gigs also set out on rescues, salvage and (whisper it quietly) smuggling expeditions

competitive career, demanding fitness, skill and courage from the rowers, while boats needed to be light, speedy and resilient. Gigs also set out on rescues, salvage and (whisper it quietly) smuggling expeditions.

Racing evolved both from the serious business of earning a living and as a means to test the performance of newly built gigs. And while the engines of the Industrial Revolution and modern technology replaced oar and sail at work, the sport has prevailed: weathering many ups and downs to ride high on the crest of a renaissance over the last few decades. The Cornish Pilot Gig Association (CPGA), which governs Cornish pilot gig racing, has over 50 member clubs, from Cape Cornwall to Porthgain in Pembrokeshire. Gigs in the Isles of Scilly are covered by the Isles of Scilly Gig Association.

Rivalry between clubs is fierce, with competitions and regattas for men, women and juniors taking place throughout summer. The annual highlight at one end of the season is the World Pilot Gig Championships in the Isles of Scilly held over the May Day Bank Holiday when more than 120 gigs and their multiple crews converge from as far away as America. The Newquay County Gig Championships in September signal the climax of the racing season.

Looe born and bred, Dave raced with Looe Rowing Club until a few years ago. 'I stopped rowing when I was 45. In gigs you are rowing without sliding seats, taking more weight on

RIGHT **Dave Currah builds Cornish pilot gigs in his boatshed above West Looe. Built to the highest standards, the rowing vessel takes about five months to construct.**

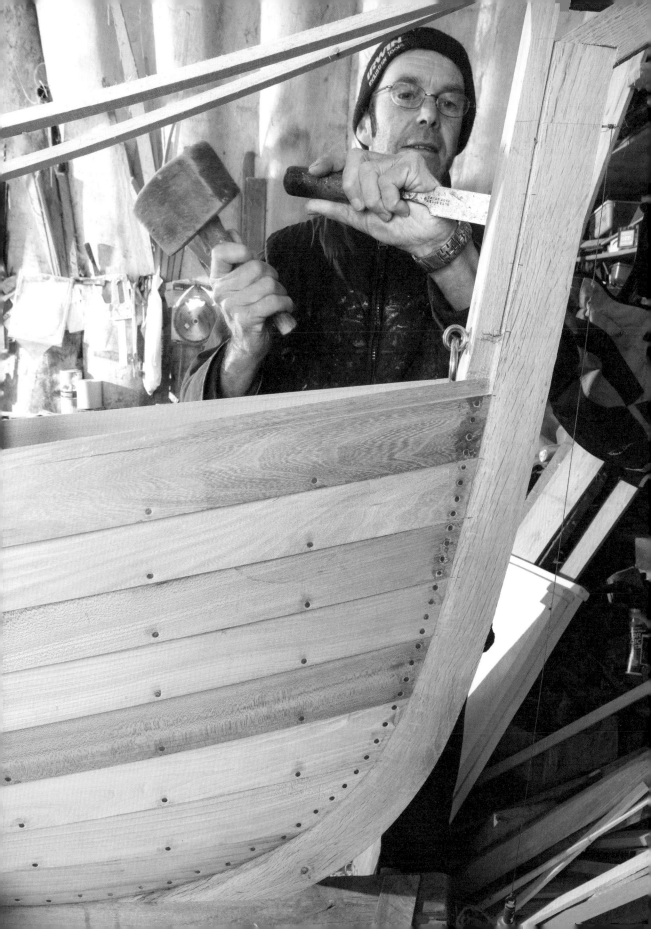

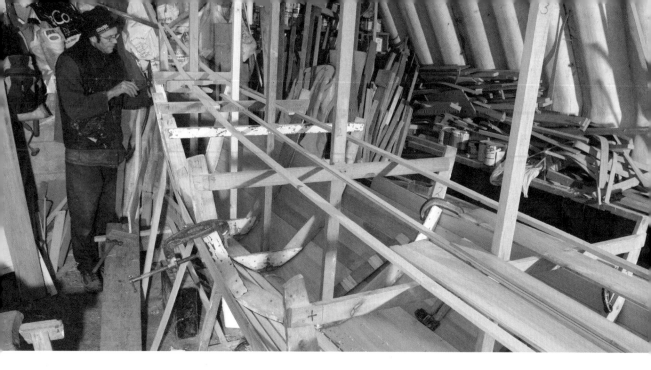

ABOVE *The gig is made to a 19th century specification using mainly hand tools.*

your back and arms than your legs. As you get older, it takes a bit of keeping up. We've got some good youngsters coming through in the club, which is positive for the future.'

Since 1992 he has built gigs for clubs all around Cornwall, including *Ryder* (1992), *Samphire* (1999) and a third one under construction in 2010 for Looe. There have also been commissions from overseas. He admits it was almost inevitable that he would follow his father into the trade.

'As kids we were always messing about with old tools and boats. We were brought up with it. When I left school I went into building for a while, but I didn't get on very well with it. So I did an apprenticeship in a boatyard in Looe, which built all sorts but mainly fishing boats.

'Then I worked with my father. We built only gigs because we got so many orders for them, to be honest. We built the first, *Ryder*, for Looe in 1992 the boat and club did well, and maybe people thought our gig was a bit faster. It took off from there. My father retired a few years back when he was 82 and now my son Tom helps out now and then.'

As stipulated by the CPGA, any gig built today follows the original specifications as laid down by the Peters family of St Mawes in the form of the gig *Treffry*. Boat builder William Peters considered this his finest gig when he completed it in 1838 and the *Treffry* is still used by Newquay Rowing Club.

'In addition to measuring 32ft by 4ft 10in, the original stipulation said gigs should be built from Cornish narrow leaf elm,' Dave explains. 'But now, because there is a shortage, you have to look farther afield for timber. As long as it is elm, it is okay. Most of the elm we use comes from Scotland.

'The gig is inspected by the Association at three stages during building: when it is laid down with the moulds up – it's the moulds that give the gig shape; when it is planked up; and when the boat is finished. There is no weight restriction on the boats, so the weight is in the size of the timber. If people start cheating you could get a much lighter boat. That's why different stages have to be checked technically, to see what is going into the gig. An average gig is roughly seven hundredweight.'

{ *Most gigs are blessed by a minister at their launch. Then everyone goes for a drink* }

A SLOW AND STEADY JOB

'There are currently four or five gig builders in Cornwall, a chap in the Scilly Isles and one in Devon.'

It takes Dave around five months to complete a gig, using mainly hand tools but also electric planers, saws and band saws.

'First, I set the keel down on a base board,' he explains. 'Then you've got what you call a hog [a structural part of the hull] that goes over the top of the keel, and planks that fit underneath the hog. This is followed by the stem or bow of the boat, and the stern posts. Once you've got those fastened down to the keel board, it's called laid down.

'Then you can take your moulds up on the keel. Ours are made of ordinary softwood, because it's easy to cut and plane up. After that, and the bulk of the work, is the clinker [overlapping] planking. Once you're planked up, then you fit the timbers inside, which most builders call ribs, and that holds the shape of the boat by fastening it in. Then I fit the gunwales and the seats have to go in.

'There are also about 46 knees to go in: they are like brackets that hold the seats out against the side of the boat. Years ago they would have been solid bits off a tree, but today we make them from two straight pieces of steamed timber that are glued at right angles. Most people do that, but we then also laminate the two pieces, which gives a lot more strength, makes them lighter, looks better and lasts longer.

'The bulk of the planking and ribs are all fastened together with copper nails, but with the boat being so long it has to be scarfed together using glue, so it seems like one piece of wood,' Dave adds.

Of course, there is much more to building a gig than these basic details and Dave happily explains the minutiae of rivets, roves and dollies, as well as rigging for sailing – another gig tradition. Suffice to say, the boat is finally painted in a club's colours: in the case of Looe, pale blue with white and a varnished top strake (plank).

'Most gigs are blessed by a minister at their launch. Then everyone goes for a drink,' Dave says wryly.

Over the years, many of the boats built by this modest and quietly spoken man have been rowed to victory in competitions. Doesn't it tweak his conscience to be constructing for clubs that will race against Looe?

'It does a little bit! But you can't make them go slower, otherwise you wouldn't get another order,' Dave replies. He has no such worries and he is also confident that gig racing will continue to be popular.

'They are pretty impressive boats and the sport gets lots of people on the water all at the same time. It's the whole tradition that appeals. Nobody else has really got anything like it.

BELOW *Clinker-built boats are constructed by overlappinng the planks of the hull. The strakes (part of the shell of the hull) are fixed together by copper nails.*

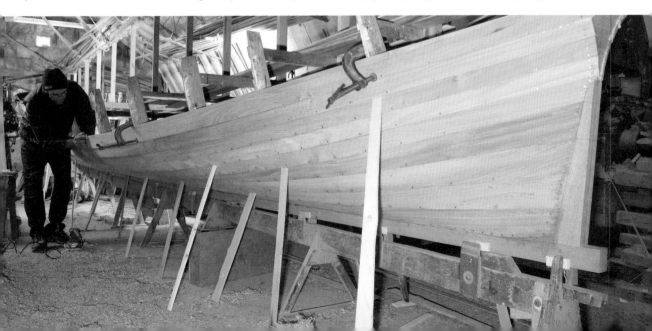

Addresses of Suppliers

VILLAGE WORKSHOP CRAFTS

The Wheelwright

Mike Rowland & Son
Wheelwrights & Coachbuilders
No. 1 Wheelers Yard
Colyton
Devon
EX24 6DT
Tel: 01297 552562
Website: *www.wheelwright.org.uk*
Email: *enquiries@wheelwright.org.uk*

The Cooper

Alastair Simms
Wadworth & Co Ltd
Northgate Brewery
Devizes
Wiltshire
SN10 1JW
Tel: 01380 732270
Website: *www.barrelsrus.co.uk /*
www.wadworth.co.uk
Email: *cooper@wadworth.co.uk*

The Tanner

J & FJ Baker & Co Ltd.
Hamlyns, King Street
Colyton, Devon, UK
EX24 6PD
Website: www.*jfjbaker.co.uk*

The Leather Bottle Maker

Phil Quallington
Green Gables,
Castle Street,
Wigmore, Herefordshire,
HR6 9UB
Website: www.*the-leather-man.co.uk*

The Papermaker

Neil Hopkins
Two Rivers Paper Company
Pitt Mill
Roadwater
Watchet
Somerset
TA23 0QS
Tel: 01984 641028
Website: *www.tworiverspaper.co.uk*
Email: *tworiverspaper@googlemail.com*

The Millwright

Martin Watts
1 Trinity Cottages
Cullompton
Devon
EX15 1PE

The Potter

Kevin Millward
2 St Anne Villas
Schoolbank
Brown Edge
Staffs
ST6 8TE
Website: *kevinmillwardceramics.co.uk*

The Rhubarb Forcer Maker

John Huggins
Ruardean Garden Pottery
Ruardean
Forest of Dean
Gloucestershire
GL17 9TP
Website: *www.ruardeanpottery.com*
Email: *ruardeanpottery@hotmail.com*

The Blacksmith

Don Barker
Website: www.*theblacksmiths.co.uk*

The Rope Maker

Norman Chapman
Outhwaites Ltd (Ropemakers)
Town Foot
Hawes
North Yorkshire, DL8 3NT, UK
Website: *www.ropemakers.com*

DECORATIVE CRAFTS

The Woodcarvers

Edwin Williams
121 St Teilo Street
Pontarddulais
Swansea
SA4 8RA
Tel: 01792 882723
Website: *www.wewilliams.co.uk*
Email: *edwin@wewilliams.co.uk*

Ian G Brennan
Hornby Close
Warsash
Nr Southampton
Hampshire
S031 9GN
Tel: 01489 574025
Website: *www.contemporarysculptor.com*
Email: *ian@contemporarysculptor.com*

The Glass Blowers

Colin and Louise Hawkins
LoCo Glass
Studio 2 Brewery Arts
Brewery Court
Cirencester
Gloucestershire
GL7 1JH
Tel: 01285 651119
Website: *www.locoglass.co.uk*
Email: *info@locoglass.co.uk*

The Goldsmith
Rhiannon Evans
The Welsh Gold Centre
Tregaron
Wales
SY25 6JL
Tel: 01974 298415
Website: *www.rhiannon.co.uk*
Email: *rhiannon@rhiannon.co.uk*

The Stained Glass Artist
Sophie Lister Hussain
Website: *www.lightlust.co.uk*

The Pub Sign Designer
Graeme Robbins
14 North View
Westbury Park
Bristol
BS6 7QB
Tel: 0117 3739147 / 07758561081
Website: www.pubsigndesign.com
Email: *pubsign@blueyonder.co.uk*

The Glass Engraver
Lesley Pyke
Unit 15b Halesworth Business Centre,
Norwich Rd,
Halesworth,
Suffolk IP19 8QJ
Website: *www.lesleypyke.com*

The Serpentine Rock Carver
PL Casley and Son
Local Serpentine Specialists
Lizard Point
Cornwall
TR12 7NU

The Silversmith
Hart Gold & Silversmiths
The Guild of Handicraft
Sheep Street

Chipping Campden
Gloucestershire
GL55 6DS
Tel: 01386 841100
Website: *www.hartsilversmiths.co.uk*
Email: *GofH@hartsilversmiths.co.uk*

BASKETRY CRAFTS

The Basket Maker
Norah Kennedy
Website: www.
norahkennedywillowworker.co.uk
Email: *norah.k@virgin.net*

The Oak Swill Basket Maker
Owen Jones
Website: www.*oakswills.co.uk*

The Bee Skep Maker
David Chubb

The Lobster Pot Maker
Nigel Legge
The Forge
Church Cove
The Lizard
Cornwall
TR12 7PQ
Website: www.*lobsterpots.co.uk*
Tel: 01326 290716

The Rush Seat Maker
AM and KM Handley
2 East Lockinge
Nr Wantage
Oxfordshire
OX12 8QG
Tel: 01235 833362
Website: *www.rushseats.co.uk*
Email: *tonyhandley1@tiscali.co.uk*

The Trug Maker
Carl Sadler
Woodman's World
Wayside
Tetbury Hill Gardens
Malmesbury
Wiltshire
SN16 9JP
Tel: 01666 824932
Website: *www.woodmansworld.co.uk*
Email: *woodmansworld@live.co.uk*

TEXTILE CRAFTS

The Tapestry Weaver
Kirsten Glasbrook
Website: www.*kirsten.glasbrook.com*

The Dyer & Felt Maker
Jane Meredith
The Forge
Byford
Hereford
HR4 7LD
Tel: 01981 590370
Website: *www.plantdyedwool.co.uk.*
Email: *jane@plantdyedwool.co.uk*

The Spinning Wheel Maker
James Williamson

The Lace Maker
Christine Springett
Website: *www.cdspringett.co.uk*

The Fabric Weaver
Margo Selby
Website: *www.margoselby.com*

WOODLAND CRAFTS

The Bowl Maker
Robin Wood
Website: www.*robin-wood.co.uk*
Email: *robin@robin-wood.co.uk*

The Broomsquire
Adam King
43 Melbourne Road
High Wycombe
Buckinghamshire
HP13 7HE
Tel: 07761 596616
Email: adam@adamking.co.uk
Website: www.*adamking.co.uk*

The Hurdle Maker
Bert Manton

The Bodger
Guy Mallinson
Website: www.*mallison.co.uk*

The Stick and Crook Maker
Bill Lowe
Website: www.*billthestickmaker.com*

The Hedgelayer
Phil Godwin
15 Bingham Close
Lewis Lane
Cirencester
Gloucestershire
GL7 1BG
Tel: 01285 641237 / 07980 301140
Email: *phil6099@live.co.uk*

The Clog Maker
Jeremy Atkinson
44 Duke Street
Kington
Herefordshire
HR5 3DR
Tel: 01544 231683
Website: *www.clogmaker.co.uk*
Email: *jeremymark@atkinsontq.wanadoo.co.uk*

The Rake Maker
John and Graeme Rudd
Website: www.*thenaturalgardener.co.uk*

BUILDING CRAFTS

The Brick Maker
Coleford Brick & Tile
The Royal Forest of Dean Brickworks
Cinderford
Gloucestershire
GL14 3JJ
Tel: 01594 822160
Website: *www.colefordbrick.co.uk*
Email: *sales@colefordbrick.co.uk*

The Dry Stone Wallers
Des Hall
7 Hammond Drive
Northleach
Cheltenham
Gloucestershire
GL54 3JF
Tel: 01451 860151

Roger Clemens
Penrose Farm
St Ervan
Wadebridge
Cornwall
PL27 7TB
Tel: 01841 540256

The Flint Knapper
Phil Harding

The Stone Mason
Andy Oldfield
Website: *www.thefringeworkshop.co.uk*

The Thatchers
Matthew Williams
David Bragg
Website: www.*rumpelstiltskin-thatching.co.uk*

CRAFTS FOR SPORT AND RECREATION

The Bowyer/Fletcher
Christopher Boyton

The Bagpipe Maker
Julian Goodacre
4 Elcho Street
Peebles

EH45 9LQ
Scotland
Website: *www.goodbagpipes.co.uk*

The Cricket Bat Maker
Tim Keeley
John Newbery Ltd
The Chalet
The County Ground
Eaton Road
Hove
East Sussex
BN3 3AF
Tel: 01273 775770
Website: *www.newbery.co.uk*
Email: *sales@newbery.co.uk*

The Guitar Maker
Paul Fischer Guitars
West End Studio, 19 West End
Chipping Norton
Oxfordshire
OX7 5EY
Tel: 01608 642792
Website: *www.paulfischerguitars.com*
Email: *paul@paulfischerguitars.com*

The Gunsmith
Graham Bull
John Foster Gunmakers
The Stables
Thorpe Road
Carlton
Stockton-on-Tees
TS21 3LB
Website: *www.johnfostergunmaker.co.uk*
Email: *info@johnfostergunmaker.co.uk*

The Whip Maker
David Thorne
Tel: 07790 954202
Website: *www.huntingwhips.co.uk*

The Gig Boat Maker
Dave Currah
No 5 Sunnycroft
North Road
West Looe
Cornwall
PL13 2EL
Tel: 01503 264738

General Information

The **Heritage Crafts Association** (www.heritagecrafts.org.uk) has been formed to support and promote heritage crafts as a fundamental part of our living heritage.

The Art Workers Guild (www.artworkersguild.org) runs a database of craft apprenticeships.

The Art Guide (www.artguide.org) gives a lengthy list of museums and collections, categorised by the type of craft, with web links to the appropriate site.

Crafts in the Countryside (www.craftsintheenglishcountryside.org.uk) offers an invaluable text (full-length book) that can be downloaded as pdf files, published in 2004 by the **Countryside Agency** and stuffed with reports and practical information on a wide range of crafts, including blacksmithing, farriery, saddle and harness making, wheelwrighting, pole lathe turning and other greenwood crafts, basketry and chair seating,

millwrighting, and heritage building restoration crafts (flint work, dry stone walling, brickwork restoration, timber framing, stonework and thatching). The (late-lamented) Countryside Agency also ran a New Entrants Training Scheme (NETS) that covered crafts such as forgework, furniture making, thatching, wheelwrighting, wood machining, blacksmithing and farriery. The **UK Craft** website directory (www.ukcraftwebsites.co.uk) gives details for a range of crafts, including those working in glass, wood, stone and textiles.

The **Building Conservation** website (www.buildingconservation.com) offers a comprehensive directory of organisations that might be of interest to those whose crafts are relevant, as well as directories of companies, products and services.

In days gone by, there were numerous **craft guilds** and City of London 'Worshipful Companies' or livery companies representing and controlling

many of the traditional crafts, going back in some cases to medieval times. Today, there are still more than a hundred City of London guilds but many have lost their major role and influence. Some are simply ceremonial or charitable organisations that may, or may not, be able to provide funds in support of the craft or may have barely any connection at all with the craft in their name. In theory they are all now philanthropic fellowships and, whether firmly bound or loosely tied to a craft or trade, they usually support education, research and welfare or nurture the skills of those actively involved in the craft. The more active ones do all they can to support craftsmen and often to develop training opportunities. Those for the blacksmiths, goldsmiths, weavers, furniture makers, wheelwrights, carpenters and stone masons are among the most active and are noted for each chapter above. These chapter sections also list other potentially useful organisations.

Index

Acknowledgements

Paul Felix:

Thank you to Sian Ellis and Tom Quinn for their collaboration on this project. Their insights and knowledge were essential for capturing the essence of the crafts people featured in this book. I would also like to thank Neil Baber and Verity Muir at David & Charles for their editorial expertise. And finally, I'd like to extend my thanks to all the craftsmen and women who gave up their time to take part in this book and without whom it wouldn't have been possible.

Mastercrafts

Tom Quinn
ISBN 13: 978-0-7153-3665-6

An exploration and a celebration of traditional British craftsmanship following the craft skills explored in the BBC TV series *Mastercrafts*.

Cost-Effective Self-Sufficiency

Eve and Terence McLaughlin, updated by Diane Millis
ISBN 13:978-0-7153-3828-5

An inspirational guide to teach you everything you need to know about growing your own food and becoming self-sufficient. This updated version of the original guide to self-sufficiency has everything you need to start the good life.

Really Rural

Janey Wilks
ISBN 13:978-0-7153-3518-5

Really Rural offers an affectionate but hilarious look at country life and traditional wisdom from popular *Country Living* columnist Janey Wilks.

Jennifer Aldridge's Archers' Cookbook

Angela Piper writing as Jennifer Aldridge
ISBN 13: 978-0-7153-3338-9

Over 150 recipes from dinner party dishes to farmhouse cakes, brought together in a season-by-season tour of the kitchens of Ambridge with Jennifer Aldridge.